The Age of Hogarth

TATE GALLERY COLLECTIONS: VOLUME TWO

The Age of Hogarth

BRITISH PAINTERS BORN 1675–1709

Elizabeth Einberg and Judy Egerton

THE TATE GALLERY

Published with the assistance of the J. Paul Getty Trust

ISBN 0 946590 80 X
Published by order of the Trustees 1988
Copyright © 1988 The Tate Gallery All rights reserved
Designed and published by Tate Gallery Publications,
Millbank, London SW1P 4RG
Colour origination by PJ Graphics
Phototypeset by Keyspools Limited, Golborne, Lancs
Printed in Great Britain by Balding & Mansell UK Limited

CONTENTS

FOREWORD

This volume is the first to be published of a planned series which will eventually catalogue the whole of the British Collection at the Tate Gallery, each volume to cover a specific period. These periods will be defined, for ease of reference, as being devoted to artists born between particular dates, but it is hoped that they will each more or less cover a distinct phase of British art, as is indeed the case with the present volume.

At present, we envisage that there will be six volumes devoted to the Historic British Collection, to be published under the general editorship of the Keeper, Martin Butlin. The titles, which are provisional, are as follows: *Tudor and Jacobean Painting* (artists born up to 1674); the present volume, *The Age of Hogarth* (artists born between 1675 and 1709); *The Age of Reynolds and Gainsborough* (artists born between 1710 and 1749); *British Romantic Painting* (artists born between 1750 and 1789); *British Painting from Wilkie to Frith* (artists born between 1790 and 1819); and *High Victorian Art* (artists born between 1820 and 1859). It is hoped that the volume covering the penultimate period, *British Painting from Wilkie to Frith*, will be the next to be published.

The catalogue series will continue in a chronological sequence with work by British artists in the Modern Collection, under the general editorship of the Keeper of the Tate Gallery's Modern Collection, Richard Morphet. Here we plan ten volumes, with the artists divided into the decades of their birth dates. The first to appear are likely to be those volumes devoted to artists born in the periods 1870–1879, *Camden Town Artists and Others*; 1800–1899, *Vorticism and Bloomsbury Painters*; and 1940–49.

Many of the works in question have in fact been catalogued before. There are important earlier publications, such as Martin Davies's National Gallery catalogue of the *British School* (1946 edition), and Mary Chamot, Dennis Farr and Martin Butlin's catalogue of *The Modern British Paintings Drawings and Sculpture* (1964), which is devoted to artists born in 1850 and after. All acquisitions since the year 1953–4 have been catalogued in detail in Tate Gallery reports, annual up to 1967–68, then biennial, or since 1974–76 in separate illustrated catalogues of acquisitions. The collection has more than doubled in size during this period.

There is a great deal of excellent material in these publications, but as they fall out of print and become increasingly inaccessible in libraries it seems sensible to launch a new multi-volume series that will be readily available to the public. We shall continue to publish catalogue entries on acquisitions as they are acquired, but the emphasis will now be on the provision of catalogues of the permanent collection.

Alan Bowness *Director*

ACKNOWLEDGEMENTS

The present volume on *The Age of Hogarth* is largely the work of two of my colleagues, Elizabeth Einberg and Judy Egerton. A few of the entries have been done by other members of the Historic British Collection. Many of the entries are based on earlier entries, written for various Tate Gallery reports by past or present members of the staff including Mary Chamot, Dennis Farr, Sir Lawrence Gowing, Robin Hamlyn, Leslie Parris and William Vaughan. Others are based on those in *National Gallery Catalogues: The British School* by Sir Martin Davies (the first edition of 1946 includes many pictures that were subsequently transferred to the Tate Gallery and which are not included in the second edition of 1959); however, Martin Davies's catalogues have acted not only as a source of information but also as an inspiration and model to the present compilers.

Like all catalogues, this one is based to a considerable extent on the work, both published and unpublished, of others. References are given where appropriate to published sources. In addition we should like to acknowledge the help of Brian Allen, Geoffrey Ashton, Angelina Bacon, Malcolm Cormack, John Ingamells, Evelyn Joll, John Kerslake, Richard Kingzett, J G Links, Sir Oliver Millar, Aileen Ribeiro, Jacob Simon and John Sunderland.

Producing some form of unity among entries by so many hands and based on so many sources is not a simple matter. The task of achieving consistency has been undertaken by Leslie Parris but it has been thought best not to impose too rigid a degree of uniformity.

The entries have also benefitted from the enthusiasm and expertise of our colleagues in the Conservation Department, who have made the physical examination of the paintings such as fascinating and profitable excercise, and those in the Library, who have run down many seemingly unobtainable publications. Finally thanks are due to Jane O'Mahony and Julia Clarkson, to say nothing of their predecessors, for typing the complex and ceaselessly corrected texts.

As the catalogue was going to press, the Tate Gallery received a most munificent gift from Mrs Joan Highmore-Blacknall and Dr Rosemary B McConnell consisting of drawings and other archival material by and relating to Joseph Highmore and later members of his family. The material includes a scrapbook of numerous drawings by Joseph Highmore himself which have yet to be fully catalogued but which it has been decided to include here in the form of a check-list so that the basic information can be made available to scholars as soon as possible.

Martin Butlin *Keeper of the Historic British Collection* September 1987

PUBLICATIONS REFERRED TO IN ABBREVIATED FORM:
see also *Literature* under individual artists

Antal 1962 — Frederick Antal, *Hogarth and his place in European Art*, 1962

Baldini & Mandel 1967 — G. Baldini and G. Mandel, *L'Opera Completa di Hogarth*, Milan 1967

Beckett 1949 — R. B. Beckett, *Hogarth*, 1949

Bénézit 1976 — Emmanuel Bénézit, *Dictionnaire des Peintres, Sculpteurs, Dessinateurs et Graveurs* 3rd. ed. 1976

Bindman 1981 — David Bindman, *Hogarth*, 1981

Burke 1955 — Joseph Burke, *William Hogarth: The Analysis of Beauty*, 1955

Croft-Murray 1962, 1970 — Edward Croft-Murray, *Decorative Painting in England 1537–1837*, 2 vols, I 1962; II 1970

Davies 1946, 1959 — Martin Davies, *National Gallery Catalogues: The British School*, 1946 and 1959

DNB 1908 — *Dictionary of National Biography*, 1908, 26 vols

Dobson 1898, 1902, 1907 — Austin Dobson, *William Hogarth*, 1898, 1902 (de luxe edition); 7th revised ed. 1907

Egerton 1978 — Judy Egerton, *British Sporting and Animal Paintings 1655–1867: The Paul Mellon Collection*, 1978

Gowing 1953 — 'Hogarth, Hayman and the Vauxhall Decorations', *Burlington Magazine*, CV, 1953, pp. 4–19

Gowing 1970 — Lawrence Gowing, 'Hogarth Revisited', *University of Leeds Review*, XIII, No. 2, October 1970, pp. 186–98

Grant 1957–61 — M. H. Grant, *The Old English Landscape Painters*, Leigh-on-Sea, 8 vols, I 1957; II 1958; III 1958; IV 1959; V 1959; VI 1960; VII 1960; VIII 1961

Grant 1970 — M. H. Grant, *A Dictionary of British Landscape Painters*, Leigh-on-Sea, revised ed. 1970

Ireland 1791, 1793, 1798 — J. Ireland, *Hogarth Illustrated*, 3 vols, I and II 1791 and 2nd ed. 1793; III (supplement) 1798

Ireland 1794, 1799 — S. Ireland, *Graphic Illustrations of Hogarth*, 2 vols, I 1794; II 1799

Kerslake 1977 — John Kerslake, *Early Georgian Portraits: National Portrait Gallery*, 1977, 2 vols

Kingzett 1982 — Richard Kingzett, 'A Catalogue of the Works of Samuel Scott', *Walpole Society 1980–82*, XLVIII, 1982

Nichols 1781, 1782, 1785 — J. Nichols, *Biographical Anecdotes of William Hogarth*, 1781, revised eds. 1782, 1785

Nichols 1833 — J. B. Nichols, *Anecdotes of William Hogarth*, 1833

Nichols & Steevens 1808, 1810, 1817 — J. Nichols and G. Steevens, *The Genuine Works of William Hogarth*, 3 vols, I 1808; II 1810; III 1817

Oppé 1948 — A. P. Oppé, *The Drawings of William Hogarth*, 1948

Paulson 1970 — Ronald Paulson, *Hogarth's Graphic Works*, New Haven and London, 1970, 2 vols, (2nd revised ed. of 1965 publication)

Paulson 1971 — Ronald Paulson, *Hogarth: His Life, Art and Times*, New Haven and London, 1971, 2 vols

Chaloner Smith 1883 — John Chaloner Smith, *British Mezzotinto Portraits*, 1883, 4 vols

Vertue I–VI — 'The Notebooks of George Vertue', *Walpole Society: Vertue I*, XVIII, 1929–30; *Vertue II*, XX, 1931–2; *Vertue III*, XXII, 1933–4; *Vertue IV*, XXIV, 1935–6; *Vertue V*, XXVII, 1937–8; *Index to Vertue I–V*, XXIX, 1940–2; *Vertue VI*, XXX, 1948–50

Waagen 1854 — G. F. Waagen, *Treasures of Art in Great Britain*, 1854, 3 vols with a supplementary volume *Galleries and Cabinets of Art in Great Britain*, 1857

Walpole's Correspondence — *The Yale Edition of Horace Walpole's Correspondence*, New Haven and Oxford, 48 vols, 1937–1983

Waterhouse 1953, 1978 — Ellis Waterhouse, *Painting in Britain 1530 to 1790*, 1953, 4th, fully revised ed. 1978

Waterhouse 1981 — *The Dictionary of British 18th Century Painters in Oils and Crayons*, 1981

Webster 1979 — Mary Webster, *Hogarth*, 1979

Whitley 1928 — W. T. Whitley, *Artists and their Friends in England 1700–1799*, 1928, 2 vols

EXHIBITIONS REFERRED TO IN ABBREVIATED FORM

AC tour 1946 *English Conversation Pieces of the Eighteenth Century*
Art Council tour: Bristol, Birmingham and Brighton 1946

BC tour 1946 *Masterpieces of British Art*
British Council tour: Chicago, New York, Toronto 1946–47

BC tour 1949 *British Painting 1730–1850*
British Council tour: Kunsthalle, Hamburg; Kunstnerns Hus, Oslo; Nationalmuseum, Stockholm; Statens Museum for Kunst, Copenhagen 1949–50

BC tour 1957 *British Painting in the Eighteenth Century*
British Council tour: Museum of Fine Art, Montreal; National Gallery of Canada, Ottawa; Art Gallery, Toronto; Museum of Art, Toledo (Ohio) 1957–8

BC tour 1960 *Painting in Great Britain 1700–1960*
British Council tour: Pushkin Museum, Moscow; Hermitage, Leningrad 1960

BC tour 1969 *Two Centuries of British Painting*
British Council tour: Birmingham, Vienna, Prague, Bratislava 1969

Manchester 1954 *Hogarth*
City Art Gallery, Manchester 1954

RA 1875 *Old Masters*
Royal Academy 1875

RA 1934 *British Art c.1000–1860*
Royal Academy 1934

RA 1954 *European Masters of the Eighteenth Century*
Royal Academy 1954–5

Tate Gallery 1951 *William Hogarth 1697–1764*
Arts Council Festival of Britain Exhibition, Tate Gallery 1951

Tate Gallery 1971 *William Hogarth*
Tate Gallery 1972

EXPLANATIONS AND ABBREVIATIONS

Measurements are given in millimetres followed by inches in brackets; height precedes width.

Exhibitions took place in London unless otherwise stated.

The place of publication is London unless otherwise stated.

AC Arts Council
BC British Council
BI British Institution
BL British Library
bt bought
FSA The Free Society of Artists of Great Britain
MS manuscript
RA Royal Academy
SA Society of Artists of Great Britain

GIACOMO AMICONI 1682-1752

Also known, less correctly, as Jacopo Amigoni. History, decorative and portrait painter, Venetian in style but with an international career. Important in English painting in helping to spread a new conception of decorative painting, replacing the complex allegories of Laguerre, Verrio and Thornhill, and painting on large canvases framed and let into the wall rather than hung on the wall itself.

Born 1682 in Naples of Venetian parents; already established as a painter in Venice by 1711. According to Vertue studied under Antonio Bellucci in Düsseldorf. Worked in Bavaria 1717-29, particularly at Nymphenburg, Ottobeuren and Schleissheim. Visited Venice, Rome and Naples 1728-9, and in 1729 went from Munich via Holland to England where he remained until 1739, visiting Paris with the castrato singer Farinelli in 1736. Married the mezzo-soprano Maria Antonia Marchesini ('La Lucchesina') 17 May 1738. Worked mainly in and near London, painting a considerable number of portraits and also collaborating with George Lambert on scenery for the Covent Garden Theatre, possibly including that for Handel's *Atalanta* in 1736. Left England for Venice August 1739 having been supplanted by Hogarth as decorator of St Bartholomew's Hospital. Encouraged Canaletto to come to England. Summoned to Spain by Ferdinand VI in 1747 and died in Madrid 22 August 1752.

LITERATURE
Croft-Murray 1970, pp.17-19, 163-4; Waterhouse 1981

EXHIBITIONS
Pietro Zampetti, *Dal Ricci al Tiepolo*, Palazzo Ducale, Venice 1969, pp.87-9

1 **Mercury about to Slay Argus** 1730-32

T 01299
Oil on canvas 655 × 645 ($25\frac{0}{4} × 25\frac{1}{4}$)
Purchased (Grant-in-Aid) 1971

PROVENANCE
...; private collector near Freiburg im Breisgau c. 1964, by whom sold to a German dealer and by him to the Galerie Munsterberg 8, Basle; sold by them, Sotheby's 24 March 1971 (53, repr.) bt Colnaghi for the Tate Gallery

EXHIBITED
English Baroque Sketches, Marble Hill, Twickenham 1974 (76, repr.); *Pittura inglese 1660-1840*, Palazzo Reale, Milan 1975 (57, repr.)

LITERATURE
Vertue III, pp.35, 46, 69; F.J.B. Watson, 'English Villas and Venetian Decorators', *RIBA Journal*, LXI, 1954, p.xx; Christopher Hussey, *English Country Houses: Early Georgian*, 1955, p.43; *English Taste in the Eighteenth Century*, exh. cat., RA 1955-6, pp.26-7, no.6; Croft-Murray 1962, pp.76-7, 272, 1970, pp.18-19, 165; T.P. Hudson, 'Moor Park, Leoni and Sir James Thornhill', *Burlington Magazine*, CXIII, 1971, pp.657-61; A. Baird, 'Jacopo Amigoni in England', *Burlington Magazine*, CXV, 1973, p.734, fig.41

This sketch is for one of the four large decorative paintings by Amiconi at Moor Park near Rickmansworth, Herts., some fifteen miles north-west of London. In the finished picture (repr. in col., Waterhouse 1981, p.19) Jupiter, accompanied by putti and an eagle, is seen reclining on a cloud overhead, surveying the scene. Argus holds a staff in his right hand and the two cowherds behind are more sharply defined. The finished picture (fig.1) is an upright with a shaped top and it is clear

that the Tate Gallery's sketch was originally also an upright, the original paint continuing over the turn-over at the top and being cut off at the present edge; there are however no traces of Jupiter and his companions in the corresponding area of the sky in the sketch, part of which has been retained. The original size of of no.1 is suggested by a companion sketch for 'Argus Lulled to Sleep', approx. 760 × 635 (30 × 25), in the Gemäldegalerie, Dresden, catalogued as by Pellegrini (see Baird, p.734, fig.42).

Moor Park was bought and rebuilt in 1720 by the city magnate Benjamin Styles, the chief architect being Sir James Thornhill who also decorated the hall with eight large inset canvases 'representing 8 heroic Virtues taken from several stories of the Antients, Greeks & Latins & Britons' (Vertue, p.35) as well as the ceiling. There was, however, a dispute over part of Thornhill's bill, leading to two lawsuits in 1728 and 1730, and in 1732 Vertue recorded that 'Mr Styles of More Park has had painted by Amiconi (I hear) 7 or 8 stories to place in his hall in lieu of those Sr. James Thornhill did – & no doubt intended as a mortification to him' (p.63).

Amiconi in fact painted only four pictures, those decorating the main walls of the hall below the gallery; the four canvases of gods above are probably by Francesco Sleter (1685-1775). They illustrate the subject of Jupiter and Io from Ovid's *Metamorphoses*. Jupiter, enamoured of the nymph Io, changed her into a heifer to protect her from the jealousy of Juno who, suspicious of what was going on, asked for the heifer and handed her over to 'hundred-eyed' Argus for safe-keeping. Jupiter asked Mercury to kill Argus, which he did after first lulling him to sleep. Juno then took Argus's eyes and used them to decorate the tail of her peacock. Io was eventually restored to human shape and gave birth to Epaphus. The four pictures show 'Jupiter and Io', 'Argus Lulled to Sleep by the Flute of Mercury', 'Mercury about to Slay Argus' and 'Juno Receiving the Head of Argus from Mercury'.

A set of four small but finished pictures by Amiconi, each approx. 775 × 650 ($30\frac{1}{2} \times 25\frac{1}{2}$), includes two variants of the Moor Park pictures: 'Argus Lulled to Sleep', in the Seattle Art Museum, and 'Jupiter and Io', in the Mayer sale, Lepke, Berlin, 7-9 October 1913, lots 432-4 with the two other pictures, showing a 'Dancing Bacchante' and a 'Sleeping Bacchante'. These seem to have belonged to Amiconi's friend the castrato Farinelli (see Jacob Simon in Marble Hill 1974, exh. cat.).

The Tate Gallery also owns a sketch for one of the earlier Moor Park decorations. This is by Antonio Verrio (T 00916) and is for the ceiling of the saloon, probably painted for the Duke of Monmouth between 1670 and 1685 but preserved when the house was rebuilt by Thornhill (see Croft-Murray 1962, p.239).

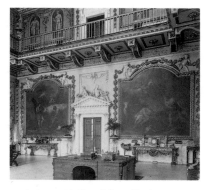

fig. 1 The Hall at Moor Park, Herts., showing two of Amiconi's four paintings of the story of Jupiter and Io *in situ* (photo: *Country Life*).

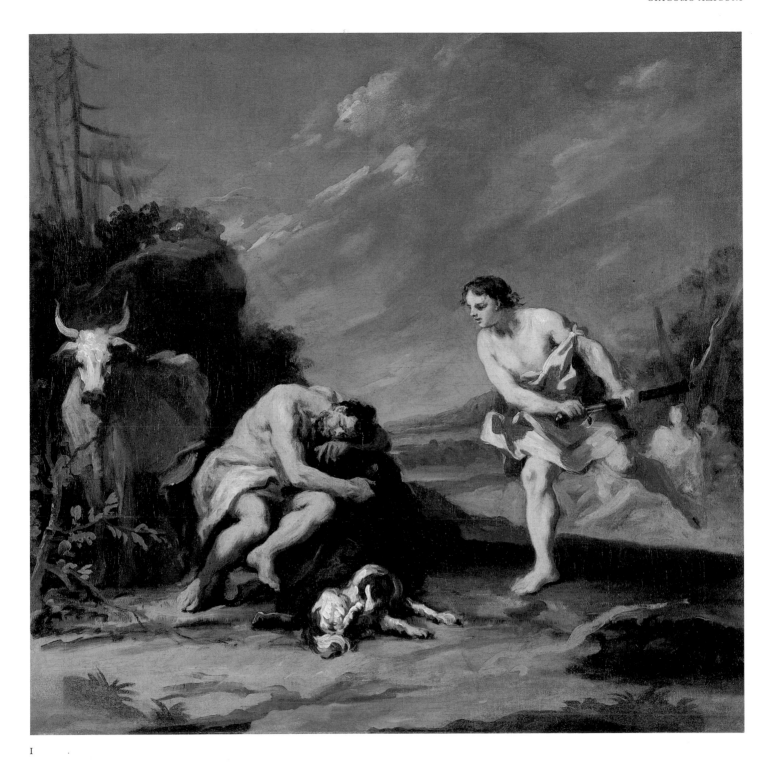

I

PETER ANGELLIS 1685-1734

Also known as Pieter, or Peter Angelles, Angillis, etc. Painter of conversation pieces, historical scenes, and rustic and urban genre, particularly market scenes with an emphasis on still-life. His sophisticated Flemish style ultimately derives from Teniers.

Born 5 November 1685 at Dunkirk, one of a generation of Antwerp artists whose influence spread to Germany as well as in England and the Low Countries. In Düsseldorf 1712 studying the Old Master collection there. Master of the Guild of St Luke in Antwerp 1715–16. Differing reports suggest that he came to England in 1712, 1716 or 1719; sometime between 1716 and 1719 seems most likely. He was living in Covent Garden Piazza 1726. Around 1722 joined Tillemans, Vanderbank and others in a scheme to paint small scenes for engravings of the life of Charles I. Left London for Italy August 1728. Died on his way back at Rennes 1734.

2 **Conversation Piece** *c*.1715–20

T 00789
Oil on canvas, painted surface 937 × 797 ($36\frac{7}{8}$ × $31\frac{3}{8}$), relined on canvas 945 × 802 ($37\frac{1}{4}$ × $31\frac{5}{8}$)
Inscribed 'PAngelles' (initials in monogram) bottom centre
Presented by the Friends of the Tate Gallery 1965

PROVENANCE
...; Mrs E.H. Peacocke; R.M. Sabin, sold 1945 to Knoedler by whom sold anon., Sotheby's 7 December 1960(73) bt Colnaghi, from whom bt by the Friends of the Tate Gallery 1965

EXHIBITED
The Conversation Piece in Georgian England, Kenwood 1965 (1)

Previously entitled 'The Marriage Contract'. It is doubtful whether this is in fact the subject, and it has also been suggested that it might be a scene from a play. The museum of the Nederlands Theater Institut in Amsterdam dates the picture to the 1730s (letter from J.W. Niemeijer of the Rijksmuseum), but this seems too late. Robert Raines (letter of 29 September 1985) likens the picture to 'The Sculptor's Studio' of 1716 in Stockholm and therefore to work done before the most probable date for the artist's arrival in England. However, the exclusively English provenance, in so far as it goes, gives slight support to a dating during Angellis's first years in England.

On the back there is a label of the 1954–5 RA exhibition, *European Masters of the Eighteenth Century*, but in the event the picture was not hung.

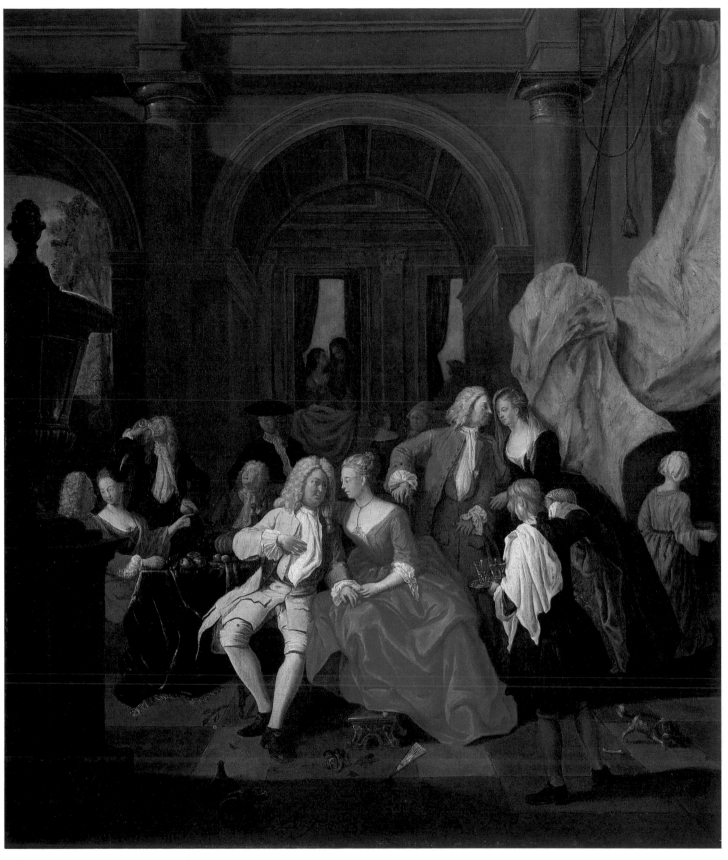

2

GEORGE BEARE active 1738, d.1749

Portrait painter of considerable talent who seems to have worked mainly in the West Country. Little is known of his training, but some fifty signed paintings, all dated between 1744 and 1749, suggest a knowledge of Mercier and particularly of Hogarth, with whom he has sometimes been confused with more justice than usual. He died at Andover, Hants., a few days before 22 May 1749, when his obituary appeared in *The Salisbury Journal*.

LITERATURE
C.H. Collins-Baker, 'A Portrait Painter Rediscovered', *Country Life*, 20 March 1958, pp.572–3, 998; Nigel Surry, 'George Beare: a note on current research', *Burlington Magazine*, CXXVII, 1985, pp.745–49

3 **Portrait of a Gentleman, Possibly Hugh Marriott** 1746

T 00201
Oil on canvas 759 × 632 (29$\frac{7}{8}$ × 24$\frac{7}{8}$)
Inscribed 'Geo; Beare.' b.l. and 'Pinxt 1746.' b.r., along edge of false oval
Purchased (Cleve Fund) 1958

PROVENANCE
. . .; in the possession of the Smith-Marriott family, Horsmonden Rectory, Kent, until sold by Geering & Colyer of Hawkhurst, Kent, in 1944 (firm's wartime records destroyed) bt Francis Harper . . .; anon. sale Sotheby's 28 January 1948 (100 as one of a pair) bt Colnaghi, and sold 27 May 1948 on their behalf by Knoedler to F. G. Rye, CBE; his son E.B. Rye, sold Christie's 27 June 1958(86) bt by the Tate Gallery

LITERATURE
Collins-Baker 1958, p.572, fig.5

The sitter has been tentatively identified as Hugh Marriott of Spelmonden, Horsmonden, Kent, who died in 1754, aged forty-three. (See also *The Gentleman's Magazine*, XXIV, 1754, p.95, where a Hugh Marriotte of Tooke's Court is recorded as having died 14 February; this is probably one and the same man. The compilers are indebted to the Revd W.F.E. Peareth, a descendant of the Smith-Marriott family, for his kind assistance.)

Throughout the eighteenth century, before assuming the name Marriott in 1811, the Smith ancestors of this family resided chiefly in the West Country. In view of the fact that most of Beare's identified portraits seem to be connected with that region, the portrait could have entered the Smith-Marriott collection from any of the family's numerous ramifications there.

In 1948 this portrait was sold as a pair to a 'Gentleman in a Grey Coat with Embroidered Waistcoat, in a painted oval, signed and dated 1747' (bt Colnaghi and probably the same as Christie's 27 July 1956, lot 83 bt Dent), but it is not possible to establish if both portraits came from the Smith-Marriott collection.

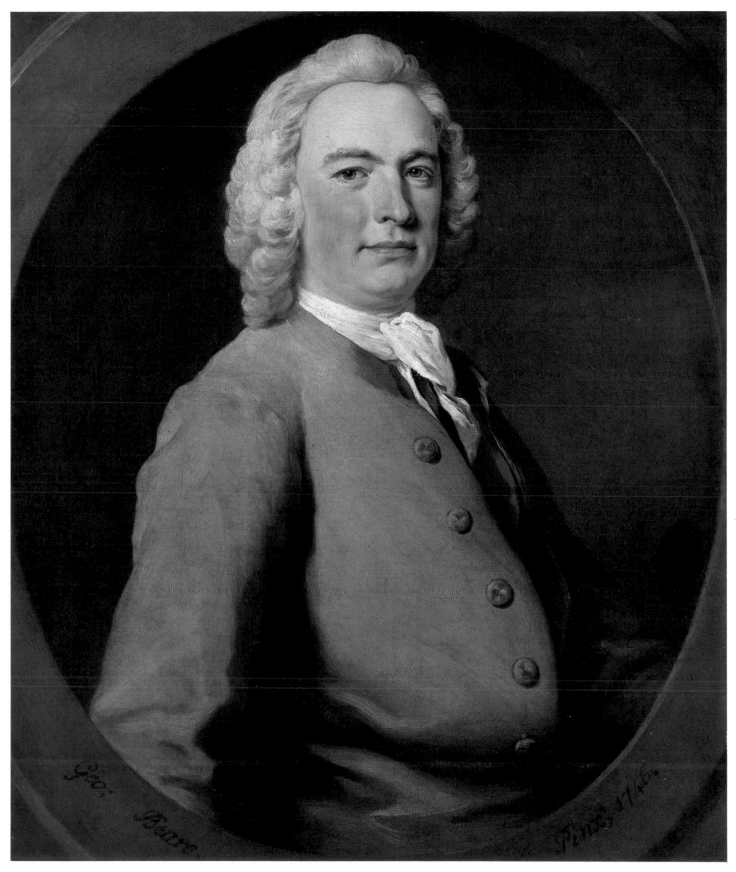

3

after LOUIS PHILIPPE BOITARD active 1734-1760

L. P. Boitard was a book illustrator and draughtsman of contemporary life. Born in France, son of François Boitard (*c*.1670–*c*.1717), illustrator and draughtsman; came with his father to England, probably in the first quarter of the eighteenth century, where he married and settled.

4 **An Exact Representation of the Game of Cricket** *c*.1760

N 05853
Oil on canvas 489 × 591 ($19\frac{1}{4}$ × $23\frac{1}{4}$)
Purchased (Grant-in-Aid) 1948

PROVENANCE
…; T. Grange, from whom bt 1948

EXHIBITED
Two Centuries of Cricket Art, Graves Art Gallery, Sheffield 1955 (2, as 'attributed to L.P. Boitard')

This is one of several versions in oil, probably by different hands, which are based on a line-engraving lettered (above) with the title 'An Exact Representation of the Game of Cricket' and (below) 'H. Roberts sculp. from a curious drawing made after the life by L.P. Boitard', published by John Bowles in several states, one dated 1743 (repr. Neville Cardus and John Arlott, *The Noblest Game*, 1969, pl.1).

Boitard's 'curious drawing' is now untraced, but was probably in pen and ink, with or without watercolour (like all his known work?). A larger oil version (622 × 990, $24\frac{1}{2}$ × $38\frac{3}{4}$), in the collection of the Marylebone Cricket Club (fig.2), appears to correspond in all details with the engraving; it bears the initials 'R.H.' lower left (?the reversed initials of H. Roberts, the engraver), and may be the first version in oil. The Tate Gallery picture differs from the engraving and the MCC version in such details as the colours of dress, the pose of the two men seated on the grass in the upper centre, keeping the score, where the right-hand figure turns his head away towards the fielders instead of concentrating on his tally-stick, and in the omission of one group of four spectators in the background on the left. Versions in oil have also been reported in private collections in England and in the USA (the latter having a wooded landscape background). One state of the engraving of 'An Exact Representation of the Game of Cricket' (fig.3) is stated by Cardus and Arlott to be dedicated 'to all Gentlemen Lovers of that Diversion'; perhaps there was an enthusiastic market among them for versions in oil, a market probably stimulated by the publication in 1744 of the first 'Laws of Cricket' (quoted in Cardus and Arlott, p.12). The wicket depicted here has only two stumps. The third stump was added to the game in 1744.

No.4 was for some years around 1960 listed in the Tate Gallery's concise catalogues as by W.R. Coates, and reproduced as a postcard with this attribution, though no record survives to explain how this evident mistake was made.

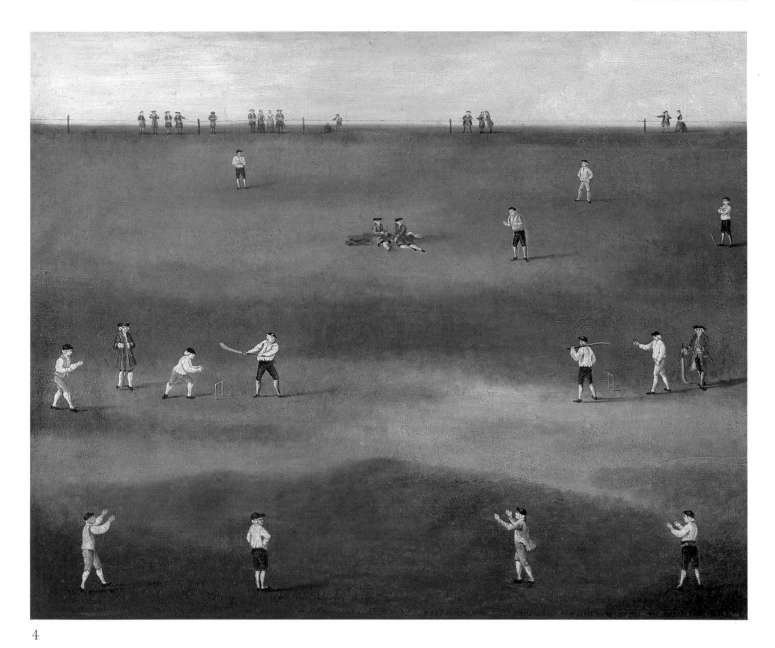

4

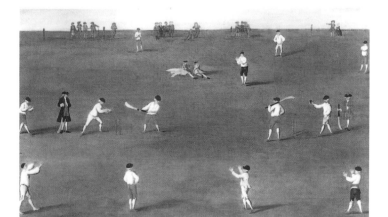

fig. 2 After L. P. Boitard: 'A Game of Cricket'.
Oil on canvas 622 × 984 (24½ × 38¾).
Marylebone Cricket Club.

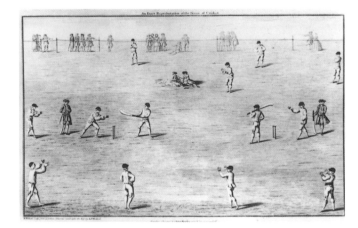

fig. 3 'An Exact Representation of the Game of Cricket'.
Engraved by H. Roberts 'after a curious drawing made
after the life by L. P. Boitard' (photo: Marylebone Cricket Club).

5 **Classical Landscape with Mountains** *c.*1720–40

N 02982
Oil on canvas 356 × 457 (14 × 18)
? Bequeathed by Richard and Catherine Jones
Garnons to the National Gallery 1854;
transferred to the Tate Gallery 1949

LITERATURE
Davies 1946, p.181 as 'ascribed to Wilson';
W.G. Constable, *Richard Wilson*, 1953, pp.105,
129–31

PROVENANCE
...;? Richard and Catherine Jones Garnons
at Colomendy by 1854

The painting is identified by a late nineteenth-century inscription in ink on the
stretcher as coming from the 'Garnons Bequest 1854 as a Wilson'. The bequest
consisted of sixteen paintings from Colomendy in Wales, where Richard Wilson
retired in old age. As the paintings were not individually listed until some years
later, it is not always certain which paintings actually formed part of the bequest,
but no.5 appears to have been inventoried in *The Return of the Pictures Acquired by the
National Gallery up to 1860* as a 'Classical Landscape' by Wilson. This would not now
be considered a possible attribution, and Martin Davies's description of it as 'a
Lambert-like imitation of Poussin' is closer to the mark as the painting seems to be
by an unidentified hand of George Lambert's generation or earlier. It was also
catalogued in 1929 as 'Roman School 18th Century'.

5

6 **Self-Portrait of an Unknown Artist at the Age of Twenty-two** *?c.*1740

N 01076
Oil on canvas 749 × 619 (29$\frac{1}{2}$ × 24$\frac{3}{8}$), relined
on canvas 769 × 639 (30$\frac{1}{16}$ × 25$\frac{1}{8}$), subject
within feigned oval
Inscribed 'Se ipse Pinxit.|Aetat. 22' b.l.
Purchased by the National Gallery 1879;
transferred to the Tate Gallery 1919

PROVENANCE
...; Samuel Boddington; Lady Webster, by
whose executors sold Christie's 9 June 1866
(302 as 'Hogarth. Portrait of a gentleman, in a
black dress and cap') bt James Hughes
Anderdon, by whose executors sold Christie's

30 May 1879 (87 as 'Aikman. Portrait of a
boy') bt Barton for the National Gallery, and
catalogued there as 'Hamlet Winstanley.
Portrait of the Artist (?)'

EXHIBITED
Summer Exhibition of Paintings and Art, Longford
Hall Art Gallery and Museum 1934 (61)

LITERATURE
Catalogue of the British and Foreign Pictures,
National Gallery, 1912, p.765, no.1076;
Geoffrey Grigson, 'George Stubbs,
1724–1806', *The Harp of Aeolus*, 1947, p.14 n.1

The inscription 'Se ipse Pinxit.|Aetat.22' lower left (fig.4) was revealed during restoration in 1981. One might reasonably have expected that the artist would have added a signature or at least a date, perhaps lower right, but there is no other inscription.

The portrait has been variously attributed in the past to Hogarth, Aikman (this attribution, as a portrait of Gay, is inscribed in pencil on the back of the relined canvas, presumably by J.H. Anderdon) and Winstanley. The National Gallery's attribution to Winstanley was presumably based on a fancied resemblance to Winstanley's self-portrait at an easel, engraved by John Faber Jnr in 1731; but no.6 does not seem to be painted in Winstanley's style, has no very close resemblance to Winstanley's features in Faber's engraving and does not include the two moles on the sitter's face which are a prominent feature of the ivory portrait bust of Winstanley signed 'GVDR' and dated 1740 (in the collection of the Victoria and Albert Museum, repr. *Burlington Magazine*, CXXIII, 1981, frontispiece and fig.103, noted on p.63)

It has also been noticed that no.6 bears some likeness in pose and features to the self-portrait (at an older age) by Arthur Pond, etching and drypoint, dated 1739 (repr. Louise Lippincott, *Selling Art in Georgian London: The Rise of Arthur Pond*, 1983, frontispiece); but no.6 is a work of considerable quality and Miss Lippincott considers (in correspondence and on visits to the Tate Gallery) that it is 'much too good a painting to have been executed by Arthur Pond while in his twenties'. Possibly the unknown artist knew of Pond's self-portrait and modelled his own pose on it; he may also have been influenced by portraits and self-portraits by Jonathan Richardson Snr and Jnr.

fig. 4 British School, Eighteenth Century: 'Self-Portrait of an Unknown Artist at the Age of Twenty-Two', no. 6: detail of inscription.

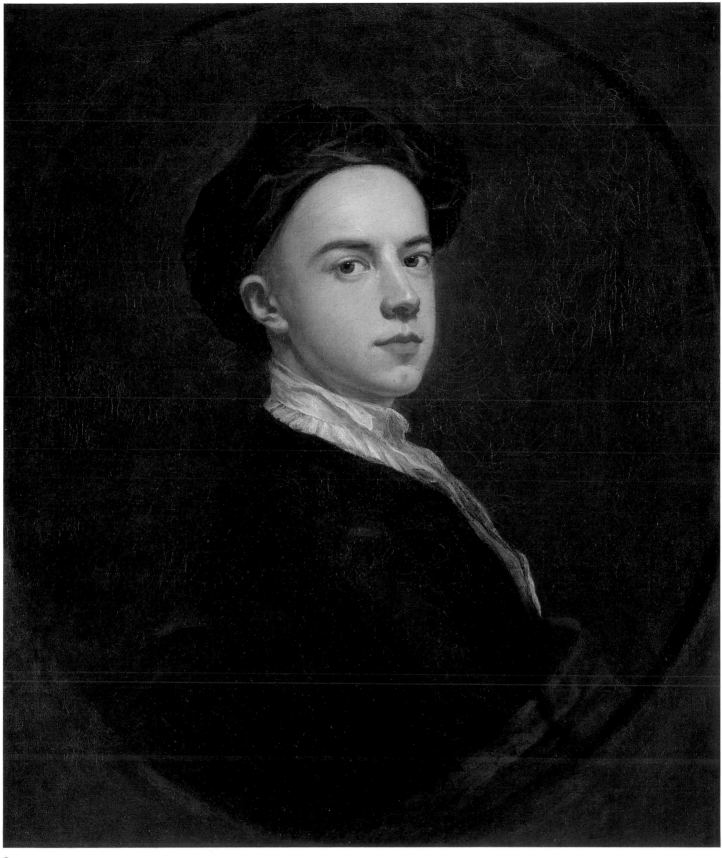

6

7 **Study of a Human Skull** *? c.*1750

N 02220
Black chalk on cream hand-made paper
178 × 199 (7 × 7¾)
Presented by the Revd John Gibson to the
National Gallery 1892; transferred to the Tate
Gallery 1919

PROVENANCE
...; Revd John Gibson by 1892

EXHIBITED
*Two Centuries of British Drawings from the Tate
Gallery*, CEMA tour 1944 (30 as Hogarth, 'a
study for "The Quack Doctor"')

LITERATURE
Michael Ayrton and Bernard Denvir,
Hogarth's Drawings, 1948, p.78, pl. 30 (as
Hogarth, 'a study for "The Quack Doctor",
dated 1744'); Davies 1959, p.56 n.104

The drawing entered the National Gallery's collection in 1892 (with no.12)
attributed to Hogarth. This attribution, retained after its transfer to the Tate
Gallery in editions of the Tate Gallery's *British School* catalogue until 1947, was
apparently based solely on what Martin Davies, more judiciously referring to the
drawing in 1959 as 'ascribed to Hogarth', termed 'some apparently chance
resemblance' to the skull which reposes (also propped up on a book, but looking
towards the right) on a table on the right of Hogarth's 'Marriage A-la-Mode III:
The Visit to the Quack Doctor' (National Gallery no.115, repr. Michael Wilson,
The National Gallery, London, 1977, p.116).

It is difficult to make confident suggestions either about the date of the drawing
or its artist's country of origin. While it is included here as British School, the artist
may prove to be Dutch or Flemish. The artist's purpose in making the drawing
appears to have been primarily to exercise his powers of observation and
draughtsmanship, which are evidently of a high order, with more sensitivity to the
play of shadows than might be looked for in an anatomical or antiquarian
draughtsman, yet with no exaggerated feeling for the macabre or for the poignancy
of a *memento mori*.

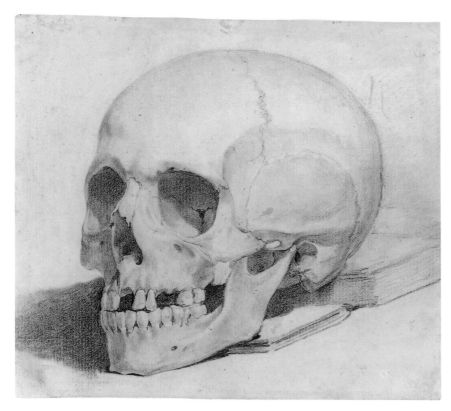

Study of a Human Skull ? c.1750

7

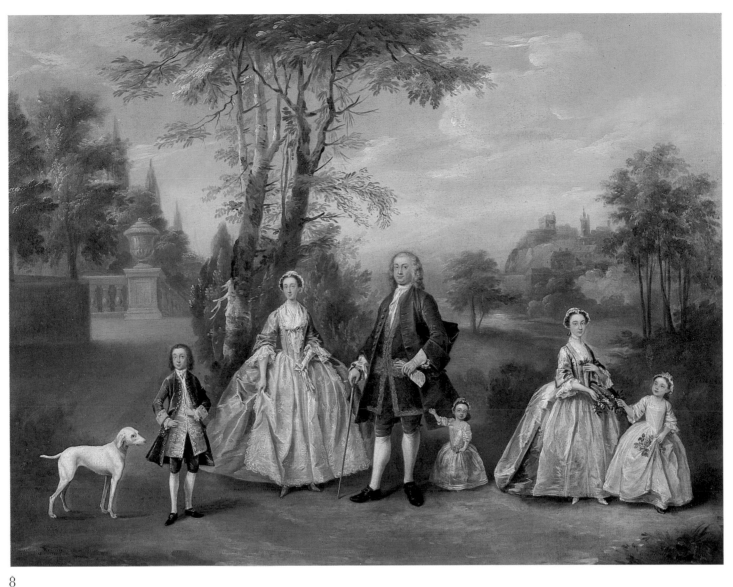

8

8 **Family Group in a Landscape** *c.*1750

N 05049
Oil on canvas 720 × 898 ($27\frac{5}{8}$ × $35\frac{3}{8}$)
Presented by Mrs Helen Alice Wilder to the
National Gallery 1939; transferred to the Tate
Gallery 1949

PROVENANCE
...; Mrs Anna Dora Denison (*née*
Cumberbatch); her god-daughter and heir
Mrs H.A. Wilder of Newton House, Tetbury,
Glos., 1939, by whom presented to the
National Gallery 'in accordance with the
wishes of the late Mrs E.F. Denison'

The family group, comprising both parents, a boy and three girls, remains
unidentified, although the tradition is that the painting descended in Mrs
Denison's family.

The style is close to some British provincial painters of this period, although the
high colour and strong blue and russet tones of the foliage and distant town
prospect are unusual and suggest Continental influence. Comparison with David
Morier (*c.*1705–70), who worked in England from *c.*1743 onwards, is possible but,
as all his documented paintings are of military subjects, must remain inconclusive.

9 **View of Greenwich Hospital** after 1750

N 04764
Oil on canvas 337 × 900 ($13\frac{1}{4} \times 35\frac{7}{16}$)
Presented by the Hon. Mrs Phillimore to the
National Gallery 1934; transferred to the Tate
Gallery 1948

PROVENANCE
...; Hon. Mrs Phillimore by 1934

Both nos.9 and 10 are by the same unknown hand and, since their shapes suggest that they were painted as over-door or over-mantel pictures, probably that of a decorative painter rather than an original artist. They entered the National Gallery's collection as by Samuel Scott, but seem rather to show the influence of Canaletto. While no.10 reveals some direct knowledge of Canaletto's work, no.9 may largely be drawn from engraved views by anonymous artists, such as the 'Greenwich Hospital' engraved by T. Bowles and published 18 June 1745 or 'A Prospect of Greenwich Hospital from the River', engraved by J. June, printed for E. Bakewell and H. Barker, n.d., c.1750. In both views there are individual variations in the foreground shipping, in a manner probably inspired by Canaletto. (The compilers gratefully acknowledge the help of Jane Dacey of the National Maritime Museum, author of 'A Note on Canaletto's Views of Greenwich', *Burlington Magazine*, CXXIII, 1981, pp.486-7.)

10 **View of Chelsea College with Ranelagh House and the Rotunda** after 1751

N 04765
Oil on canvas 337 × 898 ($13\frac{1}{4} \times 35\frac{3}{8}$)
Presented by the Hon. Mrs Phillimore to the
National Gallery 1934; transferred to the Tate
Gallery 1948

PROVENANCE
...; Hon. Mrs Phillimore by 1934

Pair to no.9. This view of Chelsea College (now called The Royal Hospital, Chelsea) reveals direct knowledge of at least part of Canaletto's 'View of Chelsea College with Ranelagh House and the Rotunda', which at some stage was divided into two parts, and was apparently not engraved. Canaletto's picture is discussed and the original composition illustrated by J.G. Links in his revised edition of W.G. Constable, *Canaletto*, 1976, I, pp.407-8, no.413, II, pl.75, and by James L. Howgego, 'A Recent Canaletto Discovery', *Guildhall Miscellany*, VII, 1956, pp.21-9, pl.5.

Canaletto exhibited his picture to the public at his lodgings in Golden Square for fifteen days from 31 July 1751 (Links, I, p.408). Links suggests (p.407) that its division into two parts 'was made fairly soon after the picture was painted' (and certainly by 1802, when the right-hand part was sold independently); and he suggests (in correspondence) that the Tate Gallery picture 'was painted by someone who had seen the right side of Canaletto's view and knew of the existence of the left although he had not seen it'.

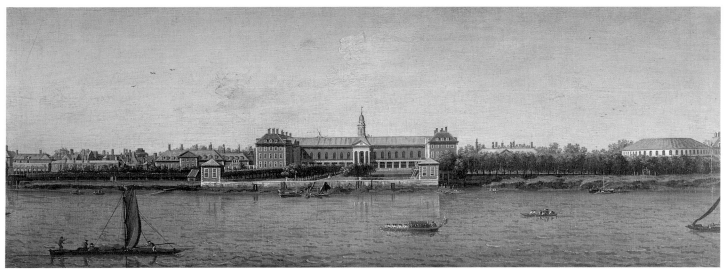

9

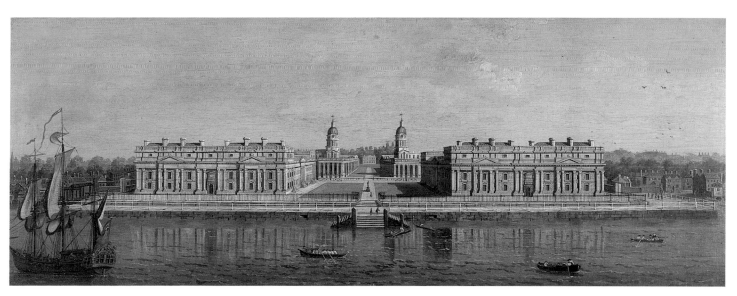

10

11　**A Family Group in a Garden**　*c.*1754

T 01896
Watercolour and gouache 392 × 357
(15$\frac{7}{16}$ × 14$\frac{1}{16}$), within a black watercolour
border probably added by a later hand, on
hand-made laid paper 430 × 396
(16$\frac{15}{16}$ × 15$\frac{9}{16}$); watermark 'IV'
Bequeathed by Alan Evans to the National
Gallery 1974; transferred to the Tate Gallery
1974

PROVENANCE
...; Alan Evans by 1974

LITERATURE
Aileen Ribeiro, *A Visual History of Costume: The
Eighteenth Century*, 1983, p.68, no.70, repr. p.69

This reputedly entered Alan Evans's collection as by Gainsborough, and was later
attributed by Alan Evans to Gravelot; while certainly not Gainsborough's work, it
seems unlike Gravelot's. The handling of the figures, the informality of the group
and its Rococo setting suggest that the artist must have been familiar with the work
of Hayman and of other artists in the circle which frequented Slaughter's Coffee
House in St Martin's Lane; but his identity is elusive. The work has great charm,
yet some unevenness in the handling suggests that it is not by one of the most
accomplished artists of that circle; for instance, the debonair yet wholly relaxed
elegance of the man's pose and the sensitivity of his portrait are not matched in the
figures of his wife and children, and the staginess of the leafy foreground is oddly at
variance with the informality of the group. Neither the family nor the setting has
been identified.

The dating of *c.*1754 is that suggested by Dr Aileen Ribeiro from the details of
costume.

12　**Study of a Man's Head**　?*c.*1765

N 02221
Pen and iron-gall ink on cream hand-made
laid paper 82 × 71 (3$\frac{3}{16}$ × 2$\frac{3}{4}$), laid down on
similar paper, within ruled ink borders
Presented by the Revd John Gibson to the
National Gallery 1892; transferred to the Tate
Gallery 1919

PROVENANCE
...; Revd John Gibson by 1892

LITERATURE
Michael Ayrton and Bernard Denvir,
Hogarth's Drawings, 1948, p.78, pl.31 (as
Hogarth '*c.*1740')

This drawing entered the National Gallery's collection with no.7, each with an
attribution to Hogarth which cannot be supported. In the case of no.12, the
attribution evidently derived from an inscription of *c.*1800 on the verso of the paper
on which the drawing is laid, which reads 'The person who gave this Drawing
assures me that it was bought of Mrs Hogarth – that it was her Husbands Portrait
and done by himself. It seems to be in the bold style of his Engravings.'

Nos.7 and 12 appear to be by different unknown hands. In no.12 the penwork
has some similarity with that of John Hamilton Mortimer; this drawing may be by
one of his colleagues at the St Martin's Lane Academy.

11

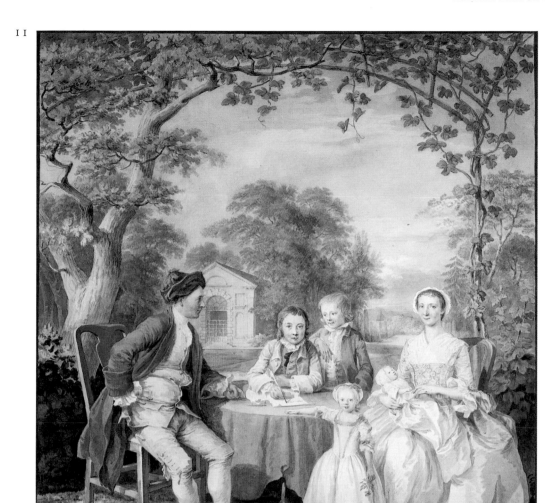

12

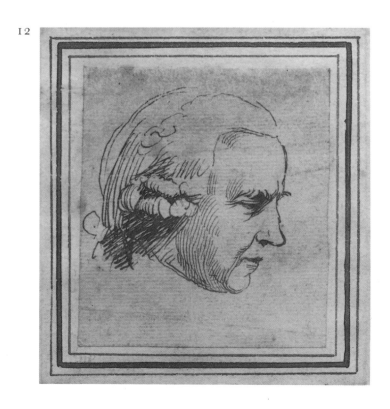

CHARLES COLLINS *c.*1680-1744

Painter of still-life and, in Vertue's phrase, 'all sorts of Birds & Game & Fowls'. Born in Ireland, and active in Dublin; described as 'an Irish master' in the catalogue of the sale of the collection of Sir Gustavus Hume in Dublin, May 1786. Painted numerous large studies of birds in watercolour and body-colour, some of which were engraved. Vertue describes his manner as 'tolerable free & masterly', and notes a large picture of birds and hares which includes Collins's 'own portrait with his hat on – leaning on one side of the picture' (present location unknown).

13 **Lobster on a Delft Dish** 1738

T 03301
Oil on canvas 705 × 910 (27¾ × 35¹³⁄₁₆)
Inscribed 'Charles Collins. Fec.ᵗ 1738' along left edge of shelf
Purchased (Grant-in-Aid) 1981

PROVENANCE
...; anon. sale, Sotheby's 12 November 1980 (47, repr.) bt Rafael Valls, from whom bt by the Tate Gallery

The lobster, its bright red shell powdered here and there with the scummy evidence of its death by boiling water, lies on what is probably an English delftware dish (i.e. of tin-glazed earthenware, the design in this case likely to be after a Chinese porcelain original); the dish waits on the bare stone shelf of a larder. No.13 derives from the Dutch still-life tradition, though a Dutch artist would almost certainly have assembled more ingredients, celebrating or possibly moralising over sensual pleasures. Among the many Dutch still-lifes which include a lobster, often on a dish which is slightly tilted (as in no.13) to show off the creature's extraordinary shape, William Kalf's 'Still Life with the Drinking-Horn of the Saint Sebastian Archers' Guild' in the National Gallery (no.6444) is among the more flamboyant.

A still-life by Collins of a lobster on a (?) pewter dish on a table, with a loaf of bread, flagons of wine, etc. (610 × 749, 24 × 29½) was with Galerie Christa Cackett, Basle, 1985-6 (fig.5). A larger painting by Collins entitled 'Lobster, Fruit and Parrot on a Table' (990 × 1245, 39 × 49), sold Christie's 23 January 1953, lot 60, bt Hart, present whereabouts unknown) is stated to be signed and dated 1736, two years earlier than no.13.

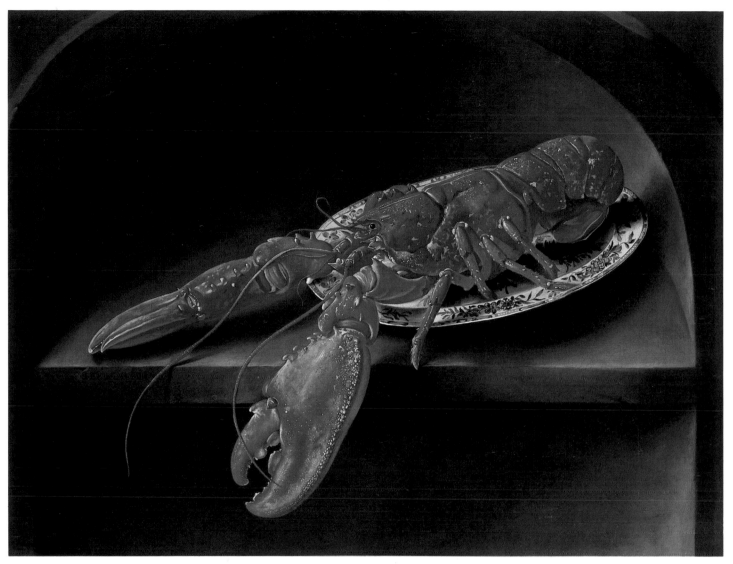

13

fig. 5 Charles Collins: 'Still Life with a Lobster on a Ledge'. Oil on canvas 610 × 749 (24 × 29½). Galerie Christa Cackett, Basle, 1985–6.

NICHOLAS THOMAS DALL active 1748-1776

Landscape and scenery painter, thought to be of Danish origin. Trained in Italy, where the decorative canvases still at Shugborough were ordered sometime before 1748 by Thomas Anson. Dall was working in London by 1756 and is recorded as a scenery painter at Covent Garden from 1757 onwards. He exhibited at the SA 1761–70, and at the RA 1771–76, having been elected ARA in 1771. Died in London 10 December 1776, his effects being sold at Langford's 10–11 March 1777.

LITERATURE
Croft-Murray 1970, p.24; Waterhouse 1981

14 **River Scene with Ruins** *c.*1756–65

N 01779
Oil on canvas 857 × 1254 (33$\frac{2}{3}$ × 49$\frac{3}{8}$)
Bequeathed by Henry S. Ashbee 1900

LITERATURE
Grant 1958, II, pp.161–2

PROVENANCE
...; H. S. Ashbee by 1900

Dall, who is known to have been in England by 1756, seems to have concentrated at first on decorative Italianate landscapes of this nature. He exhibited such subjects only, in various sizes, at the SA until 1765, after which his output began to consist largely of topographical views of country houses and British scenery.

The broad and summary manner and strongly but unsubtly expressed planes of recession into a distance devoid of any arresting focal features reflect his lifelong work as a scenery painter. His 'fat pigment' technique had a parallel in Richard Wilson who, like Dall, worked for many years in Italy. It is therefore not surprising that the picture entered the collection as a Wilson and was until recently catalogued as a work of the Wilson School, although Grant correctly attributed it to Dall on grounds of style as early as 1926.

During the restoration of the painting in 1969 the initials 'NT' were recorded on the back of the relining canvas; they appear to have been executed in a distinctive cursive script which matches the known signatures of the artist. It is probable that this represented a fragment of Dall's signature copied or traced from the back of the original canvas.

14

GAWEN HAMILTON, attributed to 1698-1737

One of the first generation of native-born painters of conversation pieces, coming close to Hogarth in style and considered by the not altogether unprejudiced Vertue to be even his superior 'in Colouring and easy gracefull likeness'. His best-known picture is the 'Club of Artists' of 1735 in the National Portrait Gallery.

Born in 1698, he arrived in London from Hamilton, in the west of Scotland, c.1726 and gave up life-size portraiture for conversation pieces c.1730; noted by Vertue as one of 'the most elevated Men in Art here now, [who] are the lowest of stature'. Lived near St Paul's, Covent Garden, and was buried there 28 October 1737.

LITERATURE
H.F. Finberg, 'Gawen Hamilton: An Unknown Scottish Portrait Painter', *Walpole Society*, VI, 1918, pp.51–58

15 An Elegant Company Playing Cards c.1725

T 00943
Oil on canvas, painted surface 680 × 565 (26¾ × 22¼) on stretcher 692 × 577 (27¼ × 22¾)
Purchased (Grant-in-Aid) 1967

PROVENANCE
The following two provenances could refer to no.15, or to one of its versions:
1) ...; according to *The Gentleman's Magazine* bt at the sale of 'the late Mr. Hammond of Colchester' (as a family piece by Hogarth), and in the collection of the Revd Charles Onley at Stisted Hall, Essex, by 1794; by descent to Onley Savill-Onley Esq., on whose death sold Christie's 16 June 1894 (56 as Hogarth) bt Colnaghi; ...
2) ...; John Andrews Dec'd., Christie's 3 March 1832 (84 as 'Hogarth: the Family of James Thornhill playing at Cards, with a portrait of the painter in the Background') bt Donovan; ...
What is certainly no.15: anon. sale Sotheby's 25 June 1941 (106) bt W. Sabin; ...; anon. sale Christie's 23 November 1951 (61 as Hogarth) bt Spink for John Tillotson, offered by him anonymously through the Hazlitt Gallery at Christie's 18 February 1955 (17) bt in ('Strong'); sold Sotheby's 8 November 1967 (39) bt Butlin for the Tate Gallery

LITERATURE
Gentleman's Magazine, LXIV, Pt.II, 1794, pp.903-4; Nichols & Steevens 1817, p.178; Nichols 1833, pp. 374-5; Dobson 1898, pp.306, 314; Dobson 1907, p.221; R. Edwards, *Early Conversation Pieces*, 1954, pp.65-6, fig.93 (for Walker Art Gallery, Liverpool, version)

Two ladies and two gentlemen are shown playing cards at a table, while a butler and a black boy serve wine from a cooler on the left. In the background a painter, equipped with palette and followed by an assistant carrying what must be a folder of sketches, appears to be passing through the room, gesturing either towards a doorway or the gentleman on the right. The lady on the right receives the solicitous attentions of both the gentleman at her side and a fawning spaniel which is jumping up at her knee, while a black cat bristles at the dog.

Since its first appearance in the late eighteenth century, the composition, of which three versions are known, has been associated with Hogarth and the Thornhill family. Stylistically, however, it seems to be much closer to the conversation pieces of Gawen Hamilton, and in 1954 Edwards detected a likeness between the artist in this composition (fig.6, Walker Art Gallery version) and Hamilton's self-portrait in 'A Conversation of Virtuosis' of 1735 (National Portrait Gallery, see Kerslake 1977, I, p.340, II, fig.951), though this remains arguable.

The Tate Gallery version, which was possibly never finished, was extensively

fig. 6 Gawen Hamilton, attributed to: 'The Card Party'. Oil on canvas 682 × 572 (26⅞ × 22⅜). Walker Art Gallery, Liverpool.

15

overpainted and crudely retouched, perhaps already in the eighteenth century. Restoration in 1985–6 revealed the thinness of the original paint and recovered the wine steward on the left, who had been painted out by an owner in the 1950s. Underneath the overpainting are the remnants of a painting of some quality, best preserved in the sensitive drawing of the black boy's head. The 1794 description of this composition in *The Gentleman's Magazine*, which may refer to this or another version, states that the area behind the 'Mulatto' boy 'was not sufficiently finished to be made out', and describes the earliest known owner of the painting as 'the late Mr Hammond of Colchester, an ingenious coach and house painter, who, it is said, worked some time under Mr Hogarth'. No one of that name is known to have been associated with Hogarth, nor has it been possible to trace anyone answering this description in the annals of Colchester (checked with the kind assistance of Mr John Bensusan-Butt), although a 'Hammon [sic], Painter', of Colchester, did exhibit a stained drawing at the SA in 1774 (113).

The painting above the chimney-piece is the same in all three versions, and represents an allegory of Painting and Sculpture. What could be its original (it agrees in size and colours) was last sold at Christie's 19 June 1987 (lot 50, 762 × 635 (30 × 25), as by 'P.B.', fig.7). In it the winged figure of Time or Truth, accompanied by two putti representing Learning and Ignorance (equipped respectively with laurel wreath and ass's ears), lifts the curtain over the Muses, who carry their respective symbols of a mallet and a painter's palette. On the rock beside them is a mask attached to a scroll inscribed with the word 'IMITATIO'. The painting is signed with a monogram 'JB', the first letter being rather faint. So far it has not been possible to establish with any certainty its authorship or provenance (nothing similar appears, for instance, in the sale of Thornhill's pictures in 1734).

Of the two other versions, the best (judging from an old photograph in the Witt Library) was in the O. Bondy collection, Vienna, 1929 (as 'Hogarth: A Card-table with Peg Woffington'), and subsequently on the New York art market (fig.8). The version differs from the other two chiefly through the absence of the dog (though overpainting cannot be ruled out), which is also absent from the very detailed 1794 description of the version then at Stisted Hall.

The version belonging to the Walker Art Gallery (fig.9) has an unbroken provenance going back to 1844, when F. Croix of Pall Mall sold it as 'The Thornhill Family' by Hogarth, claiming a tenuous Thornhill provenance for it (see typescript catalogue entry, Walker Art Gallery). Croix maintains that Sir James's natural son John Thornhill left it with a pawnbroker, whose grandson gave it to Croix's brother. The painting is, however, clearly not by Hogarth, but a contemporary copy of probably the Tate Gallery version, to which (even in its damaged state) it is visibly inferior in drawing, and in its grasp of volume, light and shade.

Latest research suggests that the artist in the painting could be Dietrich Ernst André (Theodore Andreae), born of a good family in Mitau, Courland, 1680, and died in Paris *c*.1734. He worked in Brunswick 1717–19, and then came via Holland to England where he stayed 1722–24. His main work was assisting Thornhill with the decorations of the Great Hall at Greenwich, where he worked on the large and ambitious grisaille scenes glorifying the Protestant Succession on three walls of the Upper Hall. The allegorical picture in the background of no.15 would then be a fitting representation of his speciality of grisaille-painting (i.e. imitation sculpture). The 'JB' monogram on the original might be that of André's teacher, the Dutch decorative painter Justus van Bentum, with whom he worked and travelled for twelve years. Bentum died in Leiden in 1727, but very little is known about him or his work. However, pupil and teacher might be expected to share similarities of style, and certainly the 'Allegory of Sculpture and Painting' is very close to André's known work (Croft-Murray 1962, p.263; J. Harris, 'Dietrich Ernst André: his work in England', *Connoisseur*, CLVIII, 1965, pp.253–6).

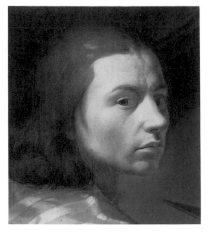

fig. 10 Dietrich Ernst André: 'Self-portrait in Striped Robe' (detail). 825 × 670 (32½ × 26⅜). Kunsthalle, Hamburg.

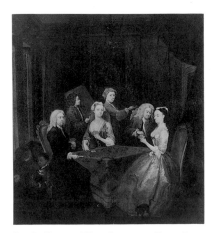

fig. 8 Gawen Hamilton, attributed to: 'An Elegant Company Playing Cards'. Oil on canvas, size unknown. Unlocated (photo: Ellis Waterhouse Archive).

Vertue writes that, while in England, André married 'a folish extravagant woman which he left here and returned to Germany again', presumably in 1724. It would therefore not seem too far-fetched to see in this composition a wedding picture, with the painter's bride seated in the centre in front of him, and his master's emblematic painting (a wedding present?) above them. This could explain the existence of several versions for presentation to family and friends.

If this were the case, then the couple on the right could indeed be Sir James and Lady Thornhill, his closest associates in England. The likenesses, particularly those in the better-preserved Liverpool version, are not incompatible with Richardson's portrait drawing of Thornhill of 1733 in the British Museum and the anonymous portrait (sometimes unconvincingly ascribed to Hogarth) of Lady Thornhill at Nostell Priory. Thornhill evidently thought well of André and had a number of works by him (including a portrait of Thornhill) in his collection.

It is difficult to make any guess as to the gentleman on the left, unless it be the bride's father, or André's chief patron in England, Richard Arundell, Surveyor-General of his Majesty's Office of Works, and as such closely associated with the Greenwich project.

André's appearance is well-documented by a very confident self-portrait at the Herzog Anton Ulrich-Museum in Brunswick, Germany, and two others in the Kunsthalle, Hamburg, one of which (fig.10), showing the head from the same angle as here, presents a marked likeness to the sitter in no.15. André painted portraits as well as miniatures, and his hand in at least one of the three versions of this picture cannot be ruled out, although comparative material is lacking.

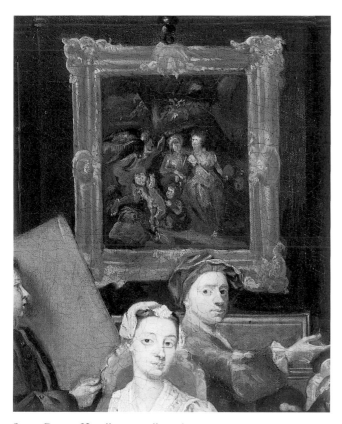

fig. 9 Gawen Hamilton, attributed to: 'The Card Party' (detail of fig. 6).

fig. 7 Justus van Bentum, attributed to: 'An Allegory of Painting and Sculpture'. Oil on canvas 750×650 ($29\frac{1}{2} \times 24\frac{5}{8}$). Signed with initials '[?J]B' Sotheby's 13 February 1985 (38, repr.).

FRANCIS HAYMAN 1708-1776

Painter of history, portraits and genre, also illustrator. Born at Exeter, Devon, 1708, died London 2 February 1776. Apprenticed to the history painter Robert Brown 1718. First employed as scenery painter at Drury Lane, became leading historical painter by mid-1730s. From *c*.1741 well-known through his decorative paintings for Vauxhall Gardens. Taught at St Martin's Lane Academy in 1740s, and his French-influenced Rococo style was readily absorbed by the young Gainsborough. In 1743-4 collaborated with Gravelot on the illustrations for Hanmer's Shakespeare. Visited France 1748. President of the SA 1766-8, Foundation Member of the RA 1768, became its Librarian 1771. Exhibited SA 1760-8, RA 1769-72.

LITERATURE
Brian Allen, 'Francis Hayman and the English Rococo', PhD thesis, Courtauld Institute, 1984; Brian Allen, *Francis Hayman*, New Haven and London 1987

EXHIBITIONS
Francis Hayman, Yale, New Haven, and Kenwood 1987

16 The See-Saw *c*.1742

T 00534
Oil on canvas 1390 × 2415 (54¾ × 95)
Presented by the Friends of the Tate Gallery 1962

PROVENANCE
Commissioned by Jonathan Tyers for Vauxhall Gardens *c*.1740, and *in situ* there before February 1744; probably removed before 1826; ...; Earl of Lonsdale, Lowther Castle sale, Maple & Co. 30 April 1947 (1897 as English School, 18th Century) bt A. Carysforth of Blackburn; sold by him to Ewart Bradshaw of Grey Flowers, Preston, Lancs., and bt back from his widow by Carysforth; sold to Appleby Bros by 1960, from whom bt by the Friends of the Tate Gallery

EXHIBITED
Francis Hayman RA, University Art Gallery, Nottingham 1960 (not in cat.); *Rococo Art and Design in Hogarth's England*, Victoria and Albert Museum 1984 (F25, repr. p.92); *Francis Hayman*, Kenwood 1987 (32, repr.)

ENGRAVED
Line engraving (in reverse) by L. Truchy, pub. 1 Feb. 1743, repr. D. Coke, *The Muses' Bower: Vauxhall Gardens 1728-86*, exh. cat. Gainsborough's House, Sudbury 1978, fig.24

LITERATURE
Anon., *A Description of Vauxhall Gardens*, 1762, p.37; *The Ambulator; or, the Stranger's Companion in a Tour Round London*, 1774, p.188, 1807, p.293; *A Brief Historical and Descriptive Account of the Royal Gardens, Vauxhall*, 1822, p.37; J.G. Southworth, *Vauxhall Gardens*, New York 1941, p.41; Lawrence Gowing, 'Hogarth, Hayman and the Vauxhall Decorations', *Burlington Magazine*, XCV, 1953, pp.10, 15, no.41, fig.20; W.S. Scott, *Green Retreats: The Story of Vauxhall Gardens 1661-1859*, 1955, p.25; S.A. Henry, 'A Further Note on the Engravings and Oil paintings of Francis Hayman in Vauxhall Gardens', *Burlington Magazine*, C, 1958, p.439; *Connoisseur*, CXLVI, 1960, advert. suppl., pl.xiii; A. Bury, 'Hayman and Vauxhall', *Connoisseur*, CXLVII, 1961, p.133; *Gazette des Beaux-Arts*, 1963, suppl. no.1129, p.50, fig.187; M. Levey, *Rococo to Revolution: Major Trends in Eighteenth Century Painting*, 1966, p.86, p.51; T.J. Edelstein and Brian Allen, *Vauxhall Gardens*, Yale Center for British Art, New Haven 1983, pp.29, 47; Allen 1984, pp.270, 282, 288, pl.296; Allen 1987, pp.108-11, fig.32

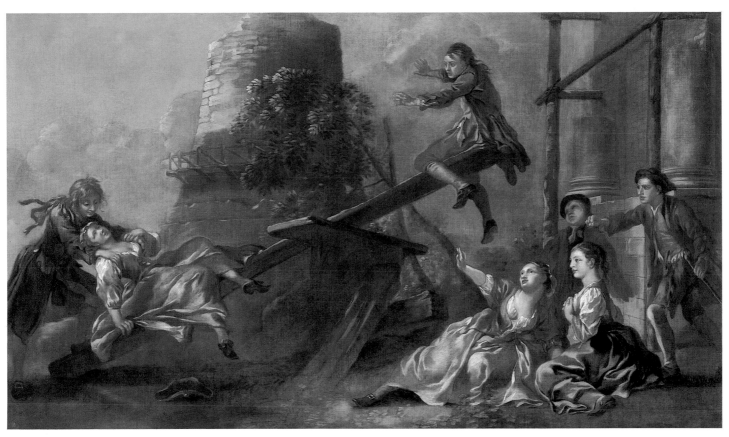

16

The painting is one of fewer than a dozen surviving panels painted by Hayman and assistants *c*.1738–60 to decorate Vauxhall Gardens. It is first recorded in Truchy's engraving of 1 February 1743/4, which was published with the text:

F. Hayman Pinx. L. Truchy sculp. from the Original Painting in Vaux-hall Garden

<div align="center">

See-Saw

Where at the top of her advent'rous Flight.
The frolick Damsel tumbles from her Height:
Tho her Warm Blush bespeaks a present Pain
It soon goes Off – she falls to rise again;
But when the Nymph with Prudence unprepar'd,
By pleasure sway'd – forsakes her Honours Guard:
That slip once made, no Wisdom can restore
She falls indeed! – and falls to rise no more.

</div>

By the 1740s the Gardens boasted over fifty painted panels, most of them fitted into the back of the supper boxes which surrounded the Grove, the focal point of the garden around the orchestra pavilion. Most of them were designed and at least partly painted by Hayman, although the involvement of Hogarth and Gravelot, in a design capacity, and of Monamy, who contributed four sea-pieces, is also recorded. 'The See-Saw' is among the better preserved and seems to have been painted largely by Hayman himself, although some of its motifs are adapted from Gravelot's engraving *See-sawing*, one of a series entitled *Jeux d'Enfants*, published in the late 1730s. From various descriptions (see Gowing 1953) it appears to have graced a box on the south side of the Grove, near Roubiliac's famous statue of Handel.

By far the greater part of the paintings depicted popular pastimes, games and

leisure activities, interspersed with theatrical, historical and genre subjects. Their chief purpose was decorative, but at the same time, as the verses attached to the set of engravings after some of the pictures make clear, they often contained a certain emblematic element that contrived to be both mildly titillating and moralising, which contributed to their interest (see Edelstein and Allen, p.25). Thus 'The See-Saw' also points to the dangers inherent in frivolous pursuits: the young people have built their makeshift toy not in an arcadian glade, but on a building site, between a solid, square building under construction, and a ruined tower or windmill, which in themselves represent stability and the lack of it. The seemingly light-hearted scene is actually the prelude to a fight, for an outraged youth rushes in from the right with the clear intention of defending an all-too-yielding girl from the excessive attentions of the beribboned fop on the opposite side, while the young people in the middle throw up their hands in horror at the impending fracas.

The painting must have been removed from Vauxhall Gardens sometime before 1826, as it is not included in the list of decorations published by Thomas Allen, *History and Antiquities of the Parish of Lambeth*, 1826, pp.365–6, nor in the Vauxhall Gardens sale of 12 October 1841.

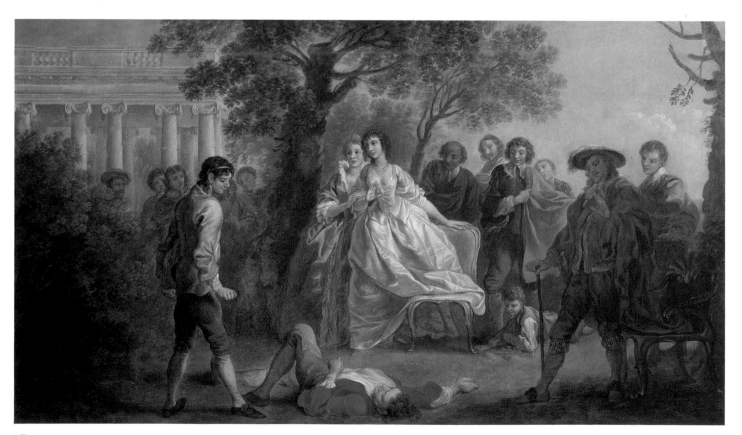

17

17 The Wrestling Scene from 'As You Like It' *c.*1740-2

T 06206
Oil on canvas 527 × 921 (20¾ × 36¼)
Purchased (Cleve Fund) 1953

PROVENANCE
...; possibly 'Scene from As You Like It' in sale of Jonathan Tyers Jnr, Christie's 28 April 1830 (28) bt Gilmore; ...;? anon. sale, Christie's 1911; ...; [Sir Alec Martin], sold Christie's 19 November 1948 (131 as de Troy) bt Jameson; ...; Dr Brian Rhodes of Yorkshire, sold Christie's 28 July 1950 (173 as de Troy) bt in; offered again at Christie's 18 December 1953 (77 as Hayman) bt Agnew for the Tate Gallery

EXHIBITED
Francis Hayman RA, Kenwood and University Art Gallery, Nottingham 1960 (16);

Shakespeare in Art, AC, St James's Square 1964 (12); *Francis Hayman*, Yale Center for British Art, New Haven, and Kenwood 1987 (37, col. pl. VII)

LITERATURE
Gowing 1953, p.16, repr.; Waterhouse 1953, pp.146-7, pl.119, 1978, p.197, fig.156; H.A. Hammelmann, 'The Art of Francis Hayman', *Country Life*, 14 October 1954, pp.1258-9; *East Anglian Daily Times*, 24 June 1954, repr.; H.A. Hammelmann, 'Shakespeare Illustration: The Earliest Known Originals', *Connoisseur*, CXLI, 1958, pp.148-9, fig.14; M. Merchant, 'Francis Hayman's Illustration of Shakespeare', *Shakespeare Quarterly*, IX, no.2, 1958, pp.142-7; M. Merchant, *Shakespeare and the Artist*, 1959, p.47; Allen 1984, p.57, no.115a, pl.18; Allen 1987, pp.16, 114, pl.VII (col.)

The subject is taken from Shakespeare's *As You Like It*, Act I, Sc. vi, showing the moment when Charles, the Duke's wrestler, has been thrown to the ground by Orlando, while Rosalind and Celia, Duke Frederick and others look on. The composition is related to Hayman's frontispiece (fig.11) to vol. II of the six-volume Hanmer edition of Shakespeare published in 1743-4, which shows a very similar group in reverse, but fitted into an upright design (Hammelmann 1954, fig.4; pen and wash drawing, 216 × 146 (8½ × 5¾) in the Folger Shakespeare Library, Washington, D.C., repr. Allen 1987, fig.82a). It is known that Hayman worked on the Hanmer designs *c.*1740-1, and that Tyers, the manager of Vauxhall Gardens, admired his Shakespearean subjects enough to commission from him, sometime shortly before 1745, four scenes from Shakespeare to decorate the Prince of Wales's Pavilion at Vauxhall. *As You Like It* was not among them, but the long, horizontal proportions of this small canvas reflect the format of Hayman's other Vauxhall decorations (e.g. 'The See-Saw', no.16) and could represent a sample design by Hayman to show Tyers what he could do in this line.

Although the provenance is not certain, Jonathan Tyers Jnr's sale in 1830 included, as lot 28, 'A Scene from the Tempest and one from As You Like It', and their combined low price of £2 17s suggests that both pictures were small. Hayman may have had a special affection for the play, for it has been suggested that the 'Mr. Hayman' who played Silvius in *As You Like It* at Covent Garden on three occasions between 1744 and 1746 was none other than the painter himself (on 2 November 1744, 24 September 1745, and 19 December 1746; see A.H. Scouten, *The London Stage 1660-1800. Part 3: 1729-1747*, 1961, pp.1127, 1182, 1273). By all accounts an outgoing and sociable personality, Hayman had close ties with the London theatre world, dating back to his early career as a scene painter at Drury Lane. On 5 February 1742 he was elected a member of the exclusive Covent Garden-based Beef Steak Club, whose members were mostly either professionally connected with the theatre, or keen amateur actors from distinguished walks of life (see W. Arnold, *The Life and Death of the Sublime Society of Beef Steaks*, 1871).

Barring Hogarth, the canvas is one of the earliest painted illustrations of Shakespeare. It is also – as its earlier mis-attribution to Jean-François de Troy (1679-1752) testifies – one of the most graceful English interpretations of the French Rococo style which Hayman readily absorbed from the French master-illustrator Hubert Gravelot (1669-1773, in England 1732/3-45), with whom he collaborated extensively.

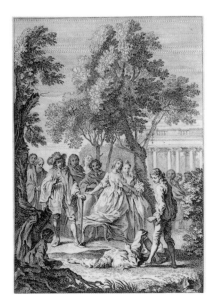

fig. 11 Hubert Gravelot after Francis Hayman: Frontispiece to Volume II of Sir Thomas Hanmer's *The Works of Shakespear*, 1743-4.

18 **Thomas Nuthall and his Friend Hambleton Custance** *c.*1748

T 00052
Oil on canvas 710 × 915 (28 × 36)
Bequeathed by Ernest E. Cook through the
National Art-Collections Fund 1955

PROVENANCE
By family descent from the sitter to Miss Ida
Nuthall; . . .; Ernest E. Cook by 1955

EXHIBITED
Francis Hayman, Kenwood 1987 (18, repr.)

LITERATURE
DNB 1908, XIV (for Nuthall); *Bearsted
Collection*, exh. cat., Whitechapel Art Gallery
1955 (5); *The Bearsted Collection: Pictures*,
National Trust 1964, p.16, no.38; J.H. Plumb,
Georgian Delights, 1980, repr. p.125; Allen
1984, no.170; Allen 1987, pp.43, 97–8, repr.

Two labels in an old hand, formerly on the back of the painting and now in the Tate Gallery Conservation Department, give the sitters as 'Thomas Nuthall Esq. of New Lodge Enfield Middlesex Solicitor to the Treasury Age 33 Died 1775' and 'His friend Hambleton Custon [sic] Esq. Weston House near Norwich Age 33 Died 1757'. If the ages given are correct, this would date the picture to 1748, a date well in keeping both with the appearance of the sitters and with Hayman's style at that period.

Hambleton Custance (1715–57) was a native of Weston, Norfolk, and became High Sheriff of the county in 1753. According to the Bearsted Catalogue (1964) a portrait of him, attributed to Ramsay and formerly at Weston House, agrees in appearance with the man on the left. In April 1748 (*Gentleman's Magazine*, XVIII, p.187) he married the local heiress Susannah Press (d. 1761), and one is tempted to see in his festive dress and 'bird-in-hand' pose the stance of a successful suitor. Their son was the 'Squire Custance' of Parson Woodforde's *Diary*.

On the right (perhaps depicted on this occasion as the unsuccessful suitor, comforted by his dog?) is Thomas Nuthall (1715–75), who in fact remained single until he married his friend's widow in 1757. Solicitor to the East India Company and the Treasury, legal adviser to William Pitt the Elder, he ultimately overreached himself in amassing lucrative official posts and fell from favour in 1772. Walpole maintained that he embezzled £19,000. He was also Ranger of Enfield Chase, which, passionate sportsman that he was, he vainly sought to preserve from disafforestation in the late 1760s. A full-length portrait of him with gun, hound and slain deer, by Nathaniel Dance, of *c.*1770, is in the Tate Gallery (T 00053, also from the collection of Miss Ida Nuthall) and clearly represents the same man at a more advanced age. On 7 March 1775 Nuthall was attacked on Hounslow Heath by a highwayman whom he put to flight after an exchange of shots. Unharmed, he wrote a description of the robber to Sir John Fielding immediately on arriving at the inn at Hounslow, 'but had scarce closed his letter, when he suddenly expired' (*Gentleman's Magazine*, XLV, 1775, p.148).

Among Hayman's generally fanciful studio settings, this painting is notable for its loving portrayal of a modest country interior, possibly a hunting-box, with its casual assemblage of rush chairs, sturdy table, guns, calendar or map and hunting apparel hanging on the wall, and a tobacco jar on the window-sill – all, whether taken from life or not, combining to evoke a country squire's idyll of a day out shooting with friends.

A similar double portrait by Hayman in the Bearsted Collection is no longer thought to represent the same sitters.

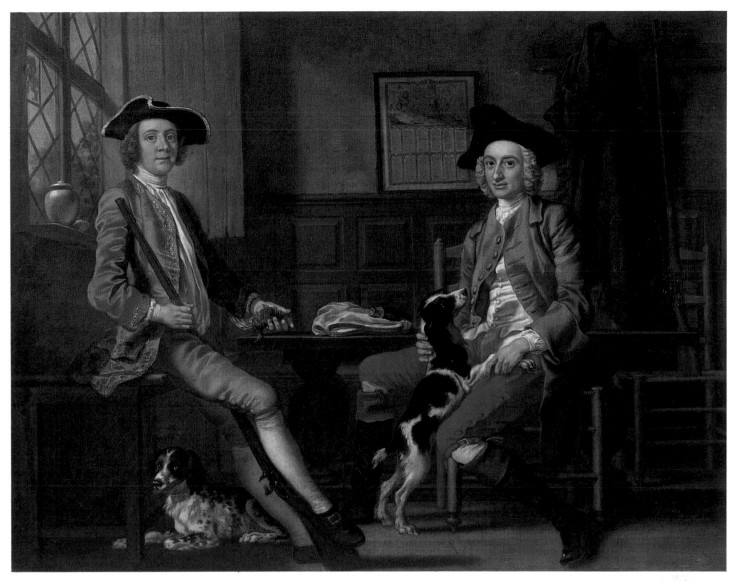

18

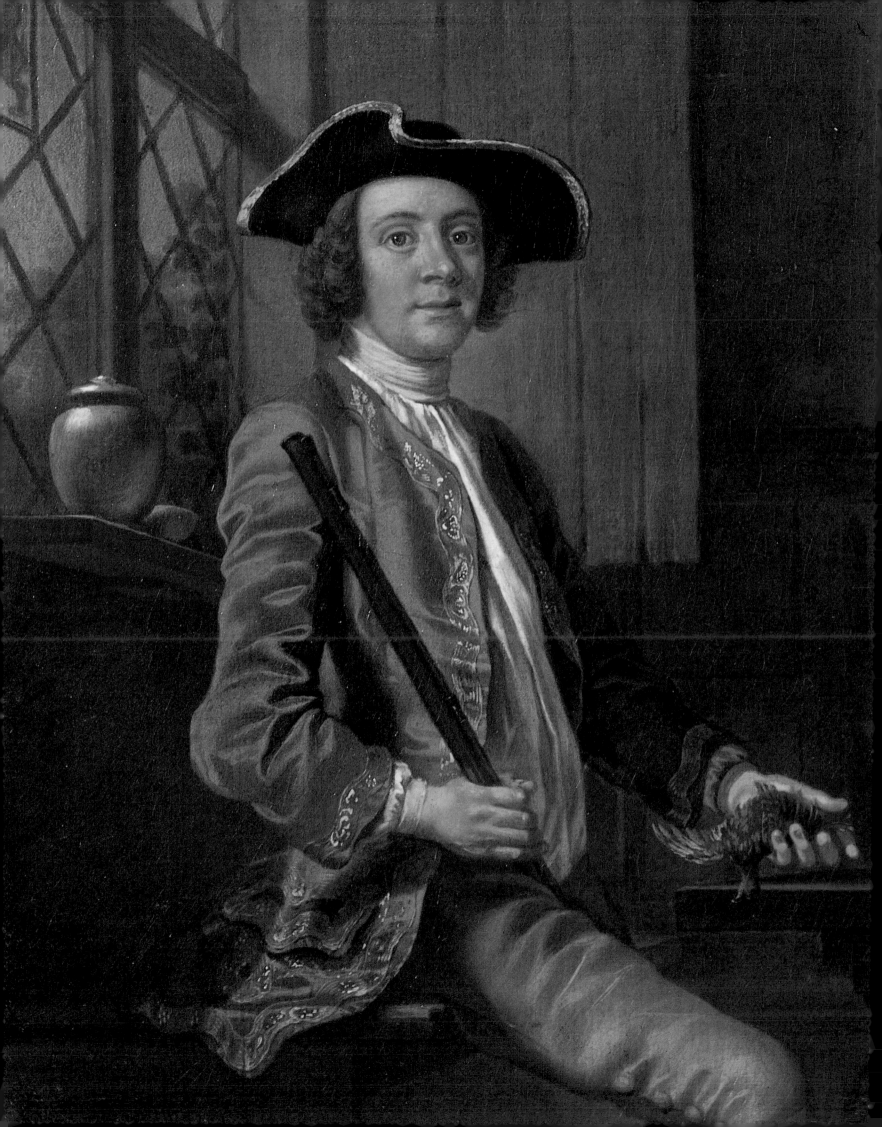

JOSEPH HIGHMORE 1692-1780

Portrait and occasional history and genre painter, also writer on theory of art. Born in London 13 June 1692, son of a prosperous coal merchant and nephew of the Serjeant-Painter Thomas Highmore (1660-1720). First studied law, but turned to painting from 1714 onwards; studied at Kneller's and St Martin's Lane Academies, and was first noticed for drawing the Knights of the Order of the Bath for engraving in 1725. Painted both full-lengths and small-scale conversation pieces, often with Hogarthian force of character and handling as well as French Rococo elegance. Travelled in the Low Countries 1732 and visited Paris in 1734. Exhibited at the SA 1760 and the FSA 1761. Retired to Canterbury in 1761 to devote himself to writing, and died there 3 March 1780. His son and pupil Anthony (1718-99) was a copyist and occasional painter of portraits and views.

LITERATURE
Obituary in *Gentleman's Magazine*, L, 1780, pp.176-9; Alison S. Lewis, *Joseph Highmore: 1692-1780*, PhD thesis, Harvard 1975, 3 vols (University Microfilms International, Ann Arbor 1980)

EXHIBITIONS
Elizabeth Johnston, *Joseph Highmore*, Kenwood 1963

19 **Mr Oldham and his Guests** *c*.1735-45

N 05864
Oil on canvas 1055 × 1295 ($41\frac{1}{2}$ × 51)
Purchased (Grant-in-Aid) 1948

PROVENANCE
According to J.T. Smith, painted for Nathaniel Oldham and after his death (*post* 1747) given to a relative, from whom bt by the sitter's godson Nathaniel Smith, who still owned it *c*.1777; ...; 'Mr. Bellamy, linen draper in Queen Street'; ...; the Revd Theodore Williams, sold Stewart, Wheatley & Allard 2 May 1827 (1947 as 'A Conversation over a Bowl of Punch at Old Slaughter's by Hogarth'); ...; Mrs Hannah, sold Sotheby's 21 July 1948 (71 as Hogarth) bt for the Tate Gallery

EXHIBITED
Kenwood 1963(37)

LITERATURE
James Caulfield, *Portraits ... of Remarkable Persons*, 1819, II, p.133; J.T. Smith, *Nollekens and his Times*, 1828, II, pp.217-20; *DNB* 1908, XIV (for Oldham); F. Antal, 'Mr Oldham and his Guests by Highmore', *Burlington Magazine*, XCI, 1949, pp.128-32, pl.6; Waterhouse 1953, p.137, pl.107, 1978, p.183, fig.145; F. Antal, *Classicism and Romanticism*, 1966, pp.167-73, fig.46 (reprint of 1949 article); Lewis 1975, I, pp.239-44, II, pp.464-5, no.121, III, fig.82

John Thomas Smith identified this conversation piece in 1827 as a picture 'that had been for the first eleven years of my life in my sleeping room' (he was born 1766), and described it as follows:

> My father's account of this picture was that Mr Oldham had invited three friends to dine with him at his house at Ealing; but being a famous and constant sportsman he did not arrive till they had dined; and then he found them so comfortably seated with their pipes over a bowl of negus, that he commissioned Highmore to paint the scene and desired that he might be introduced in it just as he then appeared. A man on the right, with a white wig and black coat, was an old school-master; and one opposite to him a farmer, both of Ealing; another, in the middle, in a red cap was the artist, Highmore; and one with his hat on, behind the farmer's chair was Nathaniel Oldham.

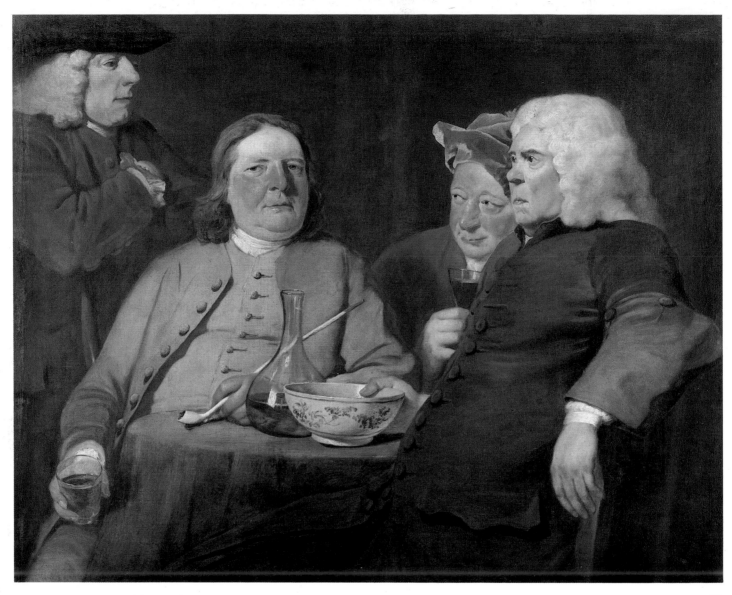

19

According to Caulfield – who also had his information from J.T. Smith – Nathaniel Oldham served with the army in India in his youth, but retired on inheriting a fortune, to pursue his interests as an extravagant collector of curiosities, and as a patron of the arts and the turf. His enthusiasms eventually bankrupted him and he apparently died a debtor in the King's Bench prison. He is said to have been 'very intimate' with Highmore, who painted a full-length of him in green hunting attire. The fate of this portrait is unknown, but Faber's undated mezzotint after it suggests a date of c.1740 or earlier (Lewis 1975, p.579, no.66, fig.180; re-engraved by P. Grove for Caulfield 1819, facing p.133). The only firm dates on Oldham are that he owned Ealing House from 1728 until June 1735 (Middlesex CRO, Acc. 112/1), and that he appears to have been still living when the 'Entire Collection of Prints, Books of Prints and Drawings of Nathaniel Oldham Esq., of Southampton Row, Bloomsbury' was sold at Cox's 25–28 February 1747 (1746 O.S.).

According to Caulfield, Oldham took refuge from his creditors for a while within the sanctuary of the court of St James's, where he took to appearing in the refreshment room on Duck Island in St James's Park wearing eccentric costume and playing several instruments for the amusement of the guests. A portrait by Highmore believed to represent him doing this was formerly with Sabin (*English*

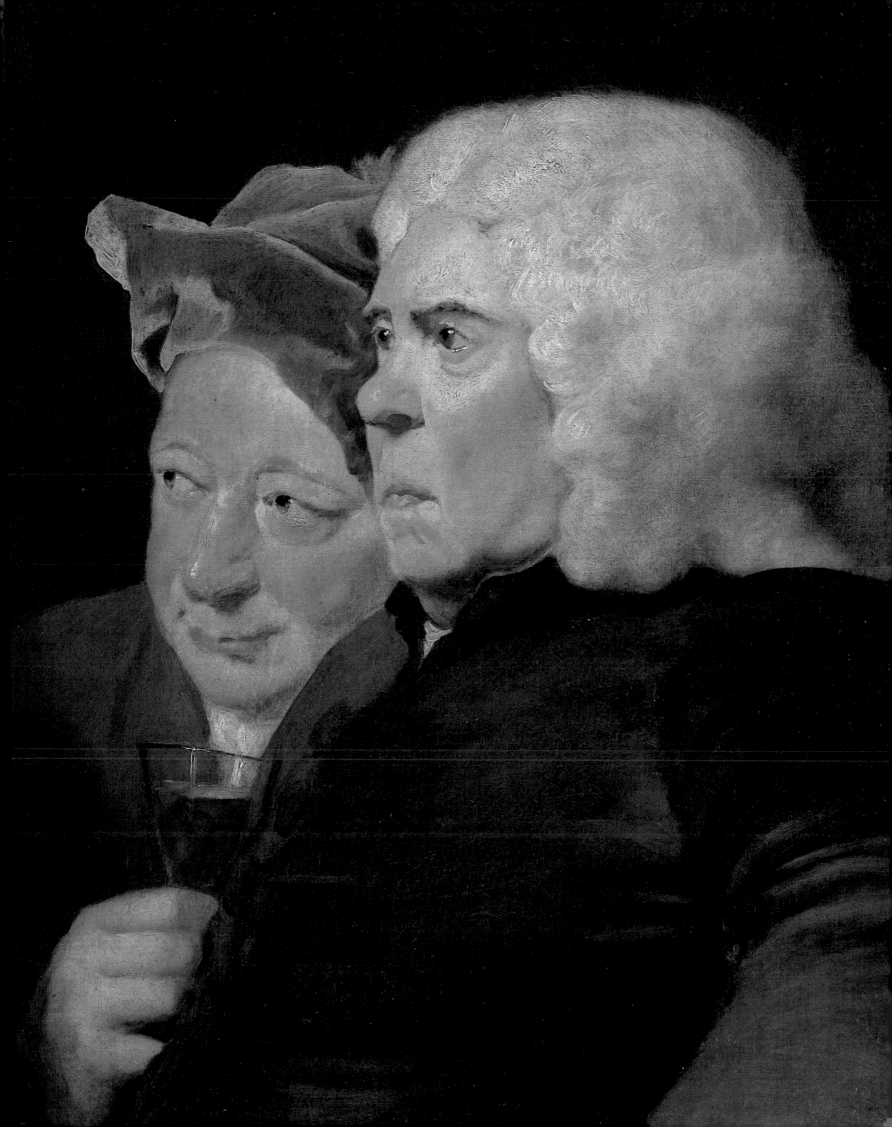

Portraits, October–November 1976, no.12, repr.; sold Sotheby's 16 July 1986, lot 221, repr.).

Although dated *c*.1750 by Antal and in Elizabeth Johnston's catalogue for the 1963 exhibition, the Tate Gallery picture almost certainly pre-dates Oldham's bankruptcy and the need to sell his collections. If Smith's account of the scene being set in Ealing is correct, one may have to accept an even earlier date for it. A portrait of such exceptional informality and forthrightness is difficult to date stylistically, although one should bear in mind that Highmore's style was formed by the mid-1720s, and that in 1735 he would have been in his forties, an age not incompatible with the somewhat wry self-portrait in this painting.

20-23 **Four Scenes from Samuel Richardson's 'Pamela'** 1743–4

N 03573–3576
Purchased (Florence Fund) by the National Gallery 1920; transferred to the Tate Gallery 1934

PROVENANCE
For the complete set: finished by May 1744 and still in the painter's studio in 1750; his sale, Langford's 5 March 1762 (24, with full set of framed prints); ...; Major Dermot McCalmont of Cheveley Park, Newmarket, sold Christie's 26 November 1920 (130 as 'Illustrations to Clarissa Harlowe' by Cornelis Troost) bt Peacock for A.H. Buttery; bt from him by the National Gallery and divided between itself, the Fitzwilliam Museum, Cambridge (II, V, VI, XII) and the National Gallery of Victoria, Melbourne (III, IV, VIII, X)

EXHIBITED
Complete set: Kenwood 1963 (15–26)

ENGRAVED
Line engraving by Antoine Benoist (III, IV, V, VI, IX, XII) and Louis Truchy (I, II, VII, VIII, X, XI), pub. 1 July 1745; reprinted, with only alteration of the year, in 1762. All plates show very minor variations of detail from the original oils

LITERATURE
Complete set: *Gentleman's Magazine*, L, 1780, p.177; A.L. Barbauld, *Correspondence of Samuel Richardson*, 1804, IV, pp. 255–6,362; C.H. Collins-Baker, 'Richardson's Illustrations', *Times Literary Supplement*, 16 December 1920, p.864; C.H. Collins-Baker, '"Pamela" in the National Gallery', *Connoisseur*, LX, 1921, pp.39–40; Whitley 1928, I, pp.47–8; T.C. Duncan Eaves, 'Graphic Illustration of the Novels of Samuel Richardson', *Huntington Library Quarterly*, XIV, 1951, p.349; Waterhouse 1953, p.136; 1978, p.182; Ursula Hoff, *Catalogue of European Paintings before 1800*, National Gallery of Victoria, 1961, pp.69–71; E.K. Waterhouse, *Three Decades of British Art*, Philadelphia 1965, pp.2–5; Paulson 1971, II, pp.10–15; J.W. Goodison, *British School Catalogue of Paintings*, Fitzwilliam Museum, Cambridge 1977, pp.102–5; Lewis 1975, I, pp.170–211, 213–15, 222–3, II, 592, nos.251–63, III, figs.152, 153, 159, 161, 163; Joseph Burke, *English Art 1714–1800*, 1976, pp.171–2

These four paintings form part of an original set of twelve (now divided equally between the Tate Gallery, the Fitzwilliam Museum, Cambridge, and the National Gallery of Victoria, Melbourne), conceived by Highmore as a pictorial rendering of Richardson's immensely popular novel *Pamela: or, Virtue rewarded*, the first part of which was published in November 1740. The other subjects (figs.12–19) are, in order of their numbering: II) Mr B. takes liberties with Pamela in the summer house; III) Pamela fainting on discovering Mr B. in the closet; IV) Pamela with Mrs Jervis, disposing of her bundles; V) Pamela setting out from Mr B.'s Bedfordshire house; VI) Pamela shows Mr Williams a hiding place for their letters; VIII) Pamela unexpectedly meets her father; X) Pamela is ill-treated by Lady Davers; XII) Pamela telling nursery tales to her children. They were not intended as illustrations to be bound with the text, but as a self-contained set of large prints for an album or for framing (the oil paintings were offered at Highmore's retirement sale in 1762 with a full set of the engravings 'fram'd and glaz'd').

The novel, written in the form of letters, tells the story of the virtuous and well-educated lady's maid Pamela Andrews, whose mistress on her deathbed confides

her to the care of her son 'Mr B.'. Unworthy of his charge, Mr B. attempts various strategems to seduce her, but in the face of Pamela's unshakeable probity, he reforms and marries her instead. The second part deals with Pamela's conquest of Mr B.'s haughty relations, whose contempt for her lowly origins is gradually replaced by admiration and respect for her personal qualities.

Richardson planned that the second edition of the novel should have frontispieces by Hogarth, but for unknown reasons these never materialised. By 1742 the novel had gone through five editions and had been translated into several languages. That year Richardson published the sixth edition (of Part I, the third of Part II) in a *de luxe* form, with twenty-nine illustrations by Francis Hayman and Hubert Gravelot. Although this edition was not a great commercial success, it may have given Highmore the impetus to produce his own set of illustrations to the novel. On 18 February 1744 *The London Daily Post and General Advertiser* carried Highmore's earliest known advertisement for a series of 'twelve prints by the best French engravers, after his own paintings representing the most remarkable adventures of Pamela in which he has endeavoured to comprehend her whole story, as well as to preserve a connection between the several pictures . . .'. It also stated that ten of the pictures were completed and could be seen at his house, the Two Lyons, Lincoln's Inn Fields, where subscriptions would be received. The fact that each plate was to have a short explanation of the scene in French as well as English shows that Highmore hoped for good sales abroad. On May 22–24 1744 *The London Evening Post* repeated the advertisement, stating that now all twelve paintings had been completed (advertisement quoted in full in a letter from W.T. Whitley, 29 November 1929, in Gallery files). The twelve plates were published on 1 July 1745 and delivered to subscribers later that month. All engravings were in reverse to the original paintings, with the exception of plates I and IX, in which it was necessary to preserve the same sense in order not to invert specific actions, i.e. writing and the fitting of the wedding ring.

Although Highmore had produced the set independently of Richardson, the two men met as a result, and a lifelong friendship ensued that ended only with Richardson's death in 1761 (see C.H. Collins-Baker, 'Joseph Highmore, Samuel Richardson and Lady Bradshaigh', *Huntington Library Quarterly*, VII, 1944, p.316). Highmore's treatment of his subject is greatly influenced, both in tone and handling, by the French Rococo gracefulness of Hayman's and Gravelot's illustrations, and his simple, clear and slightly sentimental treatment of the narrative is in complete sympathy with the tenor of the novel itself. He eschews the wealth of comment and significant detail which was characteristic of Hogarth's narrative sets, particularly of 'Marriage A-la-Mode', published only two months before 'Pamela'. Highmore's set may in fact have been one of the reasons why Hogarth abandoned his own project for a series on virtuous domesticity, 'The Happy Marriage', with which he had planned to follow 'Marriage A-la-Mode'. Hogarth would never have achieved the graceful and somewhat shallow Rococo lightness of Highmore's 'Pamela' series, in which every scene aims for an uncomplicated intimacy within a narrow space, centred on a single incident drawn straight from the narrative, without any distracting comments. In this way it conveyed something that was dear to Richardson's heart, namely, a sense of well-bred decorum. That the series became popularly associated with precisely this quality, is demonstrated by an anonymous contemporary broadsheet on the *cause célèbre* of 1750, the trial of the highwayman James Maclean, whose uncommonly gentlemanly manners had made him many friends in respectable society. It shows the prisoner being visited in his cell by 'the quality', and the elegant crowd is made up of groups and figures taken entirely from various plates of the 'Pamela' series, including Maclean himself, who is based on the bridegroom in plate IX, with chains added to his legs (repr. Hugh Phillips, *Mid-Georgian London*, 1964, p.68, fig.77).

The set of paintings remained on show in Highmore's studio, where they drew visitors and stimulated commissions, until his retirement in 1762.

20

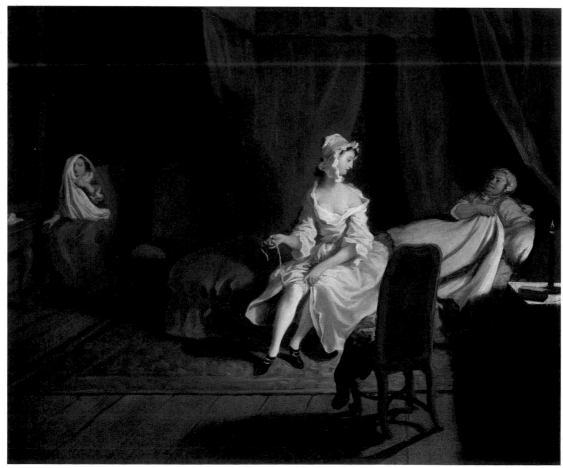

21

22

23

fig. 12 Joseph Highmore: 'Pamela II: Pamela and Mr B in the Summer House'. Oil on canvas 629 × 756 $(24\frac{3}{4} \times 29\frac{3}{4})$. The Syndics of the Fitzwilliam Museum, Cambridge.

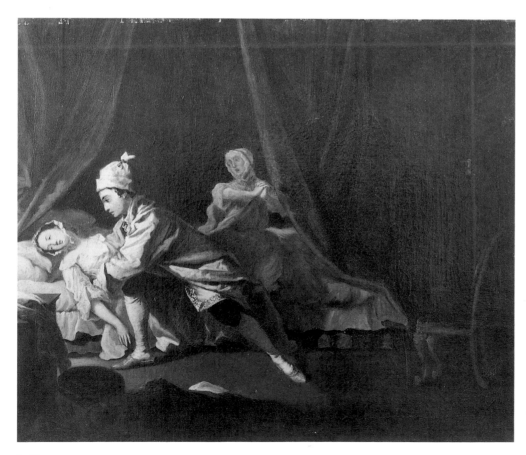

fig. 13 Joseph Highmore: 'Pamela III: Pamela Fainting'. Oil on canvas 635 × 762 $(24\frac{7}{8} \times 30)$. National Gallery of Victoria, Melbourne, Felton Bequest 1921.

fig. 14 Joseph Highmore: 'Pamela IV: Pamela Preparing to Go Home'. Morning, with a View of Cuckold's Oil on canvas 635 × 762 (24⅞ × 30). National Gallery of Victoria, Melbourne, Felton Bequest 1921.

fig. 15 Joseph Highmore: 'Pamela V: Pamela Leaves Mr B's House in Bedfordshire'. Oil on canvas 626 × 756 (24$\frac{11}{16}$ × 29¾). The Syndics of the Fitzwilliam Museum, Cambridge.

fig. 16 Joseph Highmore: 'Pamela VI: Pamela Shows Mr Williams a Hiding Place for Her Letters'. Oil on canvas 629×753 $(24\frac{3}{4} \times 29\frac{5}{8})$. The Syndics of the Fitzwilliam Museum, Cambridge.

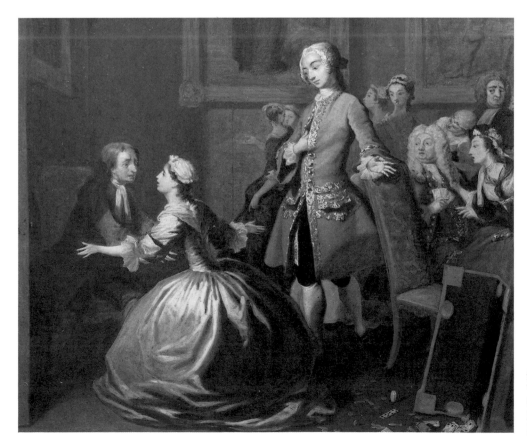

fig. 17 Joseph Highmore: 'Pamela VIII: Pamela Greets Her Father'. Oil on canvas 635×762 $(24\frac{7}{8} \times 30)$. National Gallery of Victoria, Melbourne, Felton Bequest 1921.

fig. 18 Joseph Highmore: 'Pamela
X: Pamela and Lady Davers'. Oil on
canvas 635 × 762 (24⅞ × 30).
National Gallery of Victoria,
Melbourne, Felton Bequest 1921.

fig. 19 Joseph Highmore: 'Pamela
XII: Pamela Tells a Nursery Tale'.
Oil on canvas 626 × 756
(24 11/16 × 29¾). The Syndics of the
Fitzwilliam Museum, Cambridge.

24 **The Good Samaritan** 1744

T 00076
Oil on canvas 1595 × 1448 (62¾ × 57). Repairs
to the top right corner show that the canvas
was originally some 18in (457mm) higher
Inscribed 'Jos: Highmore invenit et pinxit.
1744.' b.l.
Presented by C. Kingsley Adams CBE 1955

PROVENANCE
Painted for John Sheppard of Campsey Ash,
and presumably by descent to J.G. Sheppard
of Campsey Ashe High House, Wickham
Market, Suffolk; his sale, Garrod, Turner &
Son of Ipswich 1–4 October 1883, 3rd
day (834) bt R. Edens-Dickens (his letter in
The Morning Post, 12 December 1925, stating
that he had bought it at the above sale, and

giving size wrongly as 1575 × 1015, 62 × 40);
...; Isaac J. David & Son, Dover, in 1930s (see
correspondence in Gallery files) and after the
closure of the business said to have been stored
for many years; ...; anon. sale, Knight, Frank
& Rutley 30 December 1955 (337) bt in;
afterwards bt C.K. Adams

LITERATURE
Obituary in *Gentleman's Magazine*, L, 1780,
p.178; W.A. Copinger, *The Manors of Suffolk*,
1905–11, II, p.233 (for details of Sheppard
family); Ralph Edwards, 'Hogarth into
Highmore', *Apollo*, XC, 1969, pp.148–51, fig.5;
Paulson 1971, II, pp.11, 13; Lewis 1975, I,
pp.220–3, 549–50, nos.266, 267, II, p.592,
no.97, pp.654–5, no.45, III, figs.168, 276

This is Highmore's earliest known attempt at large-scale subject painting. The obituary of 1780, written by Highmore's son-in-law, the Revd John Duncombe, singled out '*The Good Samaritan*, painted for Mr Shepherd, of Campsey Ash' as one of his most important works 'in the historical branch'. Until recently, however, it was not clear whether this was the Tate Gallery painting, or another version, perhaps resembling the picture in the background of his 'Mr B Finds Pamela Writing' (no.20). The 1883 Sheppard sale catalogue (only known copy at the Suffolk Record Office, Ipswich Branch, Ref. SC 088/4) proves, however, that it must have been no.24 which was commissioned by the then owner of Campsey Ash High House, John Sheppard (*d.s.p.* 1747), in whose family it remained until the 1883 sale. Although unattributed, lot 834, 'The Good Samaritan, 5ft. 2in. by 4ft. 8in.' (dimensions being expressly given exclusive of the frame, height before width), tallies almost exactly with the present size of no.24. An old, presumably pre-1883, repair in the upper right-hand corner, where a missing part has been filled in with a piece taken from the cut-down section of the same painted canvas, shows that the composition was originally possibly nearly 457mm (18in) taller. It is interesting to note that the next lot in the sale, likewise hung in 'The Vestibule', was (also unattributed) '835 – Pair – Hope and Charity, 6ft. 4in. by 3ft. 4in.'. This matches the original height of no.24, and raises the possibility that Highmore may have painted a set of three pictures, of which the side panels have been lost. The High House under discussion (now demolished) was a nineteenth-century building by Salvin, and the painting (or paintings) may have been originally commissioned for a private chapel which fell victim to later rebuilding.

fig. 21 Joseph Highmore: Study for
'The Good Samaritan' (detail of
no. 66).

The Highmore scrapbook (no.66) includes an undated pencil sketch by him (fig.21) which is a very free interpretation of Hogarth's huge 'Good Samaritan' painted in 1737 for the staircase of St Bartholomew's Hospital, where it is still *in situ*. Much has been made in the past (notably by Edwards and Paulson) of this 'indebtedness', but it should be borne in mind that the subject was a popular one with painters of the older European schools, and engravings of these could have been found in any artist's collection. Highmore's ultimate composition has as much in common with Hogarth's as both have with Coornhert's engravings after Maerten van Heemskerck's 'Good Samaritan' series of 1545, to name just one of many examples. An artist as bookish and devout as Highmore could also have been aware of the many lavishly illustrated Bibles of the seventeenth century: the device of the linked hands of victim and helper can be found, for instance, with certain other parallels, in the German Strassbourg bible of 1630, illustrated by Matthew

24

Merian. While it would have been natural for Highmore to start out on his commission with a study of the only accessible large-scale work on the theme, he took pains to develop it in a different way, and the emphatic 'invenit' of his signature suggests that he was aware of possible accusations of plagiarism.

The presence – for no obvious reason, as it is nowhere alluded to in Richardson's text – of a completely different arrangement of the subject in the background of the above-mentioned illustration to 'Pamela' (on which he was working at about the same time as the 'Samaritan') could, in view of the series' predictably wide circulation and popularity, be a subtle attempt to forestall any such possible accusations of a lack of invention on his part. As he was in many ways in competition with the notoriously prickly Hogarth himself, this would have been a wise precaution.

The almost universal study among artists of the Torso Belvedere as a model for posing the male nude figure could also account for a certain family resemblance between Hogarth's and Highmore's paintings. There is a detailed drawing of it in an unpublished drawing book of studies after the antique, almost certainly attributable to Highmore, until recently in the Sir Anthony Highmore King collection (Lewis 1975, p.247, no.13) and now in the Tate, and Hogarth wrote that small copies of 'that famous trunk of a body [were] to be had at almost every plaster-figure makers' (*Analysis of Beauty*, 1753, p.64, and 1969 reprint).

Unlike Hogarth, Highmore chooses a later point in the story (Luke 10: 30–7) where the Samaritan has already tended and bound the wounds of the man who fell among thieves, and is about to help him to get up so that he can mount his horse. This calls for very different tensions (and ones, incidentally, more in keeping with those of the Torso Belvedere) in the bodies of the two men than does the more usual depiction of the application of balm to the victim's wounds. The strain of supporting the victim's arm and shoulder while the latter painfully gathers strength to stand up, justifies the Samaritan's somewhat awkward stance, and results in an unusually tense rendering of the parable.

25 A Gentleman in a Brown Velvet Coat 1747

N 04107
Oil on canvas 1265 × 1005 (49¾ × 39½)
Inscribed 'Jos:Highmore pinx:1747' l.r.
Purchased (Florence Fund) by the National Gallery 1925; transferred to the Tate Gallery 1949

PROVENANCE
...; anon. sale, Robinson's 27 June 1912 (105) bt Knoedler, sold by them to America the same year and bt back 1923, sold to the National Gallery

EXHIBITED
Kenwood 1963(22)

LITERATURE
Mrs Steuart Erskine, 'Joseph Highmore', *Studio*, XCIII, 1927, p.86, repr. p.88; J.W. Scobell Armstrong, 'Joseph Highmore, Painter and Author', *Connoisseur*, LXXXVI, 1930, p.213, repr. p.247; Charles R. Beard, 'Highmore's Scrapbook', *Connoisseur*, XCIII, 1934, p.296; Davies 1946, p.65; C.H. Collins-Baker, 'Devis, Scott and Highmore', *Antiques*, 67, 1955, p.46; David Mannings, 'A Well-Mannered Portrait by Highmore', *Connoisseur*, CLXXXIX, 1975, p.116, fig.1; Lewis 1975, II, pp.531–2, no.231, III, fig.144

One of Highmore's most elegant and successful three-quarter lengths, it is posed, as has been pointed out by Mannings, in a classically well-bred eighteenth-century attitude which '... will permit the right Hand to place itself in the Waistcoat easy and genteel ...', as prescribed in F. Nivelon's *The Rudiments of Genteel Behaviour*, published in 1737. This particular stance is described in minute detail and illustrated in plate 1 of this booklet, along with many others which can be observed in one form or another in most early eighteenth-century portraits. That such

25

modifications reflected genuine habits of deportment can be seen in the popularity of stock poses such as this, which Highmore used repeatedly as, for instance, in the portrait of Samuel Richardson, dated 1747, belonging to the Worshipful Company of Stationers. The pose and dress is repeated, fold for fold, in the portrait of 'Mr Freeman Flower', signed and dated 1747, except that either the picture or the composition has been cut about 12in. (305mm) at the bottom (exhibited Agnew, March–April 1978 (50)).

Beard's (1934) suggestion that the portrait represents the lexicographer James Harris is not tenable. A companion portrait of 'A Lady' in the 1912 sale (lot 104) remains untraced.

26–85 **The Highmore Gift**

T 04173–T 04366
Part of a collection of sketches, drawings, watercolours and other material by Joseph Highmore, his daughter Susanna (later Mrs Duncombe) and other relatives and descendants of the artist. The bulk of the material is pasted into a modern scrapbook and is undergoing conservation treatment prior to full cataloguing. The following is a check-list of works by or attributed to Joseph Highmore. All sheets have been irregularly cut; maximum dimensions only are given
Presented by Mrs Jean Highmore Blacknall and Dr R.B. McConnell 1986

PROVENANCE
By family descent from the artist to the donors

LITERATURE
C.R. Beard, 'Highmore's Scrap-Book', *Connoisseur*, XCIII, 1934, pp.290-7 and 'Highmore's Drawings for Pine's Processions and Ceremonies', *Connoisseur*, XCIV, 1934, pp.9-15 (hereafter Beard 1934a and Beard 1934b); Lewis 1975, II, pp.650-6, 659, III, figs.263-77, 279

26 T 04173 **A Standing Hound, Looking Up**
Pen and grey wash on paper 128 × 165 $(5\frac{1}{16} \times 6\frac{1}{2})$
Inscribed 'Ex dono mei Venerabilissimi Patri.' in ink along bottom

27 T 04174 **A Family Group of Seven Persons Standing on a Terrace**
Pencil on paper 152 × 184 $(6 \times 7\frac{1}{4})$
Inscribed 'JH.' in ink b.r. corner

28 T 04175 **Two Full-length Studies of a Man in Peer's Robes**
Pencil on paper 89 × 141 $(3\frac{1}{2} \times 5\frac{9}{16})$
Inscribed 'Pro Effigie Comitii Hardwicke. Cancellarii|JH.' in ink along bottom
Repr. Beard 1934b, fig.XIII

29 T 04176 **Four Male Academy Studies**
Pen on paper 102 × 190 $(4\frac{1}{16} \times 7\frac{1}{2})$

26

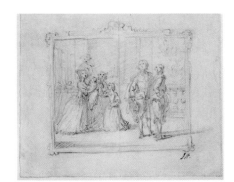

27

28

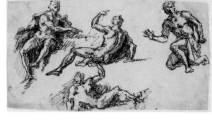

29

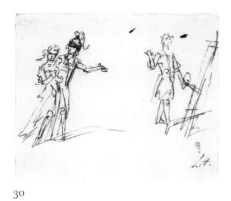

30

30 verso

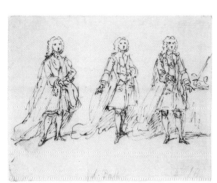

31

32

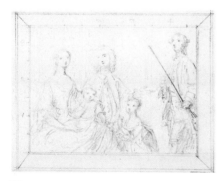

33

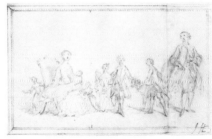

34

35

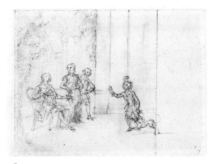

36

37

38

30 T 04177 **Sketch of a Helmeted Figure Leading a Blindfolded One Towards an Artist Standing at an Easel**

Pen and pencil on paper 119×144 $(4\frac{11}{16} \times 5\frac{11}{16})$
Inscribed 'J.H.' in ink b.r.
Verso: Sketch of a Gentleman and a Seated Lady, three-quarter length. Pencil

31 T 04178 **Sketch of a Group of Five Gentlemen Around a Table**

Pencil on paper 206×289 $(8\frac{1}{8} \times 11\frac{3}{8})$
Inscribed 'J H' in pencil b.r.
Repr. Beard 1934b, fig.x

32 T 04179 **Sketch of a Man with a Book, Opening a Door**

Pencil and pen on paper 184×152 $(7\frac{1}{4} \times 6)$
Inscribed 'J.H' in pencil b.r.
Repr. Beard 1934a, fig.IV

33 T 04180 **Three Full-length Studies of a Man in Peer's Robes**

Pencil and pen on paper 140×197 $(5\frac{1}{2} \times 7\frac{3}{4})$
Inscribed 'K. Bath' and 'J.H' in pencil along bottom
Repr. Beard 1934b, fig.XII

34 T 04181 **A Family Group of Eight Persons and a Dog, Full-length**

Pencil on paper 108×168 $(4\frac{1}{4} \times 6\frac{5}{8})$
Inscribed 'JH' in pencil b.r.
Repr. Beard 1934a, fig.v

35 T 04182 **A Family Group of Five Persons, Knee-length**

Pencil on paper 111×134 $(4\frac{3}{8} \times 5\frac{1}{4})$
Inscribed 'J H' l.r., '3–6' centre left and '4–8' top centre, all in pencil
Repr. Beard 1934a, fig.III

36 T 04183 **A Group of Four Persons and a Dog in a Garden**

Pencil on paper 114×152 $(4\frac{1}{2} \times 6)$
Inscribed 'J H' in ink b.r.

37 T 04184 **Sketch of a Child's Head and a Man on Horseback**

Pencil and brush on paper 229×332 $(9 \times 13\frac{1}{8})$

38 T 04185 **Two Full-length Studies of a Man Leaning on a Cannon**

Pencil on paper 128×197 $(5\frac{1}{16} \times 7\frac{3}{4})$
Inscribed 'J.H.' in ink b.r.

39 T 04186 **Two Full-length Studies of a Man in Robes**

Pen and pencil on paper 187 × 152 ($7\frac{3}{8}$ × 6)
Inscribed 'Sketch for Portrait of D of Richmond as a Knight of the Bath by J H.' in ink along bottom
Repr. Beard 1934b, fig.IX (detail)

40 T 04187 **Four Full-length Studies of a Man Opening a Door**

Pen and pencil on paper 103 × 198 ($4\frac{1}{16}$ × $7\frac{13}{16}$)
Inscribed 'Sketches. J.H.' in ink along bottom

41 T 04188 **Study for a Female Full-length in an Architectural Setting**

Pencil, pen and brown wash on paper
256 × 200 ($10\frac{1}{16}$ × $7\frac{7}{8}$)
Inscribed 'J H' in pencil b.r. and various measurements in pencil and ink
Probably a study for 'Portrait of Susannah, Countess of Shaftesbury', 1744, sold Christie's 27 June 1980 (152)

42 T 04189 **Two Studies of a Man's Head**

Pencil, pen and grey wash on paper 68 × 134 ($2\frac{11}{16}$ × $5\frac{1}{4}$)
Verso: Study of a nude male figure, kneeling. Pencil, pen, and grey wash

43 T 04190 **A Couple Seated on a Garden Bench**

Pen and grey wash on paper 76 × 118 (3 × $4\frac{5}{8}$)
Inscribed 'J.H' in ink b.r.

44 T 04191 **Putto with a Shepherd's Crook**

Pen and brown wash on paper 105 × 76 ($4\frac{1}{8}$ × 3)

45 T 04192 **Group of Three Ladies in a Garden**

Pencil on paper 95 × 152 ($3\frac{3}{4}$ × 6)
Inscribed 'J.H' in ink b.r.

46 T 04193 **Two Studies for a Group of Four Male Figures in an Architectural Setting**

Pencil on paper 189 × 156 ($7\frac{7}{16}$ × $6\frac{1}{8}$)

40

40

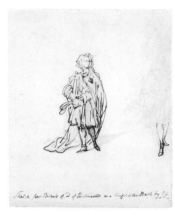

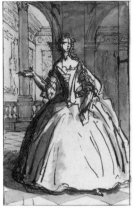

39

42

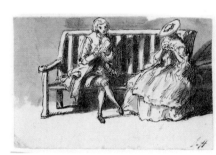

41

42 verso

43

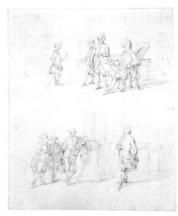

45

44

46

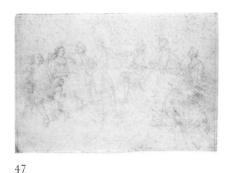

47

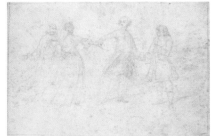

48

49

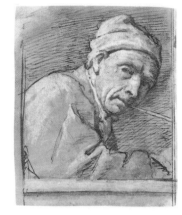

50

51

51 verso

52

53

54

55

47 T 04194 **The Harlowe Family** *c.*1745–7
Pencil on vellum 130 × 190 $(5\frac{1}{8} × 7\frac{1}{2})$
Design for an illustration to Volume 1, Letter 7, of Samuel Richardson's novel *Clarissa*, published 1747. Possibly an alternative composition to one painted by Highmore in oils $(648 × 784, 25\frac{1}{2} × 30\frac{7}{8})$, now at the Yale Center for British Art, New Haven

48 T 04195 **James Harlowe Tries to Join the Hands of Clarissa and Mr Solmes by Force** *c.*1745–7
Pencil on vellum 130 × 189 $(5\frac{1}{8} × 7\frac{7}{16})$
Design for an illustration to Richardson's *Clarissa*, Letter 78

49 T 04196 **Clarissa and Mr Lovelace at the Garden Door** *c.*1745–7
Pencil on vellum 128 × 190 $(5\frac{1}{16} × 7\frac{1}{2})$
Design for an illustration to Richardson's *Clarissa*, Letter 94

50 T 04197 **Portrait of a Man in a Cap**
Pencil, pen, brown wash and white highlights on brown paper 108 × 87 $(4\frac{1}{4} × 3\frac{7}{16})$

51 T 04198 **Seated Putto**
Ink and grey wash on paper 56 × 52 $(2\frac{3}{16} × 2\frac{1}{16})$
Verso: Fragment of a Figure Holding a Staff. Ink and grey wash

52 T 04199 **A Man Leaning on a Fence**
Ink and brown wash 67 × 89 $(2\frac{5}{8} × 3\frac{1}{2})$

53 T 04200 **Profile of an Old Man**
Pen and grey wash on paper 60 × 38 $(2\frac{3}{8} × 1\frac{1}{2})$

54 T 04201 **Study for Mercury**
Pencil, pen and brown wash on paper 184 × 146 $(7\frac{1}{4} × 5\frac{3}{4})$

55 T 04202 **Profile of a Man**
Pen on paper 106 × 64 $(4\frac{3}{16} × 2\frac{1}{2})$

[67]

56 T 04203 **Family Group of Five Persons, Three-quarter-length**

Pencil on paper 105 × 130 (4⅛ × 5⅛)
Inscribed 'En famille J.H.' in ink b.r.

57 T 04204 **Head of an Old Woman**

Pen and grey wash on paper 142 × 121 (5 9/16 × 4¾)

58 T 04205 **Study for a Female Full-length Beside a Fountain**

Pencil and pen on paper 187 × 152 (7⅜ × 6)
Inscribed 'J H' in pencil b.l.

59 T 04206 **A Paviour Seen from Behind**

Pencil and pen on paper 83 × 83 (3¼ × 3¼)

60 T 04207 **Classical Female Figure with a Palm Frond**

Pen and grey wash on paper 79 × 54 (3⅛ × 2⅛)

61 T 04208 **Front View of a Bull's Head**

Pencil and pen with brown washes and white highlights on paper 168 × 142 (6⅝ × 5 9/16)

62 T 04209 **Side View of a Bull's Head**

Pencil and pen with brown washes and white highlights, and pink touches on the muzzle, on paper 168 × 131 (6⅝ × 5 3/16)

63 T 04210 **Family Group of Five Persons in a Garden**

Pencil on paper 154 × 190 (6 1/16 × 7½)
Inscribed 'J H' in pencil b.r.

64 T 04211 **Family Group of Six Persons in a Room**

Pencil on paper 127 × 190 (5 × 7½)
Inscribed 'En famille. JH.' in ink b.r.

56

57

58

59

60

61

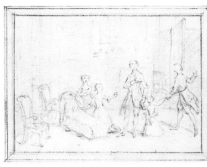

64

63

62

65

66

67

68

69

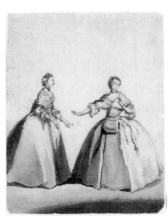

70

71

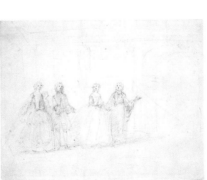

72

65 T 04212 **Head of an Old Man**
Pen and grey wash on paper 70 × 58 ($2\frac{3}{4} \times 2\frac{1}{4}$)

66 T 04213 **A Sheet of Two Studies for a Male Full-length and 'The Good Samaritan'**
Pencil and pen on paper 267 × 165 ($10\frac{1}{2} \times 6\frac{1}{2}$)
Inscribed 'J.H' in pencil b.r.
See no.24
Verso: A Group of (?) Four Figures. Pencil sketch, very faint

67 T 04214 **Two Studies for a Female Full-length**
Pencil on paper 141 × 172 ($5\frac{9}{16} \times 6\frac{3}{4}$)
Inscribed 'E Studiis Avi pro Effigie Matri mei. AH. 1724. J.H.' in ink along bottom
Repr. Beard 1934a, fig.1
Verso: Two Studies of Male Full-length Figures. Pencil

68 T 04215 **Four Studies for a Male Full-length**
Pencil on paper 254 × 197 ($10 \times 7\frac{3}{4}$)
Inscribed 'J H' in pencil b.r.

69 T 04216 **Two Classical Heads**
Pen and grey wash on paper 110 × 220 ($4\frac{5}{16} \times 8\frac{11}{16}$)

70 T 04217 **Two Ladies in an Interior**
Pencil, pen and brown wash on paper 203 × 159 ($8 \times 6\frac{1}{4}$)
This is probably an illustration for a story from contemporary life

71 T 04218 **Study for 'The Marriage of Miss Whichcote of Harpswell with the Dean of York' in Contemporary Dress, with Archway on Left** – I *c.*1749
Pencil on paper 192 × 242 ($7\frac{9}{16} \times 9\frac{1}{2}$)
The oil painting for which this and the following two sketches were made, was lent by the Trustees of the late Sir George Whichcote, Bart, and Nicholas G.W. Playne to the Kenwood exhibition 1963 (35, 1015 × 1270, (40 × 50), signed, but not dated). The marriage took place in 1749

72 T 04219 **Study for 'The Marriage of Miss Whichcote of Harpswell with the Dean of York' in Contemporary Dress, with Archway on Right** – II *c.*1749
Pencil on paper 190 × 242 ($7\frac{1}{2} \times 9\frac{1}{2}$)

73 T 04220 **Study for 'The Marriage of Miss Whichcote of Harpswell with the Dean of York' in Vandyke Dress with Archway on Right** – III *c.*1749
Pencil on paper 194 × 248 (7$\frac{5}{8}$ × 9$\frac{3}{4}$)

74 T 04221 **Two Studies for a Male Full-length**
Pencil on paper 127 × 197 (5 × 7$\frac{3}{4}$)
Inscribed 'J.H.' in ink b.r. and numbered '2' and '3' in pencil t.r.

75 T 04222 **A Conversation of Four Persons on a Terrace**
Pencil on paper 152 × 190 (6 × 7$\frac{1}{2}$)

76 T 04223 **Head of James Harris of Salisbury**
Pencil, pen and brown wash on paper 121 × 82 (4$\frac{3}{4}$ × 3$\frac{1}{4}$) pasted on paper 197 × 125 (7$\frac{3}{4}$ × 4$\frac{15}{16}$)
Inscribed 'James Harris Esq: of Salisbury' in ink along top of drawing, and 'Jos: Highmore|From the Author' in ink in upper half of larger sheet
Repr. Beard 1934a, fig.XII
James Harris (1709–80) was an amateur musician and writer, later MP for Christchurch and a Lord of the Treasury. Highmore painted several members of his family

77 T 04224 **The Back of Capt. Grose**
Pen on paper 127 × 94 (5 × 3$\frac{11}{16}$)
Inscribed with caption in ink, t.l.
Repr. Beard 1934a, fig.XI

78 T 04225 **A Sheet of Four Studies of Heads**
Pen on paper 192 × 203 (7$\frac{9}{16}$ × 8)
Inscribed 'E Studiis mei Venerabilis avi. J.H.' b.r. in ink, and 'Rump|at Bury St|Edmonds' in ink in older script upper centre beside two studies of the head of an unkempt man

79 T 04226 **Sketch of a Girl**
Pencil on paper 164 × 64 (6$\frac{1}{2}$ × 2$\frac{1}{2}$)

80 T 04227 **Portrait of Frank Merrit**
Pencil on paper 198 × 159 (7$\frac{3}{4}$ × 6$\frac{1}{4}$)
Inscribed 'Mr Frank Merrit|by ye life|by J.H.' in ink t.l.
Repr. Beard 1934a, fig.II

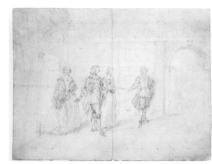

73

74

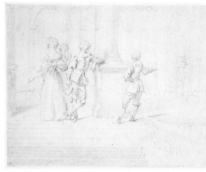

75

76

77

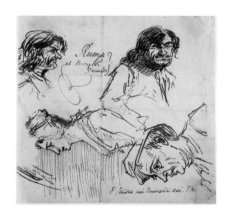

78

79

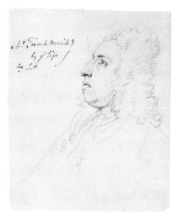

80

81

82

83

84

81 T 04228 **Studies for a Ceremonial Mace and Hat**

Pen and pencil on paper 265 × 206 ($10\frac{7}{16} \times 8\frac{1}{8}$)
Inscribed '34' in ink t.r. and various
measurements and colour notes in pencil

82 T 04229 **Portrait of a Young Man, possibly the Artist's Son**

Pencil on paper 189 × 150 ($7\frac{7}{16} \times 5\frac{15}{16}$)
Inscribed 'J H' in pencil b.r.
Repr. Beard 1934b, fig.XI

83 T 04230 **Academy Study of a Male Nude Looking Down**

Pencil, pen and grey wash on paper 241 × 170
($9\frac{1}{2} \times 6\frac{11}{16}$)

84 T 04231 **Academy Study of a Male Nude with Raised Arm**

Pencil, pen and grey wash on paper 240 × 190
($9\frac{7}{16} \times 7\frac{1}{2}$) pasted on paper 270 × 200
($10\frac{5}{8} \times 7\frac{7}{8}$)

85 T 04232 **Sketchbook of Figure Studies after Classical Statues**

Vellum binding 365 × 235 ($14\frac{3}{8} \times 9\frac{1}{4}$), with six
pages measuring 359 × 230 ($14\frac{1}{8} \times 9\frac{1}{16}$) each

86

WILLIAM HOARE *c.*1707-1792

Portrait painter in oil and crayons, born at Eye, Suffolk, probably in 1707, son of a prosperous farmer and brother to the sculptor Prince Hoare (d.1769). Pupil of Guiseppe Grisoni (1699-1769) with whom he went to Italy 1728, where he stayed for nine years, studying under Imperiali and supporting himself comfortably by copying famous masterpieces. Settled in Bath 1739 and was its most fashionable portraitist until the arrival of Gainsborough in 1759, although he remained in demand until giving up painting in about 1779. Exhibited SA 1761-2, elected RA 1769, and exhibited there 1770-9. Died in Bath, 9 December 1792, in prosperous circumstances.

His son Prince Hoare (1755-1835), also a painter, studied under him and under Mengs in Rome, but gave up painting for writing after 1785.

LITERATURE
Evelyn Newby, 'The Hoares of Bath', *Bath History*, 1, 1986, pp.90-127

86 **A Gentleman in Brown** *c.*1750

T 01888
Oil on canvas 765 × 639 ($30\frac{1}{8}$ × $25\frac{1}{8}$)
Bequeathed by Alan Evans to the National Gallery 1974; transferred to the Tate Gallery 1974

PROVENANCE
...;? Sotheby's 12 December 1951 (81) bt D. Guerault; ...; Alan Evans by 1974

The painting came to the gallery with an ascription to Thomas Hudson and the identification of the sitter as a 'member of the Foley Gray family', neither of which can be substantiated (the compiler is grateful to Ellen G. Miles and Jacob Simon, who both confirmed that the attribution to Hudson was untenable). Among the numerous family portraits attributed to Hudson in the sale of Sir John Foley Gray, Bart, of Enville Hall, Stourbridge (Christie's 15 June 1928) none corresponds with this in size. Moreover, should the painting be identical with the one which fits its description in the Sotheby's sale of 1951 ('Thomas Hudson: A Gentleman, half-length, wearing a brown coat, gold edged, his left hand resting in his waist-coat, his hat beneath his arm, $29\frac{1}{2}$ × $24\frac{1}{2}$ in.') then any connection with the Foley Grey family would seem unlikely.

Stylistically the painting fits well into Hoare's *oeuvre* after he settled in Bath in 1739, and the attribution is accepted by Mrs Evelyn Newby, who is compiling a catalogue of Hoare's works.

WILLIAM HOGARTH 1697-1764

Painter of portraits, history and contemporary narrative genre, also leading engraver; first British-born artist of European standing. Born London, 10 November 1697, son of unsuccessful classics master and writer, Richard Hogarth. Son-in-law of Thornhill (q.v.).

Apprenticed 1714 to silversmith Ellis Gamble as ornamental engraver, worked independently from c.1720. Enrolled in St Martin's Lane Academy in October 1720. Began painting in oils probably in late 1720s, and first noted as a serious painter after producing several versions of a scene from *The Beggar's Opera* of 1728. Successful throughout 1730s as accomplished painter of small-scale conversation pieces. Gained popular acclaim in 1732 with publication of engravings after the first of his 'modern moral subjects', 'The Harlot's Progress'. This was followed by other series, notably 'The Rake's Progress' (Soane Museum) in 1735, 'Marriage A-la-Mode' (National Gallery) in 1745, and 'The Election' (Soane Museum), painted in 1754-5. Set up his own academy run on democratic lines in St Martin's Lane with equipment inherited from Thornhill in 1734, and was the chief instigator of the Engravers' Copyright Act of 1735. Painted his first large-scale histories for the staircase of St Bartholomew's Hospital 1735-6; encouraged presentation and display of works by British artists at the Foundling Hospital, where his 'Captain Thomas Coram' of 1740 is one of the masterpieces of portraiture on the scale of life of this period. Visited Paris in 1743, and possibly again in 1748, and much of his fluid handling of paint suggests French influence. His theoretical work *The Analysis of Beauty*, published 1753, was not well received and much of the remainder of his life was overshadowed by quarrels with the establishment. Exhibited at the SA 1761. Died at his house in Leicester Fields 25 or 26 October 1764; buried at Chiswick.

LITERATURE
Beckett 1949; Paulson 1965; Paulson 1971; Webster 1979; Bindman 1981

EXHIBITIONS
Hogarth, Tate Gallery 1971

87 The Beggar's Opera VI 1731

N 02437
Oil on canvas 575 × 762 (22⅝ × 30)
Inscribed 'VELUTI IN SPECULUM' and 'UTILE DULCI' on ribbon to either side of royal coat of arms top centre
Purchased by the National Gallery (Temple West Fund) 1909; transferred to the Tate Gallery 1919

PROVENANCE
Commissioned by Sir Archibald Grant, MP, 2nd Bart of Monymusk (together with 'The Committee of the House of Commons', probably version now in the NPG), half-payment made 5 November 1729, still unfinished January 1731 and not collected owing to Grant's bankruptcy in May 1732; ...; acquired by William Huggins of Headly Park, Hants, inherited on his death in 1761 by his son-in-law Sir Thomas Gatehouse of Wallop, Herts.; according to Nichols &

Steevens sold by him c.1776 to the Revd Thomas Monkhouse, DD, FSA, Fellow of Queen's College, Oxford, after whose death in 1798 it became the property of his executor the Hon. and Revd Henry Jerome de Salis, Rector of St Antholin, London (d.1810); ...; with Thomas Bowerbank of Lothbury by 1817, sold by him 1833 or 4 to Dr John Murray; by descent to his grandson John Murray, from whom bt by the National Gallery

EXHIBITED
BI 1847 (149); *Art Treasures,* Manchester 1857 (25); *International Exhibition,* South Kensington 1862 (4); RA Winter 1876 (100); *A Century of British Art (Second Series),* Grosvenor Gallery 1889 (9); *Georgian England,* Whitechapel Art Gallery 1906 (Upper Gallery 60); RA Winter 1908 (85); *Jubilee Exhibition,* City Art Gallery, Bradford 1930 (45); *Art and the Theatre,* Lady

Lever Art Gallery, Port Sunlight 1949 (93); Tate Gallery 1951 (27); BC tour 1960 (3); Tate Gallery 1971 (47, repr. in col.); *Handel*, National Portrait Gallery 1985 (108, repr. in col.)

ENGRAVED
This version engraved by T. Cook for Nichols & Steevens 1817, facing p.94; the version in the Mellon Collection was engraved by William Blake in 1788, pub. 1 July 1790 (no.117), with additional key of sitters; the central group, loosely adapted from the earliest version, was crudely engraved by Joseph Sympson Jnr (d.1736) for the ticket of a benefit performance for Thomas Walker (the original Macheath of 1728).

LITERATURE
Nichols 1781, pp.15–16, 1782, pp.17–20, 1785, pp.19–23; Nichols & Steevens 1808, pp.29–30, 1817, pp.94–9 (engr. facing p.94); Nichols 1833, p.351; Dobson 1902, pp.34, 168, repr. (with original frame with carved portrait of Gay) facing p.36; Dobson 1907, p.196, repr.

facing p.22 (with frame); F. Saxl & R. Wittkower, *British Art and the Mediterranean*, 1948, p.60, item 3, repr.; R.B. Beckett, 'Hogarth's Early Painting: II: 1728: The Beggar's Opera', *Burlington Magazine*, XC, 1948, pp.167–8, fig.10; Beckett 1949, p.40, fig.17; Hugh Phillips, *Mid-Georgian London*, 1964, pp.192–3, pl.13 (col.), and key of sitters fig.265; W.S. Lewis and P. Hofer, *The Beggar's Opera by Hogarth and Blake*, New Haven and London 1965, no.VII, repr.; Baldini & Mandel 1967, p.88, no.9F, pl.3 (col.); Antal 1962, pp.26, 59, 61, 63, 65–7, 71, 74, 90, 114, 145, 178, 230 n.91, 231 n.16, 233 n.39, pl.20(b); Paulson 1970, I, pp.111, 116, 297–8, II, pls.320, 341; Paulson 1971, I, pp.180–92, 230, 275, 307, 527 nn.22–7; H. Omberg, *William Hogarth's Portrait of Thomas Coram*, Uppsala 1974, pp.54–5, pl.2; Kerslake 1977, I, p.332 (for provenance); Webster 1979, pp.12–13, 36, 97, 104, repr. in col. pp.24–5; Bindman 1981, pp.21–37; Stella Margetson, 'Sweet-Tempered Satirist: John Gay and the Beggar's Opera, *Country Life*, 19 September 1985, pp.832–3, fig.7

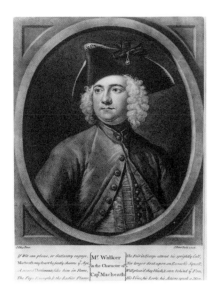

fig. 22 J. Faber after John Ellys: 'Mr Walker in the Character of Cap^n Macheath'. Engraved 1728 (photo: National Portrait Gallery, London).

fig. 24 J. Faber after John Ellys: 'Miss Fenton'. Engraved 1728 (photo: National Portrait Gallery, London).

The Beggar's Opera by John Gay (1685–1732) was a new kind of musical entertainment, first produced by John Rich at the Lincoln's Inn Fields Theatre in January 1728, where it gained immediate and unprecedented popularity. This 'new English Opera' satirised the conventional Italian operatic style by substituting popular ballads and airs, adapted by J.C. Pepusch, for formal arias, and contemporary low-life characters for classical gods and goddesses. It came at a time when Hogarth, a life-long enthusiast for the theatre, was changing his career from graphic artist to painter, and not surprisingly he found in it a suitable subject for one of his earliest excursions into oil painting, thus producing, among other things, one of the earliest known painted records of an actual stage performance.

Hogarth chose to represent one of the most dramatic moments towards the end of the opera (Act III, scene XI, air LV), set in Newgate prison, where all the main actors appear on stage together. The highwayman hero Macheath (played by Thomas Walker, fig.22) stands, dressed in scarlet and chained, in the centre. On the left, with her back to the audience, Lucy Lockit (Mrs Egleton) pleads with her father the Prison Warden (played by 'Mr Hall') to save Macheath from hanging. On the right Polly Peachum (Lavinia Fenton, figs.23, 24), dressed in white, does the same with her father (John Hippisley), a dishonest lawyer and informer; both ladies believe themselves to be married to Macheath. The players are flanked by the audience, privileged members of which sat in boxes which occupied part of the stage (a practice abolished only in 1763 by Garrick).

It is an added dimension of the drama that Lavinia Fenton as Polly faces the Duke of Bolton (fig.25), shown seated prominently in the right-hand box, wearing the Garter star and ribbon, for a celebrated aspect of the production was the fact that the Duke, twenty-three years her senior and separated from his wife, fell in love with Lavinia on the first night and thereafter became a constant attendant at performances. At the end of the season Lavinia Fenton retired from the stage to become his mistress, and eventually, on the death of his wife in 1751, Duchess of Bolton (see no.102).

Apart from the Garter motto around the royal coat of arms at the top, there are two Latin inscriptions on the ribbons on either side which encapsulate the view of the theatre and *The Beggar's Opera* in particular, as successfully holding up a salutary mirror to reality: 'veluti in speculum' ('as in a mirror'), and a quote from

[75]

Horace's *Ars Poetica*, 1.343: 'Omne tulit punctum qui miscuit utile dulci' ('He who joins instruction with delight, carries all the votes'). The quote does not presuppose great classical learning, as 'utile dulci' was a common popular phrase even among the moderately educated. It peppers, for instance, the correspondence of young men on the Grand Tour endeavouring to present their social activities in an educational light (e.g. Lee correspondence, *c*.1749-53, Beinecke Library, Yale University, New Haven).

At least six oil versions of this scene by Hogarth are known, and the Tate Gallery version is one of the last and most developed. The earliest and simplest (now in the W.S. Lewis Collection, Farmington, fig.26) was painted soon after the initial performance, possibly for John Rich, the producer of the opera. It was bought in 1762 at Rich's sale by Horace Walpole, whose signed note on the back identifies the players, and two members of the audience – Sir Thomas Robinson of Rokeby on the left, 'a tall gentleman with a long lean face', and on the right, 'Sir Robert Fagg in profile, a fat man with short gray hair much known at Newmarket'. Walpole's note (repr. Lewis and Hofer 1965, no.II) also describes it as a 'Sketch': its present heavy outlines suggest that it may indeed have once been a much slighter work that had been subsequently worked up by another hand to look like one of the more finished versions. In this early version the audience is composed of recognisable caricatures (Fagg is shown with a riding crop under his arm, turning his back to the performance), while in the more polished later versions (including the Tate Gallery's) they are rendered as straight portraits, with Fagg as the third man from the right, now facing the other way and attending the performance, while Robinson is identified with the man standing at the top against the wall on the left-hand side of the stage. The Duke of Bolton does not figure in the early versions, and was presumably added later after the scandal had gained in notoriety. There are two other versions very close to this early one, one of them, signed and dated 1728 (private collection, fig.27), and the other (fig.28) formerly in the collection of Lord Astor of Hever (sold Christie's 15 July 1983, lot 48, repr. in col.), now in the Birmingham Art Gallery. Version IV (National Gallery, Washington, fig.29) seems to be a largely abandoned attempt to rethink the groups, and is the only one without a royal coat of arms in the centre, which, however, is clearly visible under the curtain painted over it.

In 1729 John Rich ordered a larger and more elaborate version (fig.30), now at the Yale Center for British Art (605×735, $23\frac{3}{4} \times 28\frac{7}{8}$, signed and dated 1729). This shows a wider and deeper stage, places the central group on a carpet, adds the Duke of Bolton and various other figures to the audience (presumably chosen by Rich himself), and introduces the crouching satyrs holding up the curtain on either side. The Tate Gallery painting follows this version very closely, and was commissioned by Hogarth's early patron Sir Archibald Grant in 1729, along with a group portrait of the 'Oglethorpe Committee' of which Grant had been a member (National Portrait Gallery, see Kerslake 1977, I, pp.330-8, fig.942). This commission is documented by Hogarth's autograph list of 'Pictures that Remain unfinished' on 1 January 1731, now in the British Library (BL Add.MS 27995, folio I):

the Committy of the house of Commons	Sir Archibald Grant	half Payment Rec'd Novbr the 5th
the Beggars Opera	D°	1729

Without moving Macheath out of his central 'Choice of Hercules' position, this version gives greater prominence to Lavinia Fenton by placing her, dressed in white, on a carpet between the two strongest male figures, as befits the leading lady whose singing brought the house down on the opening night of what was considered initially to be a risky production, thus ensuring its unrivalled and, for Rich in particular, lucrative run. Hogarth's increasing confidence as a painter is

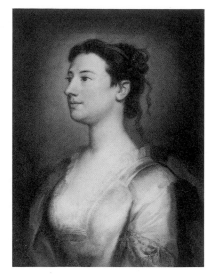

fig. 23 British School: 'Lavinia Fenton, Duchess of Bolton' *c*.1745. Pastel on paper 584×445 ($23 \times 17\frac{1}{2}$). Private Collection.

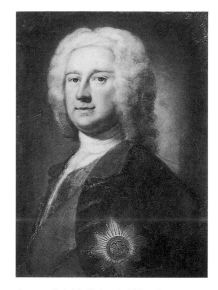

fig. 25 British School: 'Charles Paulet, 3rd Duke of Bolton' *c*.1745. Pastel on paper 597×445 ($23\frac{1}{2} \times 17\frac{1}{2}$). Private Collection.

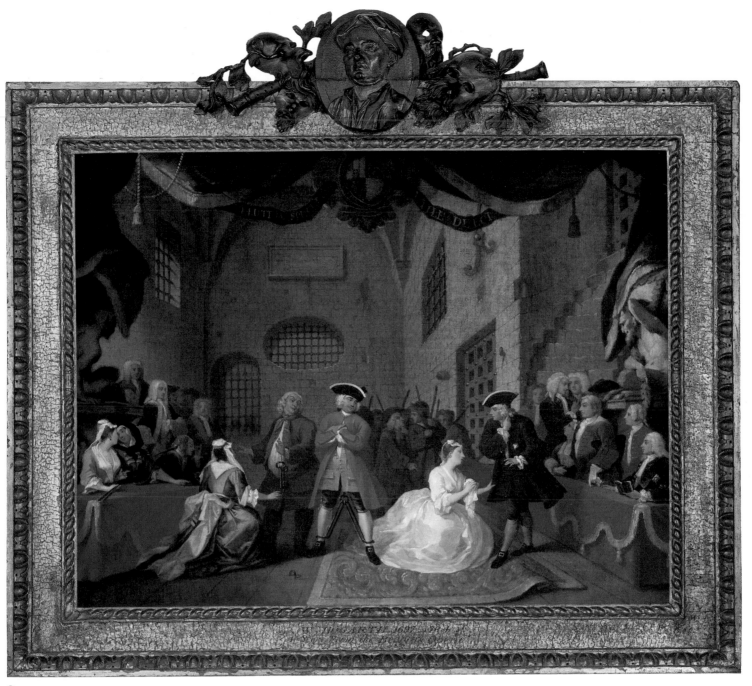

87

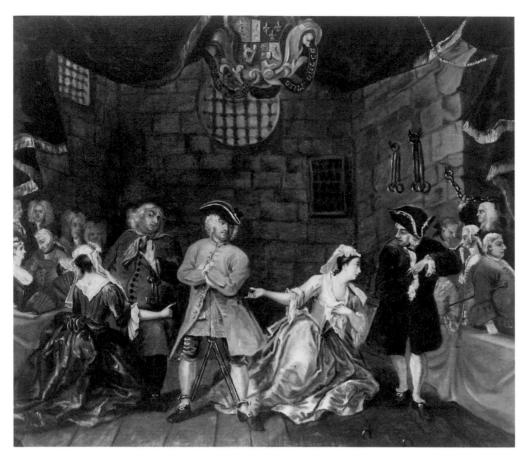

fig. 26 William Hogarth: 'The Beggar's Opera' I, *c*.1728. Oil on canvas 457 × 533 (18 × 21). The Lewis Walpole Library, Yale University.

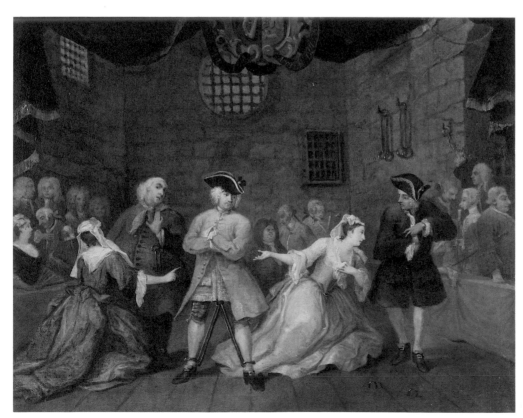

fig. 27 William Hogarth: 'The Beggar's Opera' II. Signed and dated 1728. Oil on canvas 580 × 580 (20 × 20). Private Collection.

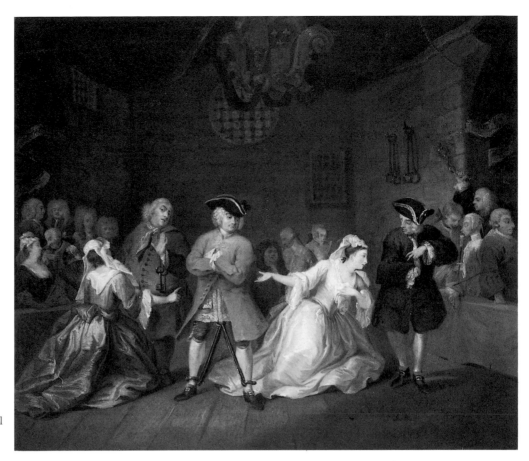

fig. 28 William Hogarth: 'The Beggar's Opera' III, *c*.1728–9. Oil on canvas 422 × 555 (16⅝ × 21⅞). Birmingham City Art Gallery.

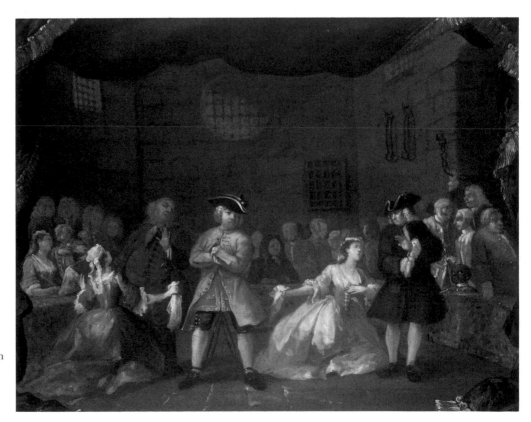

fig. 29 William Hogarth: 'The Beggar's Opera' IV, *c*.1728. Oil on canvas 511 × 612 (20⅛ × 24⅛). National Gallery of Art, Washington; Paul Mellon Collection.

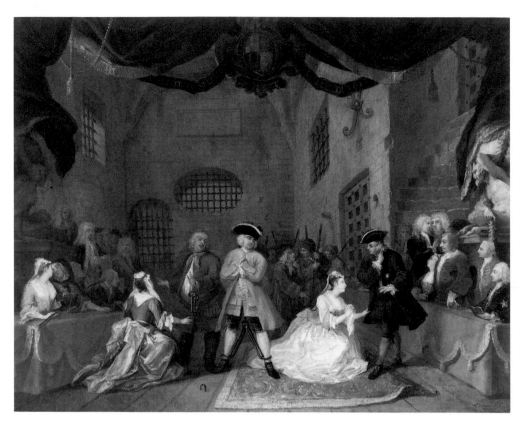

fig. 30 William Hogarth: 'The Beggar's Opera' V. Signed and dated 1729. Oil on canvas 590 × 760 (23¼ × 30). Yale Center for British Art, New Haven, Paul Mellon Collection.

fig. 31 William Hogarth: Sketch for 'The Beggar's Opera'. Black chalk with touches of white and splashes of oil paint on dark blue paper 373 × 492 (14⅝ × 19⅜). Royal Library, Windsor Castle. Copyright reserved. Reproduced by gracious permission of Her Majesty The Queen.

manifested not only in the greater spaciousness of the composition and more complex lighting of the interior, but also in the more fluent handling of paint and in the elaboration of the wings, with their handsome satyr caryatids conceived in terms of classical *contrapposto* and echoed in the poses of the audience directly below.

In 1788 William Blake was commissioned by John Boydell to engrave version v, which then belonged to the Duke of Leeds. This was finally published in July 1790, together with a smaller key (not by Blake) which not only identified the players, Robinson, Fagg and the Duke of Bolton as already described, but also the second lady from the left as 'Lady Jane Cook', the man next to her leaning forward across the box as 'Anthony Henley Esqr', the man standing directly behind him with his hand in his waistcoat, as 'Lord Gage', and next to him, wearing the star and red ribbon of the Order of the Bath as 'Sir Conyers D'Arcy'. The men standing in the box opposite are given, from left to right, as 'Mr Gay', 'Mr Rich, The Manager' and 'Mr Cock, The Auctioneer', while the man between Sir Robert Fagg and the Duke is 'Major Pounceford'. In view of their late date, however, these identifications have to remain open to some doubt.

The Tate Gallery painting is in an eighteenth-century frame surmounted by a finely carved and painted cartouche consisting of an oval portrait medallion of Gay (possibly loosely based on Rysbrack's medallion portrait of 1736 on Gay's monument in Westminster Abbey), flanked on either side by a laurel bough, flute and two three-dimensionally carved satyr's masks that echo the satyrs and the satyr's masks on the columns behind them in the painting. At some stage in the past the canvas had been cut at the edges, removing part of the masks behind the statue, especially on the left-hand side. Nichols writes in 1781 that the painting, which by then belonged to Thomas Monkhouse, 'is in a gilt frame, with a bust of *Gay* at the top. Its companion, whose present possession I have not been able to trace out, had, in like manner, that of Sir Francis Page, one of the judges, remarkable for his severity, with a halter round his neck.' The Tate Gallery painting is still in the frame so described, but the fate of its companion is not clear. It seems likely that this was the 'Committy of the house of Commons' in the National Portrait Gallery, now bereft of its special frame, but with which it was apparently still equipped at the BI exhibition of 1814 (Nichols & Steevens 1817, p.93, although the evidence is negative: Steevens, who writes about the frames and saw the exhibition, makes no mention of the 'Committy' picture no longer being in its special frame). The implication is that the Tate Gallery version of 'The Beggar's Opera' and its companion 'Committee of the House of Commons' (either the National Portrait Gallery version or another) acquired their unusual frames sometime before being split up as a pair, which happened either soon after the death of William Huggins in 1761, or at the dispersal of Gatehouse's collection *c*.1776 (Steevens gives contradictory information on this). In either case, William Huggins seems the likeliest person to have commissioned them, as his personal interest in the paintings was no less than Grant's, who probably never collected the paintings, as he went bankrupt in October 1731 and was expelled from the Commons in May 1732 for embezzling the funds of the Charitable Corporation. Huggins was not only a personal friend of Hogarth and Rich, but Sir Francis Page (d.1741) had been one of the judges who took part in the trial of his father John Huggins, former titular Warden of the Fleet Prison, which resulted from the House of Commons Committee shown in the painting (Huggins pleaded ignorance of all malpractices and was exonerated).

John Nichols claims (1782, p.20) that Horace Walpole, who owned the earliest version of this scene, also had in his collection a 'picture of a scene in the same piece, where Macheath is going to execution. In this also the likeness of Walker and Miss Fenton . . . are preserved', but nothing further is known about this painting.

A chalk sketch (fig.31) for the earlier version of this scene is in the Royal Collection (A.P. Oppé, *The Drawings of William Hogarth*, 1948, no.23, repr., and *English Drawings . . . at Windsor Castle*, 1950, p.62, no.344, pl.58).

88 Ashley Cowper with his Wife and Daughter 1731

T 00809
Oil on canvas 533 × 612 (21 × 24 1/16)
Inscribed 'W Hogarth Fecit|1731' b.l. and
'Hic gelidi Föntes, hic mollia prata –|Hic
nemus, hic ipso tecum Consumerer|aevo.' on
the pedestal of the urn
Purchased (Grant-in-Aid and Special Grant)
with assistance from the Friends of the Tate
Gallery 1965

PROVENANCE
The sitter's younger daughter Elizabeth, who
married Sir Archer Croft, Bart, in 1759; their
eldest daughter Charlotte Elizabeth who
married James Woodcock, who changed his
name to Croft in accordance with Sir Archer's
will of 1792; thence by family descent *c.*1950
to the wife of Colonel F.J. O'Meara, *née* Croft,
and sold Sotheby's 24 November 1965 (70,
repr.) bt Agnew for the Tate Gallery

EXHIBITED
Tate Gallery 1971 (35, repr. in col.)

LITERATURE
Ireland 1798, p.23; Nichols 1833, p.371;
Dobson 1902, p.177; Beckett 1949, p.42 ('The
Cooper Family'); Antal 1962, pp.180–1;
Baldini & Mandel 1967, no.42, repr.; Paulson
1971, I, pp.224, 226, 556, no.63; Webster
1979, no.35, repr.; Bindman 1981, p.47, fig.36

Ashley Cowper (1701–88), a barrister who held the office of Clerk of the Parliaments from 1740 until his death, was a friend of the artist. This delightful pastoral may have been begun as a wedding picture, when Cowper married Dorothy Oakes, probably in 1730 (the exact year of their marriage is not known). The votive scene on the urn between them, showing a bearded priestly figure officiating at an altar, would seem to support this notion, as does the apparent fact that the picture was originally conceived as a composition of two figures only: it is included in Hogarth's list of sixteen commissions he had in hand on 1 January 1731, for which half-payment had been received, as 'Another [conversation], of two, – Mr Cooper' (BL Add.MS 27995, p.1, reprinted in Ireland 1798, p.23). No commission date for it is given, but it is listed among others begun in 1730. The child was evidently added later, apparently by Hogarth himself, though not very successfully, and the lower right-hand corner of the picture shows extensive pentimenti to the landscape, the ground and the lady's skirts to accommodate the little figure. The pointed hat on her lap also seems to be a later addition, and her right hand was originally higher.

The child is probably Theodora, the eldest of the couple's three daughters, who was baptised in 1731, and died unmarried in 1824. Her younger sister Harriet (baptised 1733, married Sir Thomas Hesketh, and died 1807) may have been thinking of this family picture when she wrote in a letter to William Hayley in 1802 the surprising opinion that 'Hogarth who excell'd so much and whose fame will never dye, made all his children Frightful! He had none of his own, and my dear Father, who knew him well, has often said that he believ'd his Friend Hogarth had an aversion to the whole Infantine Race, as he always contrived to make them hideous . . .' (BL Add. MS 30803 B, p.58, quoted in Paulson 1971, I, p.556, no.63). Elizabeth, the youngest daughter, who married Sir Archer Croft, 3rd Bart, in 1759, was co-heiress of her father and would have inherited the painting for this reason (see Thomas Wright, *The Correspondence of William Cowper*, 1904, I, p.xxvii).

The painting is one of the most literal interpretations of an Arcadian setting in English art. The quotation on the pedestal is slightly adapted from Virgil's Tenth Eclogue, where the poet Gallus, a pilgrim in Arcadia, pines with unrequited love for Lycóris, an Arcadian shepherdess, musing that for all his determination to go hunting with his hounds on the rough mountains, 'Here [Lycoris] among cool fountains and soft fields,|And woodland, here with you I'd be Time's casualty', and

88

affirming that ultimately love conquers all. Appropriately, Ashley Cowper leans on a pilgrim's or shepherd's staff, a tall flowing fountain is just visible in the bosky shadows of the background on the right, while the couple's attitudes plainly suggest that, unlike that of poor Gallus, this lover's song does not fall on deaf ears.

Although the painting remained in family possession until its sale in 1965, its attribution to Hogarth was not reconfirmed until 1951, when Colonel O'Meara's colleague Major-General Hargreaves cleaned the painting, revealing the date and signature (letter dated 23 August 1978 from Major-General W.H. Hargreaves in Gallery files).

89-94 **A Rake's Progress** 1735

T 01789-01794
Six plates from a series of eight, etching and
engraving, various sizes
Transferred from the reference collection 1973

PROVENANCE
Unknown

The eight paintings for the series are now in Sir John Soane's Museum. They were Hogarth's second series of 'modern moral subjects' and were painted soon after the publication of 'A Harlot's Progress' in 1732. The subscription for the prints after them began in late 1733, but Hogarth delayed publication until 25 June 1735, the day the Engravers' Copyright Act became law. Even so, pirated copies had already appeared by that time. The set cost two guineas, but Hogarth had also a smaller and cheaper set, copied by Thomas Bakewell and costing 2s 6d, published soon after. The original copperplates were sold by Quaritch in 1921 and are now in a private collection. Louis Gérard Scotin (1690–after 1755) is thought to have assisted Hogarth with the engravings.

89 **A Rake's Progress (Plate 1)** 1735

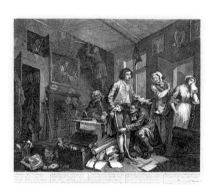

89

T 01789
Etching and engraving 318×387 ($12\frac{1}{2} \times 15\frac{1}{4}$)
on paper 465×610 ($18\frac{5}{16} \times 24$); plate-mark
362×410 ($14\frac{1}{4} \times 16\frac{1}{8}$)
Writing-engraving '*Invented Painted and
Engrav'd by W^m Hogarth, & Publish'd June y^e 25
1735. According to Act of Parliament|Plate 1.*' and
eighteen-line verse caption.

LITERATURE
Paulson 1970, I, pp. 158–70, no.132, II,
pls.138–9

Plate 1 (third state, according to Paulson) shows Tom Rakewell coming into his inheritance and going back on his promise to marry Sarah Young, a girl he seduced while a student at Oxford.

90 **A Rake's Progress (Plate 3)** 1735

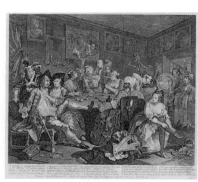

90

T 01790
Etching and engraving 318×387 ($12\frac{1}{2} \times 15\frac{1}{4}$)
on paper 466×615 ($18\frac{3}{8} \times 24\frac{1}{4}$); plate-mark
362×410 ($14\frac{1}{4} \times 16\frac{1}{8}$)
Writing-engraving '*Invented, Painted, Engrav'd,
& Publish'd by W^m Hogarth June y^e 25. 1735.
According to Act of Parliament|Plate 3.*' and
twenty-line verse caption

LITERATURE
Paulson 1970, I, pp.163–5, no.134, II,
pls.141–2

The print (third state) shows Tom Rakewell squandering his inheritance on riotous living.

91 **A Rake's Progress (Plate 4)** 1735

T 01791
Etching and engraving 318 × 387 (12½ × 15¼)
on paper 464 × 622 (18¼ × 24½); plate-mark
362 × 411 (14¼ × 16¼)
Writing-engraving '*Invented Painted & Engrav'd
by Wᵐ Hogarth & Publish'd June yᵉ 25.1735.
According to Act of Parliament|Plate.4.*' and
twelve-line verse caption

LITERATURE
Paulson 1970, I, pp.165–6, no.135, II,
pls.143–4, 246–7

91

Third state. The Rake is arrested for debt on his way to court. Sarah Young, now a seamstress, happens to witness the incident and attempts to save her former lover by offering her purse to the bailiff.

92 **A Rake's Progress (Plate 5)** 1735

T 01792
Etching and engraving 314 × 389 (12⅜ × 15⁵⁄₁₆)
on paper 464 × 619 (18¼ × 24⅜); plate-mark
359 × 411 (14⅛ × 16⅜)
Writing-engraving '*Invented Painted & Engrav'd
by Wᵐ Hogarth & Publish'd June yᵉ 25.1735.
According to Act of Parliament|Plate 5.*' and ten-
line verse caption

LITERATURE
Paulson 1970, I, pp.166–7, no.136, II,
pls.145–6

92

Third state. The Rake tries to recoup his fortune by marrying an old, rich woman. In the background, Sarah Young, who tries to stop the marriage, is being ejected from the church.

93 **A Rake's Progress (Plate 7)** 1735

T 01793
Etching and engraving 318 × 386 (12½ × 15³⁄₁₆)
on paper 464 × 622 (18¼ × 24½); plate-mark
355 × 406 (14 × 16)
Writing-engraving '*Invented &c. by Wᵐ Hogarth
& Publish'd According to Act of Parliament June yᵉ
25.1735.|Plate 7*' and eighteen-line verse caption

LITERATURE
Paulson 1970, I, pp.168–9, no.138, II, pl.148

93

Fourth state. Having gambled away his rich wife's fortune, Tom Rakewell is confined to the Fleet Prison for debt. Surrounded by proof of his failure in every walk of life, he sinks into despair.

94 **The Rake's Progress (Plate 8)** 1735–63

94

T 01794
Etching and engraving 316×387 $(12\frac{7}{16} \times 15\frac{1}{4})$
on paper 464×624 $(18\frac{1}{4} \times 24\frac{1}{2})$; plate-mark
359×410 $(14\frac{1}{8} \times 16\frac{1}{8})$
Writing-engraving '*Invented &c. Wm Hogarth &
Publish'd According to Act of Parliament June ye
25.1735 Retouch'd by the Author 1763*' and
nineteen-line verse caption

LITERATURE
Paulson 1970, I, pp.169–70, no.139, II, pls.248,
149–50

Third state, retouched by Hogarth in 1763. The Rake is now an inmate of a madhouse, probably Bedlam, but even here the faithful Sarah Young visits him and tries to comfort him. A contemporary explanation of this last plate of the series adds that Rakewell 'is afterwards confin'd down to his Bed in a dark Room where he miserably expires'.

95 **Satan, Sin and Death** *c.*1735–40

T 00790
Oil on canvas 619 × 745 (24$\frac{3}{8}$ × 29$\frac{3}{8}$) relined on
canvas 624 × 760 (24$\frac{1}{2}$ × 30)
Purchased (Grant-in-Aid and Special Grant)
1966

PROVENANCE

...; in David Garrick's possession 1767, and
after his death in 1779 by descent to his
widow; Mrs Garrick's sale, Christie's 23 June
1823 (not in catalogue, but probably MS lot
79* in Christie's master-copy) bt T.S. Forman
of Pall Mall; by descent to W.H. Forman,
then to his sister-in-law Mrs Burt, and *c.*1889
to his nephew Major A.H. Browne of Callaly
Castle, Northumberland, sold Sotheby's 27
June 1899 (56) bt Charles Fairfax Murray;
...; G. Greer, sold Sotheby's 9 December 1964
(91, repr.) bt Sabin Galleries from whom bt by
the Tate Gallery

EXHIBITED

Tate Gallery 1971 (91, repr. in col. p.24)

ENGRAVED

1. Line engraving by Charles Townley,
captioned 'Hell-Gate, Satan, Sin and Death',
pub. 15 April 1767, dedicated to the then
owner, David Garrick. J. Nichols (1781, *etc.*)
states that the plate was destroyed soon after a
very few prints from it had been made.
2. Line engraving by T. Rowlandson and
John Ogbourne in 1792 (see no.122)
3. Etching by Samuel Ireland for his *Graphic
Illustrations* 1794, I, facing p.178, after
C. Townley's engraving

LITERATURE

Nichols 1781, p.134, 1782, p.319, 1785, p.404;
Ireland 1794, pp.178–81; Nichols & Steevens
1810, pp.260–2, 1817, pp.269–70; *Gentleman's
Magazine*, XCIII, 1823, Pt II, p.63 (for mention
in Garrick sale); Ephraim Hardcastle, *Wine
and Walnuts*, 1823, II, pp.276–7; Nichols 1833,
p.363; W. Chaffers, *Catalogue of Works of
Antiquity and Art collected by the late William Henry
Forman ... and removed in 1890 to Callaly Castle,
Northumberland by Major A.H. Browne*, 1892,
pp.25, 206, no.51; Dobson 1898, pp.257, 312;
Dobson 1902, pp.186, 218; Dobson 1907,
pp.220, 263; Beckett 1949, p.72; Antal 1962,
pp.155, 180; G. Schiff, *Johann Heinrich Füsslis
Milton-Galerie*, Zurich and Stuttgart 1963,
pp.50, 133 n.229; Baldini & Mandel 1967,
p.117, no.5 L; D. Bindman, 'Hogarth's
"Satan, Sin and Death" and its influence',
Burlington Magazine, CXII, 1970, pp.153–8,
fig.29; Paulson 1971, I, pp.388, 551 n.18, II,
pp.283, 412, 453 n.96, fig.280; Hildegard
Omberg, *William Hogarth's Portrait of Thomas
Coram*, Uppsala 1974, pp.30, 35–6, 147 nn.35,
36, 38, 149 n.18, pl.5 (detail); Webster 1979,
pp.73, 76, repr. in col. p.81

This unfinished oil or sketch is an illustration to Milton's *Paradise Lost*, Book II, lines
648–726, which describe how Satan, in his ascent out of Hell on to Earth, is
challenged at the Hell-Gate by its guardian, Death. Before they can join in combat,
however, they are separated by Sin, who reveals to Satan that she is his daughter,
and that Death is the fruit of her incestuous union with him, and consequently
Satan's son.

Bindman (1970) suggests plausibly that the painting may have been begun in
the mid-1730s, at a time when the elder Jonathan Richardson read parts of his
Explanatory Notes on Paradise Lost (published in 1734) to a club of writers and artists,
including Hogarth, that met at Old Slaughter's Coffee House in St Martin's Lane.
In his *Notes* Richardson points to this scene as representing the key to the whole
work. This dating is supported by certain stylistic features of the painting, like the
colouring, and the handling of the female head of Sin, which are consistent with
this period in Hogarth's work. He had already produced two engraved illustrations
for *Paradise Lost* in about 1725, which were not, however, used (Paulson 1965, I,
nos.55, 56, II, pls.58, 59). Milton's *Paradise Lost* is, along with the works of
Shakespeare and Swift, one of the three volumes on which Hogarth rests his self-
portrait of 1745 (no.103), showing thereby the work's fundamental importance to
him in his ambitions both as a commentator on moral issues and as a history
painter. If the early dating is accepted, this would make it the earliest painting
devoted to a subject from Milton, predating Burke's seminal *Enquiry into ... the*

95

sublime and the beautiful, published in 1757, in which this passage and the description of Death in particular is singled out as an absolute example of the Sublime. Known for many years only from engravings after Townley's rare print of 1767, Hogarth's composition was to exert a profound influence on later painters of the Sublime, like Fuseli, Barry, Romney, Blake and others (for fullest discussion see Bindman 1970) and ultimately, via Gillray, even on Jacques-Louis David (L. Gowing in catalogue of the Tate Gallery exhibition 1971, p.40).

Hogarth's own composition derives certain elements, notably the figures of Satan and Death, from Sir John Medina's illustration for the same passage in the 1688 illustrated edition of *Paradise Lost,* which remained popular well into the eighteenth century. Hogarth's interpretation of the details and the dramatic lighting, however, are his own, and unfinished alterations to Satan's arm on the left (he was experimenting with raising it shoulder-high), as well as the unnaturally enormous stride of the figure, show that he was at pains to develop it into an even more dynamic representation of evil energy unleashed. Omberg's (1974) suggestion that the figure of Satan derives from studies of warriors by Cheron is not entirely convincing visually.

Samuel Ireland's statement (1794, p.178) that the subject was painted for Garrick is unlikely to be correct in view of its now generally accepted early date, although the suggestion that it was left unfinished because of a quarrel between Garrick and the painter (*Gentleman's Magazine* 1823) may reflect a failed attempt to have it finished at a later date. Be that as it may, the painting is first mentioned as being in Garrick's possession in 1767, and described as 'unfinished' in 1781 by John Nichols, who also subjected it to scathing criticism as an aberration in the work of a comic history painter.

Although the painting does not appear in the catalogue of Mrs Garrick's sale in 1823, its inclusion in it is attested by an apparently contemporary inscription on the back of the stretcher: 'Hogarth purchased [?2]3 June 1823 at Mrs Garrick's sale at Christie's by me TS Forman'. A report on the sale in *The Gentleman's Magazine* specifically mentions that Forman bought not only the 'Happy Marriage' sketch (now at the Royal Institution of Cornwall, Truro), but also 'Satan, Sin and Death', both at seven guineas each. No lot numbers are given, but Christie's master copy lists in manuscript, after some additions to the main bulk of the sale, an undescribed lot '79*', which was sold to Forman at £22 1s, a price consistent with an oil sketch, and one already noted by Dobson, who, however, does not cite his source.

The Rowlandson/Ogbourne engraving of 1792 after this composition was made from 'a painting in chiaro-scuro by R. Livesay'. This was sold in the Standly sale, Christie's 14–22 April 1845 (1220), and bought by Colnaghi. The sale also included (lot 1221) a sepia drawing of the same subject, without, however, a clear attribution to any artist.

96 **The Strode Family** *c.*1738

N 01153
Oil on canvas 870 × 915 ($34\frac{1}{4}$ × 36)
Bequeathed to the National Gallery by the
Revd William Finch 1884; transferred to the
Tate Gallery 1951

PROVENANCE
Presumably painted for the sitter, and first
recorded in the possession of his son William
1782; on his death 21 July 1809 (*d.s.p.*)
inherited by his widow Mary (*née* Brouckner,
widow of Admiral William Clement Finch),
and on her death 6 October 1813 by the eldest
son of her first marriage, the Revd William
Finch; bequeathed by him to the National
Gallery 1880, with life interest to his sister
Charlotte (d.1883); entered the National
Gallery 1884

EXHIBITED
RA Winter 1884 (38); AC tour 1946 (1); Tate
Gallery 1951 (40); Manchester 1954 (18); BC
tour 1957 (32, repr. p.79); BC tour 1960 (5);
Tate Gallery 1971 (104)

LITERATURE
Nichols 1782, p.362; Nichols & Steevens, I,
1808, pp.424–5: Nichols 1833, pp.375–6;
H. Cotton, *Fasti Ecclesiae Hibernicae*, Dublin
1848, II, pp.25–6 (for biography of Arthur
Smyth); Dobson 1907, p.207; S. Sitwell,
Conversation Pieces, 1936, p.12, pl.20; Davies
1946, pp.68–9; Beckett 1949, p.46, no.93,
repr.; Baldini & Mandel 1967, p.100, no.88,
pl.xxvii (col.); Antal 1962, pp.40, 51, 204,
pl.62a; T. Pignatti, *Pietro Longhi*, 1969, p.44,
fig.15; Paulson 1971, I, pp.205, 455, 458,
fig.175, II, p.3; Webster 1979, pp.81–2, 97,
127, repr. in col. p.90

The painting is first described by John Nichols in 1782 as 'A Breakfast-piece, preserved in Hill-Street, Berkeley-Square, in the possession of William Strode, Esq. of Northaw, Herts. It contains portraits of his father the late William Strode, Esq., his mother Lady Anne (who was sister to the late Earl of Salisbury), Colonel Strode, and Dr Arthur Smyth (afterwards Archbishop of Dublin). Two dogs are introduced, one belonging to Mr. Strode, the other (a pug) to the Colonel's'. Nichols & Steevens call the Colonel 'Mr. Samuel Strode' and add the name of Jonathan Powell, the butler. As the information clearly came from the sitter's son, it can be regarded as reliable.

William Strode (*c.*1712–55) of Ponsbourne Hall, Herts., came from a wealthy and well-connected family of South Sea brokers. He married Lady Anne Cecil (1711–52), eldest sister of the 6th Earl of Salisbury, 4 February 1736 (*Gentleman's Magazine*, vi, 1736, p.109, pagination defective in some volumes; the groom is wrongly named Thomas Stroude). Their son William was born 23 July 1738, and both the absence of children and the style of painting suggest a date of *c.*1738.

Seated on the far left is Dr Arthur Smyth (1706–71), eighth son of Thomas, Bishop of Limerick, who was to rise through many preferments to become Archbishop of Dublin in 1766 (further details of his career can be found in the manuscript catalogue entry by Lindsay Stainton and Julius Bryant for a later pastel portrait of Smyth by Thomas Frye, in the collection of the Iveagh Bequest, Kenwood). He gained an MA at Oxford in 1729, and was with Strode in Venice in 1733, at the same time as the Marquess of Salisbury, Strode's future brother-in-law. This transpires from a letter dated 19 May 1737 (Salisbury archives, Hatfield, Gen. 29/28) in which Strode refers to Smyth as 'my most Intimate Friend', and asks the Marquess to bestow on him one of the many livings in his gift.

In 1740 Smyth was in Italy again, this time as tutor to the young William Cavendish, Lord Hartington, later 4th Duke of Devonshire (*Walpole's Correspondence*, xvii, pp.10, 15–16, 23) and it may be that it was through his agency that Lord Hartington had himself painted by Hogarth on his return to England (743 × 622, $29\frac{1}{4}$ × $24\frac{1}{2}$, signed and dated 1741, Yale Center for British Art, New Haven; Bindman 1981, pl.93 in col.).

96

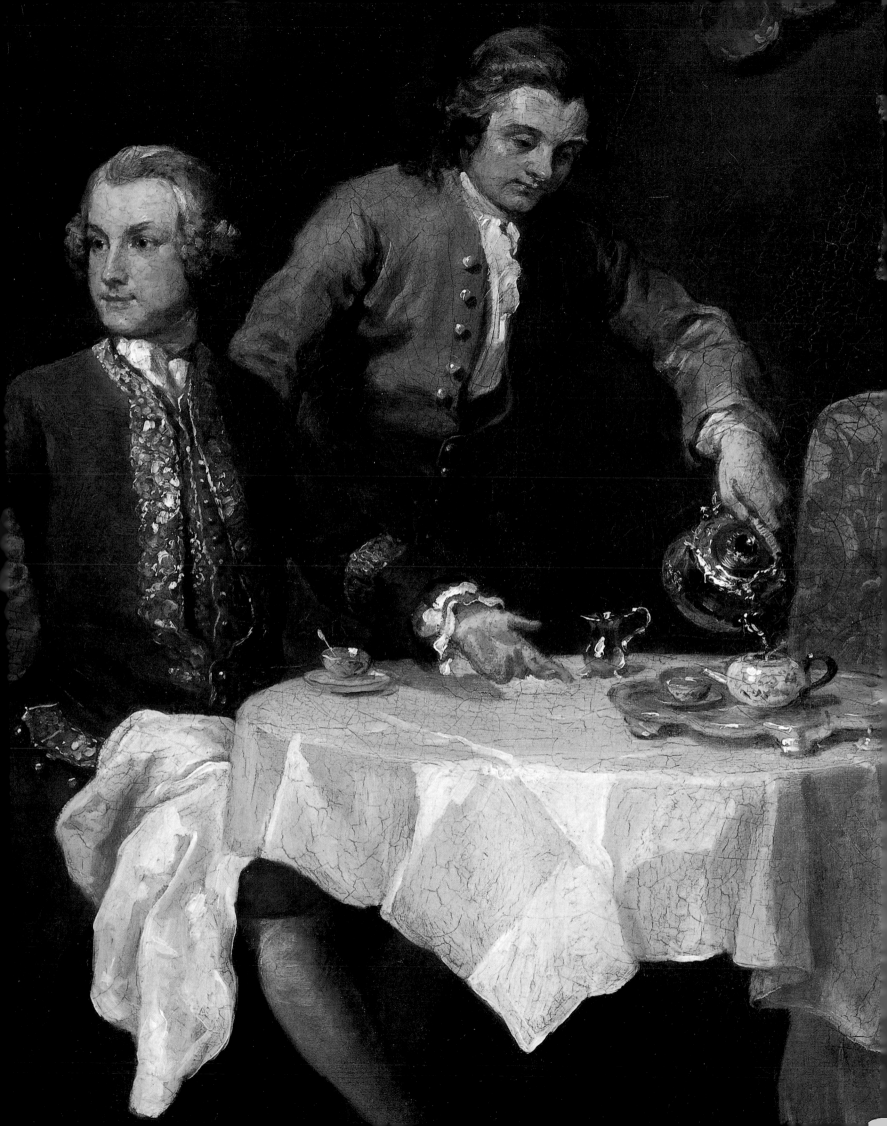

fig. 32 X-ray of 'The Strode family',
no. 96.

The pictures on the wall – a large Salvator Rosa-type landscape, a small view of Venice, perhaps by Guardi, and another small landscape in the style of Gaspard – are suitable reminders of the Grand Tour.

When the painting was cleaned and X-rayed in 1984, it became apparent that the composition had undergone considerable changes (fig.32). The book-case at the back of the room had originally been conceived as a formal pedimented doorway with two oval paintings hung high on the wall on either side; the one on the left seems to have been a portrait, that on the right (now clearly visible through the underpaint) a flower piece. The lofty barrel vault had been painted to some degree of finish before being partly covered with the curtain on the left, and the table was first painted without a table-cloth. The greatest changes, however, were to the figures themselves; William Strode originally leant slightly forward over the table towards the right, apparently looking towards his brother, who raised his arm high above Lady Anne's chair. This was not originally covered by her skirt, as the outline of its curved leg can be seen under the rim of the table. The butler stood well to the right of where he stands now, his head touching the centre of the lower edge of the large painting on the wall, and if he was pouring water into the teapot, he was doing so with his right hand, and not with his left as he is now. The dense painting of the three central figures suggests that they were painted particularly thickly to cover the earlier composition, which may have been altered to include William Strode's new wife.

The Gallery archives have a photograph of a three-quarter length portrait owned in 1967 by the Wesley Home for the Elderly, Baltimore, Maryland (gift of Miss Purnell), said to be of Lady Anne Strode and attributed to Hogarth. Stylistically it looks more like a work by Thomas Frye of c.1745-55, but the likeness to Lady Anne is reasonably close. She is shown holding a fan and wearing a black shawl over her head.

97 Thomas Pellett MD c.1735-9

T 01570
Oil on canvas 764 × 635 ($30\frac{1}{16}$ × 25)
Inscribed 'Thomas Pellet M:D: Praeses Col.Med.Lond.' in black paint along top edge of oval, and 'W Hogarth' upper right along edge of oval
Presented to the National Gallery by the Misses Rachel F. and Jean I. Alexander under the terms of a Deed of Gift 1959, entered collection (as N 06417) in 1972; transferred to the Tate Gallery 1972

PROVENANCE
...; according to letter in *The Gentleman's Magazine*, 1783, 'in the possession of a gentleman at Manuden in Essex'; ...; J. Thane, from whom bt by Thomas Gwennap before 1819; bt from him by 'Mr. Penny' 1821; ...; H.R. Willett of Shooter's Hill before 1833; ...; W.H. Forman by 1860 (as 'A Gentleman wearing a wig and Alderman's gown' by unknown artist); by descent to Major A.H. Browne 1869 and transferred by him to Callaly Castle, Northumberland, 1890, sold Sotheby's 27 June 1899 (1 as 'Man in a Wig' by Kneller) bt Colnaghi, sold to W.C. Alexander 1904 and by descent to his daughters Rachel and Jean Alexander

EXHIBITED
T. Gwennap's Gallery, 20 Lower Brook Street 1819(6); *Georgian England*, Whitechapel Gallery, 1906 (71); *The Alexander Bequest*, National Gallery 1972 (no number)

ENGRAVED
Line engraving by C. Hall, pub. 1 June 1781 by J. Thane

LITERATURE
'W.S.', letter in *The Gentleman's Magazine*, Pt.I, 1783, p.315; Nichols 1785, pp.407, 529, Nichols 1833, pp.vii, 386; *An Inventory of the Household Furniture etc. . . . at Pippbrook House, Dorking, bequeathed by the Will of William Henry Forman, Esq. dated 24 April 1860*, 1869, p.213,

97

no.7 in 'List of Paintings'. The list of paintings was reprinted almost unaltered in *Catalogue of the Works of Antiquity and Art collected by the late W.H. Forman . . . and removed in 1890 to Callaly Castle, Northumberland, by Maj. A.H. Browne*, 1892, p.205; Dobson 1902, p.185, repr.; Beckett 1949, p.59, fig.102; G. Wolstenholme & D. Piper, *Portraits of the Royal College of Physicians*, 1964, p.328; Baldini & Mandel 1967, p.104, no.114, repr.; Paulson 1971, I, p.450; A. Smith, 'Presented by the Misses Rachel F. and Jean I. Alexander: seventeen paintings for the National Gallery', *Burlington Magazine*, CXIV, 1972, p.630, fig.30; Webster 1979, p.184, no.103, repr.

Thomas Pellett (?1671–1744) graduated in 1694 as bachelor of medicine at Queen's College, Cambridge, and proceeded to his MD in 1705. He visited Italy with Dr Richard Mead in 1695 and studied for a time at Padua. In 1716 he was elected a fellow of the Royal College of Physicians, and held many offices there between 1717 and 1741, including that of President 1735–9. In this portrait he is shown in his Presidential robes and one can assume that it was painted sometime during Pellett's tenure of this office.

It would appear that Pellett was an admirer of Hogarth, as the sale of his enormous library of scientific and classical books on 7 January 1745 (Joseph Brigstock, eventually incorporated in Sotheby's) included not only a small section of prints by Callot, Coypel, Hollar and Cheron, but also first impressions of Hogarth's engravings of 'Hudibras', 'The Harlot's Progress', 'The Rake's Progress' and 'many other of his Pieces' (lots 355–6). Several sets and editions of *Don Quixote*, *Hudibras*, and a sumptuously bound copy of the text and music of *The Beggar's Opera* and *Polly* further suggest that they had certain interests in common.

The portrait was engraved by Charles Hall and published 1 June 1781 by J. Thane, who appears to have owned it at the time. The dealer Thomas Gwennap included it in his exhibition of twenty-seven works by Hogarth – some genuine, most spurious – in his Lower Brook Street Gallery in 1819, and stated in his catalogue that he had procured it directly from 'the late Mr Thane' (a copy of this rare catalogue is in the Soane Museum). Nichols then claims (1833, p.386) that the painting was bought 'at Gwennap's sale April 5, 1821, by Mr. Penny for £5.5s. Now in the collection of H.R. Willett, Esq. of Shooter's Hill'. However, in a footnote on Willett's collection in the preface of the same book (p.vii) he states that 'The Portrait of Dr. Pellett is *not* in his possession'. The next certain appearance of the painting is in Messrs Colnaghi's records, showing that it was bought as a Kneller at the Callaly Castle sale in 1899, and the only item in the Callaly Castle/Pippbrook House inventory that could correspond to the 'Kneller' is no.7, the unattributed portrait of 'A Gentleman Wearing a Wig and Alderman's Gown'.

Another portrait of Pellett, by Michael Dahl, signed and dated 1737 (Wolstenholme & Piper 1964, repr. p.328), belongs to the Royal College of Physicians.

98 **James Quin, Actor** *c.*1739

N 01935
Oil on canvas 760 × 622 (29$\frac{15}{16}$ × 24$\frac{1}{2}$)
Inscribed 'W Hogar [...] h pinx 17 [?3 ...]'
bottom left corner, and 'Mr QUIN' in yellow
paint on bottom right spandrel
Purchased by the National Gallery (Clarke
Fund) 1904; transferred to the Tate Gallery
1951

PROVENANCE
...; possibly 'A well-painted Portrait of Quin
the celebrated Actor' owned 1817 by Mr
Gwennap of Lower Brook Street; ...;
according to Dobson (1907, p.219), owned by
the actor Charles Matthews (1776–1835), but
two portraits of Quin ascribed to Hogarth he
is known to have owned are now in the
Garrick Club, and he is unlikely to have
owned this as well; ...; the 5th Marquess
Townshend, Raynham Hall, Norfolk, by
1867; Townshend sale, Christie's 5 March
1904 (61) bt Agnew, from whom bt by the
National Gallery

EXHIBITED
National Portrait Exhibition, South Kensington
1867 (348); Dublin 1872 (National Portrait
Section, no.152); RA Winter 1885 (6); *La
Peinture Anglaise*, Louvre, Paris 1938 (66,

repr.); *Art and the Theatre*, Lady Lever Art
Gallery, Port Sunlight 1949 (96); Manchester
1954 (35); BC tour 1969 (77); Tate Gallery
1971 (108, repr.); *British Portraits*, BC tour,
Bucharest, Budapest 1972–3 (13, repr.); *The
Georgian Playhouse*, Hayward Gallery 1975 (17,
repr.); *Royal Opera House Retrospective*, RA 1982
(187, repr.); *Rococo Art and Design in Hogarth's
England*, Victoria and Albert Museum 1984
(p.67, E5, repr.)

LITERATURE
Nichols & Steevens 1817, p.192; Dobson 1902,
p.185; Dobson 1907, p.219; *DNB* 1908, XVI
(for Quin); C.K. Adams, *Catalogue of Pictures in
the Garrick Club*, 1936, nos.29, 399 (for other
portraits of Quin from Matthews collection);
W.K. Firminger, 'The Members of the Lodge
of the Bear and Harrow', *Ars Quattuor
Coronatorum*, XLVIII, 1938, pp.102–37; Davies
1946, p.73; Beckett 1949, p.59, fig.153; A.P.
Oppé, *English Drawings at Windsor Castle*, 1950,
p.63, no.351, pl.61; Antal 1962, pp.58, 69, 231
n.6; Baldini & Mandel 1967, p.104, no.115,
repr.; Paulson 1971, I, pp.342, 454, II, pp.24,
26, 27, 130, 427 n.48, 452 n.84; Webster 1979,
pp.97, 102, repr.

One of Hogarth's most successful bust-portraits, it represents the leading tragic actor of the pre-Garrick era still at the height of his powers, but already showing the results of his proverbial greed at table. The heroic turn of the head and unusually elaborate (for Hogarth) carved stone surround seem to be an adaptation of the seventeenth-century Baroque bust-portrait formula and may serve to underline Quin's adherence to the old school of static and declamatory acting that was soon to be superseded by the naturalistic manner of Macklin and later Garrick.

Quin (1693–1766) was born in Covent Garden, London, the illegitimate son of an Irish barrister. By 1716 he was taking leading parts at Drury Lane, and after his great success as Falstaff in 1720 he never lost his leading position on the London stage. He was one of Hogarth's many friends in the theatre and both are listed as members of the masonic lodge which met at the Bear and Harrow, Butcher's Row, in 1730–2. In 1746 Quin appeared at Covent Garden with the rising star David Garrick in *The Fair Penitent*, where their different styles were seen to mutual advantage. Hogarth was to paint both actors and brought out this difference in the much more active poses he gave Garrick both in theatrical as well as in straight portraiture. Also in 1746, Hogarth compared Quin and Garrick, neither of whom was very tall, in a drawing, not entirely to the former's advantage: he characterised Quin's massive presence as 'a very short proportion', and Garrick's lithe and mobile figure as 'a very tall proportion' (Oppé 1950). A few years of genuine rivalry followed, but on 15 May 1751 Quin gave his last performance as a paid actor before retiring to his beloved Bath, to which he gave the famous description of 'the cradle of age and a fine slope to the grave'. During retirement he became good friends with Garrick, who wrote the epitaph for his tomb in Bath Abbey.

Vain and hot-tempered (he is said to have killed two fellow-actors in duels), he

Mr QUIN.

98

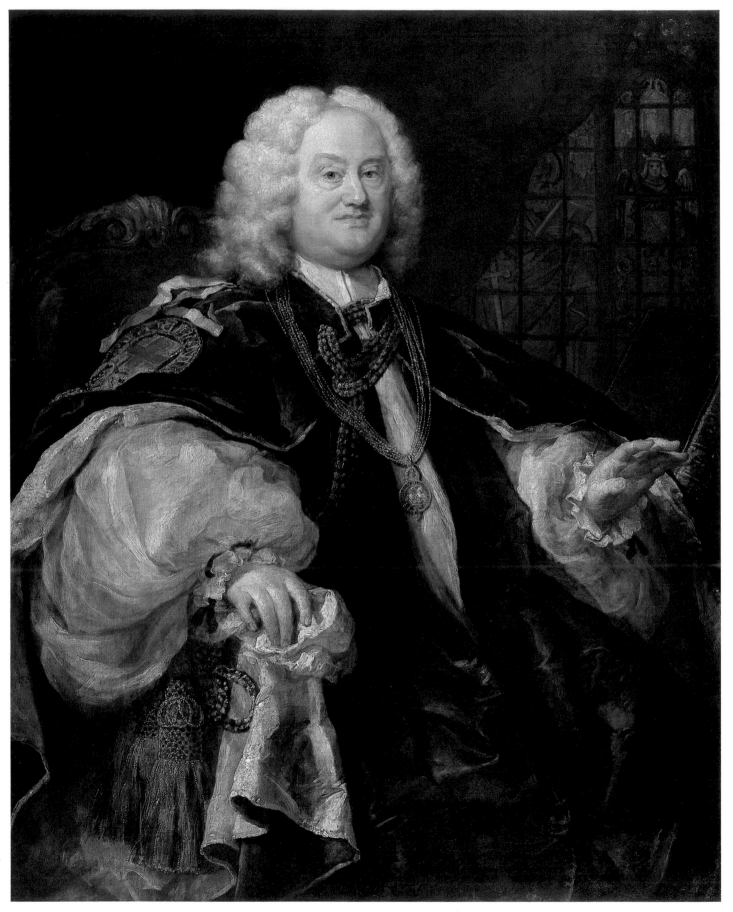

99

was also generous, convivial and possessed of a brilliant if sometimes coarse wit. He was painted by several leading artists of the time, most notably by Gainsborough, whose splendid full-length of the actor in old age is in the National Gallery of Ireland.

99 Benjamin Hoadly, Bishop of Winchester 1741

N 02734
Oil on canvas 1273 × 1015 ($50\frac{1}{8}$ × $39\frac{13}{16}$)
Inscribed 'W. Hogarth Pinx 1741' along back of chair
Purchased by the National Gallery (National Loan Exhibitions Fund) 1910; transferred to the Tate Gallery 1919

PROVENANCE
...; Lt Col. White, from whom bt by the National Gallery

EXHIBITED
Tate Gallery 1971 (118, repr. in col. p.34)

ENGRAVED
1. Line engraving by Bernard Baron, pub. July 1743, unreversed, repr. Paulson 1971, I, fig.164a
2. Line engraving by W.P. Sherlock, pub. 1759, of head only, reversed
3. Line engraving by Thomas Cook c.1800, unreversed copy of 1743 engraving by Baron (see no.118)

LITERATURE
John Hoadly (ed.), *The Works of Bishop Hoadly*, 1773, I, 'Preface' for biographical details; *DNB* 1908, XI (for Hoadly); Beckett 1949, p.52, pl.134; R. Wark, 'Two Portraits by Hogarth', *Burlington Magazine*, XCIX, 1957, pp. 344-7, fig.24; J.L. Nevinson, 'Portrait of Bishop Hoadly', *Burlington Magazine*, C, 1958, p.26; Antal 1962, pp.22, 28, 40, 46, 118, 218 n.15, 223 n.99, 245 n.48, pl.77a; Paulson 1970, I, p.266 no.226, II, pl.266; Baldini & Mandel 1967, p.106, no.146, repr., pl. XXXIV (col.); Paulson 1971, I, pp.441-5, 448, 454, pl.164b, II, 25; H. Omberg, *William Hogarth's Portrait of Thomas Coram*, 1974, pp.113, 127-35, 139 n.4, 160 n.26, 161 nn.29-35, 41, 43, 45-6, 165 nn.48, 52, 54, 57, 61, pls.40, 41 (detail); Kerslake 1977, I, pp.141-2, II, pl.387; Webster 1979, pp.94, 95, repr. p.99 (col.), p.185, no.133, repr.; Bindman 1981, pp.130-1, fig.100 (col.); J. Ingamells, *The English Episcopal Portrait 1559-1835*, 1981, pp.224-5, ill. 132 G

Benjamin Hoadly (1676-1761) is shown here in the full dignity of the office of Bishop of Winchester, to which he had been appointed in 1734, and as Prelate of the Order of the Garter, in which he was affirmed in 1738. His hand, apparently raised in blessing, is seen against the background of a leather-bound tome which is untitled, but may allude to his published sermons. Behind him is a stained glass window with the figure of St Paul (a reference to his strongly Pauline theology) on the left, and a crowned angel holding the arms of the see of Winchester on the right. Below this is another shield, probably meant to represent the royal coat of arms.

Hoadly was one of the most influential Low Churchmen of his day and his writings were regarded as a model of national piety well into the nineteenth century. His unswerving loyalty to the Whig and Hanoverian causes led to his rapid rise in the Church hierarchy, from Royal Chaplain in 1714, to Bishop of Bangor in 1715, of Hereford in 1721, Salisbury in 1723, and to Winchester, one of the wealthiest sees in England, in 1734. The last two appointments carried with them first the Chancellorship and then the Prelacy of the Order of the Garter. He was favoured at court and was a personal friend of Lord Hervey of Ickworth. Although his strongly argued latitudinarian view aroused much opposition and controversy, he had few personal enemies. In spite of his poor health – he was crippled from his student days at Cambridge and obliged to walk with sticks and to preach from a kneeling position – his household was a lively one. Worldly and amiable, he entertained lavishly and enjoyed the material benefits of his position, ensuring that his sons Benjamin (1706-57) and John (1711-76) benefited from them also. His first wife Sarah Curtis (died 1743) was until her marriage in 1701 a

professional portrait painter, and it is possible that Hogarth's intimacy with the Hoadly family had its origins in her contacts with the artistic community. Hogarth painted portraits of all the Hoadlys and their wives, in some cases more than once. John composed the verses to the prints of 'The Rake's Progress' in 1736, and Benjamin is said to have helped him with *The Analysis of Beauty*, published in 1753. All members of this circle were passionately fond of the theatre, and Hogarth is known to have participated in their amateur theatricals. It has also been demonstrated (Paulson 1971, Omberg 1974) that Hoadly's theological views, which put virtuous moral conduct above unconditional faith, had some bearing on Hogarth's choice of subjects, particularly in his attempts at history painting, and most notably in the case of his 'Paul Before Felix' at Lincoln's Inn.

Painted only one year after the great 'Thomas Coram' of the Foundling Hospital, this portrait is a splendid example of the artist's mature style. As it is Hoadly's left hand that is raised in blessing, the composition seems to have been initially planned with reversal for engraving in mind. The Garter badge on the shoulder, however, is the right way round (i.e. the buckle is to the left of bottom centre) and would have had to be adjusted for reversal, as would the Garter pendant, on which the motto 'HONI SOIT QVI MAL Y PENSE' is legible and correctly inscribed. In the event, Baron's engraving of 1743 does not reverse the composition, although in attempting to make the motto on the shoulder badge clearer (in the painting it is impressionistically illegible) he achieves the curious result that in the print the lettering is not only back to front, but runs from the wrong end of the ribbon (it should start from the buckle on the left), with the legible words placed in a part of the circlet where they could not possibly be, given the

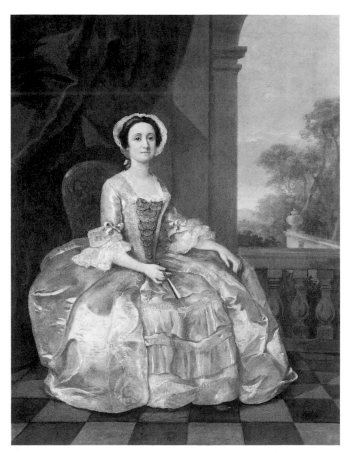

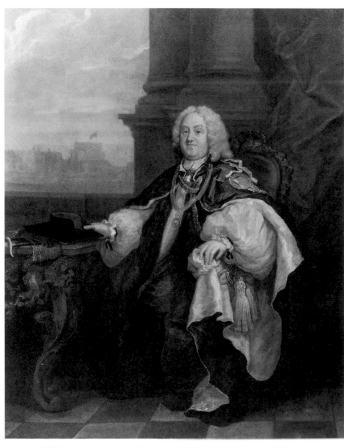

fig. 34 William Hogarth: 'Mrs Hoadly' *c*.1745, Oil on canvas 610 × 486 (24 × 19⅛). Huntington Library and Art Gallery, San Marino, California.

fig. 33 William Hogarth: 'Benjamin Hoadly' *c*.1745. Oil on canvas 610 × 481 (24 × 19). Huntington Library and Art Gallery, San Marino, California.

length of the rest of the inscription. Earlier suggestions (Wark 1957) that the print pre-dates the painting must be discounted since the discovery of the date on the painting.

Much has been written about the correct position of the Garter badge on the cloak. This problem was elucidated by Nevinson (1958), who pointed out that Chancellors and Prelates of the Order generally wore it on their right shoulder (i.e. as correctly shown in this painting), while Knights wore theirs on the left. In practice this was either not strictly adhered to, or else was the source of endless confusion through copies and reversals: a cursory glance through relevant portraits of the last three centuries will show that the badge appears on either shoulder in about equal proportions. This fact makes the question of whether the badge is on the right or wrong shoulder in the small autograph full-length of the Bishop at the Huntington Art Gallery, San Marino, California (fig.33), less of an issue, although the buckle on the circlet is on the wrong side in what appears to be an adaptation of the Tate Gallery composition in reverse. Webster (1979) plausibly argues a later date of c.1745 for this smaller version on the grounds that it and its female pendant (also in the Huntington Art Gallery, fig.34) may have been painted to commemorate the Bishop's second marriage to Mary Newey in 1745. Wark (1957) had seen the female portrait as an early work, representing Hoadly's first wife Mary Curtis, who, however, would have been around sixty in 1740 and thus too old to be the sitter represented there. It is possible, however, that the female portrait is slightly earlier than that of the Bishop, and that Hogarth merely reversed his large composition to make a visually more satisfying pendant to it, disregarding the fact that it left the Garter badge technically on the wrong shoulder.

The painting's early provenance is so far unknown, but it may have descended through the White family, which was distantly related to the Hoadlys. It has a fine contemporary frame incorporating a Bishop's mitre, with palm fronds on the top and croziers at the sides.

100 **The Enraged Musician** 1741

100

T 01800
Etching and engraving 332 × 405
($13\frac{1}{16}$ × $15\frac{11}{16}$) on paper 465 × 619
($18\frac{5}{16}$ × $24\frac{3}{8}$); plate-mark 364 × 414
($14\frac{5}{16}$ × $16\frac{1}{4}$)
Writing-engraving 'THE ENRAGED
MUSICIAN.|Design'd, Engrav'd & Publish'd by Wm.
Hogarth Novbr the 30th 1741. According to Act of
Parliament.'
Transferred from the reference collection 1973

PROVENANCE
Unknown

LITERATURE
Paulson 1970, I, pp.184–6, no.158, II, pl.170

The engraving (according to Paulson, this is the third state) is related to a monochrome oil sketch in the Ashmolean Museum, Oxford, from which however it differs in several details. The print was published as a companion to the 'Distressed Poet', the original of which is in the City Museum and Art Gallery, Birmingham. When advertising its publication in the press in November 1740, Hogarth promised that the set would be completed with a third engraving on the theme of Painting, but this never materialised.

101 **Mrs Salter** 1744 (or 1741)

N 01663
Oil on canvas 762 × 635 (30 × 25)
Inscribed 'W Hog [arth] Pinx 174[?4]' in b.r.
spandrel, and 'M.ʳˢ Salter' bottom centre on
stone surround, both in similar dark paint and
cursive script
Purchased by the National Gallery 1898;
transferred to the Tate Gallery 1951

PROVENANCE
...; Samuel Ireland, sold Sotheby's 7 May
1801 (455 as 'Mrs Salter of the Charterhouse,
not engraved') bt Vernon; ...; ? widow of
Baillie Auchie; ...; Mrs Ainge, from whom bt
by Colnaghi 1898 and sold the same year to
the National Gallery as 'Hogarth's Sister Ann'

EXHIBITED
Tate Gallery 1951 (55); Manchester 1954
(33); *Allan Ramsay: his Masters and his Rivals*,
National Gallery of Scotland, Edinburgh 1963
(41); Tate Gallery 1971 (119, repr.)

LITERATURE
J. Nichols, *Literary Anecdotes of the Eighteenth
Century*, 1812, pp.221-2, (for biography of the
Revd Samuel Salter); Nichols & Steevens
1817, pp.177, 207; *Register of Charterhouse
Chapel*, Harlean Society 1892, pp.44, 45, 55,
59; Claude Phillips, 'Hogarth's Mrs Salter',
Art Journal, 1899, pp.149-50, repr.; Dobson
1902, p.182, repr. facing p.8; Dobson 1907,
pp.215, 220, repr. facing p.148 as 'Hogarth's
Sister'; *DNB* 1908, XVII (for Samuel Salter);
H. Isherwood Kay, 'A Famous Hogarth
Rediscovered', *Connoisseur*, XCI, 1933,
pp.243-4, repr.; Davies 1946, p.73; Beckett
1949, p.60, pl.152; Baldini & Mandel 1967,
p.106, no.153, repr., and pl. XXXVII (col.);
Antal 1962, pp.29-30, 117-118, 157, 174, 217,
241 n.70; Paulson 1971, II, pp.5, 425 n.5;
Waterhouse 1978, pp.174, 176; Webster 1979,
p.186, no.142, repr.

Because of a superficial resemblance to known portraits of Hogarth himself, this was long thought to be a portrait of his sister Ann, in spite of the apparently contemporary inscription and the fact that Ann Hogarth never married. The actual identity of the sitter was rediscovered in 1933 by H. Isherwood Kay, who first published the inscription and deduced from it that the painting was probably identical with that sold from Samuel Ireland's collection in 1801 as 'Mrs Salter of the Charterhouse'.

On this evidence one can assume that the sitter is Elizabeth, daughter of Elizabeth and Richard Secker (also spelt 'Sackor') of Grantham, Lincolnshire, where she was baptised on 22 February 1719/20. She married the Revd Samuel Salter, newly appointed Prebendary of Norwich Cathedral, on 2 November 1744. If the tentative reading of the last unclear digit of the date on the picture is correct (it has also been read as 1741), this could be a marriage portrait. Salter was Rector of Burton Coggles, Lincs., from 1740, and as their two eldest children were born there, the Salters must have continued to reside in Lincolnshire for some years before moving to London. Dr Salter became Rector of St Bartholomew's near the Royal Exchange in 1756, through the patronage of the 1st Earl of Hardwicke and his son Philip Yorke, later the 2nd Earl (1720-96), whose tutor he had been. He was also preacher at the Charterhouse Pensioners' Hospital in 1754, and was appointed its Master in 1761. It is claimed (letter from the Master of Charterhouse, 15 August 1946) that Mrs Salter was the first woman to live in the Charterhouse since its foundation in 1611, as the Governors altered the regulations in 1761, allowing a married man to be Master. According to J. Nichols (1812), Elizabeth Salter, *née* Secker, was a relative of Thomas Secker, Archbishop of Canterbury 1758-68; but although his will of 1768 (Prerogative Court of Canterbury 941, folio 309) leaves a small legacy to 'my niece Elizabeth Secker', it does not mention the name Salter at all. The compiler has been unable to find any proof that the sitter was, as has been repeatedly stated, a niece of Archbishop Herring, who was also painted by Hogarth in 1744. In terms of patronage, however, the Salters would have fitted well into the circle of the Earls of Hardwicke, who were tutored in mathematics by William Jones (painted by Hogarth in 1740, National Portrait

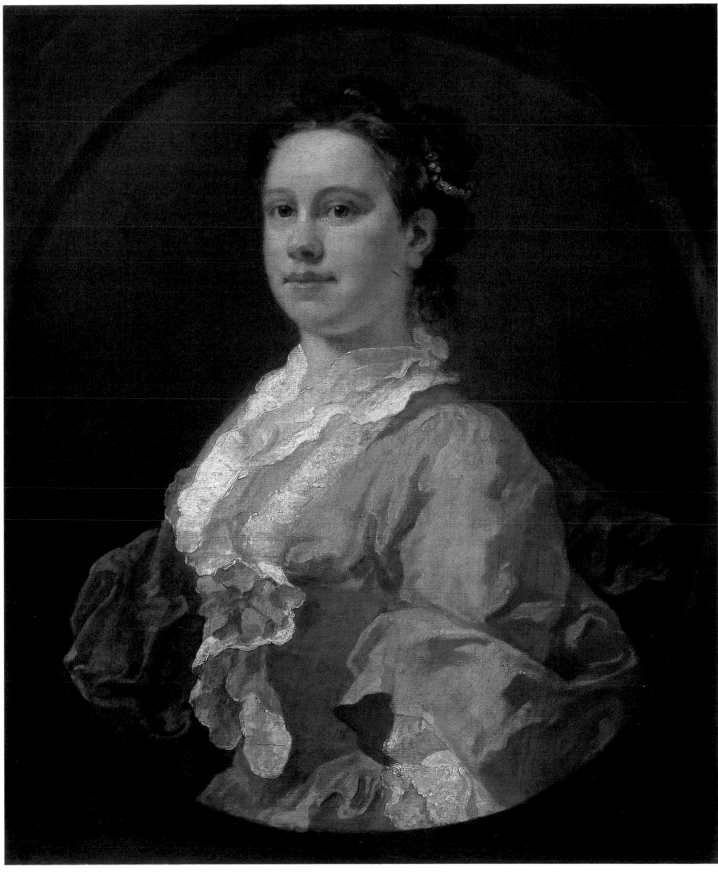

101

Gallery) and were intimate friends of the 2nd Earl of Macclesfield (also painted by Hogarth, private collection).

Nothing further is known of Mrs Elizabeth Salter, except that she was still living when her husband drew up his will in March 1778 (Prerogative Court of Canterbury, Hay 1042, folio 218); he died 2 May of that same year, and was buried in the Charterhouse.

Although it is highly likely that the painting is indeed identical with the portrait sold from Samuel Ireland's collection in 1801, there is no direct documentation for its provenance before its purchase from Colnaghi in 1898 as 'Hogarth's sister Ann, Mrs Salter'. According to a letter from Austin Dobson, dated 1 July 1908, the information on the Baillie Auchie and Ainge collections was given to him orally by the vendor, and neither of these collections can now be traced.

The particularly lively and richly coloured Rococo composition of the painting suggests that the later reading of the date, 1744 rather than 1741, is more likely to be correct and that the portrait reflects some of the panache of contemporary French painting seen by Hogarth during his visit to Paris in the summer of 1743.

102 **Lavinia Fenton, later Duchess of Bolton** *c.*1740-5

N 01161
Oil on oval canvas, 762 × 628 (30 × 24¾)
Purchased by the National Gallery (R.C. Wheeler Fund) 1884; transferred to the Tate Gallery 1919

PROVENANCE
...; Samuel Ireland by 1797, when engraved for his *Graphic Illustrations*, and sold Sotheby's 7 May 1801 (454) £5 7s 6d bt William Seguier; ...; George Watson MP, of Erlestoke Park, nr Devizes, by 1808 (who assumed the additional surname of Taylor in 1815); Erlestoke Park sale, Robins, 9 July–1 August 1832, 19th Day, 24 July (52) £52 10 0; ...;? Frederick Gaye, who lent a 'Duchess of Bolton' by Hogarth to the BI 1850 (161); ...; Sir William Miles, Leigh Court, nr Bristol, where listed by Waagen 1854; by descent to his son Sir Philip Miles, sold Christie's 28 June 1884 (30) bt Agnew for the National Gallery

EXHIBITED
BI 1814 (119, corrected in MS to 122 in some catalogues); ?BI 1850 (161); *International Exhibition*, South Kensington 1862 (41); RA Winter 1875 (137); Tate Gallery 1951 (46);

BC tour 1957 (33, repr. p.75); *Painting and Sculpture in England 1700-1750*, Walker Art Gallery, Liverpool 1958 (19); Tate Gallery 1971 (109, repr.).

ENGRAVED
1. Line engraving by C. Apostool 1797, with above title for S. Ireland's *Graphic Illustrations*, II, 1799
2. Etching by T. Cook, in reverse, for Nichols & Steevens, II, 1810

LITERATURE
Ireland 1799, pp.49–56; Nichols & Steevens, I, 1808, pp.112, 425, II, 1810, p.287, III, 1817, pp.172, 207; Nichols 1833, p.387; Waagen 1854, III, p.185; *Art Journal*, 1885, p.76, repr.; Dobson 1907, p.211; *DNB* 1908, VI, xv (for Fenton and Paulet); Beckett 1949, p.48, no.115, repr.; Antal 1962, pp.58, 118, 252 n.60, pl.69a; Baldini & Mandel 1967, p.105, no.117, repr.; Paulson 1971, I, pp.181, 554 n.19; Webster 1979, pp.97, 184 no.110, repr. p.104

The history of the portrait before Apostool's engraving of 1797 is not known, nor are Samuel Ireland's reasons for identifying it as Lavinia Fenton (1708-60), the original Polly Peachum of *The Beggar's Opera* in 1728 (see no.87). As the style of painting is consistent with Hogarth's work of the 1740s, it certainly cannot represent her, as has been often claimed, in the part of Polly, nor does the rich apparel shown here agree with the deliberately plain costume of the part, which, we are told, affected 'the simplicity of a modern quaker' (Charles Macklin,

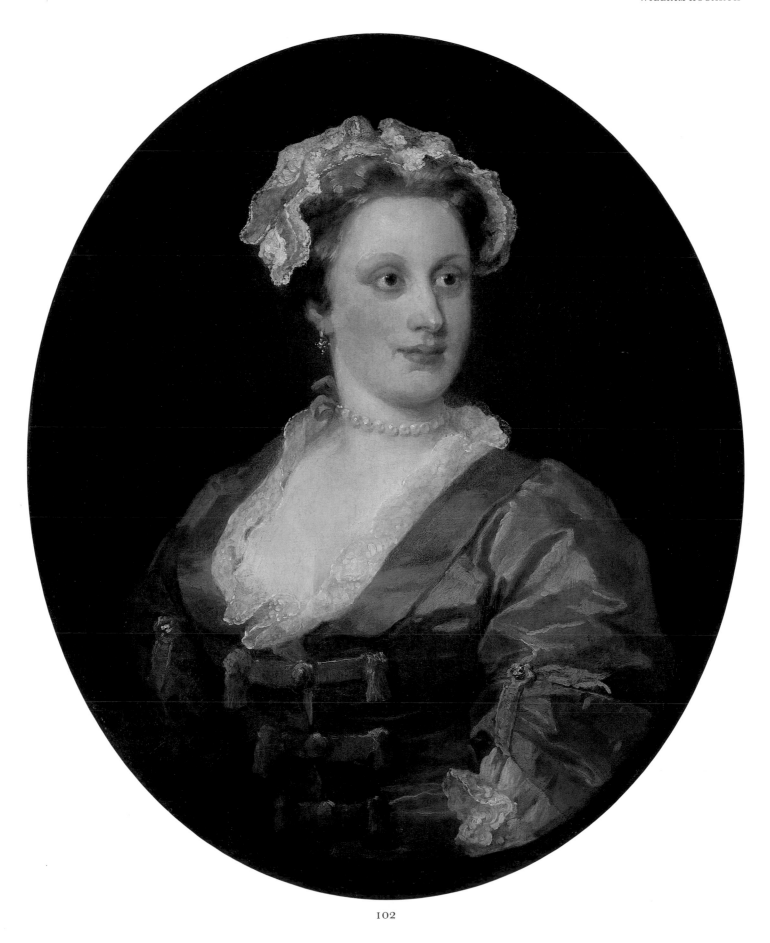

102

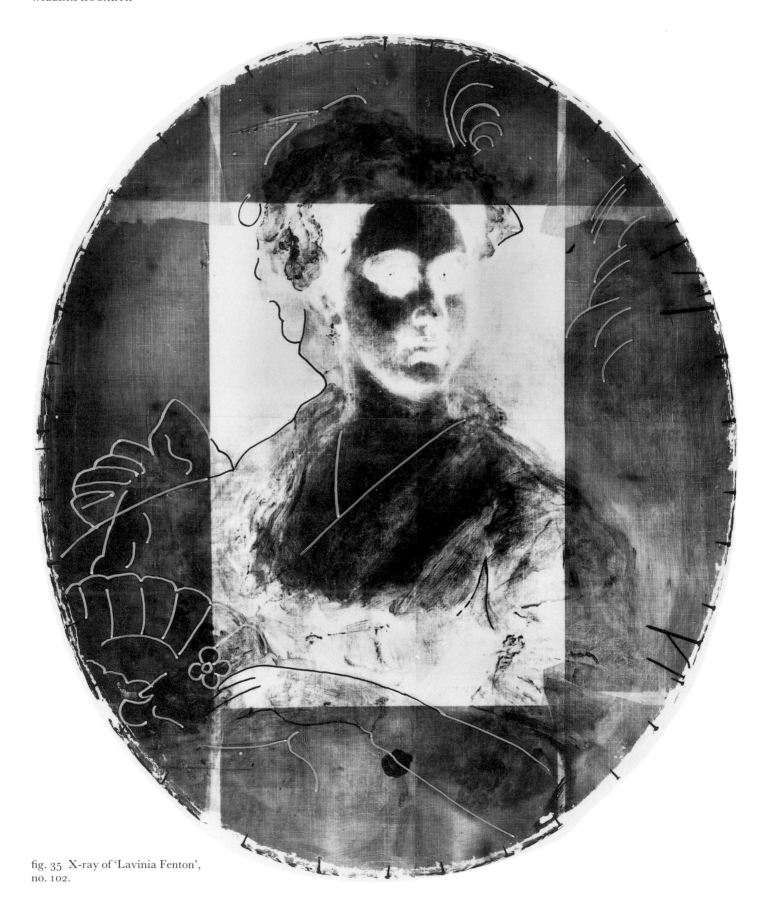

fig. 35 X-ray of 'Lavinia Fenton',
no. 102.

Memoirs, 1804, p.48). If the painting does indeed represent the actress, it would show her, as Antal already noted, in her riper years. The only certain comparison available is the portrait mezzotinted by Faber in 1728 after John Ellys, and the resemblance is not entirely convincing, even allowing for differences in age and painting styles. A set of pastel portraits of the Duke, Lavinia and their sons, of *c.*1738–40, datable from the ages of the children, still in Powlett family, also cannot offer conclusive evidence on grounds of likeness. (The compiler is indebted to Rear Admiral Powlett, Lord Bolton and Miss J.P. Smith for information on the Powlett/Paulet family).

Lavinia was the illegitimate child of a navy lieutenant named Beswick. Her mother, whose married name was Fenton, kept a fashionable coffee house near Charing Cross. The girl received a good boarding school education, but her good looks, vivacity and musical gifts gained her an early entry into the London stage, where she began to appear from 1726 onwards, always with great success. In January 1728 John Rich, the manager of Lincoln's Inn Theatre, engaged her as Polly in *The Beggar's Opera*, which became a great popular hit largely due to her performance: the success of Gay's new-style opera appears to have been in some doubt, until her affecting rendering of Polly's plea to her father to spare Macheath's life in 'O! ponder well: be not severe' carried the audience completely, launching the work on its unprecedented sixty-two-night run. Public interest was also greatly engaged by the fact that from the first night she so captivated Charles Paulet, 3rd Duke of Bolton (1685–1754), that he became a constant attendant at performances. At the end of the season Lavinia retired from the stage to become his mistress. In this role she is said to have been an accomplished and delightful companion and a model of discretion. She bore the Duke three illegitimate sons, who made successful careers in the army, navy and church (Collins, *Peerage of England*, 1812, II, pp.385–6, under Marquis of Winchester). On the death of his estranged wife in 1751, the Duke married Lavinia, and she became the second Duchess of Bolton. Widowed in 1754, her reputation was marred in the last years of her life by a liaison with an Irish surgeon named George Kelley, who became her executor and legatee. She died at Westcombe Park, Greenwich, in January 1760, and lies buried in the church of St Alphege.

The Duke is said to have been painted by Hogarth soon after his second marriage, but no such portrait is known. It is, however, just possible that this portrait might represent Lavinia round about this time, as a later dating of the painting cannot be ruled out.

Extensive pentimenti show that it was at some stage radically reworked by the artist himself, and recent X-rays (fig.35) suggest that only the face remains completely unchanged. In the original design the sitter wore a rakishly tilted hat with a tall tuft of feathers on the right, possibly with some flowers tucked under the brim on the left. She held up some drapery with her right hand and steadied an object, probably a basket of flowers, against it with her left; her decolletage was either V-shaped, or she wore a medallion on a long ribbon round her neck. The resulting over-crowding may be the reason why Hogarth altered it to the much simpler composition that it is now. Stretch marks show that the canvas was originally square and was presumably painted with a conventional false oval surround of which the inside edge is still visible. It is not known when the canvas was cut down to its present shape. The paint surface has suffered in the past, and it is probable that the dark shadows around her eyes would have been less apparent under the original glazes.

A portrait said to be of Lavinia Fenton by Hogarth was exhibited at the *National Portrait Exhibition* at South Kensington in 1867 (240, repr.), but as far as one can judge from the photograph there is nothing to substantiate either claim.

103 **Portrait of the Painter and his Pug** 1745

N 00112
Oil on canvas 900 × 699 ($35\frac{7}{16} × 27\frac{1}{2}$)
Inscribed 'The LINE OF BEAUTY|And
GRACE|W.H. 1745' on palette bottom left, and
'SHAKE|SPEARE', 'SWIFT|WORKS' and
'MIL[TON]|P[ARAD]|LOST' on back of the
three volumes, reading from top to bottom
Purchased by the National Gallery 1824;
transferred to the Tate Gallery 1951

PROVENANCE
Mrs Hogarth, from whom inherited by her
cousin Mary Lewis 1789, sold Greenwood's 24
April 1790 (47) £47 5s od bt Alderman John
Boydell; still in the collection of John and
Josiah Boydell when engraved by B. Smith
1795; probably sold by the Boydells as
uncatalogued addition to the sale of Hogarth's
'Marriage A-la-Mode', Christie's 10 February
1797, whose master-copy is inscribed by hand
'1. The Portrait of Hogarth – £47 3s od
Angerstein'; according to J. Nichols certainly
in Angerstein collection by March 1798; sold
with Angerstein collection to the National
Gallery

EXHIBITED
BI 1814 (94); *National Portrait Exhibition*, South
Kensington 1867 (352); *Exhibition of Cleaned
Pictures*, National Gallery 1947 (78); Tate
Gallery 1951 (59); Manchester 1954 (32, repr.
as frontispiece); BC tour 1957 (34, repr. p.73);
Tate Gallery 1971 (135, repr. in col. p.73);
Rococo Art and Design in Hogarth's England,
Victoria and Albert Museum 1984 (p.66, E3,
repr. pl.v in col.)

ENGRAVED
1. Line engraving by Hogarth, with
inscription '*Gulielmus Hogarth|Se ipse Pinxit et
Sculpsit 1749*' and pub. by himself March 1749
2. Mezzotint copy of above by Charles
Spooner of Dublin, 1749

LITERATURE
J. Ireland 1798, p.351; S. Ireland 1799,
pp.2–3; Nichols & Steevens, I, 1808, p.170, III
1817, p.169; Nichols 1833, p.382; G. Redford,
Art Sales, 1888, I, p.61, II, p.53; Dobson 1902,
pp.129, 173, repr. as frontispiece; A. Graves,
Art Sales, 1921, II, p.34; Dobson 1907, pp.146,
203, repr. as frontispiece; Davies 1946,
pp.67–8; Beckett 1949, p.55, pl.155; Antal
1962, pp.12, 14, 118, 25 n.31, pl.96(b);
Baldini & Mandel 1967, p.109, no.160,
pl.XLVIII (col.); J.V.G. Mallet, 'Hogarth's
Pug in Porcelain', *Victoria and Albert Museum
Bulletin*, III, no.2, April 1967, pp.45–54, fig.2;
Paulson 1970, I, pp.204–5, no.181, II, pl.193
and frontispiece; Paulson 1971, I, p.450, II,
pp.3, 4, 83, 284–5, 425 n.2, pl.190; Kerslake
1977, I, p.148, II, pl.391; Webster 1979,
pp.126–7, 186, no.153, repr. in col. (details)
pp.137–9; Bindman 1981, pp.109, 151, 195,
203, fig.119 (col.)

This portrait, which developed over several years, is also Hogarth's public statement of his artistic beliefs. It represents the artist in a still-life assemblage, as if painted on an unframed oval canvas which rests on volumes of the three authors he admired most – Shakespeare, Swift and Milton. The implication is not only that he took his inspiration from drama, contemporary satire and epic poetry, but also that he saw the art of painting as their equal. In the left foreground lies his palette, bearing a representation of the three-dimensional serpentine 'Line of Beauty and Grace' ('and Grace' has been painted out, but is now clearly visible through the transparent overpaint), which Hogarth considered to be the fundamental principle of all artistic harmony and beauty. In the opposite corner, as if to contrast the reality of nature with theoretical abstraction, sits one of Hogarth's successive favourite pugs. In this case it is probably Trump, who, according to Samuel Ireland, was modelled, like his master, by Roubiliac in the early 1740s, 'and for whom he had conceived a greater share of attachment than is usually bestowed on these domestic animals'. Hogarth was apparently fond of remarking on the resemblance between himself and his dog and probably saw in it something suggestive of his own notoriously pugnacious nature. Roubiliac's terracotta bust of Hogarth is now in the National Portrait Gallery; the model of Trump has been lost, but survives in Chelsea porcelain reproductions, including one in the Victoria and Albert Museum.

The portrait was clearly painted with engraving in mind, and Hogarth used the

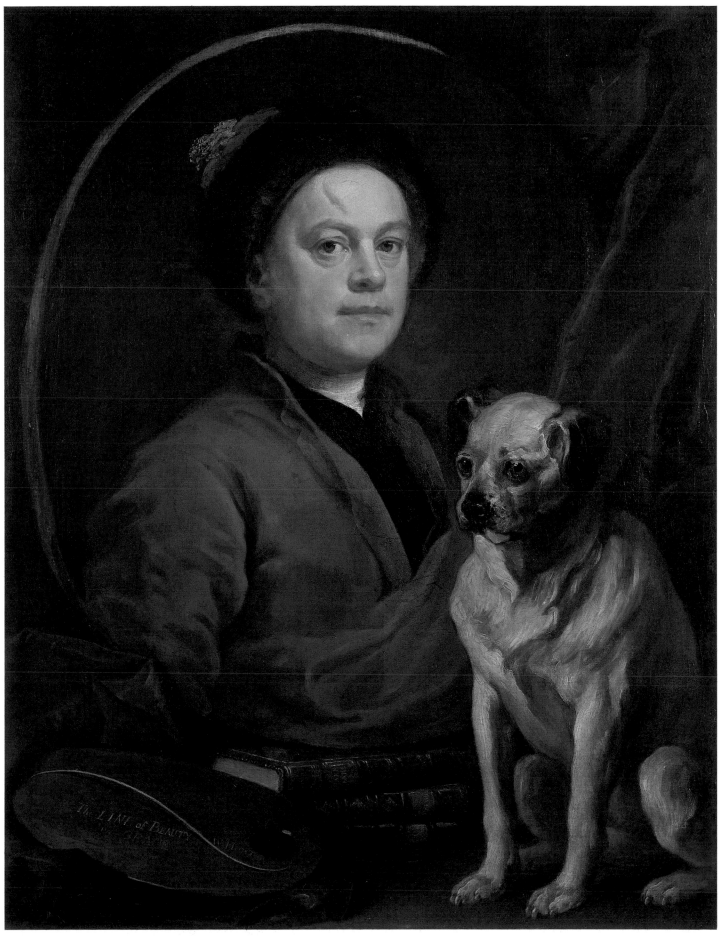

103

engraving he made from it in 1749 as the frontispiece to bound copies of his engraved works. In the print the image is reversed, except for the scar on the forehead – reputedly received in youth and displayed with pride – which the artist has adjusted to remain on the correct side, over his right eyebrow. Also included in the foreground of the engraving is a burin to represent Hogarth's work as a graphic artist; this is absent in the painting, but X-rays show that originally a graving-tool, larger than that in the engraving, lay in front of the portrait on top of the pile of books.

Another noticeable difference in the engraving are the blobs of paint on the palette, carefully graded from light to dark, of which there seems to be no trace in the original painting. These hark back to the similarly impastoed blobs of paint, shaded from white to bright red, on the palette of the unfinished self-portrait now in the Mellon collection at Yale, which is probably an abandoned earlier treatment of the same face-mask (the best, though incomplete, colour reproduction of this is in Webster 1979, frontispiece; also Beckett 1949, fig.40, and Paulson 1971, fig.170). As Hogarth was to explain later in his *Analysis of Beauty*, published in 1753 (Burke 1955, p.128) he saw the brilliant, clear colours represented by 'firm red' and white (because 'nearest to light') as equal in 'value as to beauty', and used a painter's palette of shaded blobs in plate 2 of the *Analysis* to expound his theories on tone and shade.

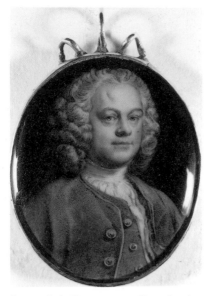

fig. 37 J. A. Rouquet, attributed to: 'Portrait of William Hogarth' *c.*1735. Enamel miniature 45 × 37 ($1\frac{3}{4}$ × $1\frac{7}{8}$). National Portrait Gallery.

The catalogue of the exhibition of restored paintings at the National Gallery in 1947 first noted the presence of numerous pentimenti, and in particular the wig which shows through the cap and the cheek near the ear. Recent X-rays carried out by the Courtauld Institute (fig.36) confirm that the painting began life as a much more conventional and gentlemanly representation of the artist, in which he wore a full wig, a flowing white cravat, and a coat and waistcoat with gold buttons. It also shows that a bunch of long brushes had originally been stuck through the thumb-hole of the palette. The oval of the self-portrait had at one time been much smaller and drawn closer to the head: the sweeping zigzag brush-stroke with which Hogarth attempted to obliterate its upper right edge is clearly visible in raking light. A very exact picture of what this original smaller oval looked like can be had from an enamel miniature (fig.37) now in the National Portrait Gallery, which seems to coincide with the X-ray image in every particular. This miniature, of which two versions are known (another is with Edwin Bucher of Trogen, Switzerland), may be by Hogarth's friend and collaborator, the Swiss enameller André Rouquet (1701–58), and looks as if it may well have been copied from this portrait as it was in its earlier stage of development. The miniatures are neither signed nor dated, but the one in the Bucher collection is in a contemporary silver-gilt case which is engraved on the back 'Wᵐ Hogarth|Painted by Zincke|1735'. Expert opinion on the whole now doubts the attribution to Zincke, and J.V. Murrell of the Victoria and Albert Museum has kindly suggested that the inscription looks stylistically later than 1735. However, he considers that the date could be an accurate record of the date the miniature was painted, and Rouquet, who worked in the style of Zincke, as a possible attribution. This would suggest that the Tate Gallery portrait could have been begun around this date: certainly the energetic handling of the wig as shown in the X-ray is very close to that of the unfinished self-portrait at Yale, which has always been considered an early work.

One can only speculate as to the reasons why Hogarth changed his image in so radical a manner by 1745. One possibility is that his trip to Paris in May 1743 to recruit French engravers to work on the 'Marriage A-la-Mode' series confronted him with an artistic community that had a much better self-image than that in Britain. The confident pride of the French artists in their own status shows itself most clearly in the magnificent artists' portraits presented by engravers as diploma works for their reception into the French *Académie*. From 1704 these had to submit to the *oeil-de-boeuf* format, in which the engraver gave the portrait an elaborate three-dimensionally conceived surround that usually incorporated emblematic

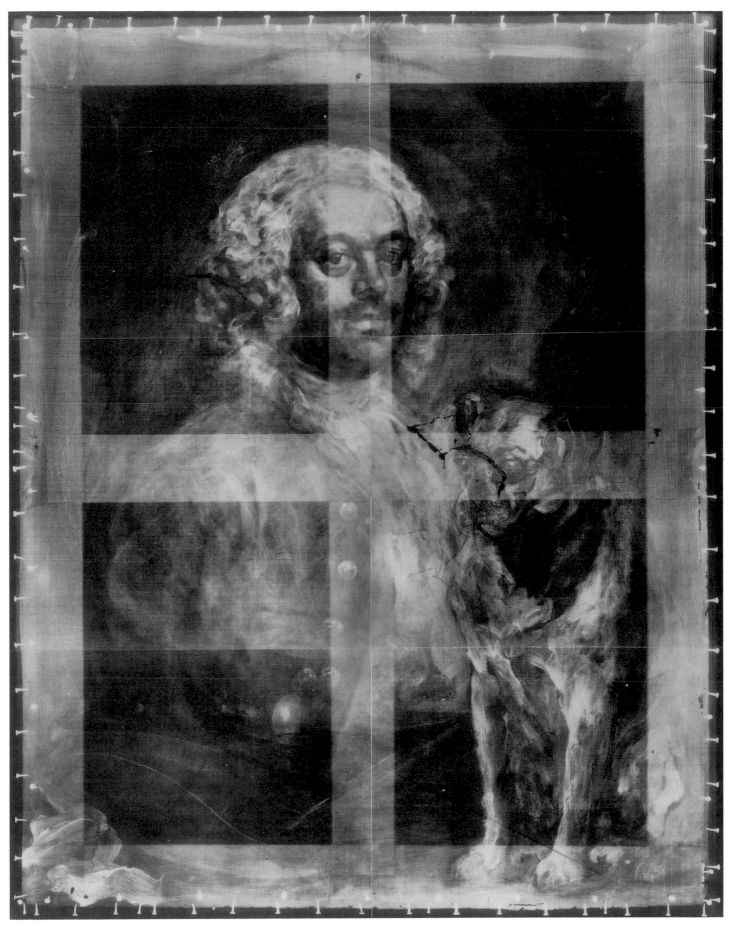

fig. 36 X-ray of 'The Painter and his
Pug', no. 103.

items like the artist's tools in the foreground. In the majority of cases the artists presented themselves not in conventional dress, but in casual artist's attire. While Hogarth may have been familiar with such *morceaux de réception* early in his career (and indeed the whole concept of his self-portrait suggests that he was), the trip may have given him the necessary jolt to prefer a more artistic image of himself over a gentlemanly one.

Hogarth's conception of the 'Line of Beauty' was less firm at this stage than might appear from the portrait. When he elaborated the idea in his *Analysis of Beauty* a few years later, he defined the 'Line of Beauty' as a gently waving line in two dimensions, and the 'Line of Grace' as a three-dimensional serpentine line. In this portrait, as in the engraving after it, the line is clearly three-dimensional, but labelled the 'Line of Beauty'. The fact that 'and Grace' has been painted out also suggests that Hogarth's ideas on this were still changing. He may have even included the line at this stage in order to provoke discussion, for in his preface to the *Analysis* he writes (apparently giving the wrong date) that 'In the year 1745 [I] published a Frontispiece to my engraved Works, in which I drew a serpentine line lying on a Painter's pallet, with these words under it, "THE LINE OF BEAUTY". The bait soon took; and no Egyptian Hieroglyphic ever amused more than it did for a time. Painters and Sculptors came to me, to know the meaning of it, being as much puzzled with it as other people, till it came to have some explanation.' Clearly, like his image of himself, his theoretical views also shifted ground in later years, leaving a complex record of their development on this canvas.

104 **The Staymaker (? The Happy Marriage V: The Fitting of the Ball Gown)**
*c.*1745

N 05359
Oil on canvas 699 × 908 ($27\frac{1}{2}$ × $35\frac{3}{4}$)
Purchased by the National Gallery with assistance from the National Art-Collections Fund 1942; transferred to the Tate Gallery 1949

PROVENANCE
...; Samuel Ireland by 1782, but not identifiable in his sale, Sotheby's 7–15 May 1801; ...; W.B. Tiffin of the Strand by 1833; ...; W.H. Forman of Pippbrook House, Dorking, before 1890, by descent to Major A.H. Browne of Callaly Castle, Northumberland, sold Sotheby's 27 June 1899 (81) bt C. Fairfax Murray; sold by him to Agnew 1908, from whom bt by Sir Edmund Davies 1908; bt from his executors by the National Gallery

EXHIBITED
RA Winter 1908 (100); *The Edmund Davies Collection*, French Gallery 1915 (19); *English Conversation Pieces*, Wembley 1924 (Room v, no.22); *Eighteenth Century Conversation Pieces*, 25 Park Lane 1930 (121); RA 1934 (228, Memorial Catalogue No.66); *La Peinture Anglaise*, Louvre, Paris 1938 (69); *One Hundred Years of British Painting*, BC tour, Lisbon and Madrid 1949 (22); Tate Gallery 1951 (58); *The French Taste in English Painting*, Kenwood 1968 (32); Tate Gallery 1971 (127, repr.)

ENGRAVED
Etching by Joseph Haynes 1782 (see no.113)

LITERATURE
Nichols 1782, pp.39–42, 102, 324–5, 1785, pp.115, 410; J. Ireland 1798, pp.125–34; Nichols & Steevens, ii, 1810, pp.267–8; Nichols 1833, p.364; W. Chaffers, *Catalogue of the Works of Antiquity and Art ... removed in 1890 to Callaly Castle*, 1892, pp.25, 206; Dobson 1902, p.187, 1907, pp.221, 267; Davies 1946, pp.74–5; F. Antal, 'Hogarth and his Borrowings', *Art Bulletin*, xxix, 1947, p.43, pls.13, 14; Beckett 1949, p.74, pl.162; Antal 1962, pp.28, 113, 115–16, 121, 204, 240 n.56, pl.180; Baldini & Mandel 1967, p.150, pl.26(col.); Paulson 1971, ii, pp.15, 18, pl.196; R. Paulson, 'Hogarth the Painter: The Exhibition at the Tate', *Burlington Magazine*, cxiv, 1972, p.76; Webster 1979, pp.115–18, 184, no.117, repr. p.123 and pp.124–5 (col. detail)

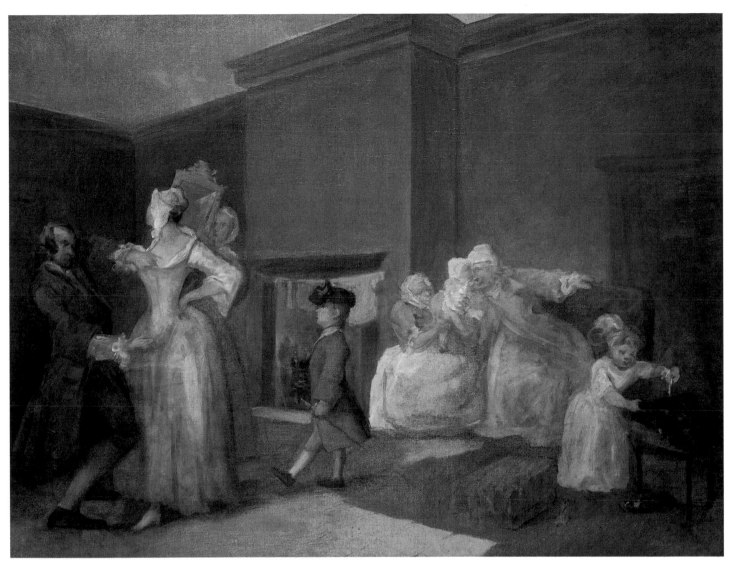

104

fig. 38 C. N. Cochin: 'Le Tailleur
pour Femme' 1737. Engraving
(Photo: Iveagh Bequest, Kenwood).

This is now generally thought to be one of the sketches for the abandoned 'Happy
Marriage' series, which Hogarth planned to produce after the success of the
'Marriage A-la-Mode' engravings of 1745 (the paintings for these of *c.*1743 are in
the National Gallery). It was to be set in the country as opposed to the town, and
was intended to contrast solid, old-fashioned virtues with the fashionable excesses
of the earlier series. Hogarth's intended plot, if indeed he had worked one out, is not
known and can only be deduced from a series of oil sketches, some of them now lost,
that are related in size, treatment and subject matter.

This particular scene could show the young country squire's wife being fitted for
the ball-gown she is to wear in the succeeding scene, 'The Dance' (no.105). Antal
(1962, pl.81a) has shown that the main group on the left was adapted from
Cochin's genre engraving of 1737, 'Le Tailleur pour Femme' (fig.38). The group in
the right background (very much Hogarth's own) shows the husband seated on a
settee, wearing a voluminous dressing-gown, playing with his youngest child which
is held up to him by a doting nurse who is kissing its bottom. The sketchy figure on
the settee has sometimes been interpreted as being female, yet Nichols, writing in
1782, understood it to be male, a view shared by Antal. Certainly the lounging
attitude is that of a man, the cut of the lapels, the long sleeves and wrist-ruffles
suggest a man's dressing-gown, worn with a night-cap over a long night-shirt.

Infra-red photographs show a pair of sturdy male legs in the under-drawing beneath the 'skirt'.

The eldest boy, equipped with cockade and toy sword, appears to be playing at soldiers, while the younger child seems to be pouring, with laudable if misplaced generosity, some milk for the cats into the staymaker's hat: infra-red photographs show the clear outline of a large cat in the bottom right-hand corner, in front of the kitten under the table (fig.39). Both are intently watching a sketchy blob on the floor which, to judge from its colour, could be some object that had fallen out of the box in front of them. As has already been noted (Webster 1979, p.118) the line of baby clothes drying in front of the fire suggests that the scene is set in the nursery.

The composition is far from resolved and shows many alterations, most notably a cabriole-legged table underneath the main group on the left, and an over-painted figure, perhaps of another maidservant, in a doorway behind the settee.

fig. 39 William Hogarth: 'The Staymaker'. Infra-red photograph showing large cat (detail of no. 104).

its owner in the crowd: he did this with considerable success in the later engraving, though such detail would have been difficult to achieve in dark oil paint. The dark strip down the right-hand margin is an afterthought and was painted by Hogarth over the original window surround which continues underneath, to serve as an effective foil to the colourful action beyond.

From the late nineteenth century onwards until recently this scene has been frequently called 'The Wanstead Assembly' due to a confusion with Hogarth's group portrait of the Child family in the great hall of their mansion at Wanstead, now in the Philadelphia Museum of Art. At the root of it is probably the radically altered Palladian setting of the scene for the print of 1753, which, according to John Ireland (*Hogarth Illustrated*, 1793, I, p.lxxvl) was said to represent Wanstead House. Since Samuel Ireland's account of 1799 it has also been usual to call it 'The Wedding Dance', on the assumption that the scene represents the ball after the wedding. The fact remains, however, that Hogarth's intended narrative is not known. We do know, however, that one scene represented the wedding procession in church. This painting was cut up some time before 1833 (possibly by 1782, when Nichols gave the opinion that 'there is little reason to lament the loss of it'), and the fragment from it in the collection of the Marquess of Exeter (Beckett 1949, fig.164) of a parson's head looks quite genuine. Nichols seems to be referring to this wedding picture when he complains (1782, p.42) that 'An artist, who representing the marriage ceremony in a chapel, renders the clerk, who lays the hassocks, the principal figure in it, may at least be taxed with want of judgment.' This has the ring of authentic irreverent Hogarthian invention, of the kind that easily upset Nichols's somewhat narrow sense of decorum and at times misled him into regarding Hogarth as an uncouth primitive. Recent X-rays of the much earlier 'Beckingham Wedding' (Metropolitan Museum, New York) show that just such a detail had been painted out in the left foreground of this otherwise very formal group. This raises the intriguing possibility that Hogarth, frustrated on this issue in an early commissioned work, subsequently made a point of including such a feature in wedding scenes where he had only himself to please, i.e. 'The Happy Marriage', and the wedding scene in 'The Rake'.

The second surviving scene is of 'The Wedding Banquet', now in the Royal Institution of Cornwall, Truro, and formerly in the possession of Mrs Garrick. It is, as Nichols rightly noted, set in the same Jacobean mansion as the Tate painting, and the principal figure in it is the old squire who raises a toast to the young couple, while the musicians (not confined to the gallery as in this picture) strike up a tune in the background.

Both Nichols and Ireland assume that the narrative culminates in the wedding itself, but this is to ignore the time-scale of 'Marriage A-la-Mode' to which this was to be a parallel. This assumption also fails to leave room for 'The Staymaker' (no.104), which stylistically belongs to this series and appears to show the young couple surrounded by children. If one were to interpret 'The Staymaker' as a scene showing the fitting of the ballgown for the ball to follow, then one could see 'The Country Dance' as a *grande finale* of the series, the first assembly given by the young squire for his tenants and neighbours after coming into his inheritance on the death of his father – after, naturally, a decent period of mourning, which was perhaps represented by one of the lost scenes engraved for Ireland in 1799, e.g. plate III, 'Relieving the Indigent' (Beckett 1949, pl.166), which has a tomb-like structure in the background. This would explain the absence here of the father so prominent in the 'Banquet', and the rather isolated female figure in the shadows at the card table on the left, who could be the widow, for whom it would be indecorous to join in the dancing. A further pointer is given indirectly by Nichols, who pillories Hogarth for his ignorance of etiquette in allowing the bride and groom to dance with each other at their wedding (Nichols's knowledge of correct behaviour in such matters may well have been better than Ireland's, who dismisses the criticism in 1799). From what we now know of Hogarth, it is highly unlikely that he would

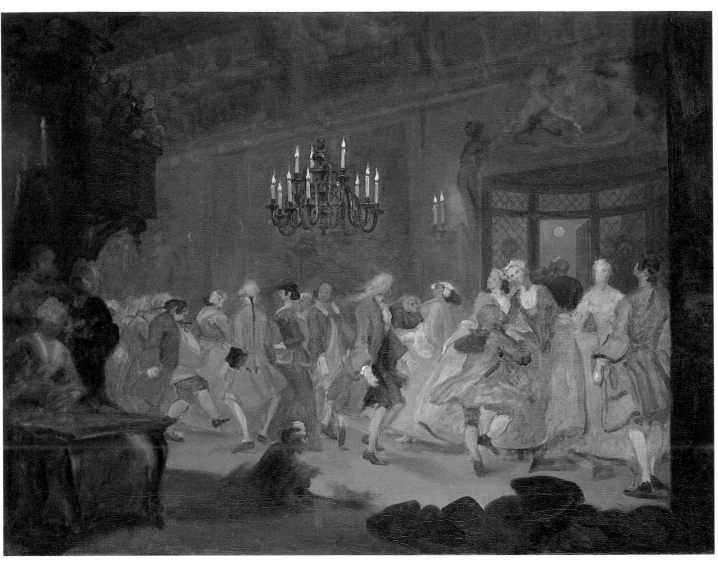

105

105 The Dance (The Happy Marriage? VI: The Country Dance) *c.*1745

T 03613
Oil on canvas 677 × 892 ($26\frac{5}{8} \times 35\frac{1}{8}$)
Purchased (Grant-in-Aid) with assistance
from the National Heritage Memorial Fund
1983

PROVENANCE
In Hogarth's studio until his death; bt from
Mrs Hogarth by Samuel Ireland before 1782;
his sale, Sotheby's 7-15 May 1801 (460 as
'The First Sketch of the Dance to the Analysis
of Beauty') £3 13s 6d bt Vernon;...; W.B.
Tiffin of the Strand by 1833;...; Charles
Meigh of Grove House, Shelton, Staffs., sold
Christie's 21 June 1850 (105 as 'The Happy
Wedding. The Ball.') bt Hoare;...; William
Carpenter of Forest Hill by 1875 when lent to
RA; bequeathed by him to the South London
Art Gallery 1899; sold by the London
Borough of Southwark to the Tate Gallery

EXHIBITED
RA Winter 1875 (35 as 'Sketch for a Country
Dance at the Wanstead Assembly, Essex'); *Old
London*, Whitechapel Art Gallery 1911 (68);
Peinture Anglaise, Musée Moderne, Brussels
1929 (86); *English Conversation Pieces*, 25 Park
Lane 1930 (123, pl.32); RA 1934 (232,
pl.XXVIII, p.23, Memorial Catalogue no.67;
AC tour 1946 (3); BC tour 1946 (5, repr.);
British Painting 1730–1850, BC tour, Lisbon,
Madrid 1949 (21); BC tour 1949 (61); Tate
Gallery 1951 (63); RA 1954 (28); *Hogarth the
Londoner*, Guildhall Art Gallery 1957 (26); BC
tour 1957 (35, repr.); BC tour 1960 (7); *British
Painting 1700–1960*, BC tour 1966, Cologne,
Zurich, Rome (7, repr.), Warsaw (29, repr.);
Tate Gallery 1971 (148, repr. in col.)

ENGRAVED
1. Adapted and engraved by William
Hogarth as Plate II for *The Analysis of Beauty*,
1753
2. Etching by T. Ryder for Ireland 1799, II, as
Plate IV of 'The Happy Marriage'

LITERATURE
Nichols 1782, pp.39-42 (for other scenes from
the 'Happy Marriage' series), 258-62, 1785,
pp.46-49, 115, 327-31; S. Ireland 1799,
pp.129-31, engr. facing p.130; Nichols &
Steevens I, 1808, p.128n., II, 1810, pp.198-9
(quoting Nichols 1782, etc.), repr. as
T. Cook's engraving after *Analysis of Beauty*,
facing p.198, III, 1817, pp.207, 258; Nichols
1833, pp.356-7; Dobson 1898, pp.94n.,
291-2, 300; Dobson 1907, pp.196, 206, 310;
Beckett 1949, pp.67-8, pl.168; Antal 1962,
pp.28, 30, 51, 105, 113-6, 163, 183, 199, 204,
209, 217, 240 nn.58-9, 241 nn.60-4, pl.94a;
Baldini & Mandel 1967, p.110, no.163,
pl.XLVII (col.); Paulson 1971, I, pp.15, 18-19,
174, II, pl.197; Jack Lindsay, *Hogarth: His Art
and His World*, 1977, pp.130-1, repr. facing
p.182; Webster 1979, pp.115-8, 186, no.147,
repr. p.122; Bindman 1981, pp.160-2, fig.127,
and in col. (detail) fig.128

Nichols, writing in 1781-2, was the first to point out that 'The Dance' is one of six scenes for the 'Happy Marriage' series planned by Hogarth as a counterpart to his 'Marriage A-la-Mode' painted *c.*1743 (see no.104). Of the three surviving sketches, this is certainly the most finished, and is arguably one of the most brilliant studies of figures in action in early eighteenth century British painting.

The scene is a country dance in the hall of an old-fashioned Jacobean country mansion; the open sky and the outlines of the village church can be seen through the window. The participants represent a gamut of individual types, from the elegant couple on the right, to the country bumpkins further down the line. One perspiring reveller has removed his wig to mop his bald pate in the cool night breeze at the open window. The silvery moonlight contrasts with the warm light of the brilliantly painted chandelier in the centre of the room – significantly, it is these two different sources of light that are the most finished parts of the painting. The action of the dance is framed by a dark foreground of which the main feature is a minstrels' gallery in the upper left corner, below which a shadowy group of people, including a lady and a clergyman, appear to be settling down to a quiet game of cards. The figure on the floor in the centre is probably the boot-boy whose task it would be to look after the pile of visitors' hats on the floor beside him. Hogarth is said to have intended to paint each hat in such a way that the viewer could identify

Showing the young married couple in a state of unbuttoned domestic bliss, surrounded by their mischievous and wholesome brood, would make a logical counterpart to the 'Levée of the Countess' in scene IV of 'Marriage A-la-Mode', where the presence of a neglected and, as transpires later, sickly child is indicated only by the child's rattle hanging by its ribbon from the back of the countess's chair. The busy and modest domestics in this scene would contrast favourably with the fashionable idlers of the other, as would the adoration, here properly bestowed upon a baby, with that evinced for a foreign castrato in the former, and the fitting of a gown for a country dance, with the preparations for the disastrous masquarade in town. Perhaps most importantly, the suggested reading of the picture would give the 'The Happy Marriage' series a time-scale similar to that of the 'Marriage A-la-Mode', which surely would have been Hogarth's intention if he had a contrasting parallel narrative in mind.

Most of what is known of the 'Happy Marriage' series comes from accounts of Samuel Ireland's collection, but much of this is contradictory and dubious, and there are no indications until long after Hogarth's death of what precisely the series as a whole consisted. According to Nichols, Ireland owned two (unspecified) sketches for the 'Happy Marriage' in 1782, as well as 'several other sketches in oil'. Presumably 'The Staymaker' was among the latter, as it was etched under this title that same year as being in Ireland's possession, without, however, any suggestion that it might belong to the 'Marriage' series. Writing in 1798, Samuel Ireland claimed to have purchased five of six oil sketches for the series from Mrs Hogarth 'many years ago', the sixth belonging to Mrs Garrick ('The Wedding Banquet', Royal Institution of Cornwall, Truro). He claims that he 'unfortunately lost, or mislaid' one of the five which represented the marriage procession in or to the church: this was cut up sometime before 1833, though fragments survive in the collection of the Marquess of Exeter (Beckett 1949, fig.164). Ireland illustrates the remaining four, of which one is 'The Dance' (no.105). The other three, none of which have been since traced, are so lacking in incident or what could be described as Hogarthian invention, that one suspects that Ireland either worked up his own interpretations from nearly indecipherable sketches, or erred in his attributions in his eagerness to make up a set (Beckett 1949, figs. 163, 166, 167). This is also suggested by his inability to fit the scenes into any kind of coherent narrative, although most writers have since adopted the sequence set out by him, i.e. (I) Courtship, (II) The Marriage Procession, (III) The Wedding Banquet, (IV) Relieving the Indigent, (V) The Garden Party, (VI) The Wedding Dance. If one accepts 'The Staymaker' as part of the series, this would bring the number of sketches associated with 'The Happy Marriage' to seven (it should be remembered that the 'Marriage A-la-Mode' consists of six scenes), and it can be argued that the two Tate Gallery sketches could represent the last two scenes in the series as it is known at present.

It is not known why Hogarth abandoned the series. Traditionally it has been suggested either that Hogarth was incapable of painting cheerful subjects, or that a happy narrative would be too lacking in dramatic incident to make an interesting series. It is equally possible that Hogarth decided that the immense labour involved in painting another set for engraving was not worthwhile, or that the market for such a subject had been saturated by the publication in July 1745 of Highmore's set of engravings after Richardson's immensely popular sentimental novel *Pamela* (see nos.20–3).

In his catalogue of the 1971 exhibition, Gowing suggests that this scene might be related to a lost decorative design for Vauxhall Gardens known only from its title 'Difficult to Please'. He also points out that Hogarth took a well-made stay as a prime illustration of the 'Line of Grace and Beauty' for Plate I of his *Analysis of Beauty* (1753), as he did the weaving line of the country dance from what could be the succeeding scene to this in the 'Happy Marriage' series, 'The Dance'.

have made a mistake of this sort, and fitting the series into the suggested time-scale would solve the problem. It would also be relevant in the sense that, as the first series began its descent into tragedy with the disintegration of a once-great estate, it would be fitting for the contrasting series to take as its conclusion the felicitous transfer of a well-run estate from one generation to the next, since inheritance and the management of property often form the mainspring of Hogarth's moral tales.

The painting remained in Hogarth's studio until his death, and his own high estimation of it is shown by the fact that he adapted the design for Plate II of his *Analysis of Beauty*, published in 1753 (fig.40). This changes the Jacobean setting to a very different Palladian one, and transforms the leading couple into aristocratic personages, in some editions even into the Prince and Princess of Wales. This design is no longer part of a narrative, but a purely didactic work to illustrate his theory that the serpentine 'Line of Grace and Beauty' lies at the basis of all that was inherently pleasing to the eye, in this instance in the weaving lines of a country dance and the graceful deportment of the leading couple. That he was already deeply involved with this theory by 1745, the presumed date of this picture, can be seen from the fact that he gave the 'Line' a prominent place in his 'Self-portrait with a Pug Dog' of that year (no.103). It is therefore quite possible that he planned from the outset that his 'happy' series should illustrate his theories of true harmony not only on a moral plane, but also on the level of design, albeit in a much more spontaneous and less didactic fashion than in the later print.

fig. 40 William Hogarth: *The Analysis of Beauty*, 1753, Plate II. Reproduced by courtesy of the Trustees of the British Museum.

106 **Thomas Herring, Archbishop of Canterbury** 1744–7

T 01971
Inscribed 'W. Hogarth pinx! 1744' centre left
above hand, 'Hogarth pinx.|1747' b.l.; and
'Thomas Herring. Archbishop of Canterbury
1747' t.r. in yellow paint
Oil on canvas 1270 × 1015 (50 × 40)
Purchased (Grant-in-Aid) 1975

PROVENANCE
By descent to the sitter's niece Mrs Richard
Stone, thence to her son George Stone of
Chislehurst, Kent; his daughter June, who
married Admiral Richard Crozier; their
daughter Mary Frances, who married Sir
Richard Biddulph Martin; thence to his great-
nephew Edward Holland Martin, sold
Christie's 7 July 1967 (103, repr.) bt Leggatt;
The Hon. Colin Tennant from whom bt by
the Tate Gallery

EXHIBITED
BI 1846 (53); *British Portraits*, RA 1956–7
(228); *The Age of Rococo*, Munich 1958 (228);
Tate Gallery 1971 (121, repr.)

LITERATURE
*Letters from the Late Most Reverend Dr. Thomas
Herring . . . to William Duncombe Esq.*, 1777,
pp.88, 89; Nichols 1782, pp.242, 464, 1785,
pp.280, 297; Nichols & Steevens, I, 1808,
p.192; Nichols 1833, p.380; J. Biddulph
Martin, *The Grasshopper in Lombard Street*, 1892,
p.93, repr.; Dobson 1907, p.173; Beckett 1949,
p.52, no.154; Antal 1962, pp.2, 20, 40, 232
n.23, fig.76a; Baldini & Mandel 1967, p.106,
no.154, repr.; J. Ingamells, 'Hogarth's "red"
Herrings: a study in iconography', *Connoisseur*,
CLXXIX, 1972, p.21, repr.; Paulson 1971, II,
pp.5–9, 27, 29, 31, 243, 425 n.15, 458 n.70,
figs.191a, b, c; H. Omberg, *William Hogarth's
Portrait of Captain Coram*, Uppsala 1974,
pp.124–5, 160; Kerslake 1977, I, pp.138–9, II,
fig.373; Webster 1979, pp.95, 101, no.145,
repr.; J. Ingamells, *The English Episcopal
Portrait 1559–1835*, 1981, pp.217–19, fig.126;
Bindman 1981, pp.125–6, fig.95

The portrait was begun in 1744 while Thomas Herring (1693–1757) was Archbishop of York, a post he held from 1743 until his promotion to the see of Canterbury in 1747. The zeal with which he mobilised in 1745 royalist forces in Yorkshire against Prince Charles made him a national hero and earned him the nickname of 'Red' Herring. He was to be one of Hogarth's most elevated sitters, and the artist appears to have been acutely aware of this. According to Nichols (1785, p.297) Hogarth reportedly observed while the Archbishop was sitting to him: 'Your Grace, perhaps, does not know that some of our chief dignitaries in the church have had the best luck in their portraits. The most excellent heads painted by *Vandyck* and *Kneller* were those of *Laud* and *Tillotson*. The crown of my works will be the representation of your Grace.'

The result is that the conscious effort to produce a work in the grand European, notably French, tradition is more noticeable in this than in any other of his portraits. Significantly, Hogarth had been to France in 1743 and Paulson (1971, II, p.8, fig.192) points out the closeness of the conception to Quentin de La Tour's portrait of 'Le Président des Rieux' of 1741. In fact the picture shares a family likeness with many eighteenth-century portraits cast in the Baroque mould by Van Loo, Largillière, Rigaud and others. Unlike the portrait of Bishop Hoadly (no.99), which was completed in 1741, no.106 affects the grandeur of simplicity by keeping to a remarkably subdued (for Hogarth) colour scheme of black and white and an olive curtain, and eschewing any 'business' of detail that might detract from the magisterial gesture of his left hand and the dominating vitality of expression. Hogarth even went against his usual tendency to overcrowd compositions by painting out one conventional background prop, a classical pedimented column which filled the left margin of the picture and which is now clearly visible under the overpaint. Hogarth's 1744 signature originally fitted logically into its base and was thus not so noticeably suspended in mid-air above the Bishop's right hand as it is now.

The painting, however, failed to please, and Herring wrote to his friend Duncombe in November 1745 that 'None of my friends can bear Hogarth's picture' (*Letters*, 1777, p.88). The Revd John Duncombe observed, when annotating his

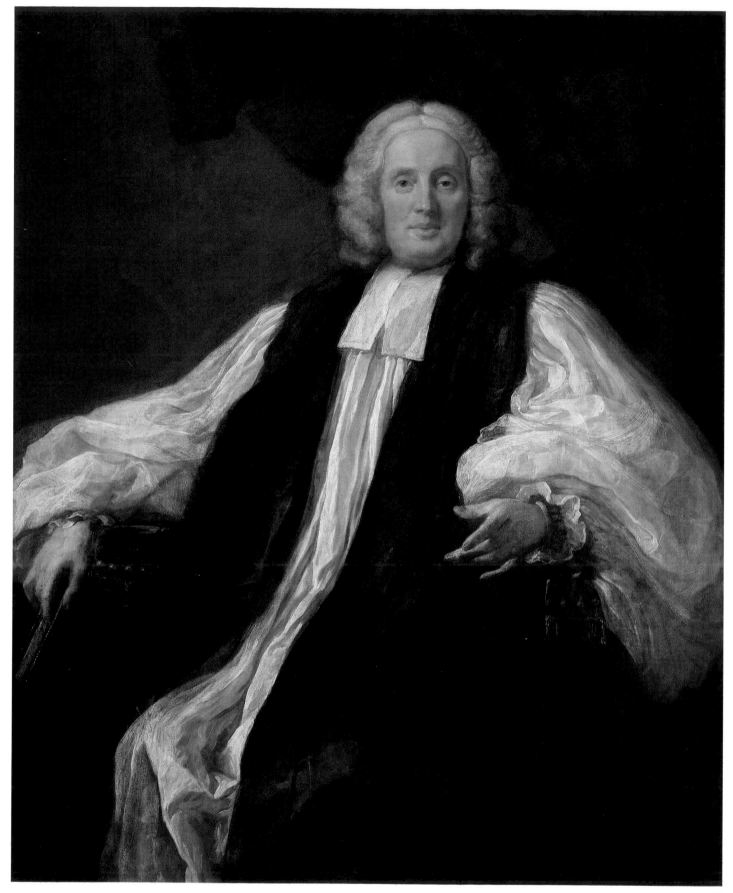

106

WILLIAM HOGARTH

father's *Letters*, that the picture as engraved by Baron '... exhibits rather a caricature than a likeness, the figure being gigantic, the features all aggravated and *outrés*, and, on the whole, so far from conveying an idea of that ... engaging sweetness and benevolence which were characteristic of this prelate, that they seem rather expressive of a *Bonner*, who could burn a heretic.'

It is probably this displeasure (rather than any rethinking in the light of his discoveries in France as suggested by Paulson) that led to the reworking of parts of the picture in 1747, as attested by the second signature in the bottom left-hand corner. It coincides with Herring's removal from York to Canterbury and was possibly an attempt to modify the painting to fit in better with his ideas of an official portrait of the Lambeth Palace series. Much repainting is noticeable about the hands which appear to have been lowered together with the arm-rests, presumably to reduce the width of the figure. The book could also have been added at this time. Similarly the shoulders have been dropped and the areas of the white lawn sleeves greatly reduced by covering them with the black gown. The solidly painted head contrasts markedly with the extraordinary breadth and fluidity of the brushwork in the rest of the painting, the white sleeve on the right in particular. How willingly Hogarth undertook the alterations is impossible to say, but it would have been his ambition to produce a likeness that satisfied, as Herring's position and popularity would have ensured a wide circulation of prints after the painting.

However, as far as we know no formal engraving was made of the picture as it was in 1744, with the exception of a hasty portrait medallion to adorn the broadsheet of Herring's York speech of 1745 (Ingamells 1972, fig.3). The engraved text of this states 'William Hogarth Pinx! ... C. Mosley sculp' and it serves to confuse the issue by showing the pose and characteristic gesture of no.106, but a completely different three-quarters view of the head. The latter is not unlike that of the portrait of Herring by an unknown hand (possibly Wills) of which there are versions both at Lambeth Palace and Bishopsthorpe, and the conclusion has been drawn from this that the Mosley engraving is a combination of the two, enabling the second portrait type to be dated to *c*.1744 on that basis. The difficulty here is that while the Hogarth pose of the Mosley engraving is in reverse to the oil, the head is in the same sense as the Lambeth–Bishopsthorpe picture, and it is unlikely that an engraver would have reversed the one and not the other. We are thus left with the possibility that the engraving does in fact represent the original state of the portrait and that the alterations Hogarth thought worthy of another signature involved no less than scraping out the old head and repainting it as we see it now. This is not immediately evident on the physical examination of the picture, and a final answer will probably be only provided by an X-ray, but evident alterations to the Bishop's left shoulder may well have been required by a change in the position of the head. A careful examination of the 1745 engraving shows that some of the sketchiest and lightest brushwork, which one would have been inclined to consider as part of the later reworking of the pictures, is already represented in the engraving, (e.g. the diagonal fold of the black gown beneath the pointing hand). At the same time, a semi-circular projection of the sleeve directly underneath the same hand, clearly shown in the engraving, has been painted over, but is still visible as a pentimento. In other words, Mosley, within his limited abilities, followed his pattern fairly closely, and in view of this approach, his head is not sufficiently close to the Lambeth–Bishopsthorpe version for it to have been taken from there.

Hogarth's portrait was formally engraved by Bernard Baron only in 1750, and as early as 1748 Herring's correspondence shows that his next sitting was to be to Thomas Hudson (*Letters*, 1777, p.89), whose workmanlike but pedestrian likeness became Herring's preferred official portrait. The Hogarth painting remained in Herring's family and, as far as is known, no copies were made after it, although John Simon Webster's presumably posthumous portrait of 1757 at Lambeth Palace (Ingamells 1972, fig.9), seems to depend on it for the likeness but not the pose.

Although Hogarth painted several successful portraits of sitters belonging to Herring's ecclesiastical circle, it appears that there was no personal rapport between the prelate who, as a young preacher in 1728 condemned *The Beggar's Opera* from the pulpit as 'a thing of very evil tendency', and the artist who found in the very same subject (no.87) the catalyst that was to lead him towards his own original style and scope in painting. It seems fitting that Hogarth's masterpiece in the grand manner, that least suited for his talent and furthest removed from the intimate satire of his 'modern moral subjects', should be his portrait of the Archbishop.

107 O The Roast Beef of Old England ('The Gate of Calais') 1748

N 01464
Oil on canvas 788 × 945 (31 × 37¼)
Inscribed 'For Mad.ᵐ Grandsire at Calais' on
label attached to the cloth under the piece of
beef
Presented by the Duke of Westminster to the
National Gallery 1895; transferred to the Tate
Gallery 1951

PROVENANCE
Still with the artist in 1761, when exhibited at
the SA; . . .; according to Nichols, Lord
Charlemont by 1781; sold by 'J. James'
(presumably Lord Charlemont's agent),
Christie's 2 May 1874 (58) bt Agnew and sold
by them the same year to H.W.F. Bolckow; his
sale Christie's 2 May 1891 (107) bt Agnew for
the Duke of Westminster

EXHIBITED
SA 1761 (44 as 'The Gate of Calais'); BI 1814
(120, 117 in some copies of cat.); Dublin 1853
(Fine Arts Section 965); Dublin 1865 (Ancient
Masters Section 50); BI 1867 (202); *British
Deceased Painters*, Leeds 1868 (1099); Dublin
1872 (Early British Section 217); RA Winter
1875 (28); BC tour 1946 (2, pl.9); Tate
Gallery 1951 (64); BC tour 1960 (8, repr.);
Tate Gallery 1971 (136, repr. in col.); *Zwei
Jahrhunderte englische Malerei*, Haus der Kunst,
Munich 1979 (28, repr.)

LITERATURE
Nichols 1781, pp.31–2, 110–11, 1782,
pp.42–4, 235–41, 1785, pp.49–50, 289–95;
Ireland 1798, pp.349–50; Nichols & Steevens,
I, 1808, pp.141–54, II, 1810, p.190, engr. III,
1817, pp.172, 253; Nichols 1833, pp.62–4,
359; Dobson 1902, pp.95, 173, 1907, p.204;
Vertue III, pp.141–2; *Walpole's Correspondence*,
XX, p.13; Davies 1946, pp.70–2; Beckett 1949,
p.70, fig.161; Burke 1955, pp.227–8; Antal
1962, pp.2–3, 6, 20, 28, 77, 122, 132, 172, 218
n.7, 241 n.78, 248 n.41, pl.111; Paulson 1970,
I, pp.202–4, no.180, II, pl.192 (1749
engraving); Baldini & Mandel 1967, p.11,
pls.XL (col.), L (detail); Paulson 1971, II,
pp.71, 75–8, 86, 129–31, 149, 196, 262, 281,
323, 396, 432 n.23, 436 n.6, 452 n.92, pl.220;
Waterhouse 1978, p.177, fig.139; Webster
1979, pp.132, 136, 148, 187 no.158, repr. in
col. pp.149, 150–1 (detail); Bindman 1981,
pp.162, 183, figs.129 (col.), 130, 131 (details)

The painting is Hogarth's comment on his second visit to France in 1748, when he was arrested in Calais as a suspected spy, and it expresses his profound disenchantment with life on the other side of the Channel.

The first mention of the event comes from Vertue in a passage dated August 1748, but probably written a little later. He reports that a group of artists, consisting of Thomas Hudson, the Van Aken brothers, Hogarth, Hayman, and the sculptor Henry Cheere, had gone to Paris, taking advantage of the freeing of the Dover–Calais passage after the May armistice that preceded the Peace of Aix-la-Chapelle signed in October that year. His (not necessarily correct) information seems to be that while the others went on from Paris to make a four- or five-week tour of Flanders and Holland, Hogarth and Hayman returned early, and 'attempting to draw some Views of Fortifications &c, were surprized & clapt into the Bastile, from whence they were soon glad to return to England'.

Next comes a more circumstantial account by Horace Walpole in a letter to Horace Mann, dated 15 December 1748:

> Hogarth has run a great risk since the peace; he went to France, and was so imprudent as to be taking a sketch of the drawbridge at Calais. He was seized and carried to the Governor where he was forced to prove his vocation by producing several caricatures of the French; particularly a scene of the shore with an immense piece of beef landing for the Lion d'Argent, the English inn at Calais, and several hungry friars following it. They were much diverted with his drawings and dismissed him.

Hogarth's own autobiographical notes, written at the end of his life and never published in his lifetime, do not mention the other artists, but broadly substantiate

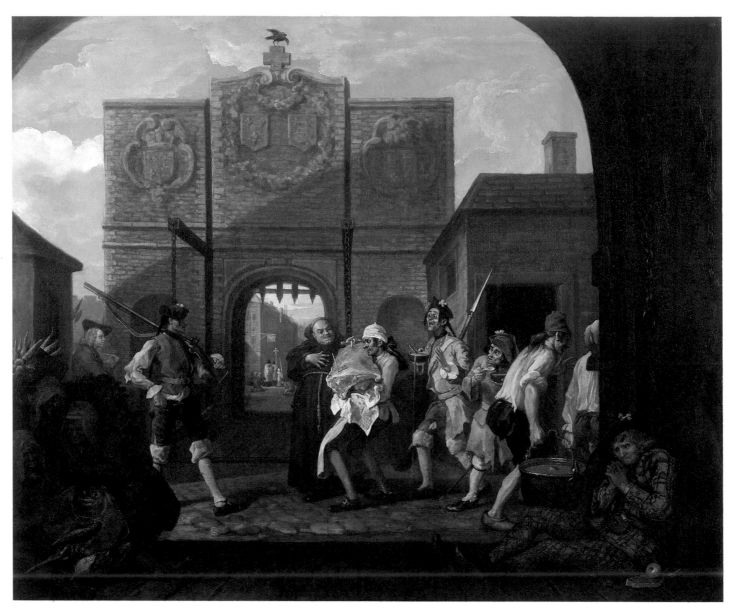

107

the above (BL Add.MS 27991, here quoted with slightly modernised spelling and punctuation; for an exact transcript see Burke 1955). He expands on his poor impression of France as a place of empty pomp, bigotry and poverty, and notes that the

fish women have faces of [word illegible] leather, and soldiers [are] ragged and lean. I [was] seized by one of them and carried to the governor as a spy, as I was sauntering about and observing them & the gate, which it seems was built by the English when the place was in our possession. There is a fair appearance still of the arms of England upon it. As I concealed none of the memorandum I had privately taken and they being found to be only those of a painter for [his] own use, it was Judged necessary only to confine me to my lodging till the wind changed for our coming away to England where I no sooner arrived but set about a Picture wherein I introduced a poor highlander fled thither on account of the Rebellion year before, browsing on scanty french fare, in sight [of] a Sirloin of Beef, a present from England, which is opposed [to] the Kettle of soup maigre. My own figure in the corner with the soldier's hand upon my shoulder is said to be tolerably like.

The first published account (Nichols 1781, p.31) adds some information which the author had indirectly from the Revd William Gostling of Canterbury, at whose house Hogarth spent the first night on his homeward journey, to the effect that the artist was put in the custody of Grandsire, the landlord of the Lion d'Argent, until his return to England. Nichols also gives the account by 'an eminent English engraver, who was abroad when it happened', thought to be either Thomas Major or Robert Strange, which adds threats of hanging from the Commandant and some rough treatment by the guards, which may or may not be subsequent dramatisation.

Hogarth must have completed the painting within a few months, for an engraving after it by himself and Charles Mosley (see no.108) was published on 6 March 1749 under the title 'O The Roast Beef of Old England'. A cantata, or ballad, based on the painting and attributed to Hogarth's friend Theodosius Forrest (1728–84) was in print by 1759 (reprinted in full in Nichols 1782, p.237, and Nichols & Steevens, I, 1808, p.148). The theme, however, was not a novel one and Hogarth was partly exploiting existing popular sentiment, as can be seen from an anonymous poem called 'Beef and Liberty' published by *The Gentleman's Magazine* in June 1748 (p.277). This gloats over the wretched existence of Jacobite exiles in France who, having forfeited their birthright to rich British fare with its 'princely loin', now have to 'cringe and starve on Gallia's envy'd coast', where '... soups and sallads shall your board supply,|And the kind priest absolve ye when ye die'. There are even earlier precedents (see O. Baldwin and T. Wilson, '250 Years of Roast Beef', *Musical Times*, April 1985, pp.203–7).

The main difference between the engraving and the painting is the crow perched atop the cross on the gate. This seems to be a later addition to the painting for, according to Nichols (1781, pp.110–11) 'soon after it was finished, it fell down by accident, and a nail ran through the cross on the top of the gate. Hogarth strove in vain to mend it with the same colour, so as to conceal the blemish. He therefore introduced a starved crow, looking down on the roast beef, and thus completely covered the defect.' No obvious repairs to this spot were found when the painting was restored in 1966, and in fact the detail provides a relevant if macabre echo to the scene directly below, where a processional cross, above which a white dove hovers in the shape of an inn-sign, is carried through the streets, juxtaposing, as it were, the very real adulation of the flesh in the foreground with the hollow worship of the 'spirit' beyond the gate. Forrest's ballad identifies the soldier with a spoonful of soup as an Irishman who had joined the French army to escape the English gallows, and the man with the beef as Madame Grandsire's cook.

The sirloin itself occupies the exact centre of the composition, and is further highlighted by the only patches of pure white in the picture – the cook's cap, cloth and apron. Yet another visual pun is achieved by painting it against one of the chains of the drawbridge, so that it seems to outweigh the brilliantly painted ragged French soldier, placed as if he were a dangling puppet on the other side of a pair of scales. The long shadow across the gate itself leads the eye to a cameo behind his back, where, enclosed in a spiky triangle of carrots, halberd and musket, Hogarth is seen sketching the scene, with a soldier's hand about to grab him by the shoulder. According to Nichols (1781, p.110), the sitter for the fat friar was his friend the engraver John Pine (1690–1756), who as a result became known as Friar Pine, much to his disgust. Hogarth was to paint him again in 1756 in the more dignified disguise of a Rembrandt self-portrait (Beaverbrook Foundation, Fredricton, New Brunswick; Beckett 1949, fig.185).

The white cockades in the soldiers' hats, the bullet-hole in that of the Irishman, and the black wound-patch on the Highlander's forehead show that they are supporters of the Stuarts and mercenaries used by the French in battle. In the left foreground a group of leathery-faced market women laugh at the human appearance of the skate, unaware how closely it resembles them. The other side of the dark and shadowy foreground is occupied by the tragic figure of the despairing

Jacobite, beside whom lies a scanty meal of raw onion, a dry piece of bread, and an empty overturned rummer.

The arms on the gate are those of England, but it is difficult to know if Hogarth has given an accurate representation of the structure, for already in 1855 Leslie noted that only the drawbridge remained as in this picture (C. R. Leslie, *Autobiographical Recollections*, 1860, I, p.232). It was finally demolished in 1895.

WILLIAM HOGARTH and CHARLES MOSLEY active 1744–d.*c*.1770

108 **O The Roast Beef of Old England ('The Gate of Calais')** 1749

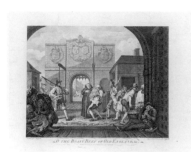

108

T 03918
Etching and engraving 346 × 440 ($13\frac{5}{8}$ × $17\frac{5}{16}$) on paper 432 × 569 (17 × $22\frac{3}{8}$); plate-mark 383 × 457 ($15\frac{1}{16}$ × 18)
Etched inscription '*For Mad^m|Grandsire|at Calais*' on label under piece of beef, and '*Grand|Monarch|P*' on the cuff of the sentinel on left. Writing-engraving '*Painted by W. Hogarth Engrav'd by C. Mosley & W. Hogarth.|O* THE ROAST BEEF OF OLD ENGLAND, &C|*Publish'd according to Act of Parliament March 6th 1749.*'
Presented by Mrs M. L. Hemphill 1984

PROVENANCE
...; Mrs M.L. Hemphill by 1984

LITERATURE
Nichols 1782, pp.42–3, 235–41; Nichols & Steevens, I, 1808, pp.148–54, II, 1810, p.190, III, 1817, p.251; Vertue VI, p.200; Paulson 1970, I, pp.202–4, no.180, II, pl.192; Paulson 1971, II, pp.77–8, 432 n.23

Engraved after the original painting of 1748 in the Tate Gallery (no.107). The subject is not reversed in the print, which differs from the painting chiefly through the absence of the crow on the cross atop the gate. Hogarth added it to the painting after the print was published, reputedly to hide a damage to the canvas. Additions seen only in the engraving, on the other hand, are the printed words on the ruffles of the sentinel on the left, to show that they are made of paper.

The print was announced in *The London Evening Post*, 7–9 March 1749, and in *The Daily Advertiser*, 8 March 1749, as published 'This Day' for the price of 5s, and 'representing a PRODIGY which lately appear'd before the Gate of CALAIS'. Mosley is not mentioned as a collaborator in the advertisement, but only on the print itself. George Vertue commented on the appearance of the print (on what must have been a hand-coloured version) by voicing a somewhat unreasonable objection to the fact that a piece of raw beef is shown, 'colour'd only red & yellow in the Middle of the print', instead of the roast of the title (VI, p.200).

Hogarth's friend Theodosius Forrest wrote a cantata based on the subject of the painting which may have been sung at public performances. It was published by Robert Sayer at the Golden Buck in Fleet Street (i.e. sometime before he began publishing from 53 Fleet Street in 1752), with a small copy of the print at the top of the sheet (for the full text see Nichols 1782, pp.237–4, and Nichols & Steevens, I, 1808, pp.148–54). The cadaverous sentinel on the left and the ragged soldier spilling his soup were used as models for figures in recruiting posters, juxtaposed with well-fed British soldiers; Hogarth's self-portrait was repeatedly used for later publications related to the artist (for full list see Paulson 1970).

WILLIAM HOGARTH

109 Heads of Six of Hogarth's Servants *c.*1750-5

N 01374
Oil on canvas, 630 × 755 (24$\frac{13}{16}$ × 29$\frac{3}{4}$)
Purchased by the National Gallery (Lewis
Fund) 1892; transferred to the Tate Gallery
1960

PROVENANCE
Mrs Hogarth, from whom inherited by her
cousin Mary Lewis 1789, sold Greenwood's 24
April 1790 (44 as 'The heads of 6 servants of
Mr. Hogarth's family') £5 15s 6d bt 'Clarke,
Strand', possibly for William Collins of
Greenwich, by whom lent to BI in 1817 and
Suffolk Street Gallery in 1833; . . .; *c.*1863 part
of stock-in-trade of William Benoni White,
sold Christie's 24 May 1879 (244) bt J.K.
Wedderburn, sold Christie's 3 June 1892 (98)
bt C. Fairfax Murray for the National Gallery

EXHIBITED
BI 1817 (80); *British Artists*, Suffolk Street
Gallery, Winter 1833 (214); *Twe Eeuwen
Engelsche Kunst*, Stedelijk Museum,
Amsterdam 1936 (65); *La Peinture Anglaise*,
Louvre, Paris 1938 (67, repr.); BC tour 1946
(3); BC tour 1949 (62, repr.); Manchester
1954 (38); Tate Gallery 1971 (197, repr.)

LITERATURE
Nichols 1782, p.88, 1785, p.98; Nichols &
Steevens, II, 1810, p.iv, III, 1817, pp.173*-4*,
197; Nichols 1833, p.383; G. Redford, *Art
Sales*, 1888, II, pp.297-8 (for Benoni White
Sale); A. Dobson, 'The New Hogarth at the
National Gallery', *Illustrated London News*, 2
July 1892, repr.; Dobson 1902, pp.130, 148,
161, 182, repr. p.15, 1907, pp.146, 188, 215,
repr. facing p.146; 'Mrs Hogarth's Sale',
Burlington Magazine, LXXXV, 1944, p.258;
Davies 1946, p.70; Beckett 1949, p.44, pl.194;
Waterhouse 1953, pp.133-4, pl.105; Davies
1959, p.68; Antal 1962, pp.173-4, 249 n.45,
pl.132; Baldini & Mandel 1967, p.112,
no.177, pls. LX-LXI (col.); Paulson 1971, II,
pp.244-6, pl.264; Waterhouse 1978, p.179,
fig.141; Webster 1979, pp.142, 187, no.162,
repr. in col. p.143; Bindman 1981, p.195,
fig.156. Also repr.: W. Gaunt, *The Great
Century of British Painting: Hogarth to Turner*,
pls.30, 31 (detail)

One of Hogarth's most spontaneous and masterly works in portraiture, this sketch
represents, according to reliable sources, six servants of the Hogarth household. It
is not known who they are individually, but Samuel Ireland (1794, p.169)
mentions that the Hogarths had an old servant called Ben Ives, who could be the
old man in the top right corner. Mrs Hogarth is also known to have had a servant
called Samuel, and a housemaid who was with them at Chiswick, a 'Mrs Chappel,
of Great Smith Street, Westminster', who lived to be a centenarian well into the
nineteenth century. Some of Mrs Chappel's recollections were used in Edward
Draper's 'Memorials of Hogarth', *Pictorial World*, 26 September 1874 (quoted in
Paulson 1971, II, pp.451-2 n.74). The painting may have hung in the artist's studio
along with other portraits of his family, and could have served to demonstrate his
ability to catch a likeness in all age-groups – indeed, the range of flesh tones
represented is remarkable.

 Although the informal directness of the group clearly puts it into the category of
'friendship' portraits, painted either for the sheer love of painting or out of affection
for the people represented, or both, it could also be seen as a realisation in painterly
terms of the kind of categorising accumulation of heads and objects that are
frequent in Hogarth's graphic work and which aim to express the full range of some
given concept, in this case all the facial characteristics from youth to age as in the
'seven ages of man', a subject already dealt with by him in the surround of Plate 2 of
The Analysis of Beauty, 1753.

 It is not possible to date the work exactly, but stylistically it would appear to be
fairly late. The beginnings of a seventh head, probably female, have been laid-in in
the lower left corner, and the left-hand edge of the young woman's bonnet next to it
has been narrowed as if to accommodate it. The left edge of the canvas has been cut,
removing half of the oval of the laid-in head. The remaining heads have been

109

brought to a high degree of finish, although their placing on the buff ground makes it clear that the painting was never meant to be taken any further. Composition- ally, however, the painting is given an overall unity by all the heads being lit from the same side, and each is loosely paired in the angle from which it is seen with the head above or below. At the same time each maintains its separateness by looking out at its own distinct focal point, and the fact that none of their lines of vision intersect creates a sense of balanced dignity unusual in a painting that makes no apparent claim to being a formal composition.

The painting is first mentioned by Nichols in 1782, who, when commenting on Hogarth's good relations with his servants, states: 'of most of these he painted a strong likeness on a canvas still in Mrs Hogarth's possession'. It was bought at the sale of her collection in 1790 (according to Horace Walpole's annotated copy of the catalogue, published in the *Burlington Magazine*, LXXXV, 1944) by 'Clarke of the Strand'. As Nichols & Steevens name the owner of the painting in 1810 as 'William Collins Esq, of Greenwich', and state in the subsequent (1817) volume that he had bought it at Mrs Hogarth's sale, it is likely that Clarke was his agent. The lender to the 1833 exhibition is mentioned only as 'Collins', so that it could be the same owner, or his descendant. After this the painting reappears in the 1879 sale of the stock-in-trade of the late William Benoni White, dealer in Brownlow Street, Holborn, where it had apparently 'remained for the last sixteen years since his retirement from business' (Redford 1888, quoting *The Times*, 28 May 1879).

Dobson records (*Illustrated London News*, 1892) that among the volumes of papers formerly owned by Hogarth's patron James Caulfield, 1st Earl of Charlemont, then currently on sale at Quaritch's, was a pencil drawing of this painting, signed with the initials of the etcher Richard Livesay, dated 1788, and entitled 'Hogarth's Servants'. As Livesay was Mrs Hogarth's lodger at Leicester Square and produced many facsimiles after Hogarth's drawings for her, this seems reliable evidence, although no etching seems to have been produced after this drawing.

WILLIAM HOGARTH and LUKE SULLIVAN 1705-1771

110 **The March to Finchley** 1750-61

T 01802
Etching and engraving 418×542 $(16\frac{7}{16} \times 21\frac{3}{8})$
on paper, irregularly cut, 464×621
$(18\frac{1}{4} \times 24\frac{7}{16})$; plate-mark 444×558
$(17\frac{1}{2} \times 21\frac{15}{16})$
Writing-engraving '*A Representation of the
March of the Guards towards Scotland, in the Year
1745.|Painted by Willm. Hogarth & Publish'd Decbr
31st. 1750. According to Act of Parliament|Engrav'd
by Luke Sullivan|Retouched and Improved by Wm.*

Hogarth, republish'd June 12th. 1761|To His
MAIESTY *the* KING *of* PRUSSIA, *an*
Encourager of ARTS *and* SCIENCES!'
Transferred from the reference collection 1973

PROVENANCE
Unknown

LITERATURE
Paulson 1970, I, pp.277-80, no.237, II, pl.277

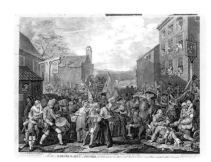

110

After the painting of 1749-50 in the Foundling Hospital. Hogarth offered two rates of subscription to the print in 1750, 7s 6d and 10s 6d. The higher rate included a ticket for the lottery of the original painting. In less than two months Hogarth sold 1,843 out of the 2,000 tickets, and on closing the subscription gave the remaining tickets to the Foundling Hospital. The winning number was among the latter. The engraving by Hogarth's assistant Sullivan was delivered to subscribers in December that year. This is, according to Paulson, the eighth state of the print, reissued, with some retouching by Hogarth himself, just over a decade after the first printing.

The scene is set at the Tottenham Court Turnpike north of London, where the English Guards gathered before marching to Finchley to guard the northern approaches to the capital against expected Scottish invaders. Their chaotic disarray before departure is contrasted with the orderly formations of troops in the background, ready to march.

WILLIAM HOGARTH

111 **Gin Lane** 1751

T 01799
Etching and engraving 357×305 $(14\frac{1}{16} \times 12)$
on paper 621×470 $(24\frac{7}{16} \times 18\frac{1}{2})$; plate-mark
387×326 $(15\frac{1}{4} \times 12\frac{13}{16})$
Writing-engraving 'GIN LANE|*Design'd by
W. Hogarth|Publish'd according to Act of Parliamt.
Feb.1.1751.*' and a twelve-line verse caption
Transferred from the reference collection 1973

PROVENANCE
Unknown

LITERATURE
Oppé 1948, p.48; Paulson 1970, I, pp.209-11, II, pls.199, 200

111

Hogarth's illustration of the evils of gin-drinking was published as a pair with 'Beer Street', as part of a campaign against the uncontrolled production and sale of cheap gin. It culminated in the Gin Act of 1751, through which the number of gin shops was greatly reduced. The original copperplates for both prints are now in the Metropolitan Museum, New York, and the drawings in the Pierpont Morgan Library (Oppé 1948, pl.74). Another drawing for 'Gin Lane', dubiously attributed to Hogarth, is in the Huntington Art Gallery, Huth Collection. No.111 is, according to Paulson, the fourth state of the engraving.

112 **Paul before Felix** 1752–62

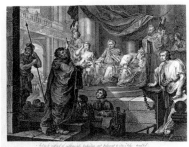

112

T 01805
Etching and engraving 384 × 508 ($15\frac{1}{8}$ × 20)
on paper 467 × 619 ($18\frac{3}{8}$ × $24\frac{3}{8}$); plate-mark
428 × 523 ($16\frac{7}{8}$ × $20\frac{5}{8}$)
Writing-engraving '*And as he reasoned of
righteousness, temperance, and Judgment to come,
Felix trembled.|Engraved by W.^m Hogarth from his
Original Painting in Lincoln's Inn Hall, &
publish'd as the Act directs, Feb. 5. 1752.|Plate 2*'
Transferred from the reference collection 1973

PROVENANCE
Unknown

LITERATURE
Oppé 1948, p.46; Paulson 1970, I, pp.217–18,
no.192, II, pls.207, 280; C. Whitfield, 'William
Hogarth's "Paul before Felix" at Lincoln's
Inn', *Burlington Magazine*, CXII, 1971,
pp.210–14

Hogarth's original painting for this was executed in 1748 for Lincoln's Inn, where it
still hangs. His assistant Luke Sullivan was first called upon to make an engraving
after it, based on a drawing by Hogarth (in reverse to the painting) now in a private
Scottish collection (Whitfield 1971, fig.54). Hogarth introduced in it several
changes to the composition, and then set the resulting print aside as unsatisfactory.
It was later issued with the same publication date as Hogarth's own engraving
here. This latter is much closer to the painting as it now appears after recent
restoration: in the nineteenth century Sullivan's engraving had been used as the
basis for some extensive overpainting of the work.

'Paul before Felix' was published as a companion to 'Moses brought to
Pharaoh's Daughter' (no.113). This, the fourth state of the print, was issued some
time after 1762. Hogarth's drawing for it is in the Pierpont Morgan Library, New
York (Whitfield 1971, fig.53).

WILLIAM HOGARTH and LUKE SULLIVAN 1705–1771

113 **Moses Brought to Pharaoh's Daughter** 1752–62

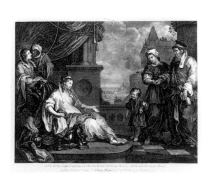

113

T 01798
Etching and engraving 390 × 505 ($15\frac{3}{8}$ × $19\frac{7}{8}$)
on paper 465 × 619 ($18\frac{5}{16}$ × $24\frac{3}{8}$); plate-mark
426 × 526 ($16\frac{3}{4}$ × $20\frac{11}{16}$)
Writing-engraving '*And the child grew & she
brought him unto Pharaoh's daughter & he became
her son. And she called his name Moses.|From the
Original Painting in The* Foundling Hospital
*Engrav'd by Will.^m Hogarth & Luke Sullivan.|
Published as the Act directs Feb.^y 5 1752*'
Transferred from the reference collection 1973

PROVENANCE
Unknown

LITERATURE
Paulson 1970, I, pp.218–19, no.193, II, pl.208

Engraved after the painting Hogarth presented to the Foundling Hospital in 1747,
where it still hangs. It was first published in 1752 as a companion to 'Paul before
Felix' (no.112). Both prints were re-issued in 1759 with the addition of some
disparaging remarks about the paintings from Joseph Warton's 'Essay on the
Genius and Writings of Pope', published in 1756, engraved at the bottom. They
were issued again with the remarks erased after Warton had offered an apology in
the second edition of his 'Essay' in 1762. Both this print and no.112 are from this
last issue (fourth state, according to Paulson), after the lines relating to Warton had
been removed.

114-15 **An Election** 1755-8

T 01796-7
Two plates from a series of four, etching and
engraving, various sizes
Transferred from the reference collection 1973

PROVENANCE
Unknown

Hogarth's four 'Election' pictures, now in Sir John Soane's Museum, were begun
around 1754 and completed in 1755 and partly took as their theme the Oxfordshire
election of that year. The corruption of the proceedings, the power of the mob and
the ultimate absurdity of the election (a Whig parliament immediately overruling
the Tory victory) were among Hogarth's concerns in the series. The print based on
the first of the pictures was issued in February 1755, but the remaining three were
not issued until early in 1758, despite the dates given in their publication lines. In a
newspaper announcement of February 1757 Hogarth attributes the delay to 'the
Difficulties he has met with to procure able Hands to engrave the Plates'. His own
difficulty with the first plate 'An Election Entertainment' had persuaded him to
look elsewhere for the engraving of the others: to Grignion for the second (no.114)
and to collaboration with F.M. de la Cave and Aviline for the third 'The Polling',
and fourth (no.115) respectively.

CHARLES GRIGNION 1717–1810 after WILLIAM HOGARTH

114 **Plate 2: Canvassing for Votes** 1758

114

T 01796
Etching and engraving 405 × 537 ($15\frac{15}{16} \times 21\frac{1}{8}$)
on paper 470 × 621 ($18\frac{1}{2} \times 24\frac{7}{16}$); plate-mark
441 × 557 ($17\frac{3}{8} \times 21\frac{7}{8}$)
Writing-engraving 'CANVASSING *for*
VOTES. *Plate* II|*Painted by W. Hogarth,*
Engrav'd by C. Grignion|*Published 20th Febry 1757.*
As the Act directs.|*To His Excellency Sr. Charles*

Hanbury Williams Embassador to the Court of
RUSSIA. *This Plate is most humbly Inscrib'd By*
his most Obedient humble Servant.|*Will.m Hogarth.*'

LITERATURE
Paulson 1970, I, pp.226–35, no.199, II, pls.218,
219

The second plate (of which this is the sixth state) centres on a farmer who is being offered bribes by both political parties.

WILLIAM HOGARTH and FRANÇOIS ANTOINE AVILINE 1727–1780

115 **Plate 4: Chairing the Members** 1758

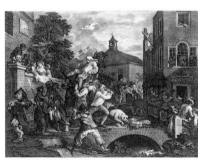

115

T 01797
Etching and engraving 403 × 540 ($15\frac{7}{8} \times 21\frac{1}{4}$)
on paper 444 × 619 ($17\frac{1}{2} \times 24\frac{3}{8}$); plate-mark
443 × 552 ($17\frac{7}{16} \times 21\frac{3}{4}$)
Writing-engraving 'CHAIRING THE
MEMBERS. *Plate 4*|*Engrav'd by W. Hogarth &*
F. Aviline.|*Published 1st Janry 1758 as the Act*
directs|*To the Honble George Hay, one of the Lords*

Commissioners of the ADMIRALTY, *&c. &c.*
This Plate is most humbly Inscrib'd By his most
Obedient humble Servant|*Will.m Hogarth.*'

LITERATURE
Paulson 1970, I, pp.234–5, no.201, II, pls.253,
221

The last print of the series (third state) shows the successful but unworthy candidates borne by their constituents through the streets, while strife and intrigue continue around them.

WILLIAM HOGARTH

116 Sigismunda Mourning over the Heart of Giuscardo 1759

T 01046
Oil on canvas 1004 × 1265 (39½ × 49¾)
Inscribed 'W. Hogarth pinx'|1759' b.r.
Bequeathed by J.H. Anderdon to the National
Gallery 1879; transferred to the Tate Gallery
1919

PROVENANCE
Painted 1758–9 for Sir Richard (later Earl)
Grosvenor, who withdrew from the
commission; remained in the painter's studio
until his death; Mrs Hogarth; on her death in
1789 passed to her cousin Mary Lewis, sold
Greenwood's 24 April 1790 (52) £58 16s bt
Alderman John Boydell, offered as one of the
prizes in a Lottery for Boydell's Shakespeare
Gallery drawn 28 January 1805; . . .;
'Phillips', offered Christie's 27–8 June 1807
(84); . . .; according to Nichols & Steevens sold
Christie's July 1807 for 400 gns, but no such
sale can be traced; according to Nichols &
Steevens with Messrs Boydell in 1808 and
1810; . . .; J.H. Anderdon by 1814 when lent
to BI

EXHIBITED
Langford's Auction Rooms 16–18 February
1761; SA 1761 (43, withdrawn after ten days);
Boydell's Shakespeare Gallery 1790(S); BI
1814 (162); BI 1856 (118); *Art Treasures*,
Manchester 1857 (21); RA Winter 1870 (43);
Tate Gallery 1951 (70); Tate Gallery 1971
(211, repr. p.86)

LITERATURE
Nichols 1781, pp.42–7, 1782, pp.60–8, 1785,
pp.69–78; Ireland 1798, pp.195–217; Nichols
& Steevens, I, 1808, pp.189–90, 311–36, engr.
(by Basire) facing p.321, II, 1810, p.iv, III,
1817, pp.174, 197; Nichols 1833, pp.52–8,
278–84, 362–3; [Edward Draper], 'Memorials
of Hogarth', *Pictorial World*, 26 September
1874; Dobson 1902, pp.114–16, 174, repr.
facing p.116, 1907, pp.121, 125–7, 134, 164,
169, 205, 273, 275, repr. facing p.124: Whitley
1928, I, pp.175–7; *Walpole's Correspondence*, IX,
p.365; F. Saxl & R. Wittkower, *British Art and
the Mediterranean*, Oxford 1948, no.61, fig.1;
Beckett 1949, p.73, pl.196; Burke 1955,
pp.219–21; Antal 1962, pp.156–8, pl.131c;
Baldini & Mandel 1967, p.114, no.194, repr.;
Paulson 1970, I, pp.284–5, no.245, II, pl.289;
Paulson 1971, II, pp.179, 235, 243, 262, 266,
270–8, 280, 282–3, 286, 291, 295–6, 316, 319,
323–5, 331, 334, 348–9, 376–7, 388, 418–19,
436 n.8, 452 n.84, 460–1 n.39, 470 nn.27, 30,
pl.275; Webster 1979, pp.174–6, 188, no.183,
repr., repr. in col. p.172; Bindman 1981,
pp.200, 203, fig.161

ENGRAVED
1. Etching, unfinished, by James Basire, pub.
5 May 1790
2. Etching (said to be of original sketch) by
Robert Dunkarton, pub. T.B. Freeman & Co.
1 February 1793
3. Stipple engraving by Benjamin Smith,
published J. & J. Boydell 4 June 1795

The subject is taken from Boccaccio's *Decameron*, as retold in Dryden's *Fables*, published in 1699. It shows Sigismunda, daughter of prince Tancred, grieving for Guiscardo, one of her father's attendants, whom she had secretly married. Enraged by the unequal match, Tancred had Guiscardo killed, and sent Sigismunda his heart in a golden goblet. As a result, Sigismunda takes poison and dies in front of her remorse-racked father.

The subject appealed to Hogarth as being a particularly suitable one with which to demonstrate the superiority of the visual arts over the spoken word. The high point of the poem is Dryden's elaborate description of Sigismunda's silent grief: 'Mute, solemn sorrow, free from female noise,|Such as the majesty of grief destroys . . .'. It is echoed by a quotation from Horace, written by Hogarth into the margin of his autobiographical notes dealing with this painting (BL Add. MS 27991, folio 38), to the effect that the passions are more readily moved by what we see than by what we hear. He writes further that 'my whole aim was to fetch Tear(s) from the Spectator . . .', as effectively as tragedians do on the stage. Above all, the painting was to prove to the world that he could rival the acknowledged Old Masters in the field of history painting. In the event, the attempt proved a bitter failure and caused Hogarth great unhappiness.

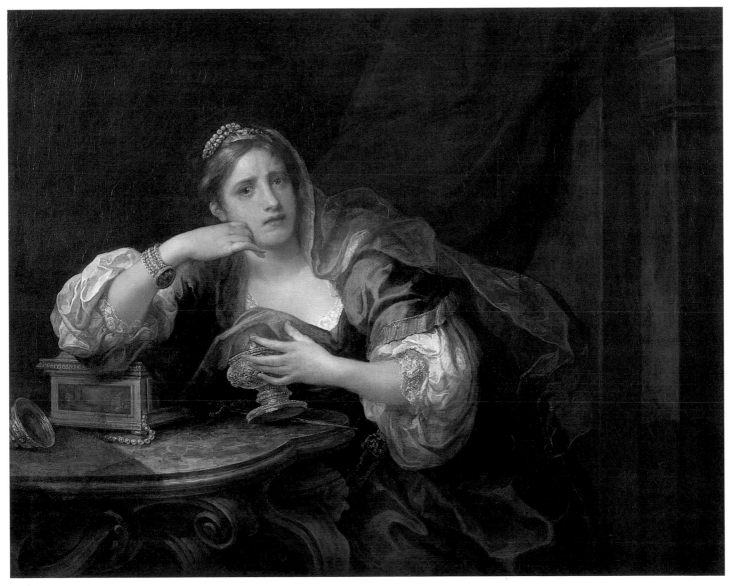

116

The painting was under way by the end of 1758, when Hogarth wrote on 23 November to his friend William Huggins, complaining of feeling his age – he had just turned sixty – and of the fact that he had

> hardly been able to muster up spirits enough to go on with the two Pictures I have now in hand because they require so much exertion, if I would succeed in any tolerable degree in them. notwithstanding the terms they are done upon are the most agreeable that can be wish'd for, I am desir'd to choose my subject, am allow'd my own time, and what mony I shall think proper to ask: one is for my Lord Charlemont the other for Sr. Richard Grosvenor, one should not conceal the the [sic] names of such as behave so nobly . . . (MS. in the collection of Mrs Donald F. Hyde; see Paulson 1971, II, pp.264-5).

Lord Charlemont's painting was the genre piece 'The Lady's Last Stake' (Albright-Knox Art Gallery, Buffalo, New York), for which Hogarth was to receive in due course £100 and a very flattering note from Charlemont. The young Sir Richard Grosvenor (1731–1802, raised to the peerage in 1761) probably saw the painting in Hogarth's studio and offered him the same generously open terms for another painting, possibly expecting to receive something similar. In his account of the affair, written at the end of his life in 1764 and enlarged upon in his subscription book in which he kept all the letters relating to these commissions as contrasting examples of good and bad patronage (BL Add.MS 22394 folios 32-7), Hogarth maintains that he had been prevailed upon '. . . to undertake Painting this difficult subject, which being seen and fully approved by his Lord[hp] whilst in hand, was after much time and utmost effort finished . . .'.

Hogarth's choice of subject and asking price of £400 were prompted by his irritation at the unprecedented price of £404 5s paid for a feeble seventeenth-century 'Sigismunda mourning over the heart of Guiscardo' (fig.41), then attributed to Correggio, at the sale of Sir Luke Schaub's collection (Langford's 26 April 1758, lot 29, bt Sir Thomas Sebright; Duke of Newcastle collection; offered Christie's 31 March 1939, bt in). Hogarth rightly doubted the attribution, and was outraged by the sums collectors were prepared to pay for second-rate works merely because, he thought, they were old. Moreover, he also knew that Sir Richard had spent in excess of £1,000 at the sale (*Gentleman's Magazine*, XXVIII, 1758, p.225). On 13 June 1759 he wrote to Sir Richard to say that the painting was finished, naming his price, but reiterating their agreement that 'you would use no ceremony of refusing the Picture, when done, if you should not be thoroughly satisfied with it'. Sir Richard's coolly polite reply made it clear that he found the painting distasteful, and that he was far from eager to take the painting off Hogarth's hands. Deeply wounded, Hogarth released him from the agreement, and the painting remained in his studio.

fig. 41 Francesco Furini (1604–1646): 'Sigismunda' c.1640. Trustees of the Estate of the 7th Duke of Newcastle, deceased; on loan to Birmingham City Art Gallery.

Hogarth's high estimation of the work was partly conditioned by the immense labour he put into it in his intense anxiety to succeed. In some verses on the Sigismunda affair, composed by him with the help of his friend Paul Whitehead in August 1759, he notes that he worked on it 'at least two hundred days' (original MS. in New York Public Library, Berg Collection, published in Paulson 1971, pp.277-8), and asserts that ignorant connoisseurs will recognise its true worth only when it had become blackened with age. In keeping with this, he chose the subject of 'Time Smoking a Picture' as his design for the subscription ticket during his first unsuccessful attempt to get the painting engraved in 1761. He arranged for the painting to go on display at Langford's Rooms on 17–18 February (advertisements in *Lloyd's Evening Post*, *Public Advertiser*, and others, on 16 February 1761) in order to collect subscriptions for an engraving. Subscription began on 2 March, but was stopped on 26 March, and the fifty subscriptions collected were returned. In June 1764 he instructed Edward Edwards to make a drawing of the painting and sent it to his friend Dr George Hay to look at, explaining that James Basire was to undertake an engraving from it, while he would do the head himself (MS letter to

fig. 42 Etching by James Basire,
1794, after William Hogarth, 1759.
Reproduced by courtesy of the
Trustees of the British Museum.

George Hay, dated 12 June 1764, Historical Society of Pennsylvania, published in Paulson 1971, II, p.418). In the event this remained unfinished, and Basire published it as such in 1790 (fig.42, Paulson 1965, pl.289, and J. Burke & C. Caldwell, *Hogarth Engravings*, 1968, pls.256A and (detail) 256B). It is interesting to note that the lower part of the composition differs considerably from the painting, showing more of the lower part of the figure and differences in the carving of the table. During relining in the past the canvas was cut on all sides and it is impossible to say at this stage whether Hogarth cut and repainted the lower part at some later date, or whether the design, which on the whole looks better balanced in the print, was adapted for the engraving only.

In May 1761 Hogarth included the painting in the SA exhibition at Spring Gardens. According to a later source (Letter by 'M.M.' in *St James's Chronicle*, 8–10 April 1790), he is said to have posted a man near the picture to make notes of any criticisms. Apparently there were many, and he particularly noted one that complained that the folds of Sigismunda's white sleeve were too regular. There is evidence that this area was repainted, and it is known that Hogarth withdrew the painting from the exhibition after ten days, replacing it with one from the 'Election' series. Horace Walpole, who pilloried the painting in his *Anecdotes of Painting* and condemned it in immoderate terms, in a letter to George Montagu of 5 May 1761, as a portrait of a 'maudlin whore', also said her fingers were 'bloody with the heart as if she had just bought a sheep's pluck in St. James's market'. If accurate, this is another detail later altered by Hogarth, and pentimenti around her fingertips seem to bear this out. As for the heart, according to J. Nichols it was painted from an injected one provided for Hogarth by his surgeon friend Caesar Hawkins.

As this is one of Hogarth's most laboured works, it is not surprising to find other evidence of extensive over-painting and alteration. The green curtain in the background covers an embroidered swag and tassel, and possibly a window. The table was originally a different shape, and a white napkin or paper drooping over its edge has been painted out. There are also changes to Sigismunda's veil and neck, and the crinkly paint surface of her face suggests several layers of repainting here also.

A curious detail which is absent in Basire's engraving is the lost-profile head of a man in a cap in the carved table-leg facing Sigismunda. It has a certain resemblance to Hogarth himself as seen in his late self-portrait of *c*.1757 (National Portrait Gallery), but looking more elderly and hunched. While there is no documentary proof that this is indeed the case, a 'signature' of this nature in a painting of such paramount importance to him is not inconceivable, particularly if the model for Sigismunda was his wife Jane, as suggested by John Wilkes in his attack on the painting in his *North Briton*, no.17 (published 25 September 1762), where he described it as a 'portrait of Mrs Hogarth in an agony of passion'. In her reminiscences Mrs Chappel of Westminster, who had been a maid of the Hogarths (see no.109), also claimed that Sigismunda had been modelled on Jane Hogarth herself, as the artist remembered her weeping over the death of her own mother, Lady Thornhill, who had died in 1757 (Draper 1874). A similar statement is made by John Ireland in 1791 (I, p.XCIV). Such a juxtaposition of the spouses would have been particularly poignant in view of the parallels between the subject of the painting and Jane's own secret marriage to her father's assistant, which reputedly incurred for them, initially at least, Sir James's unmitigated disapproval.

Hogarth apparently instructed his wife not to sell the painting for less than £500 in her lifetime. The fact that Mrs Hogarth refused to acknowledge Walpole's complimentary volume of his *Anecdotes*, published in 1780, in which he warmly praises Hogarth's genius but roundly condemns 'Sigismunda', is also an indication of her continued sensitivity on the subject. The painting received more official criticism in December 1790, when Reynolds obliquely referred to it in his 14th Discourse as an imprudent and presumptuous attempt by Hogarth at 'the great historical style, for which previous habits had by no means prepared him'.

The drawing for the engraver by Edward Edwards already mentioned may have been included in the 1790 sale of Mrs Hogarth's collection, in the section under 'Loose Prints and Drawings', among 'the first sketches of Sigismunda', sold, as part of lot 28, to an unnamed buyer for £1 2s. This was probably Samuel Ireland, because his sale at Christie's, 6 May 1797, included, as lot 138, an 'Original Sketch in Oil for Sigismunda, and a Drawing by Edwards, R.A.. touched upon by Hogarth for the use of the Engraver – 5.5.0.'. Their present whereabouts are not known. The first oil sketch is known only from Dunkarton's engraving of 1793, and shows an upright instead of the final horizontal composition.

WILLIAM BLAKE 1757-1827 after William Hogarth

117 **Beggar's Opera, Act III** 1790

T 01801
Etching and engraving 402 × 539
($15\frac{13}{16}$ × $21\frac{3}{16}$) on paper 470 × 619 ($18\frac{1}{2}$ × $24\frac{3}{8}$);
plate-mark 457 × 502 ($17\frac{15}{16}$ × $22\frac{7}{8}$)
Writing-engraving '*Painted by W.ᵐ Hogarth|
Engraved by W.ᵐ Blake*|BEGGAR'S OPERA,
ACT III|"*When my hero in Court appears, &c.*"|
*From the Original Picture, in the Collection of his
Grace the Duke of Leeds. Publish'd July 1ˢᵗ 1790, by
J. & J. Boydell, Cheapside, & at the Shakespeare
Gallery Pall Mall London.*' and details of the size
of picture
Presented by Sir Geoffrey Keynes 1933;
transferred from the reference collection 1973

PROVENANCE
...; Sir Geoffrey Keynes by 1933

LITERATURE
Ireland, II, 1793, facing p.322 (key to persons
represented); Dobson 1907, p.272; Geoffrey
Keynes, *Engravings by William Blake: The
Separate Plates*, 1956, pp.73-4, no.XXXII, 4th
state; W.S. Lewis & P. Hofer, *The Beggar's
Opera by Hogarth and Blake*, New Haven 1965,
no.IX, repr.; Paulson 1970, I, p.71, 1971, I,
p.527, n.23

The version engraved here by Blake was acquired by the 4th Duke of Leeds at the
John Rich sale in 1762 (see no.87 for Hogarth's final painted version of this scene).
It remained with the Dukes of Leeds until 1961 and is now in the collection of the
Yale Center for British Art, New Haven. The original copperplate of Blake's print
was in the collection of Mr Philip Hofer, Cambridge, Massachusetts. The
engraving was published by the Boydells for the Hogarth folio of 1790, together
with a separate key (repr. Lewis & Hofer 1965, p.14) identifying various members
of the audience. In the Boydell *Catalogue of Plates*, 1803, this print is described as a
companion to Dodd's engraving of 'The Indian Emperor' (no.120).

117

THOMAS COOK ?1744-1818 after William Hogarth

118 **Dr Benjamin Hoadly, Bishop of Winchester** *c*.1800

T 03827
Engraving 321 × 264 (12⅝ × 10⅜) on paper
573 × 442 (22 9/16 × 17⅜); plate-mark 424 × 292
(16 11/16 × 11½)
Writing-engraving '*Painted by W^m. Hogarth|*
Engraved by T. Cook.|The Right Reverend Father in
*God|*D^R BENJAMIN HOADLY, LORD
BISHOP OF WINCHESTER|*Prelate of the*
Most Noble Order of the Garter|London: Published
by G. & L. Robinson, Paternoster Row, & F. Cook,

N^o. 38, Tavistock Street, Covent Garden' and the
Bishop's seal within the Garter ribbon in the
centre
Transferred from the reference collection 1984

PROVENANCE
Unknown

LITERATURE
As for no.99

118

Hogarth's original painting of the Bishop is no.99 above. An engraving after it
(facing the same way as the painting) by Bernard Baron was published in July 1743
(Paulson 1970, no.226, pl.266) and led to the erroneous assumption that this was
also the date of the original, which, however, is signed and dated 1741. Cook's
engraving appears to be closer to Baron's print than to the original painting and
was probably copied from the former. Although it is undated, it probably pre-dates
Cook's much simplified, reduced and reversed version of it printed in 1809 by
Longman, Hurst & Rees as an illustration to Nichols & Steevens 1810, facing
p.164.

119 **Bambridge on Trial for Murder by a Committee of the House of Commons** 1803

T 01795
Engraving 396 × 526 (15 9/16 × 20 11/16) on paper
467 × 619 (18⅜ × 24⅜); plate-mark 444 × 559
(17½ × 22)
Writing-engraving 'BAMBRIDGE ON
TRIAL FOR MURDER BY A
COMMITTEE OF THE HOUSE OF
COMMONS|*Engraved by T Cook from an*
Original Painting by W^m. Hogarth in the possession

of M^r. Ray. Published June 1^st 1803, by G. & J.
Robinson, Paternoster Row, London.'
Transferred from the reference collection 1973

PROVENANCE
Unknown

LITERATURE
Kerslake 1977, I, pp.330–8

119

The original of this engraving, which is also reproduced in Nichols & Steevens, III,
1817, facing p.90, as being in the collection of Robert Ray, is now lost, and may
have been a copy after Hogarth. He painted several versions of the scene, but the
only ones now known are an oil sketch in the Fitzwilliam Museum, Cambridge,
and a finished painting in the National Portrait Gallery (no.926).

Complaints about the treatment of inmates of the Fleet Prison led to the
appointment in 1728-9 of a Committee of the House of Commons to inquire into
the state of gaols in England. The Committee examined the Warden of the Fleet
Prison, Thomas Bambridge, several times in early 1728, and in May that year he
was tried at the Old Bailey for the murder of one of the prisoners, but was acquitted.
The title of Cook's print is inaccurate: Bambridge is shown being examined in the
Fleet Prison, not tried at the Old Bailey.

ROBERT DODD ?1748-1816 after William Hogarth

120 **The Indian Emperor** 1792

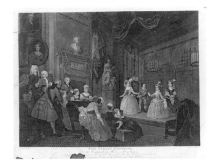

120

T 01804
Engraving 406 × 540 (16 × 21¼) on paper,
466 × 603 (18⅜ × 23¾); cut to plate-mark
Writing-engraving (with some losses through
damage to the paper) '*Painted by
Wᵐ Hogarth|Engrav'd by Robᵗ Dodd|THE
INDIAN EMPEROR,|Or the Conquest of
Mexico; Act 4. Scene 4.|As perfor [...]r 1731, at Mᵗ.
Conduit's, Master of the Mint, before the Duke of
Cumberland &c|[...] the original Picture in the
Collection of Lord Holland.|Publish'd Janʸ. 1 1792,*

*by J. & J. Boydell, Cheapside, & at the
Shakespeare Gallery Pall Mall.'*
Transferred from the reference collection 1973

PROVENANCE
Unknown

LITERATURE
Ireland,II, 1793, facing p.331 (key to sitters);
Dobson 1907, pp.272-3; Paulson 1971, I,
pp.301-4, 540 n.2

The scene, the original painting for which is still in the collection of Lord Holland's descendants, shows a private children's performance of Dryden's *The Indian Emperor or The Conquest of Mexico*, produced by John Conduitt, Master of the Mint, at his town house in Hanover Square, and repeated at the Duke of Cumberland's request at St James's Palace before the Royal Family on 27 April 1732. Conduitt commissioned Hogarth to commemorate the occasion with a conversation piece 'of the young People of Quality that acted at his house'. Hence Boydell's much later key to the sitters, which identifies some of the grown-ups whose heads are averted, is unlikely to be accurate. In Boydell's *Catalogue of Plates*, 1803, Dodd's print is described as a companion to Blake's engraving of 'The Beggar's Opera' (no.117).

JOSEPH HAYNES 1760-1829 after William Hogarth

121 **The Stay-Maker** 1782

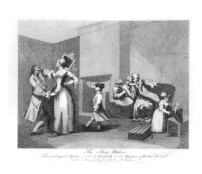

121

T 03828
Etching 265.× 352 (10⁷⁄₁₆ × 13⅞) on paper
352 × 403 (14⅞ × 15⅞); plate-mark 318 × 384
(12½ × 15⅛) cut at top margin
Writing-engraving '*The Stay-Maker|From an
Original Sketch in Oil by Hogarth in the Possession
of Mᵗ. Samᵗ. Ireland|Etch'd by Jos. Haynes Pupil to
the late Mᵗ. Mortimer|Publish'd as the Act directs
Febʸ. 1 1782 at Nᵒ. 3 Clements Inn'*
Transferred from the reference collection 1984

PROVENANCE
Unknown

LITERATURE
Nichols 1782, p.324; Dobson 1907, p.267

This etching is the earliest record of the original oil sketch now in the Tate Gallery (no.104), which has come to be known by the title of this print, although it probably belongs to 'The Happy Marriage' series. The print is also interesting in that it records Joseph Haynes as a pupil of the painter John Hamilton Mortimer (1740-1779).

THOMAS ROWLANDSON 1756 or 7-1827 and JOHN OGBOURNE 1755-1837 after William Hogarth

122 **Satan, Sin and Death** 1792

T 01680
Etching and engraving 273 × 348 ($10\frac{3}{4}$ × $13\frac{11}{16}$) on paper 314 × 373 ($12\frac{3}{8}$ × $14\frac{11}{16}$); cut to plate-mark
Writing-engraving '*W. Hogarth pinx.*|
T. Rowlandson fe. Aq.For.|J. Ogbourne sculp.|SATAN, SIN AND DEATH.|*From Milton's Paradise Lost, Book the 2ᵈ| The original Picture by Hogarth is in the Possession of Mʳˢ Garrick| This from a Painting in Chiaro-Scuro by R. Livesay.|London, Published June 1, 1792* by J. Thane *Rupert Street Hay Market.*'
Purchased (Gytha Trust) 1972

PROVENANCE
...; Christopher Drake Ltd, from whom bt by the Tate Gallery

LITERATURE
D. Bindman, 'Hogarth's "Satan, Sin and Death" and its Influence', *Burlington Magazine*, CXII, 1970, pp.153-8, fig.33

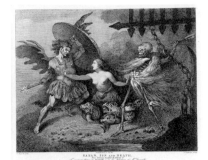

122

The original painting for this is in the Tate Gallery (no.95). The whereabouts of Livesay's copy is not known. Livesay was Mrs Hogarth's lodger in Leicester Square 1777-85 and executed for her several facsimiles after Hogarth's drawings.

UNIDENTIFIED ENGRAVER Nineteenth Century, after William Hogarth

123 **Henry the Eighth and Anne Boleyn**

T 01803
Engraving 438 × 357 ($17\frac{1}{4}$ × $14\frac{1}{16}$) on paper 619 × 467 ($24\frac{3}{8}$ × $18\frac{3}{8}$); plate-mark 482 × 384 ($18\frac{15}{16}$ × $15\frac{1}{8}$)
Writing-engraving '*Design'd by Wᵐ. Hogarth|King Henry the Eighth & Anna Bullen.*'
Transferred from the reference collection 1973

PROVENANCE
Unknown

LITERATURE
Paulson 1970, I, p.137, no.116

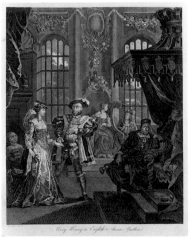

123

This is an unreversed copy, not listed by Paulson, after Hogarth's print of *c.*1728-9 of his decorative design for the Prince's Pavilion at Vauxhall Gardens. The character of the writing-engraving suggests that it is an early nineteenth-century copy.

THOMAS HUDSON 1701-1779

Portrait painter, born in Devon to a family of prosperous tradesmen. Pupil and son-in-law of Jonathan Richardson Snr. Adhered to a formal and conservative style heavily dependent on good studio organisation and drapery painters such as the Van Aken brothers. Reynolds, Wright of Derby, Mortimer and others were apprenticed to him, and he was the most prolific portraitist of the 1740s and 1750s, until overshadowed by Reynolds in the late 1750s. Visited France and the Netherlands in 1748 and Italy in 1752. Exhibited SA 1761-6, but went into prosperous retirement sometime around 1765. Amassed a notable collection of Old Master drawings and paintings. Died at Twickenham, 26 January 1779.

LITERATURE
Ellen G. Miles, *Thomas Hudson (1701-1779)*
Portraitist to the British Establishment, PhD thesis,
Yale 1976, pub. University Microfilms
International, Ann Arbor, on demand

EXHIBITIONS
Ellen G. Miles and Jacob Simon, *Thomas Hudson*, 1979, Kenwood

124 **Samuel Scott** *c.*1731-3

N 01224
Oil on canvas 1220 × 978 (48 × 38½)
Purchased by the National Gallery 1886;
transferred to the Tate Gallery 1913

PROVENANCE
...; R.T. Simpson, by whom sold to the
National Gallery

EXHIBITED
Samuel Scott Bicentenary, Guildhall Art Gallery
1972 (94); Kenwood 1979 (4, repr.)

LITERATURE
Evelyn Davies, 'The Life and Work of Thomas Hudson', MA thesis, Courtauld Institute, 1938, no.94; J.D. Prown, *John Singleton Copley*, 1966, I, p.61, fig.221; Miles 1976, no.165; Kerslake 1977, I, p.244, II, fig.714

This informal portrait of Samuel Scott (1702-72), painter of marine and later of Thames-side London views, can be dated to around 1731-3 from a mezzotint of it by John Faber (see Chaloner Smith 1883, no.319). It is thus one of Hudson's earliest known portraits, as well as one of his most relaxed, showing his almost exactly coeval fellow-artist leaning on the back of a chair, holding a drawing of ships, in a knee-length pose which minimises Scott's well-known shortness of stature.

Hudson and Scott were at this time at the very beginning of their careers, and it

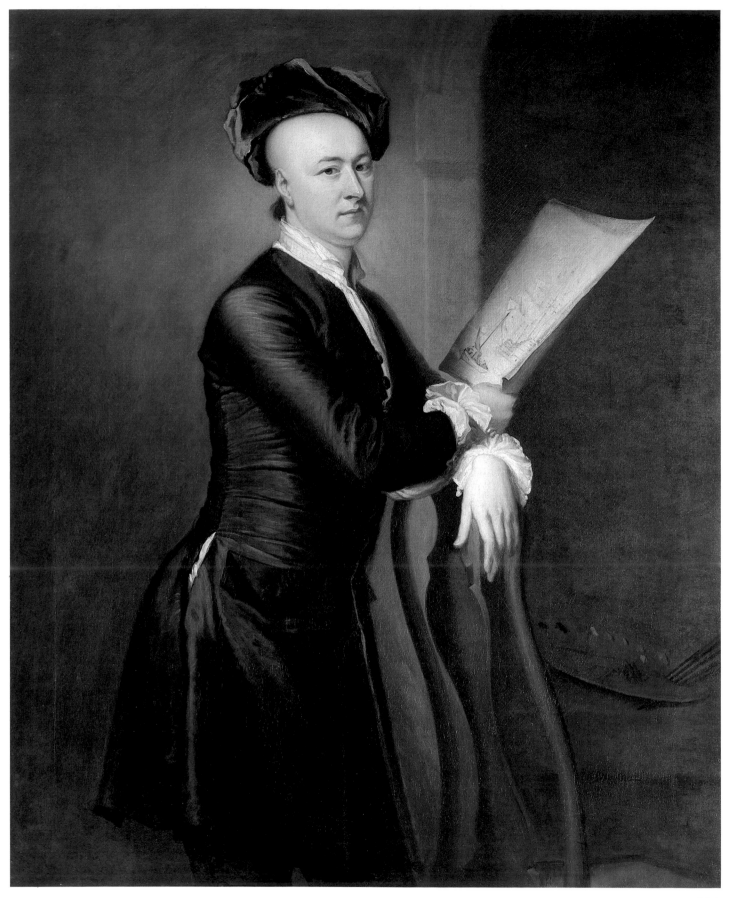

124

has been suggested that the mezzotint may have been intended as a form of advertisement for them both in a concerted effort to build up patronage in their respective branches of painting. It is interesting to note that the accounts of the Courtenay family (who were lifelong patrons of Hudson) at Powderham Castle, Devon, record payments to Hudson for several sea-pieces in 1728 and 1737, and to Scott in 1739 (Miles & Simon 1979, no.4). No marine paintings by Hudson are known, and it is thus difficult to say whether at this early stage he was a rival to Scott, or a middleman for him. The latter would seem more likely, both in view of Hudson's unswerving devotion to portrait painting, and of the fact that in the 1730s he was also willing to occupy himself with other sidelines of the painting profession such as picture cleaning and restoration. In later life both painters crowned their professional success by acquiring villas in Twickenham, where they were near neighbours from 1755 onwards; Hudson's sale of 25 February 1785 shows that he owned at least two sea-pieces by Scott.

The pose of this portrait was adapted from Faber's engraving by J.S. Copley for his portrait of John Amory (Boston Museum of Fine Arts).

125 **Portrait of Mrs Collier** 1744

N 04804
Oil on canvas 737 × 610 (29 × 24) in painted oval
Inscribed 'Ann Collier-Picture Drawn by M.ͬ Hudson 1744.' on stretcher in sepia ink, in a contemporary or near-contemporary hand
Bequeathed by the Misses Mary Metford Badcock and L.M. Badcock of Taunton 1935

PROVENANCE
. . .; the Misses Mary M. Badcock and L.M. Badcock by 1935

LITERATURE
Cecily Radford, 'Mrs. Ann Collier of Topsham', *Devon and Cornwall Notes and Queries*, XXVI, 1954–5, p.88; Miles 1976, p.212

Attached to the back is a wooden plank from the original stretcher, bearing the inscription and two contemporary labels, one inscribed 'Mrs Collyer', and the other '[?of] Topsham-Devon|Born Augt. 29.ᵗʰ 1700.|Married Sept. 2.ⁿᵈ 1739.|Died-Dec.ͬ 31.ˢᵗ 1783.|Maiden name|Anne Nicholls–'. The authenticity of this inscription is partly confirmed by the Quaker registers of Topsham – an important Quaker centre – which, while they do not appear to have a record of the marriage, do record the death of Benjamin Collier at Topsham on 1 December 1758, aged sixty-one, and that of Ann, his relict, at Bridport on 31 December 1783. In her will, dated 9 August 1777, Mrs Collier left £500 in 3% consols for binding out poor children of the parish to some business or trade or to sea 'without respect of party or sect' (information from correspondence with Cecily Radford, 1954, in Gallery files).

The painting is a particularly charming example of Hudson's more intimate portrait style of this period and is typical of his widespread portrait practice in his native county of Devon in the 1740s.

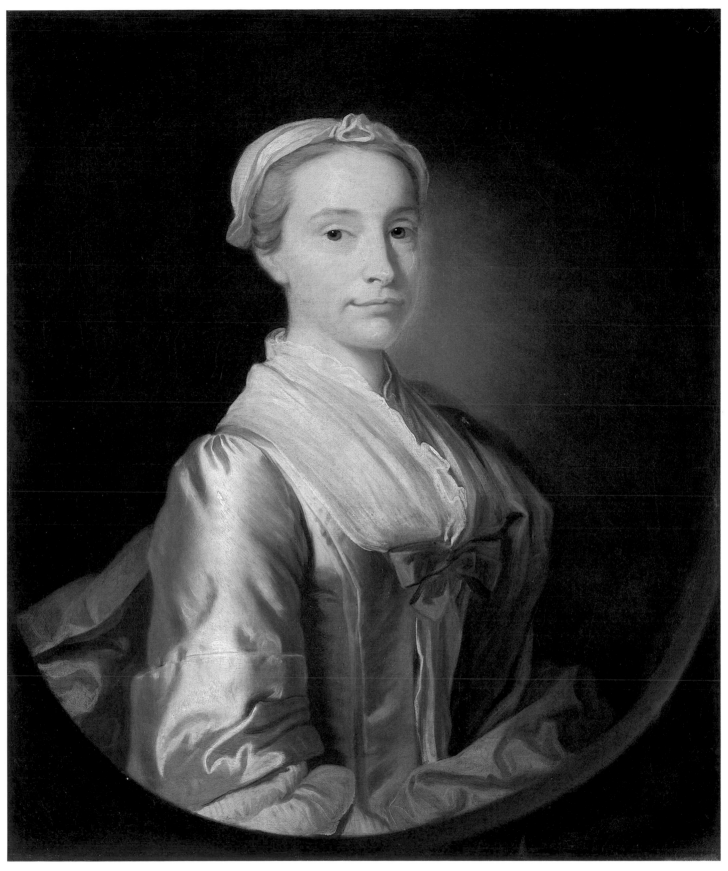

125

126 **Mrs Sarah Ingram** *c.*1750-5

T 00401
Oil on canvas 1270 × 1015 (50 × 40)
Bequeathed by Mrs E.M.E. Commeline to the
National Gallery 1960; transferred to the Tate
Gallery 1971

PROVENANCE
By family descent to the testator

LITERATURE
Miles & Simon 1979, nos.29–31

A label on the back of the frame, presumably written by Colonel Charles Ernest Commeline, whose second wife was the testator, reads: 'Mrs. Sarah Ingram of Bourton-on-the-Water, died abt.1770, 5th Grandmother. C.E. Commeline'. At the time the portrait entered the collection, a cousin of Colonel Commeline, Mr D.A.F. Shute (correspondence in Gallery files), informed the compilers that the portrait had been brought into the family by Colonel Commeline's father's first wife Emily Charlotte Morrison, and that her grandmother was believed to have been an Ingram. 'Bourton-on-the-Water' is probably a mistake for 'Bourton-on-the-Hill', as there are no records of any Morrisons or Ingrams at the former, while the latter is near Longborough, Glos., the Commeline home, where A.C.H. Morrison, the father of Emily Charlotte, was vicar from 1846 to 1865.

The portrait is a good example of Hudson's work at the height of his popularity, when his by now somewhat old-fashioned style was about to be overtaken by the more modern and inventive approach of his former pupil Reynolds. Probably little but the face is by Hudson himself, as the glossy silks bear the stamp of a highly professional drapery painter, the best of whom at this period was Alexander Van Aken (1701–57). Typically, Hudson uses a pose of longstanding currency: it is a variant, in reverse, of one recorded as early as *c.*1747 in the portrait of 'Mrs Champernoune' (Miles & Simon 1979, nos.29–31, repr.). Two drawings of that composition were made by the then chief drapery painter to Hudson, Joseph Van Aken (*c.*1699–1749), presumably to serve as a model for later repetitions within the studio, with only minor alterations to allow for changes in fashion. A later close repetition of Mrs Ingram's pose, with only such minor variations as lie within the scope of a drapery painter, can be found in the portrait of 'Mrs Anne Istead', signed and dated 1756, now in the Vermont University collection, USA (repr. Waterhouse 1981, p.185).

The portrait was previously attributed to Highmore.

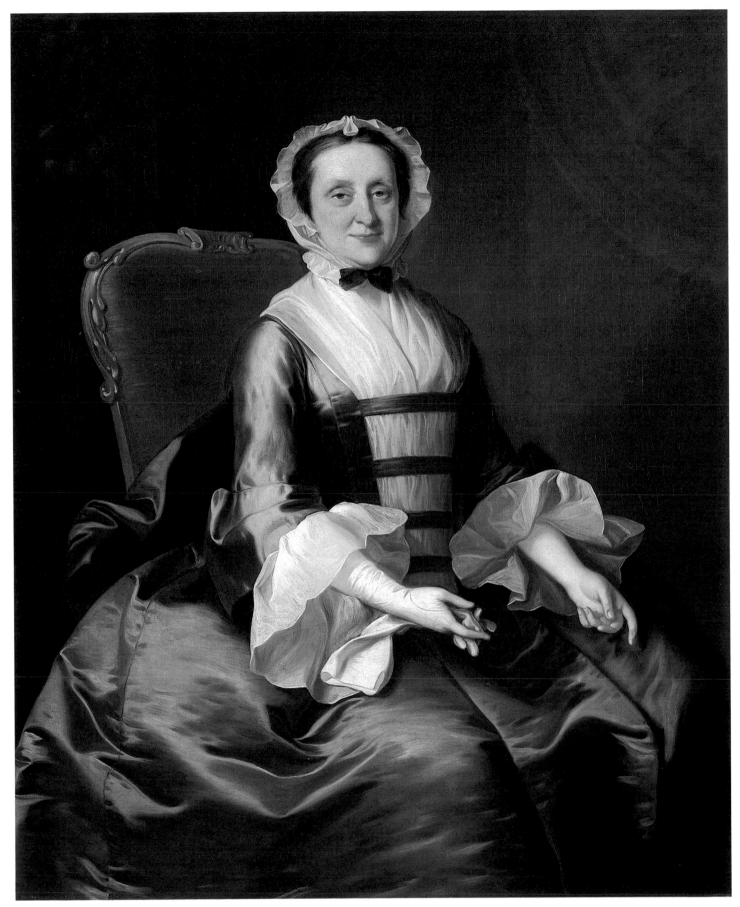

126

GEORGE LAMBERT 1700-1765

Landscape and scenery-painter. Said to have been born in Kent. Pupil of one 'Hassel', but first noticed as an imitator of Wootton's classical landscapes. Established topographical painter by 1730s, and in 1732 painted, in collaboration with Scott, a series of six views of Indian ports for the East India Company. Scenery painter at Lincoln's Inn Theatre in 1720s, and from 1732 at the Covent Garden Theatre. With Rich and Hogarth founder of the Beef Steak Club. Worked in pastels in 1740s. Exhibited SA 1761-4. Died London 30 or 31 January 1765, a few days after being elected first President of the newly incorporated Society of Artists.

EXHIBITIONS
George Lambert 1700-1765, Kenwood 1970

127 **A View of Box Hill, Surrey** 1733

N 05981
Oil on canvas 908 × 1842 (35¾ × 72½). The painting was once folded back at least 12 in (305 mm) on the left to fit a smaller stretcher
Inscribed 'G. Lambert 1733' centre foreground
Purchased (Grant-in-Aid) 1951

PROVENANCE
...; in the Bedford Collection at Woburn Abbey by May 1802; Bedford Sale, Christie's 19 January 1951 (29) bt Agnew for the Tate Gallery

EXHIBITED
Kenwood 1970 (5, repr.); *Landscape in Britain c.1750-1850*, Tate Gallery 1973-4 (29, repr.); *Pittura inglese 1660-1840*, Palazzo Reale, Milan 1975 (45, repr. pl.III in col.)

LITERATURE
J. Hayes, 'British Patronage and Landscape Painting – IV', *Apollo*, CXXXV, 1967, p.256; R. Paulson, 'Hogarth the Painter: The Exhibition at the Tate', *Burlington Magazine*, CXIV, 1972, p.72, fig.9 (detail); Luke Herrmann, *British Landscape Painting of the Eighteenth Century*, 1973, pl.1 (col.); D. Piper (ed.), *The Genius of British Painting*, 1975, p.182, repr.; J. Sunderland, *Painting in Britain 1525-1975*, 1976, p.232, fig.49; J. Barrell, *The Dark Side of the Landscape*, 1980, pp.42-8, repr. p.43; M. Rosenthal, *British Landscape Painting*, 1982, pp.30, 38, fig.22; H. Prince, 'Landscape through Painting', *Geography*, LXIX, no.302, pt.1, 1984, pp.11-12, fig.7

It has now been established that this is a view of Box Hill, Surrey, showing the Mole Gap, and the Mickleham Downs on the left, seen from some point on Ranmore Common. It has also been plausibly suggested that the viewpoint is taken from the former Denbies Carriage Drive, now part of the North Downs Way (letter of 8 September 1984 from Ethel Clear of the Dorking Museum). Denbies was at this date a small farm on the slopes of the North Downs which was bought in 1734 by Jonathan Tyers, manager of Vauxhall Gardens and soon to become a notable patron of British artists. Tyers (1702-67) was intimate with the convivial artistic fraternity of St Martin's Lane to which Hogarth, Hayman and Lambert belonged, and it is possible that this painting of 1733, and its companion in the Yale Center for British Art, New Haven, relate in some way to Tyers's acquisition of Denbies the following year (for the fullest history of Tyers's estate see Brian Allen, 'Jonathan Tyers's Other Garden', *Journal of Garden History*, I, no.3, 1981, pp.215-38). There is, however, no record of Tyers ever having owned such a view or views. Prominent in the foreground are three gentlemen, one of whom is working at a drawing board,

127

while another man lies on the ground beside a picnic basket, pointing sadly at an overturned wine bottle. Harvesting is in progress in the cornfield on the right, with one labourer at work, while the other sharpens his scythe in the shade, beside a countrywoman seated on the ground with a leather ale bottle by her side. Another is walking along the path through the corn with a child in her arms, and there are other figures in the distance, including a man on horseback approaching along the edge of the cornfield.

Painted at a time when the only reason for a specific view of the English countryside was still either the prospect of a town or mansion, or some sporting activity, this work poses something of a puzzle. This is also true for the companion painting at Yale (fig.43, also signed and dated 1733, 902 × 1360, $35\frac{1}{2} × 53\frac{1}{2}$) whose shorter width and more lopsided composition suggest that it may have been

fig. 43 George Lambert: 'A View of Box Hill, Surrey, with Dorking in the Distance'. Signed and dated 1733. Oil on canvas 904 × 1361 ($35\frac{11}{16} × 53\frac{9}{16}$). Yale Center for British Art, New Haven, Paul Mellon Collection.

reduced on the right side, as the Tate Gallery picture had formerly been substantially reduced on the left. It shows a similar group of gentlemen picnicking on a hillside, and appears to have been taken from a position to the left of that in the Tate Gallery picture, taking in Box Hill on the left and looking towards Dorking in the distance (letter of 17 December 1984 from L. Locock of the Box Hill Management Committee to Malcolm Cormack, Yale Center for British Art).

Lambert's method of painting views was to make an accurate on-the-spot drawing of the topography, and then to 'frame' the scene on canvas with wings of decorative trees or shrubs and a built-up foreground with appropriate, usually fanciful, figures. The latter were usually painted by other hands – as probably in this case – but their importance in the general composition is demonstrated by frequent *pentimenti* showing careful adjustments: here it can be clearly seen that the active labourer originally swung his scythe to the left. It cannot be entirely ruled out that some of the figures may be by Lambert himself, since he is said to have owned drawings by Hogarth for his use as models. The British Museum has a wash drawing by Hogarth (no.1953-2-18-1) of a labourer with a scythe (fig.44), inscribed in an old hand 'This & the following 6 Sketches were made from Nature by Hogarth for his Friend George Lambert ye Landskape Painter'; it is presumably one of seven such sketches which belonged to Samuel Ireland (his sale Christie's 6 May 1797, lot 131). As has been pointed out by Barrell and others, two reapers would be far from sufficient to harvest a field of this size; like the framing trees and the picturesque cloud formations, the figures are there to give appropriate animation to the landscape rather than to record actual agricultural methods.

Both paintings are first recorded, already showing their difference in size, in 'The List of Pictures with their Dispositions and Size as placed at Woburn Abbey May 1802' (MS Bedford Office, London), according to which the 'Landscape – with Mowers of Corn at Bottom – 5.1–3.0' was in the West Attic and the 'Landscape Hills and Fields (the fellow to one in W. Attic) – 4.5–2.11' in the Lumber Room. One can also speculate that the paintings may have been commissioned by John Russell, 4th Duke of Bedford, possibly as a record of favourite outing places near his house in Surrey. Before inheriting the Dukedom and Woburn Abbey on the death of his brother in October 1732, he and his wife Diana Spencer were furnishing a modest house in the village of Cheam. They enjoyed taking the air on Banstead Downs, and were almost certainly familiar with the nearby beauty spot of Box Hill (G. Blakiston, *Woburn and the Russells*, 1980, p.98). When his formidable mother-in-law, Sarah, Duchess of Marlborough, inspected the Cheam house on 2 April 1732, she considered it 'a very pleasing habitation, particularly as it was within half a mile of the finest downs and best air in England, and within two hours of driving from London' (Gladys Scott Thomson, *Letters of a Grandmother*, 1943, p.18). She goes on to compare it very favourably with Lord Herbert's recently built Westcombe House at Blackheath, which Diana's brother John Spencer seems to have thought of buying. Diana, however, had on some previous visit liked it or, as her grandmother put it, it was 'a place I am fearful you once commended to me' (ibid. p.21), and she was also impressed by Lord Herbert's plans for Wilton, which she visited in July 1732 (ibid. p.52).

Significantly, at least two of Lambert's set of four fine views of Westcombe House, now at Wilton, can still be seen to be dated 1733, and it is possible that Lord Herbert (who became the 9th Earl of Pembroke in January 1733) recommended Lambert to the Bedfords. His work must have met with approval, because according to George Scharf (*Catalogue of Pictures at Woburn Abbey*, privately printed 1890) there were at least nine other pictures by Lambert in the Woburn Collection, most of them classical scenes, all of which bar one, have left the collection. Those that can still be identified do not seem to be autograph works, though very much in his style, and may have been executed in collaboration with pupils or assistants.

The compilers gratefully acknowledge topographical information given by L.H. Locock, J.H.P. Sankey, R.S.R. Fitter and C.M. O'Brien.

fig. 44 William Hogarth: Study for 'A Man with a Scythe' *c.*1732. Pen and wash drawing 184 × 134 ($7\frac{1}{4} \times 5\frac{1}{2}$). Reproduced by courtesy of the Trustees of the British Museum.

128 **Classical Landscape** 1745

T 00211
Oil on canvas 1035 × 1168 (40¾ × 46)
Inscribed 'G. Lambert 1745', b.l.
Purchased (Cleve Fund and Grant-in-Aid)
1958

PROVENANCE
...; probably acquired by John Pemberton
Heywood (1755–1835); by descent to Lt-Col.
A. Heywood-Lonsdale, sold Christie's
24 October 1958 (85) bt Leggatt

EXHIBITED
Whitchurch Art Exhibition, Whitchurch,
Shropshire 1880 (171 as by Wilson); *Landscape
in Britain c.1750–1850*, Tate Gallery 1973–4
(24, repr.); *Gaspard Dughet*, Kenwood 1980
(61, repr.); *Wilson's Early Contemporaries*, Tate
Gallery 1982 (4, repr.)

LITERATURE
Luke Herrmann, *British Landscape Painting of
the Eighteenth Century*, 1973, p.23, fig.11

Until its sale from the Heywood-Lonsdale collection, this painting had a companion (fig.45) entitled 'Wooded Landscape with Gipsies', also signed and dated 1745 (now in the Government Art Collection). Although often this kind of 'pure' or imaginary landscape served a primarily decorative purpose, the existence of pairs such as this does show that they could on occasion embody certain intellectual concepts. The Tate's picture is one of Lambert's most assured exercises in the manner of Gaspard Dughet, with figures in Arcadian pastoral dress shown against a background of distant classical buildings, bathed in silvery morning light. Its companion has an evening sky, medieval gabled buildings in woods, and a family of ragged gipsies in the foreground, and is composed in a style derived from the Dutch School, possibly Esaias van de Velde. It shows that Lambert was not only the earliest British landscape painter to have some real understanding of the principles of classical landscape composition, but also that he was one of the first to make a close study of the Dutch seventeenth-century school. It was Lambert's particular achievement to play the two styles off against each other in a matching pair, and may have even been intended as a broader comment on the dawn and decline of civilisation.

The Heywood-Lonsdale collection, though the product of several generations, was largely formed by John Pemberton Heywood (1755–1835) and his grandson Arthur Pemberton Heywood-Lonsdale (1835–97). This picture was probably bought by the former in the 1830s, though it may have been acquired by his son of the same name (1803–77) and the Mrs Heywood who lent it to the *Whitchurch Art Exhibition*, in Shropshire, in 1880 may have been his widow. His father Arthur (1719–95) is also known to have bought pictures (see M.G. Compton, 'Compiler's Note' in *The Heywood-Lonsdale Loan*, exh. cat., Walker Art Gallery, Liverpool 1959; and letter from the author in Gallery files).

128

fig. 45 George Lambert: 'Evening
Landscape with Gypsies'. Signed
and dated 1745. Oil on canvas
1066 × 1187 (42 × 46¾). Government
Art Collection.

129 **Moorland Landscape with Rainstorm** 1751

T 04110
Oil on canvas 305 × 423 (12 × 16⅝)
Inscribed 'G:L: 1751' b.r.
Purchased (Grant-in-Aid) with assistance
from the Friends of the Tate Gallery 1985

PROVENANCE
...; ? Lambert sale, Langford's 18 December
1765 (3, one of 'Six small landscapes'); ...;
English private collector, from whom bt by the
Tate Gallery 1985

Lambert's known topographical work is confined to areas around London, Dover, the West Country, and the North between Yorkshire and Durham. Topographically this sketch, which is unusually fresh and direct for its date, seems to belong to the latter group. Set-piece views of Durham, Richmond, Rievaulx and Kirkstall by him are dated between 1734 and 1753, although this in itself gives little clue to when precisely he visited these areas, as he was in the habit of repeating the same composition throughout his working life: for instance, the oil version of 'The Great Falls of the Tees, Co. Durham' which he exhibited at the SA in 1762 (Spink & Son, repr. in col. in their house magazine *Octagon*, October, XXII, no.3, 1985) is based on a pastel of the same view dated 1746 (exh. Kenwood 1971, no.20).

Unlike any other work known by him (even the Tate Gallery's 'View of Box Hill', no.127, has a famous landmark for its subject) this seems to be an exercise in pure landscape painting for its own sake, aiming to catch the fleeting effects of sunlight and weather on a bleak moorland landscape with a few farm buildings, stone walls and sheep. The location could be in the North of England in summer, and, interestingly enough, unusually severe rain-, snow-, and thunder-storms were recorded in Yorkshire in the early summer of 1751 (e.g. *Gentleman's Magazine*, XXI, 1751, pp.231, 233, 235).

In spite of being very lightly and thinly painted (the pinkish-beige ground is clearly visible), it is unlikely to be an on-the-spot sketch made in the open. Lambert's method was to make careful pencil drawings of a given location, and then to work it up in oils in the studio, adding an artificial foreground and decorative 'wings' of rocks and trees to frame the view. This is probably the case here, with the dark outcrop on the right dramatised by a bent sapling that, together with the streaks of rain and the windswept country couple in the foreground, helps to create the breezy atmosphere of the painting. This early attempt to capture in oils the feel of an open English landscape and its weather points the way towards the *plein-air* sketches of Thomas Jones (who may have been Lambert's pupil) later in the century, and pre-dates Canaletto's 'Old Walton Bridge with a Rain-squall' of 1754 (Dulwich Picture Gallery) as well as Stubbs's remarkable oil studies of the rubbing-down house on Newmarket Heath of *c*.1765 (Paul Mellon Collection, and Tate Gallery T 02388).

The history of this landscape before its recent appearance is unknown, but Lambert's sale on 18 December 1765 included, as lot 3, 'six small landscapes' by him, which may be connected with the numeral '5' inscribed in pencil in an old hand on the back of the stretcher.

129

MARCELLUS LAROON 1679-1772

Painter and draughtsman (chiefly in pen and ink) of conversation pieces, musical assemblies and stage scenes, fancy, low-life and near-caricature subjects; few of these are specifically identifiable people or scenes (though a few portraits are known), many are of a somewhat ambiguous nature and all of them are free from moralising pretensions. His rather thin oil-painting technique is distinctive, giving an effect which Waterhouse (1981, p.218) likens to 'stained tapestry'.

Born Chiswick 2 April 1679, son of the Dutch-influenced portrait and genre painter Marcellus Lauron (sometimes called 'Old Laroon'; born 1648/9 in the Hague, son of a French-born artist; came to England when young; for a time drapery assistant to Kneller; member of Painter-Stainers' Company 1674; died London 1701/2). Trained by his father, inheriting Dutch influences and later absorbing French influences, e.g. from Watteau engravings. Earliest dated work (drawings) 1707. Spent some time in Kneller's studio *c*.1712. Had meanwhile travelled as a page from 1698 and seen some military service. Served in the Army 1704, 1707-12, 1715-18 and from 1723/4 until his retirement with the rank of Captain, apparently on full pay, in 1732. For the remainder of his long life, painted and drew 'for diversions' (Vertue), his Army pay and bachelor status freeing him to work mainly for pleasure and to choose his own subjects. By nature gregarious and clubbable, consorting much with artists, actors and musicians. Most active in 1730s and 1740s, but continued to work until his death at the age of ninety-three, his latest work showing neither loss of gusto nor any marked deterioration in an habitually rather tremulous line. Had moved, probably in late 1750s or early 1760s, to Oxford, where he died 1 June 1772.

LITERATURE
Robert Raines, *Marcellus Laroon*, 1966

EXHIBITIONS
Marcellus Laroon, Festival Hall Gallery, Aldeburgh, and Tate Gallery 1967

130 Riders Encountering a Figure of Fate *c*.1730

T 00911
Oil on canvas 905 × 699 ($35\frac{5}{8} \times 27\frac{1}{2}$)
Purchased (Grant-in-Aid) 1967

EXHIBITED
Aldeburgh and Tate Gallery 1967 (68 as 'Scene from *Macbeth* (?)')

PROVENANCE
...; J.O. Flatter, sold Christie's 17 March 1967 (148 as 'The Knight and the Beggar Woman') bt Agnew for the Tate Gallery

LITERATURE
Robert Raines, 'Two Paintings and a Drawing by Marcellus Laroon', *Apollo*, LXXXVI, no.65, 1967: 'Supplement, Notes on British Art, 8', pp.1-2, fig.1

This picture came to light too late for inclusion in Robert Raines's monograph and catalogue, 1966, but was included in the Laroon exhibition the following year and fully discussed in Raines's *Apollo* article, also of 1967 (*op.cit.*). It had been sold earlier in 1967 as 'The Knight and the Beggar Woman'; but although encounters between riders and beggars recur in Laroon's work, this subject is more puzzling.

Raines suggests that it represents a scene from *Macbeth*, presumably the occasion on which Macbeth, accompanied by Banquo (and there is a second horse and rider in no.130) first encounters the witches. He rightly draws attention to supernatural

130

elements in the picture, noting that 'the old woman's gesture is not one of supplication but rather of exhortation or warning', that pentimenti suggest that she was originally depicted as a hunchback with pendulous breasts, that an owl sits in the tree above her and that the leading horse is evidently terrified. The most obvious difficulty about this interpretation is that each of Macbeth's encounters is with three witches (presided over, once, by Hecate), and it seems most unlikely that even the most economical production or the most imaginative representation of the play would reduce three witches to one. Raines's suggestion that no.130 may have been inspired by Sir William Davenant's 'operatic' version of the play (more often performed in the first half of the eighteenth century than Shakespeare's original), in which Hecate has a more prominent role, is no more convincing. Even in Davenant's version (reprinted by Christopher Spencer, *Davenant's Macbeth from the Yale Manuscript*, New Haven 1961) there is no scene in which either Hecate or a single witch appears by herself. Hecate expressly chides the witches for appearing initially to Macbeth without her ('Why did you all Traffick with Macbeth|'Bout riddles – & affairs of Death|And call'd not me ...', III, viii, Spencer 1961, pp.121–2); and Hecate's familiar, 'my little spirit' who 'sits in a foggy cloud and stays for me' (until both ascend in a 'machine'), is specifically named as 'Malkin', the familiar appelation of a cat, not an owl.

If Macbeth hardly seems the inspiration for no.130, the probability remains that it represents a scene from some unidentified, perhaps now forgotten opera; certainly the armour worn by the riders seems to echo 'classical' theatrical costume of the early eighteenth century, and Laroon, who apparently himself performed on the stage as a singer for about two years from 1698, retained his interest in the theatre. The subject may therefore rather lie in some Italianate opera, perhaps derived from Ariosto or Tasso, dealing with the well-worn, almost fairy-tale theme of heroes confronted, in a wood or at a crossroads, by an enigmatic and often foully disguised figure posing a choice between the path of self-advancement and that of virtue.

131 **Interior with Figures** *c.*1750

N 04420
Oil on canvas 457 × 385 (18 × 15¼)
Presented by Julian Lousada through the
National Art-Collections Fund 1928

PROVENANCE
...; L.H. McCormick, sold Christie's
1 December 1922 (76 as 'A Merry Party, a
group of four ladies and gentlemen round a
table') bt Gordon; ...; Julian Lousada, by
whom presented to the Tate Gallery

EXHIBITED
Aldeburgh and Tate Gallery 1967 (15)

LITERATURE
NACF *Report 1928*, 1929, repr. facing p.37;
Antal 1962, p.100, pl.51a; Raines 1966, p.118,
no.22, pl.45. Also repr.: Sacheverell Sitwell,
Narrative Pictures, 1937, pl.43

Raines (1966, p.80) notes that with certain exceptions 'it is probably correct to regard the conversations as largely fancy pictures – in which some figures may be portraits and some architectural details may be real'. If any of the figures in no.131 are portraits, their identity has been lost. Their setting suggests that this is middle-class company, either at home or in the private parlour of an inn. Details of costume, décor and furnishings certainly indicate a much less affluent way of life

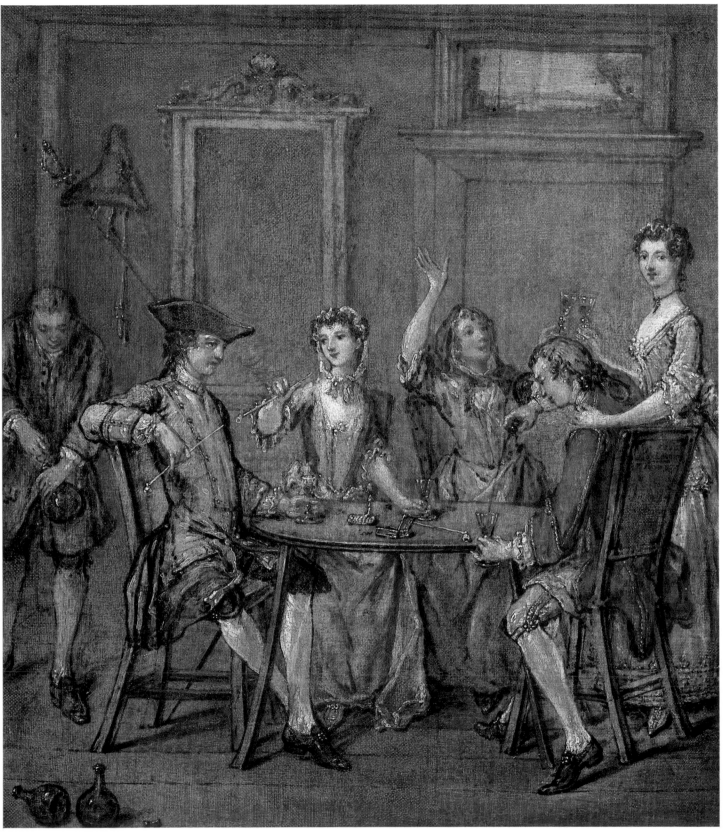

131

than Laroon represents in, for instance, 'A Dinner Party', 'A Musical Conversation' or 'A Musical Assembly' (Raines 1966, no.1, pl.5; no.28, pl.54; no.10, pl.3), but a more comfortable and private one than in his scenes of tavern life (e.g. no.5, pl.35; no.9, pl.52).

As so often with Laroon, the mood and the individuals' relationship to each other are ambiguous, even disquieting. The women appear to be in better spirits than the men, who may be trying to stare down some ill fortune. Raines identifies one of the women as a bawd, though there seems little foundation for this. Antal's comparison of the picture with the 'Tavern Scene' in Hogarth's 'The Rake's Progress' seems far-fetched.

132 Two Gentlemen Going Shooting, with a Dog and a Groom with Two Shooting Ponies 1771

N 03642
Pen and brown ink over pencil, with some grey and brown wash, 475 × 329 ($18\frac{11}{16} \times 12\frac{15}{16}$), within ruled ink margins, overall size 496 × 333 ($19\frac{9}{16} \times 13\frac{1}{8}$)
Inscribed 'Mar. Laroon. F. 1771' b.r. within ruled margin
Presented by Captain Henry Scipio Reitlinger through the National Art-Collections Fund 1922

PROVENANCE
...; Henry Scipio Reitlinger by 1922

EXHIBITED
Works of British Artists (1750–1850) on Loan from the Tate Gallery, City of Plymouth Museums and Art Galleries 1939 (12); *Two Centuries of British Drawings from the Tate Gallery*, CEMA tour 1944 (41); Aldeburgh and Tate Gallery 1967 (50)

LITERATURE
NACF *Report, 1922*, 1923, repr. facing p.39; Raines 1966, p.136, no.69, pl.73

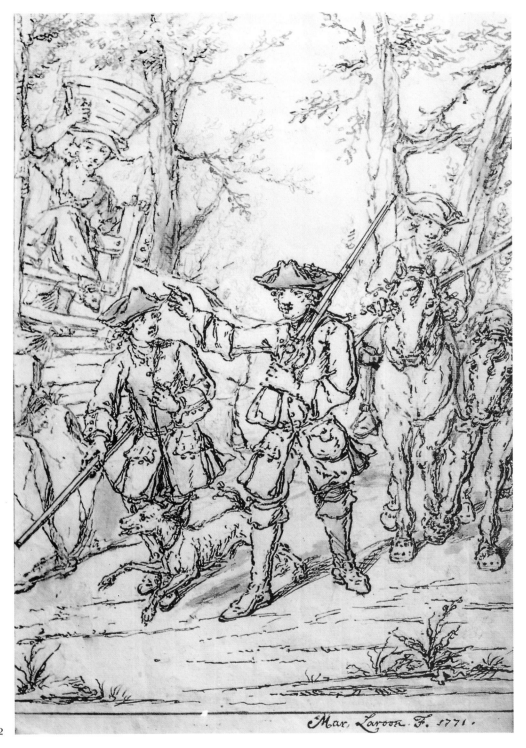

132

JAMES LATHAM 1696-1747

Portrait painter, born in Co. Tipperary, probably a member of the now extinct family of Lathams of Meldrum and Ballysheehan. Educated in Antwerp, where he became a Master of the Guild of St Luke 1724-5. Said to have returned to Dublin by 1725, and probably visited England in the 1740s, as the influence of Highmore is very noticeable in his work of this period. Died in Dublin 26 January 1747.

LITERATURE
W.G. Strickland, *Dictionary of Irish Artists*, 1913; A. Crookshank & the Knight of Glin, *The Painters of Ireland c.1660–1920*, 1978, pp.38–44

EXHIBITIONS
Irish Portraits 1660–1860, exh. cat., Dublin, London, Belfast, 1969–70

133 **The Rt Hon. Sir Capel Molyneux 3rd Bart** 1740

N 05801
Oil on canvas 1346 × 1080 (53 × 42½)
Inscribed 'R! Hon? S! Capel Molyneux Bar! Member for the University 1740' upper centre left, probably in a late eighteenth-century hand
Purchased (Grant-in-Aid) 1947

PROVENANCE
...;? by descent to Mrs T.E.M. Talbot, only daughter of Sir Capel Molyneux, 7th Bart; first recorded at Castle Dillon 1913, but not in Castle Dillon sale 2–4 October 1923; ...; anon. sale, Knight, Frank & Rutley, 5 March 1926 (304) bt Agnew, from whom bt by Tate Gallery

EXHIBITED
Old Masters, Agnew's June 1933 (40 as by William Hoare)

Sir Capel Molyneux (1718-97) of Castle Dillon, Co. Armagh, was one of the sixteen children of Sir Thomas, 1st Bart, Physician General to the Army in Ireland and President of the College of Physicians of Ireland, and his wife Catherine Howard. He attended Trinity College, Dublin, 1734-7, and succeeded his brother as 3rd Bart in 1739. He was MP for Dublin University 1769-76, which gives a *post quem* date for the inscription, which, however, there is no reason to doubt, as the portrait was probably painted in 1740 to mark the sitter's recent accession to the title.

The portrait is first recorded in an inventory of pictures at Castle Dillon, the property of Mrs Talbot, taken in October 1913 (kindly communicated by Miss Eileen Black, Ulster Museum). Then and subsequently attributed to William Hoare, it was reattributed to Latham by the Knight of Glin in 1973.

There is a large group portrait of Sir Capel Molyneux and his four children by John Astley, signed and dated 1758, also originally from Castle Dillon (on permanent loan to the Ulster Museum, Belfast), in which the likeness corresponds well with this portrait.

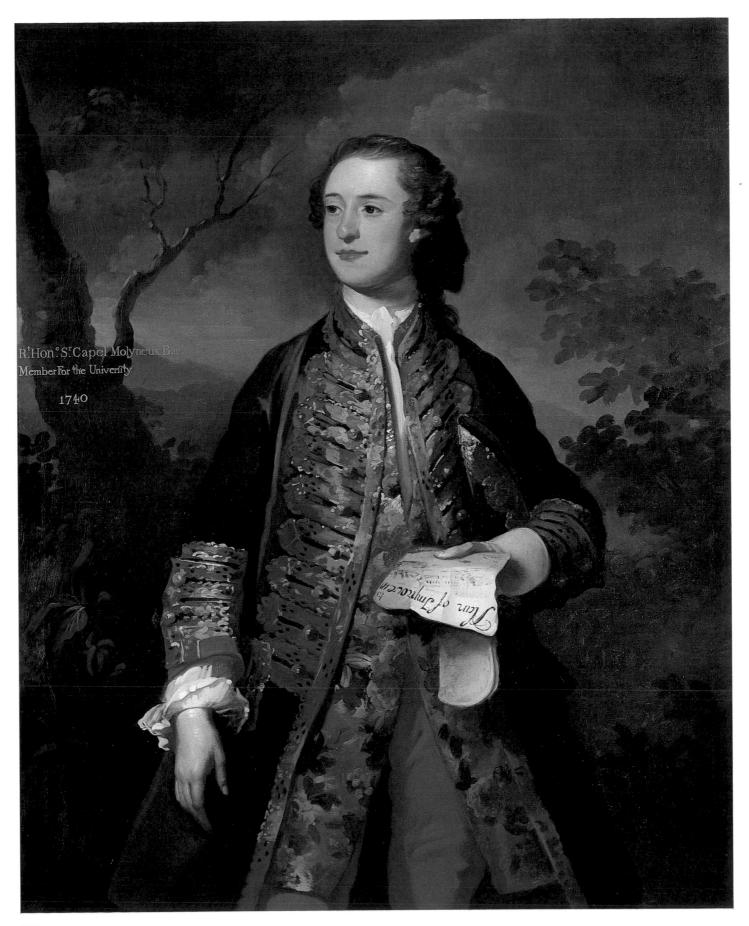

133

PHILIP MERCIER ?1689-1760

Painter of portraits and a pioneer in England of conversation pieces and 'fancy pictures'; an important figure in the introduction of French taste into England.

Born in Berlin, probably in 1689 (or 1691), son of a French Huguenot tapestry worker employed by the Elector of Brandenburg; trained in Berlin, partly by Antoine Pesne, French-born Court Painter to Frederick I of Prussia from 1711. Travelled in France, acquiring familiarity with work of Watteau, in whose work he dealt (and some of which he etched and perhaps even forged) and evidently in Italy; he held a sale of pictures 'collected abroad' in London 1742.

Probably settled in England 1715. His first English patrons were Hanoverian courtiers, for whom he painted portraits and conversation pieces. Received official court patronage for similar work almost immediately after the arrival from Hanover in December 1728 of Frederick, Prince of Wales: appointed as Prince's Principal Painter (1729-36) and Library Keeper, a post involving purchase of pictures (1730-8). Member of St Luke's Club between 1726 and 1735. Within a decade, had fallen from royal favour and temporarily retired from London (? to Northamptonshire, for a year during 1736-7).

Returned to London by October 1737, now concentrating on 'fancy pictures', in this genre evidently influenced by Chardin. Based in York 1739-51, the period of his greatest activity, painting portraits and sentimental domestic subjects, with his eye on the print market; many works engraved (including a 'fancy' series), chiefly by Faber Jnr and Houston. Visited Ireland 1747, and Scotland 1750. In Portugal for a year, 1751-2, with portrait commissions from English merchants. Returned to London 1752; exhibited three works at first exhibition of SA 1760; died 18 July 1760.

Married firstly Margaret Plante, London, 1719; secondly, Dorothy Clapham, London, 1735. The work of his second wife, his daughter Charlotte (1738-62) and (?) his son Philip is noted by Ingamells and Raines 1978.

LITERATURE
John Ingamells & Robert Raines, 'A Catalogue of the Paintings, Drawings and Etchings of Philip Mercier', *Walpole Society*, XLVI, 1978, pp.1-70

EXHIBITIONS
Philip Mercier, York City Art Gallery and Kenwood 1969

134 The Schutz Family and their Friends on a Terrace 1725

T 03065
Oil on canvas 1022 × 1257 (40¼ × 49½)
Inscribed 'Ph:Mercier· Pinxit· An: 1725.' b.r.
Purchased (Grant-in-Aid) 1980

PROVENANCE
...; ? painted for Baron Georg Wilhelm Schutz of Shotover House, Oxford; by descent to George Vandeput Drury 1839; his creditors' sale (Chancery Court case Spickernell v. Hotham and others) Farebrother, Clarke and Lye, 6th day, 26 October 1855 (663);...; Dr W.E. Biscoe, Holton Park, Oxford; according to Randall Davies, sold from Biscoe collection before 1907 (but not in Biscoe sale, Christie's 20 June 1896);...; J. Pierpont Morgan sale, Christie's 31 March 1944 (133) bt Knoedler;...; Viscount Rothermere by 1946, sold Christie's 22 November 1974 (94, repr.) bt Leger, from whom bt by Tate Gallery

EXHIBITED
AC tour 1946 (6, repr.); York and Kenwood 1969 (11, repr.); *Old Master Paintings*, Leger Galleries 1977 (7, repr. in col.)

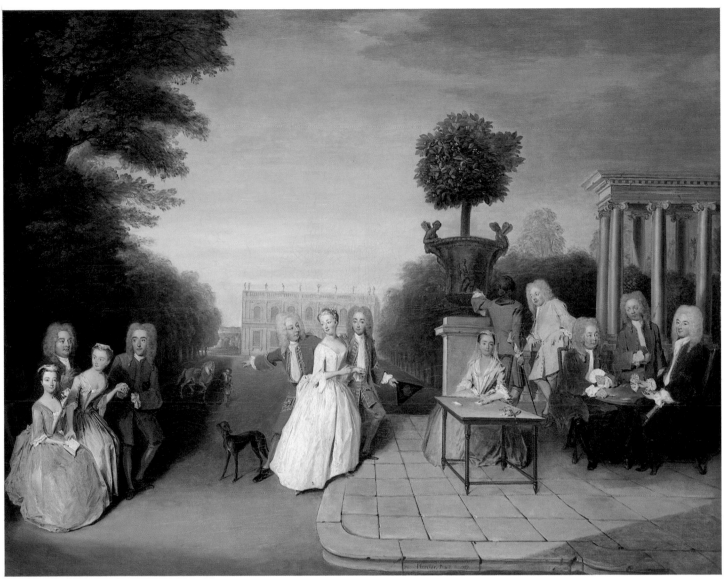

134

LITERATURE
Randall Davies, *English Society of the 18th Century in Contemporary Art*, 1907, p.38; Ralph Edwards, 'Mercier's Music Party', *Burlington Magazine*, xc, 1948, p.308; Waterhouse 1953, pp.141, 148 n.2; John Ingamells, 'A Hanoverian Party on a Terrace by Philip Mercier', *Burlington Magazine*, cxviii, 1976, pp.511–15, fig.93; Waterhouse 1978, p.188; Ingamells & Raines 1978, p.31, no.85, pl.12a (detail), p.64, no.279, pl.126

The painting is thought to represent various members of the Schutz family of Hanover and their friends, in a setting that is emblematic of the legitimacy of the Hanoverian Succession.

The exact identification of the individual figures remains unclear, but in 1907 Randall Davies cited an undocumented source (possibly an old label, now lost) which stated that the group included 'Baron and Lady Schutz, Dr Tessier, Mrs Blunt, the daughter of Sir Timothy Tyrell, Mrs Bensoin, Colonel Schutz, and Count Betmere'.

Ingamells (1976 and 1978) identifies them (together with their ultimate appointments at Court) as Augustus Schutz (*c.*1693–1757), Keeper of the Privy

Purse and Master of the Robes to George II; his wife Penelope, *née* Madan, formerly ward of General James Tyrrell of Shotover, Lady in Waiting to Queen Caroline; Dr George Lewis Tessier of Celle (naturalised 1705, d.1742), Physician in Ordinary to George II and his Household; Colonel Johann Schutz (d.1773), younger brother of Augustus, Keeper of the Privy Purse and Master of the Robes to Frederick, Prince of Wales; and either Count Hans Caspar von Bothmar (1656–1732), principal Advisor to George I, or his son, who was a close friend of the Schutzes.

There is some difficulty in accepting the suggested identification 'Mrs Blunt' as Eleanor Blount, *née* Tyrell, wife of Charles Blount of Tittenhanger, Herts., as according to *DNB* sources she pre-deceased her husband who died in 1693. Also, a daughter of Sir Timothy Tyrrell would be likely to be at least in her seventies by the date of this picture, an age difficult to reconcile with the appearance of any of the sitters. For the unidentifiable 'Mrs Bensoin' one could, however, suggest Eleanor Benson, second wife of William Benson (1682–1754), engineer and amateur architect, Auditor of the Imprest and briefly, in 1718, successor as Surveyor General to Sir Christopher Wren. Benson was closely associated with the Hanoverian court and was involved in the design of the famous fountains of the Palace of Electors of Hanover at Herrenhausen.

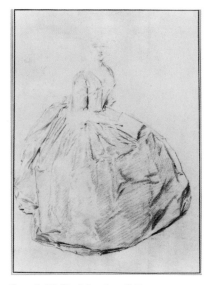

fig. 46 Philip Mercier: 'Woman Holding a Book'. Study for no. 134. Red chalk 292 × 187 ($11\frac{1}{2} \times 7\frac{3}{8}$). Sotheby's 26 June 1969 (45).

The Shotover provenance lends considerable weight to these identifications, even allowing for the probability that by 1907 they may have become somewhat garbled in detail. The setting was then wrongly identified as Shotover House, Oxfordshire, which passed from the Tyrrells to the Schutzes on General James Tyrrell's death in 1742. Ingamells suggests that the building in the background is a schematic representation of the Banqueting House in Whitehall and stands for the Stuart dynasty. By the same token, the orange tree in the garden urn would symbolise William III and the House of Orange, while the white horse being led forward in the middle distance could represent the House of Hanover, whose device was a horse *courant argent*.

The picture has also the appearance of being a wedding portrait, with the richly dressed groom in the centre leading his bride, dressed in pink, with white flowers in her hair, from one family group to another. If the couple were, as Ingamells suggests, Penelope and Augustus Schutz (whose exact wedding date is unknown, but is variously put as 1717 and 1727), then it would be possible to see the gentleman standing with them, one hand on the bridegroom's shoulder, the other pointing to the horse and groom, as General James Tyrrell, whose ward and heiress the bride was. He was promoted Colonel in 1709 and Brigadier-General in 1727, so that his military-style scarlet coat could represent the imprecise uniform of his day. The greyhound may be a family device, as a greyhound *courant argent* was part of their descendants' arms by the nineteenth century (see Burke's *Landed Gentry*, 1846, under Vere-Drury).

According to Vertue, Mercier came to London in 1715–6 'recommended by the Court at Hanover'; he remained closely associated with it until the mid-1730s. He brought with him a small-scale genre style which took its inspiration from France in general, and from Watteau in particular. This, one of his earliest dated paintings, shows its Watteauesque affinities in the drily delicate handling and colour, and is one of his most elegant and complex works on this scale. It is also one of the earliest examples of the informal small-scale portrait group or conversation piece, which was soon to develop into one of the most characteristic native British genres of the eighteenth century.

A red chalk study by Mercier (fig.46), again very close to the manner of Watteau, for the figure of the seated lady with a book on the extreme left was sold Sotheby's 26 June 1969, lot 45, repr. (see Ingamells & Raines 1978, no.279).

135 **A Music Party** *c.*1737–40

T 0922
Oil on canvas 1025 × 1270 (40⅜ × 50)
Inscribed 'Reicrem ['Mercier' in reverse].
fecit' b.c.
Purchased (Grant-in-Aid) 1967

PROVENANCE
...; anon. sale, Sotheby's 7 July 1965 (74)
bt M. Bernard, from whom bt by the Tate
Gallery

EXHIBITED
York and Kenwood 1969 (Addenda, 73, repr.)

LITERATURE
Ingamells & Raines 1978, pp.6, 60, no.256 (as
'Music Party III')

Mercier suffered a considerable reversal of his fortunes during 1736. He had been Principal Portrait Painter to the Prince of Wales since 9 January 1729, with a guarantee of £200 worth of work per annum (plus various honoraria), but was replaced by John Ellys as the Prince's painter on 7 October 1736. Vertue, writing in '173$\frac{6}{7}$', noted that after his dismissal Mercier 'seemed to retire into the country' (this retirement may have been to Northamptonshire for a year), but had 'lately' returned to London, where he not only began once more to 'commence portrait painting' but also 'has painted several pieces of some figures of conversation as big as the life conceited plaisant Fancies & habits. Mixt modes really well done – and much approvd off' (Vertue III, p.82). Although Mercier had already painted such 'fancy pictures' while in the Prince's service, he probably turned increasingly to them in re-establishing his practice. Ingamells and Raines (1978, p.4) note that 'on some he used a reversed signature, *Reicrem* ... presumably to mark his determination to start again'. Since it seems reasonable to assume that a signature in this reversed form would have been used on works painted after Mercier's return from retirement (and probable that that retirement lasted for a year), a rather later date than Ingamells and Raines's '*c.*1736' is here suggested for no.135.

Quite apart from the significance of its reversed signature, no.135 seems to be more freely painted and therefore almost certainly later in date than two similar subjects which Ingamells and Raines (1978) catalogue as 'Music Party I', *c.*1725, and 'Music Party II', ?1725–30 (p.60, no.254, repr. pl.lc, and no.255).

135

136 **A Girl Sewing** *c.*1750

T 00759
Oil on canvas 760 × 635 (30 × 25)
Inscribed 'PM.' in monogram lower left
Purchased (Grant-in-Aid) 1965

PROVENANCE
...; Dr Robert Jaimeson; his grand-niece,
Mrs Gertrude Bell; anon. sale, Sotheby's
9 December 1964 (114, as 'H. Morland, The
Sewing Lesson') bt Sidney Sabin; bt by the
Tate Gallery from Sabin Galleries

EXHIBITED
York and Kenwood 1969 (*Addenda*, 73, repr.)

LITERATURE
Ingamells & Raines 1978, p.53, no.227

No.136 is typical of the 'innocent anecdotal subjects' on which, as Ingamells and Raines point out, Mercier deliberately concentrated, with his eye on the print market, after his loss of the Prince's favour in 1736. Many of his fancy pictures were engraved in series, such as the ages, seasons, elements, senses, times of day and scenes of domestic occupations or amusements. A 'Sewing' picture was engraved by J.S. Negges, as one of a set of four 1755–60, the others depicting 'Washing', 'Knitting' and (though not after Mercier) 'Reading'; the print shows the young woman who is sewing wearing a shawl and mob cap (Ingamells and Raines 1978, no.150: the original painting is lost). Another 'Girl Sewing', 1875 × 1525 (75 × 61), is dated by Ingamells and Raines to *c.*1750 (no.166); they have not identified which picture Mercier exhibited as 'A Girl Sewing' at the Society of Art, Manufactures and Commerce (34) in 1760, the year of his death.

136

PETER MONAMY 1681-1749

Marine painter who modelled his style chiefly on that of William van de Velde (d.1707), whose work became accessible in the form of prints, especially after the publication in 1725 of sixteen engravings by Elisha Kirkall; but Charles Harrison-Wallace stresses that 'Far too many of Monamy's paintings seem far too naive for him ever to have been schooled by the superlative van de Veldes', and points out that Monamy borrowed from a variety of sources.

Baptised 12 January 1680/1 at St Botolph's-without-Aldgate, London, son of Peter Monamy (merchant) and his wife Dorothy. Apprenticed 3 March 1696 to William Clark, Master of the Painter-Stainers Company (whom Vertue, III, p.14 calls 'a Sign & house painter on London Bridge'); himself admitted to that livery 23 November 1726. Lived in London; took an apprentice 1708, and may have built up a workshop. Chiefly painted ship portraits, naval battles, calms and storms. Painted four scenes for the decoration of supper-boxes at Vauxhall Gardens, c.1740-3 (engraved 1743); ten engravings by P.C. Canot after works by Monamy published 1746; presented a marine painting (now lost) to the Foundling Hospital, for which (with Samuel Wale and Thomas Gainsborough) he received thanks, 11 May 1748. Buried at St Margaret's, Westminster, 7 February 1748/9.

EXHIBITIONS
Charles Harrison-Wallace, exhibition catalogue, *Peter Monamy 1681-1749 Marine Artist*, Pallant House Gallery, Chichester 1983 (no pagination): note that the 'Catalogue' is a selective chronological list of forty-five identifiable and representative works by Monamy, not a list of works exhibited in 1983

137 **Ships in Distress in a Storm** *c.*1720-30

T 00807
Oil on canvas 756 × 1065 ($30\frac{1}{8}$ × $41\frac{7}{8}$)
Inscribed 'P:Monamy:pinx[?it]:'on spar lower left
Purchased (Grant-in-Aid) 1965

PROVENANCE
...; D. Honeysett *c.*1945, anon. sale Christie's 19 November 1965 (56) bt Butlin for the Tate Gallery

Both ships in the foreground appear to be naval, and are two-deckers with forty to fifty guns each; they date from the end of the seventeenth century, and have the round gun ports which were abolished in 1700. A third ship on the horizon may be of the same size and age. It is unlikely that Monamy was depicting a particular occasion or that the rocky headland on the right is a specific place. The subject may have been inspired by the great gale of 1703 or the occasion in 1707 when Sir Cloudisley Shovell's fleet was in distress on the Scillies; though Charles Harrison-Wallace considers that stylistically this work dates from after 1720. (The compilers are grateful for the help of Mr Roger Quarm, National Maritime Museum, and Mr Charles Harrison-Wallace over this entry.)

137

BALTHASAR NEBOT active 1730–after 1765

Painter of open-air genre scenes, topographical landscape and some portraits: his portrait of Thomas Coram with the Foundling Hospital in the background was engraved 1751. Life obscure. Waterhouse (1981, p.255) records that he was of Spanish origin and married in London 1729/30; Harris (1979, p.160) suggests that he established himself within a circle of genre painters working in and around Covent Garden, including Peter Angellis (*q.v.*, whose subjects of fishmongers' and vegetable-sellers' stalls are close to Nebot's), Joseph van Aken (*q.v.*) and ?Peter Rysbrack. Known for his paintings of market scenes in the 1730s, for a series of views of Hartwell House and its gardens, Bucks., 1738 and for fourteen views at Studley Royal and Fountains Abbey, one dated 1762.

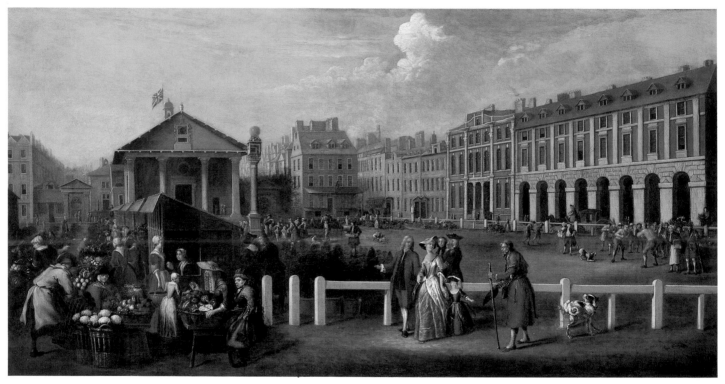

138

138 **Covent Garden Market** 1737

N 01453
Oil on canvas 640 × 1230 ($25\frac{1}{2}$ × $48\frac{3}{8}$)
Inscribed 'B.Nebot. F. 1737' along the edge of
the market-woman's stool to the left of the
rails, lower left of centre
Purchased by the National Gallery 1895;
transferred to the Tate Gallery 1955

PROVENANCE
...; Lord Dover (?by 1833–6), by descent to
4th Viscount Clifden, by whose executors sold
Robinson & Fisher 25 May 1895 (? 686 as by
Pugh) bt for the National Gallery

EXHIBITED
On long loan to London Museum, c.1945–65

LITERATURE
C.H. Collins-Baker, 'Nebot and Boitard',
Connoisseur, LXXV, 1926, p.3, fig.1. Also repr.:
Survey of London, XXXVI, 1970, pl.28a, wrongly
dated 1735

This view is from the south-east of the Piazza, near the Russell Street entrance,
looking west, showing the east (sham entrance) front of St Paul's Church, the
sundial column surmounted by a sphere erected in the centre of the Piazza in
1668–9 (demolished 1790) and King Street with part of the north side of the Piazza
on the right.

Fruit and vegetable stalls and booths line the south side of the Piazza. It was from
this side that the market developed. Described as 'new' in 1654, the market was
authorized by letters patent obtained by the Earl of Bedford (as landlord) in 1670,
authorizing him and his heirs (later Dukes of Bedford) 'to hold forever a market in
the Piazza on every day in the year except Sundays and Christmas Day for the
buying and selling of all manner of fruit, flowers, roots and herbs'. Some brick-built
permanent shops were erected along the south side in 1678; more were added in
1705–6 (only one corner of these is visible in Nebot's view: the others are out of
sight on the left). Compared with the crowded scene in Samuel Scott's 'Covent
Garden Piazza and Market' of c.1754–8 (in the collection of the Duke of Bedford,
repr. *Survey of London*, XXXVI, 1970, frontispiece) the market in Nebot's view is quite
small. The size and diversity of the market increased rapidly from c.1740; by the
early nineteenth century it extended over the whole of the Piazza.

Noting the date of 1737 on this picture, Collins-Baker (1926) comments that
'only two years later than Hogarth's *Rake's Progress*, and nine years before
Canaletto's arrival in England, Nebot was producing ... genre combined with the
sort of topographical painting which we usually regard as post-Canaletto.'

A version possibly by another hand, with a few small variations, was sold at
Christie's 26 October 1945 (137). Another, with several extra figures, is in Lord
Lonsdale's collection.

SAMUEL SCOTT ? *c.*1702–1772

Painter and draughtsman (sometimes in watercolour) of sea-pieces, river views, especially on the Thames, and some inner London Views. Born *c.*1702, ?the son of Robert Scott, barber-surgeon, of 4 Tavistock Row, Covent Garden; named as rate-payer there and elsewhere in Covent Garden until 1758, meanwhile acquiring a house at Twickenham. His early paintings were sea-pieces based on and sometimes copied from Willem van de Velde (1633–1707), many of whose drawings he acquired. His earliest dated sea-piece 1726; his earliest known pictures of naval engagements 1740–1. His earliest dated finished London view is of 1746, the year of Canaletto's arrival in England; he was probably spurred on to develop earlier drawings into pictures by the stimulus Canaletto gave to the demand for London views. Made numerous versions of many of his pictures. Elected Governor and Guardian of Foundling Hospital 1746. Pupils included Sawrey Gilpin 1749–56 and William Marlow 1754–9. Exhibited Society of Artists, 1761–5 and elected Fellow 1765. Crippled with gout by 1765, and painted little afterwards. Retired first to Ludlow, then to Bath, whence he sent one picture to the RA in 1771; died at Bath 12 October 1772, aged seventy according to William Marlow.

LITERATURE
Richard Kingzett, 'A Catalogue of the Works of Samuel Scott', *Walpole Society 1980–1982*, XLVIII, 1982, pp.1–134

EXHIBITIONS
Paintings and Drawings by Samuel Scott, Agnew 1951; *Samuel Scott, Paintings and Drawings*, Guildhall 1955; *Samuel Scott Bicentenary*, Guildhall Art Gallery 1972

139 **Admiral Anson's Action off Cape Finisterre, 3 May 1747** *c.*1749–50

T 00202
Oil on canvas 1645 × 2970 ($64\frac{3}{4}$ × 117)
Inscribed (probably later in the eighteenth century) 'Admiral Anson's Engagement with a Squadron Commanded by Monsr de la Ionquiere May 1747' bottom centre
Purchased (Cleve Fund) 1958

PROVENANCE
Commissioned by John Montagu, 4th Earl of Sandwich (1718–92) by descent to Victor Montagu, Viscount Hinchingbrooke (succeeded as 10th Earl of Sandwich 1962, but disclaimed his titles for life) from whom bt through Agnew by the Tate Gallery

EXHIBITED
Recently Acquired Pictures by Old Masters, Agnew 1957 (not in cat.)

LITERATURE
Paget Toynbee (ed.), 'Horace Walpole's Journals of Visits to Country Seats, &c', *Walpole Society*, XVI, 1928, pp.49–50; Kingzett 1982, pp.33–5, version C, pl.10

Two other versions of this subject are catalogued by Kingzett: version A (1050 × 1862, 42 × $74\frac{1}{2}$), traditionally described as having been painted for Lord Dover but more probably commissioned by the Anson family for Shugborough as part of a celebration of Lord Anson's victories, and now in the collection of the National Maritime Museum (fig.47), and version B (1016 × 1791, 40 × 71, signed and dated 1749), probably commissioned by Lord Hardwicke and now in the collection of the Yale Center for British Art (fig.48). No.139 was commissioned by the Earl of Sandwich, First Lord of the Admiralty, 1747–57, and elder brother of William Montague, who commanded the *Bristol* in the Cape Finisterre battle; it is the largest and probably the best-preserved of three versions, and almost certainly (see below) the latest of the three.

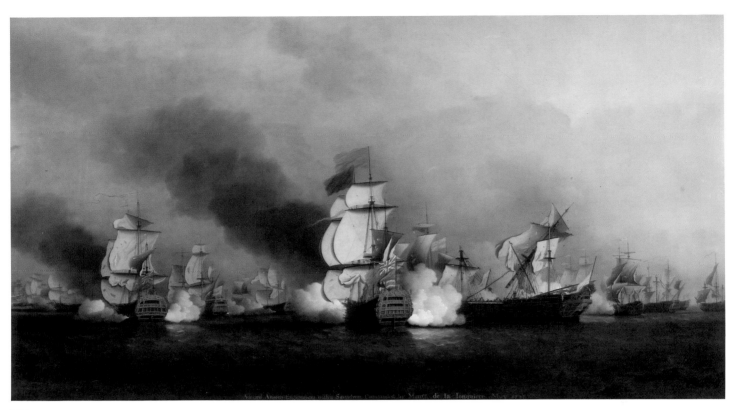

139

The victory off Cape Finisterre was the first English naval success in the War of the Austrian Succession. The task of the English fleet was to block communication between France and her North American colonies. On 3 May 1747, Anson, recently promoted to Vice-Admiral of the Blue, intercepted and attacked a convoy of merchantmen escorted by nine men-of-war under their Commander-in-Chief M. de la Jonquières. Anson distinguished himself by skilfully manoeuvring his forces against the retiring enemy fleet in such a way as to prevent its escape. By the end of the battle, he had captured ten ships, six of which were men-of-war and the rest East Indies merchant vessels. For his part in the battle, Anson was rewarded with a peerage. None of Scott's versions can be regarded as an accurate representation of a particular situation during the course of the action off Cape Finisterre; they should be considered as monuments reconstructed afterwards by the artist from first-hand accounts. A study of Admiral Anson's despatches, dated 11 May 1747 (*Adm. 1/87*), and of the ships' logs provides a good general account of the progress of the battle, but disparities of timing of events by individual commanders complicate any attempt to relate specific events with the finished painting. Of the fifteen ships in Anson's fleet only eight got into action, the flagship *Prince George* (90 guns) being just too late herself, against the French fleet of thirty-eight ships, only nine of which were men-of-war. The enemy was first sighted by Captain Gwyn of the Sloop *Falcon* at 4 p.m. the day previous to the battle and the English fleet caught up with the French at 9.30 a.m. on 3 May. Just after 2 p.m. Anson, whose ship appears in the centre foreground wearing the blue flag of Vice-Admiral of the Blue at the fore topmast, signalled his fleet to 'chace to the S.W.' and this is probably the meaning of the red, white and blue horizontally striped flag flying from the mizen shrouds and visible below the blue ensign. At 3 p.m. he ordered his fleet to attack without regard for line of battle and hoisted the appropriate red signal flag at the main masthead, which is also shown in the painting.

The artist seems to have chosen the moment when, between 6 and 7 p.m., the French Commodore's ship *Invincible* (74 guns) under M. Grout de Saint-Georges

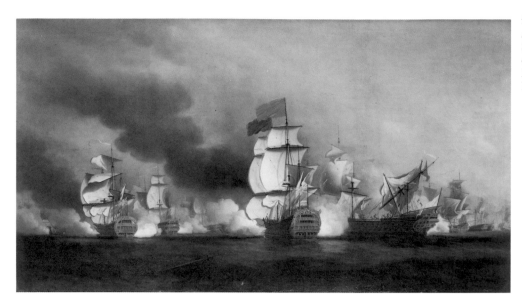

fig. 47 Samuel Scott: 'Admiral Anson's Action of Cape Finisterre'. Signed and dated 1749. Oil on canvas 1066 × 1892 (42 × 74½). National Maritime Museum, London.

struck her colours to Anson. The French vessel lies to starboard of the *Prince George*, her mainmast has just been shattered and her fore topmast has already been shot away. According to the log of Lieut. John Lockhart of the *Devonshire* (66 guns) the *Invincible* struck her colours at 5.30 p.m., and the *Devonshire*, wearing the flag (red cross on white) of Peter Warren, rear-Admiral of the White and Anson's second-in-command, may be seen just beyond the *Invincible*.

The French flagship *Le Sérieux* (64 guns), under M. de Jonquières, who struck to Captain Edward Boscawen in the *Namur*, cannot be identified with certainty, although she may be among the cluster of ships on the extreme right of the painting, or beyond the English ship with a long striped pennant at the main masthead, possibly the *Namur*, which is discharging a broadside to starboard and whose bow lies at right-angles to the stern of the *Invincible*. On the left, the English ship in the foreground may be either the *Bristol* (50 guns) under William Montagu, younger brother of Lord Sandwich, or the *Yarmouth* (64 guns) under Captain Piercy Brett. If the *Bristol* in intended, then the ship on her starboard bow would be the *Diamant* (34 guns, rated at 56) under Hoguart, but Lieut. John Bagster's log records that she was the last French vessel to strike her colours after a chase which took her some miles away from the main battle area. On the other hand, Anson wrote in his despatches: 'The Yarmouth and Devonshire having got up and engaged the Enemy, and the Prince George being near the Invincible and going to fire onto her, all the ships in the Enemy's Rear Struck their Colours between six and seven o'clock, ...' and from this description it seems likely that the *Yarmouth* is intended, whose commander, Captain Brett, was a friend of both Anson and Scott and may have advised the artist on the painting.

Scott's three versions agree in general composition and disposition of the ships (apart from minor differences such as the inclusion in no. 139 of four extra ships on the horizon on the left and of not one but two pieces of floating wreckage in the foreground). The version at Yale is dated 1749; the version in the National Maritime Museum is probably the picture described by Horace Walpole in a letter of 23 March 1749 (see below). That no. 139 was the last version, datable to sometime between 1749 and 1750, may be deduced from a correction made in the Commodore's pennant worn by the *Invincible*. In the National Maritime Museum and Yale versions, a long white pennant is shown at the masthead, but M. le Capitaine de Frégate Vichot, of the Musée de la Marine, Paris, has pointed out that a long white pennant would be worn at the main masthead only by a Commander-in-Chief of the French Navy at this date, i.e., de la Jonquières of the *Sérieux*. Grout de Saint-Georges of the *Invincible* was only a Captain at the time of

the action and would not, therefore, be allowed to wear a white *cornette* at the mizen of masthead. M. Vichot thinks it possible that the centre part of the painting shows not the *Invincible*, but the *Sérieux*, striking to the *Prince George*, even although in the Tate version a white *cornette* (not a long pennant) flies from the mizen instead of the main masthead, its more usual position. In the Tate picture this error has been corrected to show a broad white pennant (*cornette*) at the mizen masthead, the correct form for a French second-in-command.

Horace Walpole commented in a letter to Horace Mann of 23 March 1749, after seeing (? or hearing about) what was probably the first version at Shugborough:

> He [Anson] has lately had a sea-piece drawn of the victory for which he was lorded, in which his own ship in a cloud of cannon was boarding the French admiral. This circumstance, which was as true as if Mademoiselle Scudéry had written his life (for he was scarce in sight when the Frenchman struck to Boscawen) has been so ridiculed by the whole tar-hood, that the romantic part has been forced to be cancelled, and only one gun remains firing at Anson's ship (*Walpole's Correspondence* IX, p.38)

Walpole, poking fun at Anson (whose projected Navy Bill, 1749, had made him unpopular in some quarters), is himself guilty of inaccuracy in speaking of the *Sérieux* striking her colours to the *Prince George* since, as described above, Scott has depicted the *Invincible* on her starboard side.

Walpole visited Hinchinbrooke on 30 May 1763, and noted ('Journals', *op.cit.*) that 'a large piece by Scott, of the engagement between Admiral Anson and Jonquieres' hung 'in the best eating room'.

fig. 48 Samuel Scott: 'Admiral Anson's Action off Cape Finisterre, 3 May 1749'. Oil on canvas 1016 × 1791 (40 × 71), in its original frame. Yale Center for British Art, New Haven, Paul Mellon Collection.

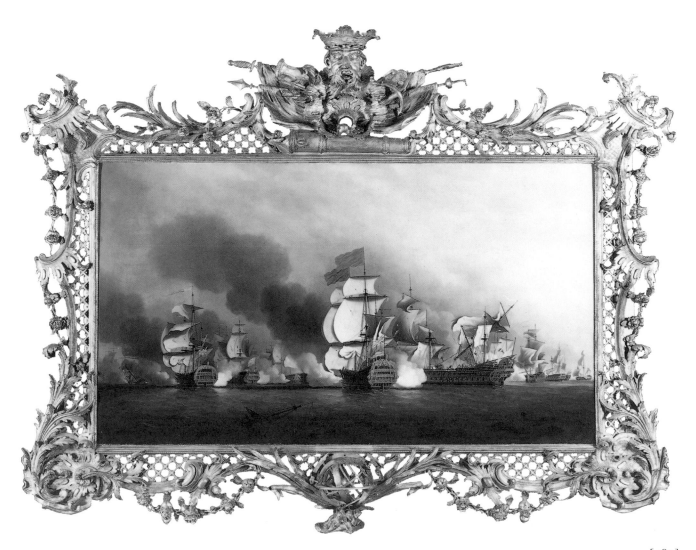

140 **An Arch of Westminster Bridge** *c.*1750

T 01193
Oil on canvas 1355 × 1640 ($53\frac{1}{4}$ × $64\frac{1}{2}$)
Purchased (Grant-in-Aid) 1970

PROVENANCE
Perhaps painted for Sir Lawrence Dundas, but
more probably purchased by him at the
artist's sale, Langford's, 4 April 1765 (74, 'a
large piece – of part of Westminster Bridge');
Dundas sale, Greenwood's 30 May 1794 (16 as
'View through one of the arches of
Westminster Bridge looking towards
Blackfriars, with boats and figures bathing',
52 × 56 in) 34 gns bt de Grey (?Annabel de
Grey, who succeeded as 5th Baroness Lucas,
1797); by descent to the 9th Baroness Lucas
(also 12th Baroness Dingwall), who d.1958,
having married, in 1917, Colonel Howard
Lister Cooper from whom bt by the Tate
Gallery

EXHIBITED
RA 1934 (252, *Commemorative Catalogue*,
pl.XXXIII); *100 Years of British Painting,
1730–1830*, BC tour, Lisbon and Madrid 1949
(40); *Paintings and Drawings by Samuel Scott*,
Agnew 1951 (23); *Samuel Scott Bicentenary*,
Guildhall Art Gallery 1972 (31)

LITERATURE
Waterhouse, 1953, p.117, pl.95b; Kenneth
Sharpe, 'Westminster Bridge by Samuel
Scott', 1964 (MS in author's possession, copy
in Tate Gallery catalogue files); R.J.B.
Walker, *Old Westminster Bridge*, 1979, p.159;
Kingzett 1982, pp.62–4, version E, p.64, pl.23

Until the construction of 'Old' Westminster Bridge (later so-called, after its
demolition to make way for the erection of the present bridge, 1854–62), London
had only one bridge (London Bridge) over the Thames; the city's rapid growth
had, long before 1700, made this inadequate. After much discussion over the point
at which the river should again be bridged, on 20 May 1736 the 'Act for Building a
Bridge across the river Thames, from the New Palace Yard in the City of
Westminster to the opposite Shore in the County of Surrey' was passed, and
Commissioners were appointed to select its builder. Designs were submitted by
Nicholas Hawksmoor (then in the last year of his life), by the Swiss-born engineer
Charles Labelye (who had already assisted Hawksmoor with calculations), by
John Prince and by Batty Langley. The Commissioners selected Labelye as
designer and engineer, confirming his appointment on 10 May 1738, at a salary of
£100 a year, with subsistence of ten shillings a day.

On the afternoon of 29 January 1739, 'the first Stone, which weigh'd upwards of
a Ton weight, for building the Main Arch of the new Bridge, was laid by the Right
Hon. the Earl of Pembroke ... with great Formality, Guns firing, Flags displaying,
&c.' On 14 November 1747, Labelye declared that the Bridge was 'completely
finish'd, and the whole was performed in seven Years, nine Months, and sixteen
Days from the laying of the first Stone' (quotations are from Walker 1979, pp.60,
95, 172). But settlement of the piers was soon found to have damaged several
arches, making immediate repairs urgent; and the bridge was not finally opened to
traffic until 18 November 1750.

Scott made many sketches of the bridge, from various viewpoints, during the
various stages of its construction, later composing paintings (of which there are in
most cases several versions) from his sketches, and, as Walker notes (1979, p.232),
'juggling with the time sequence of his paintings, building them up from
appropriate pages of his sketch-books'. None of these views should therefore be read
as documentary records, accurately depicting progressive stages in the bridge's
construction; and some of them may have been made years after the completion of
the activities they depict.

Sharpe (1964) suggests that the composition of no.140 reveals the influence of
Canaletto, who had arrived in England in 1746; in particular he cites one of
Canaletto's drawings which shows a similar viewpoint (fig.49, in the collection of
the British Museum, 1905-5-20-1, repr. *Walpole Society*, IX, 1921, pl.XIIIA). Walker

140

(1979, p.235), commenting on Scott's and Canaletto's treatment of the view, notes that 'the loving care with which he [Scott] cherished the subtle colour combination provided by Labelye's use of Portland and Purbeck stone shows a perceptiveness which the great Venetian sometimes missed in his English views'.

Canaletto's drawing (fig.49), though taken from a little further back, shows the landing-stage from which Scott must have made his studies for this subject, and helps to establish the fact that, of the fifteen arches in Old Westminster Bridge, Scott's view in this composition is of the second and third arches (technically described as west 52' and 56') from the bridge's Westminster abutment. The view through the arches is of the northern bank of the Thames, from Westminster towards the City of London; reading from left to right, one can see, under the second (left) arch, the Fishmarket Wharf, Montagu House and the houses of Mr Joshua Smith, the Duke of Portland, Mr Andrew Stone, the Countess of Portland and the Earl of Pembroke, and the York Buildings Water Tower; and, under the third (right) arch, the Savoy, with St Mary-le-Strand behind it, and a glimpse of old Somerset House and its gardens.

Four other versions of this view are catalogued by Kingzett: A, 895 × 1180 (35 × 46½), National Gallery of Ireland, Dublin; B, 895 × 1015 (34¼ × 40), Lewis Walpole Library, Farmington; C, 270 × 397 (10⅝ × 15⅝), Tate Gallery N01223,

see; D, 1060 × 1180 (41½ × 46½), Yale Center for British Art, New Haven (repr. Walker 1979, p.261). All are probably based on one or both of two drawings in Scott's sale, Langford's, 13 January 1773 (33, 'Two views of Westminster Bridge . . .'; see Sharpe 1964). Since these studies include the domed turrets on top of the piers (recessed on the inner sides of the bridge to offer rest or shelter to pedestrians), they may well have been drawn between 21 February and 14 November 1747, when this work was completed; this part of the bridge was not affected by the settlement which made repairs above other piers urgent, delaying the bridge's opening (see the contractors' journals and letter-books, BL Add. MS. 27587, extensively used by Walker 1979). But Scott's painted versions may have been made months or even years after the bridge's opening, though it may be noted that the Dublin picture (version A, fig.50) shows the wrought-iron lamp standards which were erected (though not in fact over these two arches of the bridge) just before the bridge's opening.

fig. 50 Samuel Scott: 'An Arch of Westminster Bridge'. Oil on canvas 889 × 1182 (35 × 46½). National Gallery of Ireland, Dublin.

Each of the five versions shows variations in the arrangements of boats, figures, etc., but as Sharpe points out, the major difference between versions A, B and C, considered as one group, and versions D and E, considered as another, is that the first three all fail to depict the underside of the arch on the right. The Yale Center picture and no.140 (versions D and E) show a deliberate and visually very satisfying squaring up and tightening of the composition, and their inclusion of the view of the underside of the right arch is surely a 'correction' that makes these two later than the other three.

Most of the versions seem to celebrate – in no.140, perhaps, most satisfyingly of all – the moment when the masons have put the final touches to the stonework of the domed turrets, pausing on their apparently ramshackle yet practical enough wooden platform (a detail perhaps inspired by Canaletto) to share a flagon of beer. Kingzett particularly applauds the 'monumentality' of the composition of no.140, adding that here, after Scott had watched and sketched the bridge throughout its construction, 'it seems that almost deliberately he chose the final moment when the last touches were being added to the parapet.' Certainly the impromptu drinking seems like a well-earned celebration, and as such provides, as Kingzett notes, a 'characteristically human touch in Scott's work'. One should however note that the stonework on the left-hand turret is still apparently unfinished (unless Scott has deliberately falsified its appearance into 'flatness' to reduce too prominent a feature on the extreme left of his picture, as in the smaller Tate Gallery version, C), and that work may yet remain to be done on the rest of the bridge's fifteen arches.

fig. 49 Antonio Canaletto: 'Part of Westminster Bridge', c.1747. Pen and wash 414 × 730 (16¼ × 28⅝). Reproduced by courtesy of the Trustees of the British Museum.

141 **An Arch of Westminster Bridge** *c*1750

N 01223
Oil on canvas 270 × 397 ($10\frac{5}{8}$ × $15\frac{5}{8}$)
Purchased by the National Gallery (Clarke Fund) 1886; transferred to the Tate Gallery 1949

PROVENANCE
Probably the artist's sale, Langford's 4 April 1765 (13, 'A small view of part of Westminster Bridge'); ...; Henry Graves & Co. until 1886, when bt by the National Gallery

EXHIBITED
18th Century Painting, East Kent and Folkestone Art Centre, Folkestone, 1967 (22); *Views of the Thames from Greenwich to Windsor by Eighteenth Century Artists working in England*, Marble Hill House 1968 (11); *Royal Westminster*, Royal Institution of Chartered Surveyors, London 1982 (192)

LITERATURE
Kingzett 1982, pp.62–4, version C, p.63 (wrongly given as on panel)

This is the smallest of five versions of this subject, listed under no.140, *q.v.* for an account of the construction of the bridge and Scott's interest in it.

No.141 may be Scott's first version in oils of this subject, which evolved from pencil studies made on the spot (see below). Like versions B and C, it fails to depict the underside of the right-hand arch, a failure corrected in versions D and E. Comparison with no.140 (version E) shows that in that picture Scott also modified the too-prominent dome on the turret at the extreme left of no.141 into a flat (or flatter) shape. In no.141 the group of masons about to celebrate the apparently imminent conclusion of their work includes three rather than two figures; one has perched a wicker basket (? for tools) on the ledge of the parapet, a rather intrusive detail which Scott omitted in no.140.

141

142 **A Morning, with a View of Cuckold's Point** *c.*1750-60

N 05450
Oil on canvas 520 × 962 (20½ × 37⅞)
Presented by H.F. Tomalin to the National
Gallery 1944; transferred to the Tate Gallery
1953

PROVENANCE
Probably the artist's sale, Langford's 4 April
1765(55); ...; William Hartman, sold Curtis
& Henson 14 July 1927(410) bt Pawsey &
Payne; Knoedler 1927; Cotswold Gallery
1930, from whom bt by H.F. Tomalin

EXHIBITED
London River, Valence House, Dagenham
1960; Guildhall 1972(42)

LITERATURE
Hilda F. Finberg, 'Samuel Scott', *Burlington
Magazine*, LXXXI, 1942, p.201, pl. lb; Robert
R. Wark, *Early British Drawings in the
Huntington Collection*, San Marino, California,
1969, pp.42-3, repr. p.42, fig.11; Luke
Herrmann, *British Landscape Painting of the
Eighteenth Century*, 1973, p.33, pl.25 B;
Kingzett 1982, pp.76-7 (A, p.76), pl.27a

See no.143

143 **A Sunset, with a View of Nine Elms** *c.*1750-60

T 01235
Canvas 515 × 960 (20¼ × 37¾)
Presented by the Friends of the Tate Gallery
1970

PROVENANCE
Probably the artist's sale, Langford's 4 April
1765 (56); ...; William Hartman, sold Curtis
& Henson 14 June 1927 (411) bt Pawsey &
Payne; Knoedler 1927; Gooden & Fox May
1945, from whom bt Stanley A. Kirsch 1945;
by descent to his daughter, Mrs Noelle
Woodford, from whom bt 1970

EXHIBITED
The Shock of Recognition, Mauritshuis, The
Hague (44, repr.) and Tate Gallery 1971 (42,
repr.); Guildhall Art Gallery 1972 (41); *Look
Alike: Themes and Variations in Art*, National
Gallery of Scotland, Edinburgh, 1982 (5, with
Jan van Goyen, 'Dutch River Scene', coll.
National Gallery, Scotland)

LITERATURE
Hilda F. Finberg, 'Samuel Scott', *Burlington
Magazine*, LXXXI, 1942, p.201, pl. la; Kingzett
1982, pp.76-7 (C, p.77), pl.28b

The titles given above to nos.142 and 143 are based on the assumption that the paintings are identifiable as the companion pieces sold at Scott's sale in 1765 (55, 'A Morning, with a View of *Cuckold's Point*', and 56, 'Its Companion, a Sun Set, with a View of Nine Elms'). The two paintings appeared as consecutive lots in the Curtis and Henson sale of 1927, in which they were entitled 'The Thames at Deptford' (no.142) and 'The Thames at Battersea' (no.143), but were later sold separately by Knoedler. The Tate Gallery's acquisition of no.143 in 1970 reunited the pair.

Both Cuckold's Point and Nine Elms are on the south bank of the Thames. Cuckold's Point marks a sharp bend of the river a little below the parish church of St Mary, Rotherhithe; beyond it stretches Limehouse Reach. Nine Elms is the name given to the area now most conspicuously dominated by (the new) Covent Garden Market. Since the banks of the Thames have been greatly altered at both Cuckold's Point and Nine Elms during the last two centuries, and no accurate visual record of either during the eighteenth century would appear to be extant, the evidence for these identifications must remain circumstantial. A number of features in the pictures do, however, strongly support the association. The morning and

142

143

evening effects specified in Scott's 1765 titles are clearly visible in nos.142 and 143, Cuckold's Point being seen in a silvery morning light and Nine Elms in an evening glow. Furthermore, the identity of no.142 as a view of Cuckold's Point can be established with some certainty since the unusual feature which gained the location its name, a post surmounted by a pair of horns, is included. Other parts of the picture, in particular the stairs, ferry, timber-yards and distant dock, also coincide with what is known of the appearance of Cuckold's Point at this time (see Harold Adshead, 'Cuckold's Point', *The Port of London Monthly*, XXIX, 1954, pp.197–9; some impression of this part of the river can also be gained from Rocque's *Map of London*, 1746).

Similarly, it is reasonable to suppose that no.143 represents Nine Elms pier. The large trees in the background are presumably the tall elms which gave the area its name. The church in the distance is probably St Mary's, Battersea.

fig. 51 Samuel Scott: Study for 'A Morning, with a View of Cuckolds Point'. Pencil and grey wash 134 × 324 (5¼ × 12¾). Huntington Library and Art Gallery, San Marino, California.

fig. 52 Samuel Scott: 'Four Men Careening the Hull of a Boat with another Bringing Faggots for their Fire'. Ink and wash 197 × 310 (7¾ × 12¼). London Borough of Southwark, South London Art Gallery.

Scott, whose paintings reveal a strong feeling for tonal effects, often included references to weather and light conditions in the titles of his pictures. Nos.142 and 143 seem, however, to be the only works in which he specifically contrasted different times of day.

Scott appears to have taken an interest in Dutch-inspired riverside scenes of a semi-rural nature after his acquisition of a country retreat at Twickenham in 1749. Another version of no.142, in a private English collection (Kingzett 1982, pp.76–7, B), is documented as one of three Thames views bought from Scott in 1761; nos.142 and 143 may date from about the same time.

Kingzett notes that a drawing, presumably for the subject of no.142, was included on the first day of Scott's studio sale on 12 January 1773 (57, 'Two, a View of Greenwich Hospital and 1 of Cuckold's Point'). This was probably the pencil and grey wash drawing for the buildings and the beached rowing-boat in the right-hand half of the picture, now in the Huntington Collection (fig.51; Kingzett 1982, pp.105–6, D 111, p.27c). An ink and wash drawing of 'Four Men Careening the Hull of a Boat with Another Bringing Faggots for their Fire', in the South London Art Gallery, is a study for the men working on the beached boat (fig.52; Kingzett 1982, p.97, D 90, pl.27b).

Kingzett also notes (p.77) that lot 74 among the drawings in the studio sale of 1773 included '1 near Chelsea', which could perhaps have been a drawing for no.143, but is now untraced.

144 A View of Westminster Bridge with Parts Adjacent engr. 1758

N 00314
Oil on canvas 300 × 540 (11¾ × 21¼)
Presented by Robert Vernon to the National
Gallery 1847; transferred to the Tate Gallery
1919

PROVENANCE
...; Robert Vernon by 1847

EXHIBITED
Guildhall Art Gallery 1955(12)

ENGRAVED
Line-engraving by P.C. Canot, pub. 25
February 1758, as a pair to 'A View of London
Bridge ...' (after no.145, q.v.)

LITERATURE
Vernon Heath, *Recollections*, 1892, p.348;
Kingzett 1982, pp.60–2, as 'Westminster
Bridge with Neighbouring Houses', version C,
p.61

There are four other versions (see below) of this view. It is rarely possible to suggest precise dates for Scott's London views, still less for the different versions of them. A date of c.1750–7 is suggested for no.144 since it was this version which was engraved by Peter Charles Canot and published (as a pair to the engraving of no.145, q.v.) on 25 February 1758. The engraved title reads in full, 'A View of Westminster Bridge with parts adjacent as in the Year 1747', but in fact none of the oil versions of this view could have been painted (or at least completed) as early as 1747, since all of them show the wrought-iron lamps upon the bridge's turrets, which were not placed there until October 1750.

Details of Canot's engraving and of subsequent reissues are given in Kingzett 1982 p.62, (E2). One of the eighteenth-century reissues (lettered 'A View ... as in the year 1760') is reproduced in Hugh Phillips, *The Thames about 1750*, 1951, p.131, fig.145, with a key identifying the range of buildings adjoining the bridge's Westminster abutment as (from left to right) Manchester Stairs, Manchester Court, the backs of the Dorset Court houses (united by a single pediment to appear as a single house) and the side of Derby Court.

Kingzett notes that all versions of this view are based on a large panoramic drawing (340 × 1092, 13⅜ × 43, fig53) which apparently remained in Scott's studio until his sale of 1773 (and is now in the British Museum, 1865-6-10-1324; Kingzett 1982, D97, p.19b). He points out that this drawing must have been made before the arches' abutments were completed, i.e. before 19 January 1745, but that all the versions painted in oils show not only the completed arches but also the lamps in position on their turrets, instancing this as a case where Scott 'used an earlier drawing for the framework of the picture and added the subsequent architectural features by the time he came to paint the scene'.

Kingzett (1982, pp.60–2) notes four other versions of the painting: A, 685 × 1143 (27 × 45), in the collection of the Worshipful Company of Fishmongers; B, 457 × 1372 (18 × 54), in the collection of the Earl of Radnor (fig.54); D, 400 × 762 (15½ × 30), private collection, UK; E, 940 × 1522 (37 × 60), in the collection of Lord St Just. He suggests that the tightness of handling and lack of atmosphere in no.144 are due to the fact that this version was painted for the engraver's use.

fig. 54 Samuel Scott: 'A View of Westminster Bridge with Parts Adjacent'. Oil on canvas 456 × 1372 (18 × 54), overdoor. Private Collection (photo: Courtauld Institute of Art).

fig. 53 Samuel Scott: Study for 'A View of Westminster Bridge with Parts Adjacent'. Dated topographically by Kingzett before 19 January 1745. Indian ink and grey wash tinted with watercolour 340 × 1092 (13⅜ × 43). Reproduced by courtesy of the Trustees of the British Museum.

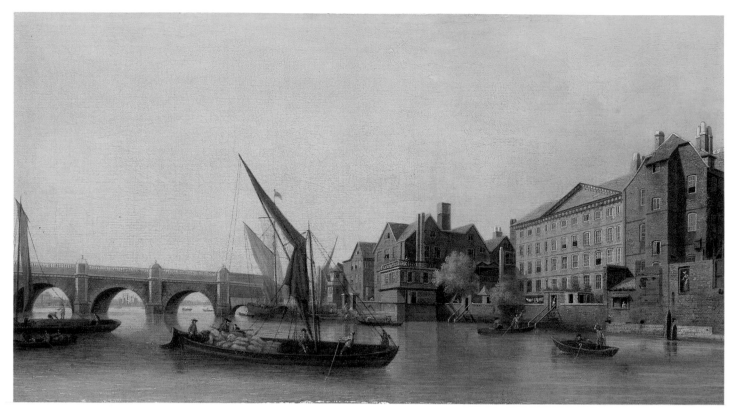

144

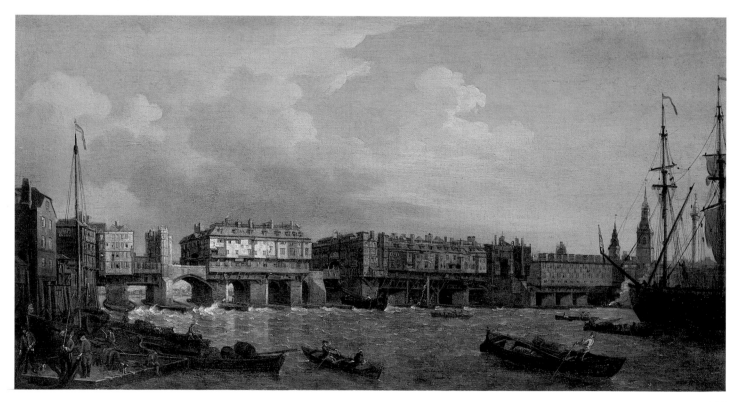

145

145 **A View of London Bridge before the Late Alterations** engr. 1758

N 00313
Oil on canvas 285 × 545 ($11\frac{1}{4} × 21\frac{1}{2}$)
Presented by Robert Vernon to the National
Gallery 1847; transferred to the Tate Gallery
1919

PROVENANCE
...; Robert Vernon by 1847

ENGRAVING
Line-engraving by P.C. Canot, pub. 25
February 1758, as a pair to 'A View of

Westminster Bridge...' (after no.144, *q.v.*) 'to
be had at Mr. Scotts in Henrietta Street
Covent Garden'

LITERATURE
Vernon Heath, *Recollections*, 1892, p.348;
Hilda F. Finberg, 'Canaletto in England',
Walpole Society, IX, 1921, p.49; Kingzett 1982,
pp.43-9, version J, p.48

The view is of Old London Bridge as it looked shortly before 1760, when the houses upon it were finally demolished. The bridge itself (London's only bridge until the opening of Westminster Bridge in 1750) was constructed about 1209; its twenty piers supported nineteen irregularly spaced arches. Building upon the bridge itself progressed erratically over the next 600 years, without any coherent planning and subject to recurring disasters, particularly fire. Reading from left to right, the buildings depicted on the bridge itself are a group of houses last rebuilt after the fire of 1725; the Great Stone Gateway (originally built in the thirteenth century, incorporating a drawbridge and portcullis and impregnable to human attack), also rebuilt after the fire of 1725; a group of houses with railed roof gardens, rebuilt in the seventeenth century; the drawbridge, once regularly raised to let tall-masted ships pass, already 'ruynous' by 1500, when Henry VII insisted on its being raised (apparently for the last time) for his royal barges, and permanently 'fixed' in 1722; Nonesuch House, an elaborately decorated building pre-fabricated in Holland, slotted into the site of the Old Drawbridge Gate in 1577 and by now in the last stages of decay; a group of seventeenth-century houses known as 'The Middle', also with railed roof gardens; the remains of the Chapel of St Thomas, partially demolished in the 1550s, converted into tenements and latterly the premises of the stationers Wright & Gill; the Waterworks (with the Water Tower) which supplied the City of London; and, most recent of all, the block of elegant shops designed by George Dance the Elder, built about 1745 and known as 'The Piazza' from its inner, colonnaded street frontage. Rising behind the bridge are the church spires of St Michael, Crooked Lane and St Magnus the Martyr, with a view of the monument between the masts of the ship on the right (a key to this view, based on a drawing evidently derived from Canot's 1758 engraving after Scott, is given in Peter Jackson, *London Bridge*, 1971, pp.56-7).

No.145, painted as a pendant to no.144 (*q.v.*), is one of eleven versions of a composition whose popularity evidently owed much to general nostalgia for the bridge as it had appeared in former centuries. It is the Tate Gallery version which was used for Canot's engraving, published in 1758 (see above). Details of the other versions, and of the drawings in Scott's studio sale of 1773 on which the composition was probably based, are given in Kingzett 1982. The picture entitled 'View of London Bridge as in the year 1757' which Scott exhibited at the Society of Artists in 1761 (99) was, Kingzett suggests, probably the version now in a private collection, Canada (fig.55 is Kingzett's version C).

fig. 55 Samuel Scott: 'A View of London Bridge before the Late Alterations'. Oil on canvas 456 × 1372 (18 × 54), overdoor. Private Collection (photo: Courtauld Institute of Art).

after SAMUEL SCOTT

146 A View of the Thames with the York Buildings Water Tower *?c.*1760–70

N 01328
Oil on canvas 603 × 1105 ($23\frac{3}{4}$ × $43\frac{1}{8}$)
Purchased by the National Gallery out of the
Wheeler Fund 1891; transferred to the Tate
Gallery 1891

PROVENANCE
...; Colnaghi, from whom bt by the National
Gallery 1891 (as by Samuel Scott)

This is a copy, by a competent but probably unidentifiable near-contemporary, of a subject by Samuel Scott of which Kingzett 1982 (pp.54–5) catalogues three versions. The copyist probably worked from version C, which shows the final arch of the bridge fully built and is likely to have been commissioned to celebrate its completion in 1750. As Kingzett notes, Canaletto made a drawing and two paintings from almost the same viewpoint, and may have been working from Scott's first study for his picture, or more probably from Scott's first version of it, painted *c.*1742–3.

The subject was evidently a popular one. Other copies by unknown hands have passed through the art market; the copyists usually follow Scott's architectural details, but provide their own variations, as the artist of no.146 does, on the shipping and figures.

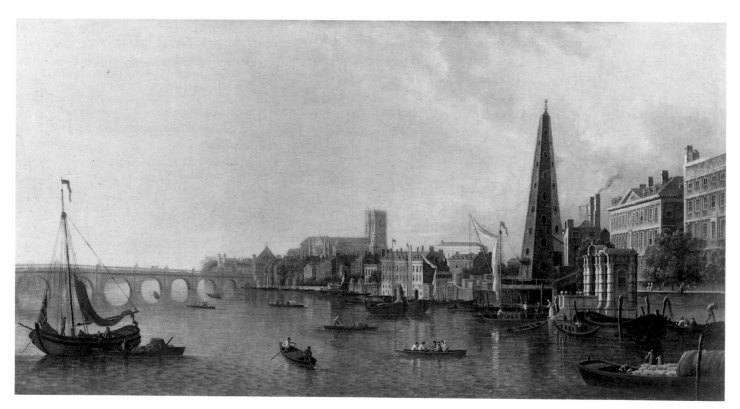

146

JAMES SEYMOUR ?1702-1752

Sporting painter and draughtsman. Born ?1702, presumably in London, son of James Seymour (d.1739), banker, jewel merchant and supplier of plate for racing trophies in Mitre Court, Fleet Street. The elder Seymour was an amateur draughtsman, specialising in pen and ink studies of heads, a dealer in prints and drawings and a member of the Virtuosi Club of St Luke; declared bankrupt in 1736, for which Vertue (III, p.86) blames his son's extravagances. Vertue sums up the younger Seymour's career thus:

> Jimmy Seymour ... from his infancy had a genius to drawing of Horses – this he pursued with great Sprit. set out with all sorts & of modish extravagances. the darling of his Father run thro some thousands – livd gay high and loosely – horse racing gameing women &c country houses never studied enough to colour or paint well. but his necessityes – obliged him. to work or starve. thus his time passed. the latter part of his life in baseness and want of all necessaries. and dyed in Town. in the lowest circumstances & in debt – Southwark June – 1752. aged about or under 50 ...

The Gentleman's Magazine, XXII, p. 336, gives 30 June 1752 as the date of death of 'Mr. Seymoor, an ingenious painter, particularly eminent in horse-painting'.

Presumably learnt draughtsmanship from copying prints and drawings in his father's collection; perhaps encouraged by Wootton and Tillemans, fellow-members with his father of the Virtuosi Club, learning particularly from Wootton's manner *c.*1715-30 of painting a racehorse with groom and jockey in profile and close-up. ?Earliest signed and dated racehorse painting 1721; prolific and apparently steady output thereafter indicates a more continuous professional practice than Vertue suggests. Many of his racehorse portraits and some hunting scenes and interiors of stables engraved in 1740s and 1750s; may occasionally have worked for Thomas Butler, printseller and middlemen between sporting patrons and painters, and was associated with Thomas Spencer (*q.v.*), ?his pupil. Seymour's drawings are fluent and expressive; his oil paintings are more static, and are distinguished by directness and crisp details of saddlery, dress, etc. His life and work need scholarly investigation, if Vertue's account is to be tested and if distinction between Seymour's work and that of his imitators is to be made.

147 **Chestnut Horse with a Groom near Newmarket** *c.*1730–40

T 02265
Oil on canvas 661 × 1040 (26 × 41⅛)
Bequeathed by Miss Agnes Clarke 1978

Clarke (formerly citizens of USA), who settled
after World War II at Killagorden House,
Idless, Truro, Cornwall

PROVENANCE
...; according to Miss Clarke's solicitors,
probably bt in the 1950s in England by Miss
Clarke and/or her brother, John Semple

EXHIBITED
British Sporting Paintings, Fermoy Art Gallery,
King's Lynn 1979 (4)

A pack of hounds disappearing to the right in the middle distance suggests that the
main subject is probably a hunter, held by a groom waiting for his master, rather
than a racehorse; the hounds' quarry is likely to be the hare, since coursing near
Newmarket was very popular. The horse is a chestnut stallion, with a white star on
the forehead and a white marking on the muzzle; the saddlecloth is white edged
with blue. The groom's livery jacket is dark green, brass-buttoned, and his
topboots are spurred. Without further clues, the horse and his master are
impossible to identify.

The picture appears to have been painted from Warren Hill, to the east of
Newmarket town. In the centre of the distant view of Newmarket rises the spire of
St Mary's Church. A large two-storied building with projecting wings, deliberately
and perhaps disproportionately featured in the distance on the right, may be the
stable-block of the horse's owner, but no longer stands and cannot now be
identified (information kindly supplied by Canon Peter May, Newmarket, to
whom at the suggestion of the Suffolk Record Office the problem of identifying the
view was referred).

147

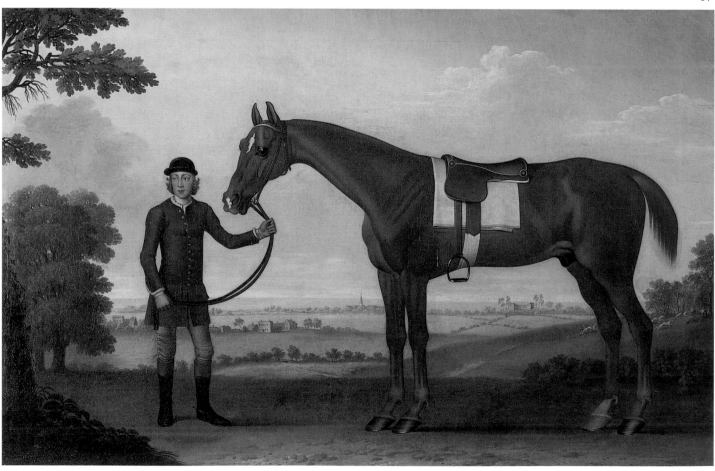

Chestnut Horse with a Groom near Newmarket *c.*1730–40

148

148 **Mr Russell on his Bay Hunter** *c.*1740

T 02372
Oil on canvas, 870 × 1108 (34½ × 43⅝)
Presented by Mr Paul Mellon KBE through
the British Sporting Art Trust 1979

PROVENANCE
. . . C.B. Kidd, sold Sotheby's 23 November
1966 (169, repr.) bt Ackermann for Paul
Mellon

EXHIBITED
British Sporting Paintings, Fermoy Art Gallery,
King's Lynn 1979 (3, repr. in col. on cover of
cat.)

LITERATURE
Egerton 1978, p.45, no.48, pl.17; Christopher
Neve, 'Gift from a Galloping Anglophile',
Country Life, 30 August 1979, p.585, fig.3

An old label on the back reads 'Paternal Ancestor (Russell)'. Mr Russell, preceded
by a hound, is portrayed in the hunting-field; he turns to face the spectator,
revealing individual features and an alert expression which have together
stimulated Seymour to one of his ablest and most sympathetic exercises in human
portraiture. The sitter, who appears to be in his forties, has so far eluded precise
identification. Given Seymour's continued association with Newmarket, a tenta-
tive suggestion is that he may be a junior member of the family of Admiral Russell

(created Baron Shingay and Earl of Orford for his victory over the Dutch at La Hogue; d.1729), who acquired the manor of Chippenham Park, just outside Newmarket.

Details of costume, such as the firmly tied breeches-lacings and the buttoned leather strip above the knee to keep the breeches from riding up, are sharply observed and painted with Seymour's customary meticulousness.

149

149 **A Kill at Ashdown Park** 1743

T 01115
Oil on canvas 1805 × 2390 (71 × 94)
Inscribed 'J. Seymour pinxit. 1743' on stone
wall b.l.
Purchased (Grant-in-Aid) with assistance
from the Friends of the Tate Gallery and with
individual contributions from Mr A.H.
Carnwarth, the Macdonald-Buchanan
Trustees, Frank Partridge and Sons, Sir Colin
Anderson, Sir Henry and Lady D'Avigdor
Goldsmid, The Hon. Mrs Peter Samuel, Mrs
Cynthia Fraser and others 1969

PROVENANCE
Presumably commissioned by Fulwar, 4th
Baron Craven; by descent to Cornelia,
Countess of Craven, sold Sotheby's 27
November 1968 (118, repr.) bt Ackermann for
a private collector in the USA but export
licence witheld, whereupon bt by the Tate
Gallery

LITERATURE
Roger Longrigg, *The History of Foxhunting*,
1975, pp.60, 62, and 65, repr.

The principal figure is Fulwar, 4th Baron Craven of Hampstead Marshall, Berkshire, wearing a tricorne hat and seen in profile on his dark grey hunter. He is portrayed at the age of about forty; born between 1700 and 1704, he was the younger son of William, 2nd Baron Craven, by his wife Elizabeth Skipwith, after whose brother Sir Fulwar Skipwith he was presumably named. Fulwar Craven succeeded as 4th Baron Craven on the death of his elder brother, William, 3rd Baron Craven. He was educated at Rugby School and at Magdalen College, Oxford; he died unmarried at Benham Valence, Bucks., on 10 November 1764.

Ashdown House, which is clearly visible in the background on the left in Seymour's picture, was built c.1665 by an unidentified architect as a hunting-lodge for William, 1st Baron Craven (the constant supporter of Elizabeth of Bohemia); the principal Craven seat was at Hampstead Marshall, near Newbury. The plan of Ashdown House is a straightforward square, set facing the four cardinal points of the compass. An octagonal cupola crowned by a golden ball surmounts the roof, commanding a very wide view of the Berkshire Downs. Seymour's viewpoint is from the south-east, on Kingstone Downs, looking towards the south and east (i.e. the back) of Ashdown House. The two hills on the right of the picture appear to be Weathercock Hill and (further from the spectator) Crowberry Tump (the compilers are grateful to the Berkshire County Archivist for establishing the viewpoint). A panoramic view of the house and park drawn by Leonard Knyff and engraved by Johannes Kip, published in *Britannia Illustrata*, 1708, shows them to have remained unchanged in Seymour's painting of 1743.

Longrigg suggests (p.65) that the 4th Lord Craven began fox-hunting in 1739 (the year of his succession); his successors maintained the pack. He notes that Seymour portrays tricolour (black, white and tan) foxhounds, with some of the blood of the Duke of Richmond's kennels at Charlton in Sussex, and that the Cravens were typical of the territorial magnates who maintained the hunt at their own expense.

Seymour shows the foreground littered with 'sarsens', the distinctive sandstone boulders that still characterise the district.

Other paintings by Seymour in the Craven sale (Sotheby's 27 November 1968) show the 4th Lord Craven in other sporting pursuits. One of these works (119, repr.), also set on the Berkshire Downs, represents him coursing, apparently with the same two greyhounds which are portrayed chasing a hare in the background on the right in no.149; some of the horses appear to be the same in both pictures.

Attributed to James Seymour 1702-1750

150 **Pointer Bitch** *c.*1740

T 02264
Inscribed 'J:S' b.l.
Oil on canvas 921 × 1046 ($36\frac{1}{4}$ × $45\frac{1}{8}$)
Bequeathed by Miss Agnes Clarke 1978

PROVENANCE
...; according to Miss Clarke's solicitors,
probably bt in the 1950s in England by Miss

Clarke and/or her brother, John Semple
Clarke (formerly citizens of USA), who settled
after World War II at Killagorden House,
Idless, Truro, Cornwall

Some doubts must attend a positive attribution to Seymour, since the style, particularly in the rather loosely painted background, does not seem crisp enough for this to be Seymour's own work. Similar initials appear on other paintings and drawings which are unlikely to be by Seymour himself, although evidently (like no.150) contemporary with his work.

The pointer bitch is seen in profile in the foreground, and again (her distinctive markings establishing her identity) in the middle distance, this time in action, with a sportsman and two shooting ponies, one held by a groom. This is evidently a commissioned portrait of a particular animal, perhaps prized both for her skill in the field and for breeding purposes. All clues to her identity are now lost, but the prominent thistle in the foreground on the right may indicate that her proud owner was Scottish.

150

STEPHEN SLAUGHTER 1697-1765

Portrait painter. Baptised at St Paul's, Covent Garden, 13 January 1697, attended Kneller's Academy 1712 (Vertue III, p.77 and VI, p.169). The Edward Slaughter recorded at the St Martin's Lane Academy in 1720 (Vertue VI, p.170) is probably his younger brother (see Burial Register of St Mary Abbots, Kensington, for 24 November 1773, and Slaughter's will of 1764/PCC Rushworth 198). According to Vertue 'liv'd abroad, at Paris and Flanders near 17 years', returning to England in 1732/3. Divided his time between Dublin and London throughout 1730s and 1740s; became Keeper and Surveyor of the King's Pictures in 1744. Executed murals of Spenser's *Faerie Queene* for the Chinese Temple at Stowe 1745. Shared his Kensington home with his brother and sisters (including his widowed sister the artist Mrs Judith Lewis) and died there 15 May 1765. Seems to have painted little after 1750.

LITERATURE
A.C. Sewter, *Connoisseur*, CXX, 1948, p.10;
Anne Crookshank & the Knight of Glin', *The Painters of Ireland c.1660–1920*, 1978, p.41

151 The Betts Family *c.*1746

N 01982
Oil on canvas 736 × 615 (29 × 24¼)
Bequeathed (as by Hogarth) by Mrs Anne Sealy to the National Gallery 1879 (and deposited there from then on), with life interest to her daughter Miss M.N. Sealy (d.1905); transferred to the Tate Gallery 1919

PROVENANCE
...; Mathew Raper, FRS, in 1817; ?thence by indirect descent to the donor

LITERATURE
Nichols & Steevens, III, 1817, p.182; E. Einberg, 'The Betts Family: A lost Hogarth that never was', *Burlington Magazine*, CXXV, 1983, pp.415–16, fig. 30

The sitters are described in detail in Nichols & Steevens 1817, p.182, by the then owner of this painting Mathew Raper (1741–1826), FRS, Vice President of the Society of Antiquaries and a Director of the Bank of England:

> A Family Picture, in which Mrs Betts is represented sitting with a child in her lap. On her right side stands her eldest surviving daughter, Miss Anne Betts; and on her left, is the youngest daughter, Rebecca, married to Mr Edmund Anguish, who stands behind her. He was brother to the Rev. Thomas Anguish, Rector of Deptford, and uncle to the Accountant-General, Thomas Anguish. He was the father of the infant lying in the lap of Mrs Betts, whose name was Anne, and afterwards married the writer of these anecdotes. In the foreground of the Picture, on the right-hand side, Dr Hoadly is represented sitting with a case containing a miniature picture of his first wife in his hand, in order to entitle him to a place in the picture, representing a family to which he had always been much attached.

Mathew Raper was convinced that the picture was by Hogarth, and claimed that his family also owned a portrait by Hogarth of Elizabeth Betts, the lady whose miniature Dr Hoadly is holding and whom he had married in 1733. Her portrait

remains untraced, and the date of her death is unknown; the widower remarried in 1747. Raper's information enables one to date the painting to *c.*1746, as his wife, Anne Anguish (1745-1824), the baby in the picture, appears to be about a year old.

The prominence given in the composition to Dr Benjamin Hoadly (1706-57), son of the Bishop of Winchester, physician to the royal household and popular dramatist, even while setting him respectfully apart from the rest of the Betts and the Anguishes, shows that the family set considerable store by this connection and was particularly desirous of making a visual record of it. It is interesting to note therefore that there is a similarity between Hogarth's head-and-shoulders portrait of the same sitter (now in the Art Gallery of New South Wales, Sydney, repr. Beckett 1949, fig.130) and the Tate Gallery picture that is close enough to suggest that the Tate Gallery likeness was taken from the Hogarth portrait, rather than from the live sitter. The Sydney picture is dated to the early 1740s and is thought to have belonged to the Doctor's brother John Hoadly of Winchester, so that it could have been easily made available for copying.

As Mathew and Anne Raper had no children, their heir was their nephew Felix Vincent Raper, a Major-General in the Bengal Army. He died at his Hyde Park home in 1849, and although there is no mention of the Tate Gallery painting in his will, the name Sealy appears among its administrators, allowing one to postulate a family connection between the Rapers and the donor. Many of the above details could be said to be reflected in a garbled sort of way in the Hogarth attribution (impossible on grounds of style) and the title, 'The Hoadly Family in Hyde Park', under which the picture entered the national collection in 1879.

Although there are no securely documented works by Slaughter on this small scale, comparisons with his known portraits on the scale of life (e.g. 'Sir Hans Sloane', 1736, at the National Portrait Gallery and 'John Hoadly, Archbishop of Armagh', 1744, at the National Gallery of Ireland) show enough similarities in technique to make him the most likely candidate so far.

151

152 **Sir George Lee** 1753

T 00674
Oil on canvas 762 × 635 (30 × 25)
Inscribed 'The Right Hon^{ble} Sir George Lee',
t.l. and 'Step^{n} Slaughter Pinx.^{t} 1753' t.r., on
painted oval
Presented by Leggatt Bros through the
National Art-Collections Fund 1964

PROVENANCE
...; Lee family, Hartwell House, Aylesbury,
Bucks.; by descent to Mrs Benedict Eyre, sold
Sotheby's 26 April 1938(82) bt the Hon Mrs
Nellie Ionides, sold by her executors Sotheby's
27 May 1964 (15) bt Leggatt

LITERATURE
DNB 1908, XI (for Sir George Lee)

Sir George Lee (1700–58), eminent lawyer and politician, was the fifth son of Sir Thomas Lee, 2nd Bart, and Alice Hopkins. He became a Member of Parliament in 1733, and represented various West Country seats until his death in December 1758. He was appointed a Lord of the Admiralty in 1742, and was knighted in 1752, becoming a Privy Councillor. At the time of this portrait he held the offices of dean of Arches and judge of the Prerogative Court at Canterbury, and was also treasurer to the Dowager Princess of Wales 1751–7.

He was probably the uncle of William Lee of Totteridge Park (see Vanderbank no.161).

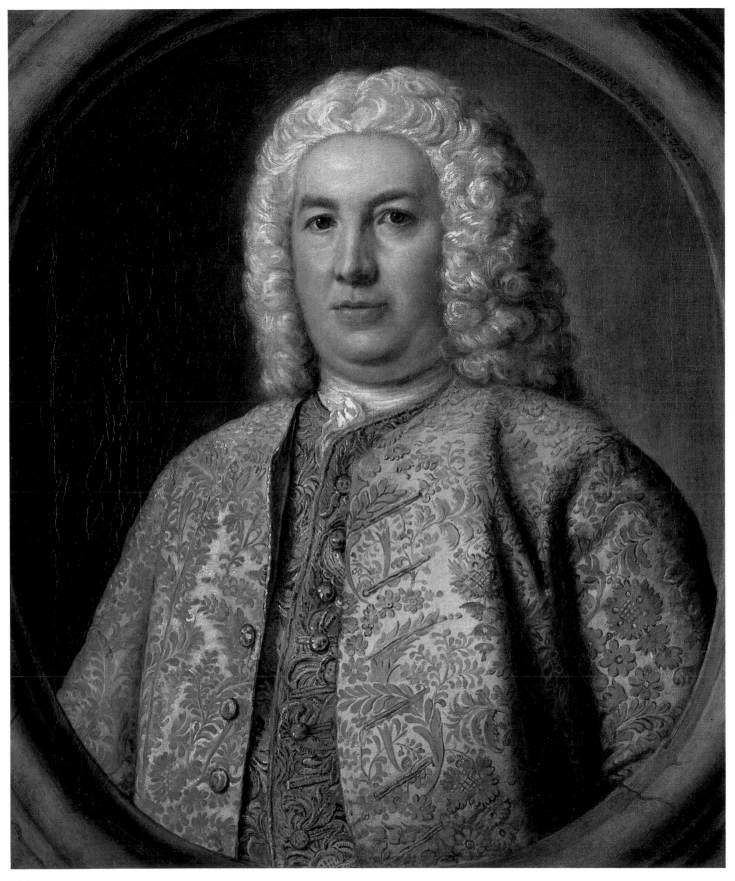

152

FRANCESCO SLETER 1685-1775

Decorative and history painter, said to be a Venetian by birth. Nothing is known of his early training or career, but his style is close to Amiconi and Sebastiano Ricci. First recorded in England in 1719, executing decorative work for the Duke of Chandos at Canons. Also worked at Moor Park, Stowe and Moulsham Hall, and lastly for the Earl of Westmorland at Mereworth Castle, Kent. He died there 29 August 1775, aged ninety, and was buried in Mereworth churchyard.

LITERATURE
Croft-Murray 1970, pp.277-8.

153 A Representation of the Liberal Arts: Ceiling Design for the State Dining Room at Grimsthorpe Castle *c.*1724

T 03465
Oil on canvas 613 × 762 (24⅛ × 30)
Purchased (Grant-in-Aid) 1982

PROVENANCE
...; anon. sale Sotheby's 19 February 1975(91 as by Amiconi) bt Lawrence Riolfo of Venice, sold by him to Sarawood Antiques, bt R.I.H. Paul, by whom sold through Harari & Johns to the Tate Gallery

LITERATURE
H. A. Tipping & C. Hussey, *The Work of Sir John Vanburgh and his School*, 1928, p.317, fig.463 (as by Thornhill); Croft-Murray 1970, pp. 277-8, fig.24; J. Lees-Milne, *English Country Houses: Baroque 1685-1715*, 1970, pp.190-2, figs.313-14

Vanburgh completed Grimsthorpe Castle for Peregrine Bertie, 2nd Duke of Ancaster, in 1724, which is presumably when work on the interior decorations of the State Rooms was begun. These have been previously attributed to Sir James Thornhill and to Antonio Bellucci, but this seems unlikely both on stylistic grounds and in view of the fact that Bellucci is now known to have left England in 1722. Croft-Murray, who recognised the true nature of this sketch in 1975, attributes the Staircase and the State Dining Room ceilings to Sleter on grounds of style.

The final version of this composition as executed at Grimsthorpe (fig.56) is somewhat different from this sketch, having been made into a broader design, with more figures and with some of the groups differently disposed in relation to each other. For instance, the scholar writing in front of the figure holding up a light, probably emblematic of Knowledge, is transposed from the lower right here to the lower left corner of the finished version, with Knowledge now holding up the light with her other arm, making it more the focal point of the entire composition. She is flanked there by the additional winged figure of Time, who further emphasises the light by pointing up towards it. In the final painting the composition is made wider still by the addition of two extruded semicircular ends, while the architectural surround, shown in the sketch here, is abandoned.

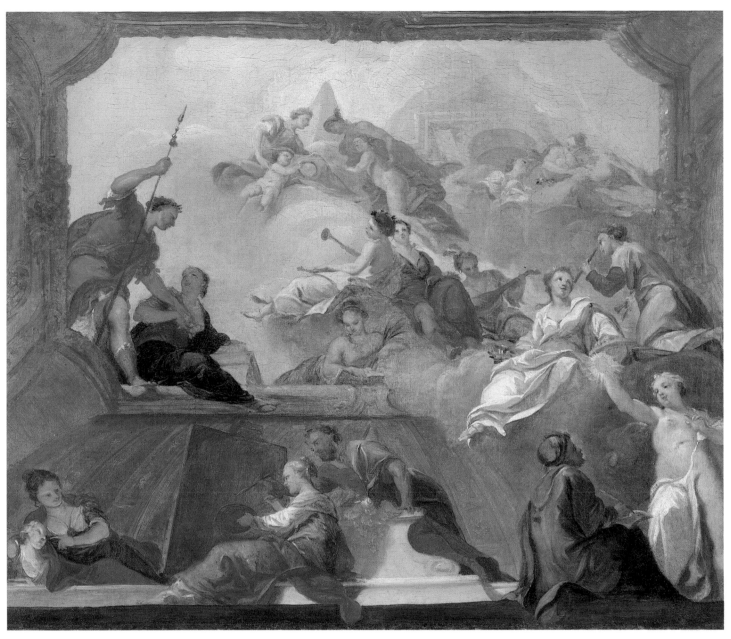

153

fig. 56 Finished Ceiling Decoration
in the Dining Room at Grimsthorpe
Castle *c.*1724.

THOMAS SPENCER active 1740-1756

Painter of horses. His career is obscure, but he was evidently an associate (?and pupil) of James Seymour, whose style he followed, and with whom he was associated in a series of racehorse portraits published by Thomas Butler. Both may have worked for Butler, bookseller, publisher of sporting prints and advertiser of his readiness to supply sporting paintings (some of which bear Butler's own name) to gentlemen who wanted them. On Seymour's death in 1752, Vertue noted 'a paragraph in the news papers pufft to the highest pitch for drawing horses – but this was to notify a scholar he had named Spencer, who follows the same business' (III, p.86).

154 A Bay Hunter Held by a Groom, with a Stag-hunt in the Background c.1750

T 02373
Oil on canvas 1150 × 1355 ($45\frac{1}{4}$ × $53\frac{3}{8}$)
Presented by Mr Paul Mellon KBE through
the British Sporting Art Trust 1979

PROVENANCE
...; anon. sale, Christie's 16 June 1961 (8 as 'A Chestnut Hunter' by John Wootton, repr.) bt Ackermann, from whom bt by Paul Mellon 1961

EXHIBITED
Painting in England 1700–1850: Collection of Mr and Mrs Paul Mellon, Virginia Museum of Fine Arts, Richmond, Virginia 1963 (309)

LITERATURE
Egerton 1978, p.55, no.57

The bay hunter, with its distinctive markings (white star, and three white socks) is portrayed in profile facing left, bridled but unsaddled; a blue-coated groom holds its reins, as if waiting for his master. In the middle distance a stag-hunt is in progress, and here the hunter is again depicted, now ridden by his master (in a red coat), galloping to the right in a group of riders to hounds in full cry after a stag. Spencer uses a similar device of combining a foreground portrait of a hunter with a background scene showing the horse in action in 'Scipio', which remains in the Mellon Collection (Egerton 1978, p.54, no.56, col. pl.9).

The style is evidently closely modelled on Seymour's, though the handling is more naive and the colouring considerably more garish than Seymour's.

154

SIR JAMES THORNHILL 1675 or 6-1734

Decorative painter in the Baroque style, the first major British artist to work in the manner brought to this country by Verrio and Laguerre; occasional portrait painter and architect. His best-known works are in the Painted Hall, Greenwich, and at St Paul's. Teacher and father-in-law of Hogarth (*q.v.*).

Born 25 July 1675 (some authorities give 1676), in or near Weymouth, Dorset, of an ancient Dorset family, though his father, a younger son, was a grocer. Probably brought up by his maternal uncle Dr Sydenham in London. Apprenticed 9 May 1789 to a distant relative, Thomas Highmore (uncle of Joseph, *q.v.*, and minor painter who became Serjeant Painter *c.*1703). May have worked with Laguerre *c.*1696; *c.*1702-4 assisted Verrio at Hampton Court. Freeman of the Painter-Stainers Company 1 March 1703/4. Painted scenery for Thomas Clayton's opera *Arsinoë*, first produced 16 January 1704/5. Worked at Stoke Edith, Herefordshire, the same year, and at Chatsworth 1706. Commissioned to paint the Lower Hall at Greenwich 1707, completed 1714; painted the Upper or Officers' Hall 1718-25. Competed against Pellegrini, Cheron, Berchet and G.P. Caternaro for the decoration of the dome of St Paul's 1709-10; Laguerre was chosen but Thornhill, a Protestant and Englishman, replaced him in 1715, completing the work in 1721. Other decorative schemes include work at Hampton Court (in preference to Sebastiano Ricci), Blenheim, All Souls, Oxford, and Moor Park, where he also acted as architectural adviser but lived to see his paintings replaced by works by Amiconi (see no.1).

Visited the Low Countries in 1711 and Paris in 1717. History Painter in Ordinary to the King 1718; Serjeant Painter and Master of the Painter-Stainers Company 1720. Knighted 1720, buying back the family seat of Thornhill Park. MP for Weymouth 1722. FRS 1723. Director of Kneller's Academy 1711, but this broke up when he took over as Governor in 1716; later opened a room in his own house as a free studio. His fortunes declined in the 1720s when he lost the job of decorating Kensington Palace to William Kent. Copied the Raphael cartoons at Hampton Court 1729-31. Died 4 May 1734 at Thornhill Park. His natural son John (d.1757) succeeded him as Serjeant Painter, but seems to have been of no importance as an artist.

EXHIBITIONS
Sir James Thornhill, exh. cat., Guildhall Art
Gallery 1958; Croft-Murray 1962, pp.69–78,
265; *Sir James Thornhill of Dorset*, exh. cat.,
Dorset County Museum, Dorchester 1975

155 **Three Studies for 'Thetis in the Forge of Vulcan, Watching the Making of Achilles' Armour'** *c.*1710

T 01551
Pen and wash over pencil on paper 253 × 400 (9$\frac{15}{16}$ × 15$\frac{3}{4}$); size of each drawing from left to right 160 × 106 (6$\frac{1}{4}$ × 4$\frac{3}{16}$), 154 × 110 (6$\frac{1}{16}$ × 4$\frac{5}{16}$), 156 × 109 (6$\frac{1}{8}$ × 4$\frac{1}{4}$)
Inscribed 'Iron-Rowler 2 ftt|Brass for one lock|Hinge table|Chimney piece 10 high|House Office–' in pencil above sketch on left, presumably in Thornhill's hand
Purchased (Grant-in-Aid) 1972

PROVENANCE
...; Major Herbert Turnor, MC, of Stoke Rochford, Lincs., by descent to his daughter Mrs R.S. McCorquodale, sold Christie's 6 June 1972 (6, repr.) bt Baskett for the Tate Gallery

EXHIBITED
English Baroque Sketches, Marble Hill House, Twickenham 1974 (30)

LITERATURE
W.R. Omsun, 'A Study of the Work of Sir James Thornhill', PhD thesis, University of London 1950; Croft-Murray 1962, p.270; Michael Gibbon, *Hanbury Hall*, National Trust guide 1967; J. Lees-Milne, 'Hanbury Hall, Worcestershire', *Country Life*, 11 January 1968, pp.66–9; J. Lees-Milne, *English Country Houses: Baroque*, 1970, pp.195–206; A.M. (ed.) *Hanbury Hall, Worcestershire*, National Trust guide 1979, pp.11–17

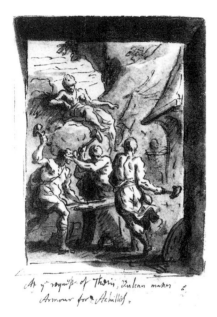

fig. 57 Sir James Thornhill: Study for 'Thetis in the Forge of Vulcan'. Pen and wash drawing. Reproduced by courtesy of the Trustees of the British Museum.

The subject is taken from Book XVIII of the *Iliad*, where the nereid Thetis, mother of Achilles, persuades Vulcan to make a set of impregnable armour for her son, after his old armour had been captured in battle by Hector.

Among the several related drawings of scenes from the *Iliad* by Thornhill in the British Museum is a more worked-out version of the right-hand sketch on the Tate Gallery sheet (fig.57). It is set in an architectural frame and inscribed by Thornhill: 'At ye request of Thetis, Vulcan makes Armour for Achilles' (BM 1865-6-10-1330). Thornhill used this design in a squarer and less upright format for the west wall (A.M. 1979, repr. p.16) of the staircase at Hanbury Hall, Worcestershire, which he decorated for the wealthy lawyer Counsellor Thomas Vernon (1654–1721) with three large scenes and two subsidiary roundels illustrating the story of Achilles (fig.58). The decorations are dated by Edward Croft-Murray to about 1710, and one would therefore assume that the sketches, including the Tate Gallery sheet, immediately pre-date Thornhill's activity at Hanbury Hall. A number of other sketches and drawings for the Hanbury scheme exist, notably at the Courtauld Institute, London, and the Cooper-Hewitt Museum, New York (see exh. cat. by Jacob Simon, *English Baroque Sketches*, Marble Hill 1974).

The subject of the forge of Vulcan, with three Cyclops standing around an anvil with hammers raised, was well-known both in antiquity and the Renaissance. A Roman sarcophagus showing this scene was engraved as plate 66 for Pietro Bartoli's and J.P. Bellori's *Admiranda Romanae antiquitatis et veteris sculpturae vestigia*, 1693, a work mined by many artists for compositional ideas. Thornhill's design for Hanbury Hall has been seen in the past as a modified version of Tintoretto's painting of the same scene in the Doge's Palace, Venice (Omsun 1954, p.18). There are, however, many other versions of the subject which, while none of them identical, have a better claim to be Thornhill's prototypes, among them Tintoretto's 'Forge of Vulcan', now in the North Carolina Museum of Art, where the disposition of figures is closer to Thornhill's final version (*North Carolina Museum of Art Bulletin*, I, 1957, no.1, pp.3–5, repr.). A widely engraved version of the subject

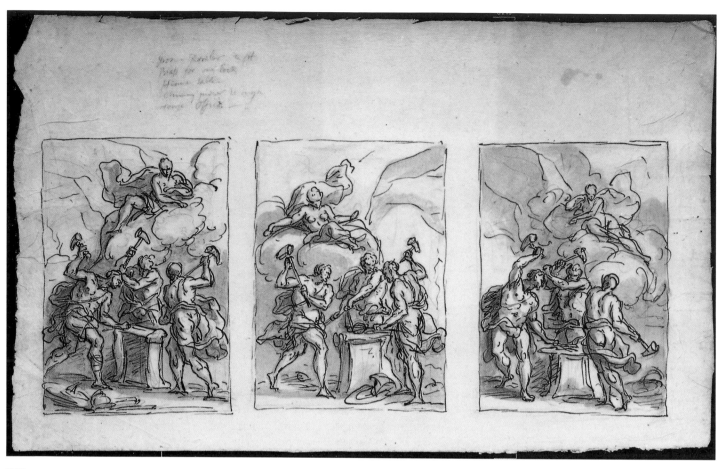

155

fig. 58 Sir James Thornhill: Finished Design on the Staircase at Hanbury Hall *c*.1710 (photo: A. F. Kersting).

was the now-destroyed 'Forge of Vulcan' by Primaticcio at' Fontainebleau, showing four instead of three figures around the anvil, but very similar in movement to Thornhill's first version. Vasari's decorations for the Sala degli Elementi in the Palazzo Vecchio, Florence, were also well known, and the middle sketch on the Tate sheet is close to his scene showing the Cyclops forging Jupiter's lightning. The sale of Thornhill's prints and drawings on 26 February 1735 (photocopy of cat. in Courtauld Institute, London) included many unspecified items by all these artists.

Closer to Thornhill's time, the subject was used, sometime before 1696, by Antonio Verrio in the decorations of the Heaven Room at Burghley House, and also by Louis Laguerre in the State Drawing Room at Chatsworth, painted sometime between 1689 and 1694. As Thornhill worked at Chatsworth *c*.1707 (Croft-Murray 1962, p.267) this could perhaps be regarded as his most immediate source. Thornhill was greatly influenced by Laguerre, and no less than fourteen, possibly sixteen, oil sketches and designs by him were included in Thornhill's studio sale of 24–25 February 1734 (lots 72–8; catalogue published *Burlington Magazine*, LXXXIII, 1943, pp. 133–6). Another precedent in England is 'Vulcan Forging the Arms of Achilles' by Gerard Lanscroon, signed and dated 1705, on the staircase of Powis Castle. All show a strong resemblance that probably owes more to classical prototypes than to direct copying from each other.

Thornhill's treatment of the nereid Thetis departs from the classical tradition which normally shows her fully dressed and firmly attached to the ground, e.g. the Roman frescoes at Pompeii, where Vulcan shows Achilles' shield to a matronly seated Thetis. The glamorous cloud-borne female here is more reminiscent of a goddess of the first rank such as Venus, and clearly the reason why the drawing was known in the past as 'Venus watching the forging of the arms of Aeneas'. Thornhill's inscription on the British Museum sketch, however, clearly shows which camp of the Trojan war he intended to represent.

The Tate Gallery's oil sketch, formerly known as 'Venus Presenting Arms to Aeneas' (no.156), seems to be related to this design.

156 **Thetis Accepting the Shield of Achilles from Vulcan** *c.*1710

T 00814
Oil 489 × 498 ($19\frac{1}{4}$ × $19\frac{5}{8}$) on wood 498 × 515
($19\frac{5}{8}$ × $20\frac{1}{4}$)
Purchased (Grant-in-Aid) 1965

PROVENANCE
...; G. Maione 1965; his daughter Miss P.
Maione, sold Christie's 10 December 1965 (89

as 'Aeneas Receiving Arms from Venus' by
Pellegrini) bt Butlin for Lawrence Gowing;
sold by him to the Tate Gallery

LITERATURE
Jacob Simon, *English Baroque Sketches*, exh. cat.
Marble Hill, Twickenham 1974, no
pagination, under no.30

The subject of this panel, which may have been originally intended for the decoration of a coach, is somewhat ambiguous. Thornhill's sketchbook in the British Museum (accession no.1884–7–26–40, p.23 recto) includes an upright design which shares certain compositional details with no.156 and is inscribed 'Vulc. pres[ng] to Venus Aen[ss] Armour'. In this drawing Vulcan is shown fully dressed in cap and working clothes, with a hammer at his belt. As the figure in the Tate Gallery panel is more in keeping with the representation of a hero, the painting was formerly entitled 'Venus Giving Arms to Aeneas'. This however begs the question as to why Aeneas should be shown in a veritable storehouse of armour, with an attendant equipped with a hammer at his heels. It could equally well be a more heroic rendering of Vulcan, and the 'cuts' across his leg below the knee might be intended to represent his lameness. Vulcan's forge was usually sited underground, and the scene here is set in the mouth of a cavern in which the Cyclops are seen at work in the distance. The nude female figure on a cloud surrounded by putti would indeed at first sight suggest a goddess of the first rank, like Venus, except that it is known that Thornhill depicted the mother of Achilles, the nereid Thetis, in similar fashion (see no.155). Moreover, the pearl, coral and possibly seaweed ornaments in her hair accord well with the representation of a sea-nymph, and there is a hint of stormy waves in the bottom right background. The description of the sumptuous gold and silver shield made for Achilles is one of the set-pieces of the *Iliad*, and accords well with the object held aloft here. On balance, the closeness of the design to the Hanbury Hall decorations (fig.59) makes its identification with the story of Achilles preferable to that of Aeneas.

The coat of arms on a shield in the bottom right-hand corner has not been identified, and anyway seems to have been altered at least once.

The panel originally had a pointed top, and was made up to its present square shape by the addition of two triangular pieces of panel, approximately 126 × 248 × 279 ($5 × 9\frac{3}{4} × 11$), to the top corners. These added sections are painted over, but are hidden by the present frame.

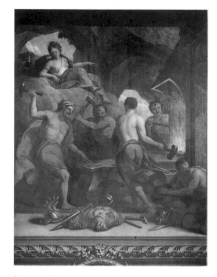

fig. 59 Sir James Thornhill:
'Finished Design on the West Wall of
the Staircase at Hanbury Hall'
*c.*1710 (photo: Royal Commission
on the Historical Monuments of
England).

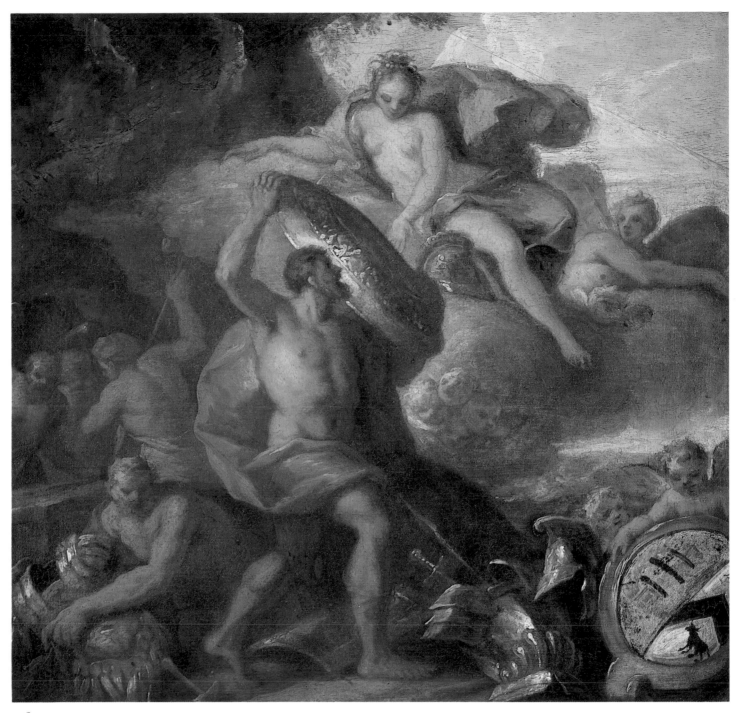

156

157 The Apotheosis of Romulus: Sketch for a Ceiling Decoration, Possibly for Hewell Grange, Worcestershire *c*.1710

N 06200
Oil on canvas 460 × 520 (18⅛ × 20½)
Purchased (Cleve Fund) 1953

EXHIBITED
Pittura inglese 1660–1840, BC, Palazzo Reale,
Milan 1975 (20, repr.)

PROVENANCE
...; bt H.D. Molesworth in Brighton 1939 (as
by Tintoretto) and sold to H. Calmann 1953

LITERATURE
Croft-Murray 1962, p.270

This sketch for an oblong ceiling design in a painted false stucco surround with indented corners, represents the reception of a hero in Olympus. He is shown stepping out of a horse-drawn chariot and being presented to the assembled gods by a helmeted Mars.

A ceiling composition similar in overall shape and concept but less precise in detail can be found in Thornhill's sketchbook in the British Museum (fig.60, 1884-7-26-40, p.65 recto), inscribed 'L^d Plimouth's Hall.Ceil.18 ftt high at Hewill Hall near Bromsgrove'. This refers to Hewell Grange, the Earl of Plymouth's seat in Worcestershire, which was destroyed at the end of the last century and of which little record remains.

Iconographically, the hero represented here appears to be Romulus, who, according to Ovid (*Metamorphoses*, Book XIV), was taken up to Olympus in the chariot of his father Mars. The canine silhouette behind him would then be the She-wolf of Rome, an animal sacred to Mars, who nurtured the hero in infancy. Its turned head is almost identical (in reverse) to that in a roundel drawing of the She-wolf nursing Romulus and Remus (fig.61) in Thornhill's sketchbook (BM accession no.1884–7–76–40, p.33, recto), where it is part of a sequence of sketches dealing with the Romulus legend, thought to be unused designs for Stoke Edith. The She-wolf also accompanies Romulus in the apotheosis of the hero on the ceiling of the Second George Room at Burghley House painted sometime before 1691 by Antonio Verrio. Although the designs in no way resemble each other, Verrio was a profound influence on the much younger Thornhill, who studied his work closely and may have even worked with him in about 1702–4.

Various elements in the design are echoed in a number of sketches of heroic apotheoses in the British Museum sketchbook, and a possibly related oil sketch was lent by Sir Lawrence Gowing to the Thornhill exhibition at the Guildhall Art Gallery in 1958(1).

fig.61 Sir James Thornhill: 'The She-Wolf of Rome'. Sketch, probably for Stoke Edith. Reproduced by courtesy of the Trustees of the British Museum.

157

fig. 60 Sir James Thornhill: 'Ceiling
Design for Hewell Hall'.
Reproduced by courtesy of the
Trustees of the British Museum.

PETER TILLEMANS *c.*1684–1734

Painter and draughtsman chiefly of topographical landscapes, Thames-side views and sporting scenes; also recorded are some decorative and scenery paintings, battle-pieces and a few portraits. Born *c.*1684 at Antwerp, the son of a diamond-cutter, and trained there as a copyist; in 1708 was brought to England by 'Turner, a picture dealer' for whom he copied battle scenes and painted small genre pictures.

By 1711 had joined Kneller's newly founded Academy of painting; later joined the Society of St Luke (and was its Steward, 1725). Lived chiefly in Westminster, but travelled to execute commissions; by 1715 had acquired his most faithful patron, Dr Cox Macro, of Little Haugh, Suffolk. In 1719, commissioned by the antiquary John Bridges to make about 500 drawings for a projected history of Northamptonshire; 'from this to drawing views of gentlemen's and noblemen's seats was a natural step, and from topographical panoramas to enlivening them with strings of horses was another' (Waterhouse 1953, p.216).

Raines notes that the bulk of Tillemans's work was done after about 1720, painting various country houses and the views from them; also painted Thames-side views at Greenwich, Chelsea, Richmond and Twickenham. Several paintings of racing at Newmarket and some hunting pictures are known; four of them (three views of Newmarket racecourse and 'The Fox Chase'), engraved by Claude du Bosc and published in 1723, are among the most spectacular early sporting prints in England. Died at Dr Cox Macro's house in Suffolk, 19 November 1734.

LITERATURE
Robert Raines, 'Peter Tillemans, Life and Work, with a List of Representative Paintings', *Walpole Society*, XLVII, 1980, pp.21–59

158 **Foxhunting in Wooded Country** *c.*1720–30

T 02376
Oil on canvas 1020 × 1170 (40⅛ × 46 1/16)
Presented by Mr Paul Mellon KBE through the British Sporting Art Trust 1979

PROVENANCE
. . .; Wheeler Ltd, Ryder Street, 1961; Gooden & Fox, from whom bt by Paul Mellon 1961

EXHIBITED
Painting in England 1700–1850: Collection of Mr and Mrs Paul Mellon, Virginia Museum of Fine Arts, Richmond, Virginia 1963 (301)

LITERATURE
Egerton 1978, p.34, no.35, pl.11; Christopher Neve, 'A Gift from a Galloping Anglophile', *Country Life*, 30 August 1979, p.585, fig.4

The fox in the background centre is not only hotly pursued by hounds running in from the right but is also threatened by hounds from the left; the chase has been through a wood, the pack and its followers have divided and the fox is cornered, for the winding river on the left leaves no way out. The circular movement of this composition may be compared with that of the 'Staghunt in a Forest' by Johannes Hackaert and Nicolaes Berchem, *c.*1650 (no.829 in the collection of the National Gallery, London); the similarity may well reflect one of Tillemans's legacies from

158

the sporting art of his native country. The attribution to Tillemans is therefore retained here, although in a field where Tillemans's style is close to that of John Wootton, and even to that of Wootton's master Jan Wyck, it cannot be entirely certain.

There is a timeless, almost classical air about the landscape which suggests an ideal rather than actual setting for this foxhunt; however, an ancient stone building with a round tower in the middle distance on the left might suggest that the scene was drawn from northern, possibly border country in England.

JOSEPH VAN AKEN (also Vanhaecken) ?1699-1749

Portrait, genre and drapery painter. Came to London from Antwerp with his brother Alexander (1701–57), and possibly an older brother Arnold (d.1735/6), c.1720. Painted drapery for most of London's art establishment, particularly Hudson and Ramsay. Lived at Southampton Row, Bloomsbury (as stated in the catalogue of his sale at Langford's, 11 February 1750), where he died on 4 July 1749, according to Vertue aged about fifty and having spent over thirty years in England.

159 An English Family at Tea c.1720

N 04500
Oil on canvas 993 × 1162 ($39\frac{1}{8}$ × $45\frac{3}{4}$)
Presented by Lionel A. Crichton to the National Gallery through the National Art-Collections Fund 1930; transferred to the Tate Gallery 1955

PROVENANCE
...; Charles Newton-Robinson 1908 when lent to RA (not in his sale Christie's 3 April 1914); ...; Lionel A. Crichton by 1930

EXHIBITED
RA Winter 1908 (102 as 'The Walpole Family' by Hogarth); AC tour 1946 (4 as 'A Tea Party', painter unknown); on loan to the Victoria and Albert Museum 1973–1975; *English Portraits*, National Museum of Western Art, Tokyo 1975(16)

LITERATURE
R. Edwards, 'The Conversation Pieces of Joseph Van Aken', *Apollo*, XIII, 1936, p.79; Davies 1946, p.15; G.B. Hughes, 'Tea-Kettles and Urn-Stands', *Country Life*, 28 December 1951, p.2155, fig.1, and 13 September 1956, p.549, fig.1 (for discussion of silver and furniture); R. Edwards, *Early Conversation Pictures*, 1954, p.167, ill.78

This early example of an informal group portrait of a family and its servants is clearly a realistic representation of the ceremony of tea-drinking in about 1720, although the architectural setting might be fanciful. The dating is based on the appearance of the costume and silver, both of which have a strong element of the Queen Anne style. The sitters remain unidentified. The canvas has been cut on the left-hand side, so that the maidservant holding the kettle probably did not originally occupy the very central position she does now; other signs of the loss are the remnants of a shadow on the floor on the left, and the absence of the object which the gentleman on the extreme left should probably be looking at.

The Bacchus statue appears in other works by Van Aken, and must have been a standard prop: for instance in 'Sportsman and his Servant in the Grounds of Country House' (Sotheby's 12 March 1986, lot 108, repr. in col.) it is placed in open parkland. It also appears in 'A Musical Conversation' signed by J.F. Nollekens (Sotheby's 28 November 1953, lot 38, 477 × 629, $18\frac{3}{4}$ × $24\frac{3}{4}$), which is so close in handling and style to the signed Van Aken 'Music Party' in the Towner Art Gallery, Eastbourne, that one suspects the two Antwerp-born artists of close collaboration in England. The 'Bacchus' has close affinities with Louis Garnier's statue of the same subject carved sometime before 1699 for the gardens of Versailles, of which many small bronze casts were made (the compiler is grateful to Dr Jennifer Montagu for this information). Joseph Van Aken's sale at Langford's

159

on 11 February 1750 (cat.: BL C119–182) included a large number of casts and terracotta models among them, as lot 49, a 'Bacchus by Mr Rysbrack'. It is possible to speculate that this could have been the model for the statue in the picture, although Rysbrack's only otherwise recorded 'Bacchus', made in 1750 for Stourhead and now in the Gulbenkian Collection in Lisbon, does not resemble the statue in this picture (information kindly supplied by Malcolm Baker of the Victoria and Albert Museum).

The picture was first correctly attributed to Van Aken by Ralph Edwards in 1936. Its previous attribution to Hogarth was never generally accepted, and a false inscription 'Wᵐ H' on the tea-caddy was removed during restoration in 1956. The compilers are grateful to Stella Mary Newton for help on dating the costume.

JOHN VANDERBANK 1694-1739

Portraitist, painter of subject pictures and book illustrator. Important in the development of an academy of painting. According to Vertue, originated the fashion for painting women in a Rubens costume with a portrait of his wife in 1732. Also according to Vertue he would have carried all before him after the death of Kneller had it not been for his dissipated way of life.

Born in London 9 September 1694, the son of John Vanderbank, Chief Arras Maker to the Wardrobe and head of the Soho Tapestry Manufactory. Probably studied under his father and Richardson; in Kneller's Academy from 1711. Established an academy of painting with Louis Cheron in St Martin's Lane 1720. His first certainly signed work dates from the same year. Visited France to avoid his creditors May–October 1724, but seldom out of debt. His illustrations to *Twenty-Five Actions of the Manège Horse* were published in 1729 and those to *Don Quixote* in 1738. Painted Queen Caroline 1736. Died 23 December 1739 at his home in London.

LITERATURE
Hans Hammelmann, *Book Illustrators in Eighteenth-century England*, 1975, pp.79-86

160 Don Quixote Addressing the Goatherds 1730

T 00937
Oil on oak panel, 407 × 295 (16 × 11⅝)
inscribed 'J. Vanderbank fecit 1730' b.r.
Purchased at Christie's (Grant-in-Aid) 1967

PROVENANCE
...; ?James Toovey; ...; sold anon., Christie's 28 July 1967 (383) bt Tate Gallery

LITERATURE
Vertue III, 1934, pp.44, 98; Waterhouse 1953, pp.135, 139 n.4; Andrew Causey, 'Don Quixote through a Painter's Eyes', *Illustrated London News*, 28 October 1967, pp.38-9; H.A. Hammelmann, 'Eighteenth-Century English Illustrators: John Vanderbank 1694-1739' *The Book Collector*, XVII, 1968, pp.289-93, 297-8; John Ingamells, 'John Vanderbank and Don Quixote' *City of York Art Gallery Quarterly Preview*, XXI, July 1968, pp.763-7; H.A. Hammelmann, 'John Vanderbank's "Don Quixote"', *Master Drawings*, VII, 1969, pp.3-15, pl.3b; Hammelmann 1975, pp.81-2, 85; Waterhouse 1978, p.181

An old inscription on the back of the panel reads 'Vanderbank Senior pinxit anno 1730'. Vertue, in 1730, noted 'living near Cavendish Square. Mr. John Vanderbank drawings for the History of Don Quixot – & paintings on Pannels. – several heads very well painted from the life –' (*op. cit.*, p.44), and in 1739, recording his death 'in Hollis Street near Cavendish Square', mentions that 'to the last years of his life he had the good fortune to have a Friend for his Landlord – who never took any money for his rent ... let him paint anything what he would for it – (Storys of Don Quixot)'; he also suggests that the landlord took all the works remaining in his house at Vanderbank's death (*op. cit.*, pp.97-8).

This panel is one of a series of paintings by Vanderbank illustrating Cervantes's *Don Quixote*, a project that seems to have occupied the artist from 1723 onwards. They are related to two sets of drawings in the British Museum, to a further set in the Pierpont Morgan Library, New York, and to the sixty-eight engravings illustrating a de luxe edition of the book published in 1738. The first set of drawings in the British Museum are in pen and wash over pencil and measure between about 189 × 134 (7¼ × 5¼) and 209 × 168 (8¼ × 6⅝); they bear signatures and dates

160

covering each year from 1726 to 1730, are numbered from 1 to 62, and lack the frontispiece and six other of the engraved designs; one design was not engraved. The second more finished series was that used for the engravings and is bound into an extra-illustrated copy of the 1818 four-volume edition of *Don Quixote* in the Pierpont Morgan Library, New York. The drawings are in pen and wash finished in Chinese white (which has oxidised in some cases) and measure approximately 247×190 ($9\frac{3}{4} \times 7\frac{1}{2}$) on paper 267×201 ($10\frac{1}{2} \times 7\frac{15}{16}$). Most are signed and dated 1729, some more specifically with dates in August and September of that year. There are drawings for all sixty-eight plates with five exceptions. The third equally finished series is also executed in pen and wash over pencil finished in Chinese white. The drawings range in size from about 295×218 ($11\frac{1}{8} \times 8\frac{5}{8}$) to 259×378 ($10\frac{3}{8} \times 14\frac{7}{8}$) Only twenty-five examples, in the British Museum, are known. The sketch for the frontispiece is signed and dated 1729 and one other drawing, exceptional in format, 1735. The engravings first appeared in the four-volume edition published in the original Spanish by J. & R. Tonson in London in 1738, and were reissued by the same publishers in the two-volume translation by Charles Jarvis in 1742. Nearly all of the subjects were engraved by Gerard Vandergucht, though two are by Claude du Bosc, one by Bernard Baron and one is anonymous, and the tailpiece was engraved by Paul Fourdrinier. Originally Hogarth was to have had a share in the engravings and executed six after his own drawings, but these were not used. Plate 2, showing Don Quixote in his study, was engraved by George Vertue and is dated 1723, as are two wash drawings, rather different in character from the others, in the Witt Collection, Courtauld Gallery, and on the London art market in 1967 (L.G. Duke; ...; Sotheby's 20 November 1986, lot 15 repr.); none of the other plates are dated, but were presumably executed *c.*1729-30.

In the case of the subject of the Tate Gallery's pictures, 'Don Quixote addressing the Goatherds', there is an extra preliminary drawing on the verso of the drawing from the first series in the British Museum (1862–10–11–809; repr. Hammelmann 1969, pl.la). This is in pen alone and shows Don Quixote addressing two figures only, seated beneath a tree on the left; Sancho Panza drinks from a flask on the right; there is no hut. The recto (repr. Hammelmann 1969, pl.lb) is inscribed 'Jo. V. Invent 1729. 7' and contains most of the same features as the oil but is less densely composed with more sky and foreground. The donkey is shown on its own by the tree on the right while the standing figure forms part of the group of five figures on the left; the other four figures are generally similar to those in the oil but differently placed.

The Pierpont Morgan Library drawing (repr. Hammelmann 1969, pl.2a), which is inscribed 'J. Vanderbank.Fecit. 1729', omits the tree and donkey on the right and replaces them by a solitary standing figure holding a staff as in the oil; the figure with a crook directly facing Don Quixote is now seated. The engraving, plate 8 in both the 1738 and 1742 editions and inscribed 'Jnº: Vanderbank invt et Delin:' and 'GerVanderGucht Sculp.', is practically identical and is in the same direction.

It was at this point that Vanderbank seems to have painted another small oil picture of the subject (repr. Hammelmann 1969, p.2b). This was sold anonymously at Sotheby's on 13 May 1920 (in 169), bought 'Aldham', and again in the Miss Alice Sophie Heldmann sale, Puttick and Simpson at Worton Court, Isleworth, 13–14 March 1939, 2nd day (in 296), bought Leighton. The hut is now shown with a gable end and again there is no tree on the right; the extreme left-hand figure is an old man instead of the young plump-faced youth wearing a hat of the engraving and earlier drawings.

The drawing from the larger series in the British Museum (1862–10–11–872; 265×256 ($11\frac{1}{8} \times 10\frac{1}{16}$); repr. Hammelmann 1969, pl.3a) is closest to the Tate Gallery's oil and probably just precedes it: at the point where the drawing has an extra figure standing behind the group on the left with his hand on the nearest support of the hut, the oil shows signs of such a figure having been painted out. The

composition of the oil is more compressed than in the drawing but both differ from the other oil, and the engraving and Morgan Library drawing, in that there are both a tree and a standing figure with a staff on the right, and also in the form of the hut, which now has a broad eave sloping down towards Don Quixote. Like the other oil, but not the engraving, the extreme left-hand figure is an old man.

At least thirty-three companions to the Tate Gallery's panel are known. When sold in 1939 the other version of no.160 was framed together with seven scenes related to the engraved plates 15, 19, 27, 38, 39, 57, 65 and one other unidentified scene; another frame contained nine further scenes (plates 4, 9, 11, 37, 46, 47, 64, 67, 68), and the lot was completed by a further scene framed on its own. When the same group of works was sold in 1920 they were described as sixteen panels and three canvases; from photographs it is possible to identify one of the canvases as being related to plate 64 but not the other two. Some of the pictures were signed and dated 1731, 1734 and 1735 or 1736. At present this group is only known from photographs taken in 1939.

Fourteen more scenes were sold at Sotheby's on 15 March 1967 (128), bought Marshall Spink. Twelve are on panel and relate to plates 3, 12, 21, 23, 33, 35, 44, 45, 51, 53, 58, 63, while two on canvas relate to plates 42 and 60. Two examples are dated 1730 and one 1733, and eight were reproduced in the *Illustrated London News*, 28 October 1967, pp.38-9, 46. They are now distributed between the City of Manchester Art Gallery (plates 3 and 23), the Huntington Library and Art Gallery, San Marino (plates 12 and 44), the City of York Art Gallery (plate 21), the Iveagh Bequest at Marble Hill, Twickenham (plates 42 and 63), and private collections. All came from the collection of the nineteenth-century bookseller James Toovey. Another set of four panels was sold at Christie's 19 July 1985 (lot 91A, repr.).

In addition to these three groups a variant of the second Huntingdon Library Picture, also on panel, was sold at Christie's on 14 June 1968 (127), bought Gooden and Fox. Earlier sales include six unidentified panels sold at Christie's 29 June 1956 (11), bought W.M. Sabin and Sons. Two further panels, 'The Bather alarmed' and 'Don Quixote and Sancho Panza', both signed and the latter at least also dated 1730, were in the Seward sale, Robinson and Fisher, 18 March 1926 (181). Another sale at Christie's, 18 March 1913, included eleven unidentified panels as lot 119, bought Heigham, together with two larger canvases, 1225 × 1005 (49 × 39½), of 'Don Quixote meeting the Princess' and 'The Companion', as lot 118, bought Baron de Quinto. These were probably the thirteen Don Quixote scenes, undescribed, sold at Christie's 3 June 1909 (8), bought Renton; they were also from the Toovey collection, which may also be the source of the Tate Gallery picture.

What prompted the oil paintings is not certain. They are not direct replicas of the drawings or engravings, nor do they form a necessary link in the evolution leading from the smaller, sketchier drawings through the more finished drawings to the engravings. The length of time taken over the venture, from the first dated drawing of 1723 to the publication of the engravings fifteen years later, may have led the impecunious artist to exploit his material in independent pictures, perhaps for a decorative scheme; besides the two large canvases sold in 1913 the known pictures fall into two main groups, one being of the same upright format as no.160, the other of the same height but nearer square. Vertue's note, given above, suggests that he may have given them to his landlord in lieu of rent.

The scene depicted comes from *Don Quixote*, Book 1, Chapter 3, when Don Quixote and Sancho Panza are lodging with some goatherds for the night. Inspired by a handful of acorns Don Quixote addresses them on the Golden Age and the necessity of knight-errantry in a period of decline; meanwhile Sancho Panza concentrates on food and wine.

The compiler is indebted to the late Hanns Hammelmann for help on this entry.

161 A Youth of the Lee Family, probably William Lee of Totteridge Park 1738

T 03539
Oil on canvas 1679 × 1068 (66⅛ × 42⅟₁₆)
Inscribed 'Jnº Vanderbank Fecit 1738.' b.l.
Purchased (Grant-in-Aid) 1982

PROVENANCE
...; by descent to Mrs Benedict Eyre (neé Lee)
of Hartwell House, sold Sotheby's 26 April
1938 (27c) bt M. Harris; ...; the Duke of
Kent by February 1939; by descent to the
Duchess of Kent, sold Christie's 14 March
1947 (58) bt Middleton; ...; Lord Hesketh,
sold Sotheby's 21 November 1979 (104, repr.);
...; anon. sale Sotheby's 10 November 1982
(18, repr.) bt by Tate Gallery

LITERATURE
W.H. Smyth, *Aedes Hartwellianae*, 1851, p.96;
Kerslake 1977, I, p.166 (for ?the sitter's father)

At the Hartwell House sale in 1938 this was thought to represent William Lee
Antonie of Colworth MP (1756–1815), but this is evidently impossible in view of
the date of the painting. The subject is more likely to be his father, William Lee of
Totteridge Park (1726–78), who would have been around twelve or thirteen at the
time this portrait was painted. His father was Sir William Lee of Hartwell
(1688–1754), Lord Chief Justice and Privy Councillor from 1737, in which year he
also was knighted. It may be significant that he was also painted by Vanderbank in
1738; the original of several copies was in the Hartwell sale of 1938, lot 49, and was
also bought by M. Harris (a copy is reproduced in Kerslake 1977, II, figs. 458, 489).
William was his only son by his first wife Anne Goodwin (d.1729) and inherited the
manor of Totteridge, near Barnet, which the Lord Chief Justice purchased in 1748.
From 1827, after the male Lee line became extinct, both Hartwell and Totteridge
Park were vested in the female line of the Chief Justice's descendants.

It is also possible that the painting could represent one of the sons of the Lord
Chief Justice's brother, Sir Thomas Lee, Bart (1687–1749), either Thomas
(1722–*d.s.p.* 1740) or Sir William, 4th Bart (1726–99).

William Lee of Totteridge Park married Philadelphia, daughter of Sir Thomas
Dyke, Bart, of Lullingstone Castle, and died on 13 August 1778, aged fifty-two.
Both he and his wife are buried in Hartwell Church.

The painting is in a dramatic white and gold frame of *c.*1750, decorated with
carved swags of drapery and flowers, topped with an eagle, that was *en suite* with
other frames and furniture original to Hartwell.

Vanderbank, who consciously affected the manner of Rubens and Van Dyck,
appears to have based this composition on Van Dyck's renowned portrait of
Philippe le Roy, Seigneur de Ravels (Wallace Collection, London).

161

Attributed to W. VAN DER GUCHT active 1740

or WILLIAM JONES active 1738, d.?1747

162-3 **Two Scenes from Colley Cibber's 'Damon & Phillida'**

PROVENANCE
...; T. Lumley, sold Christie's 21 June 1940
(91 as 'Mercier School') bt Mrs P. Aitken; sold
Sotheby's 27 November 1974 (81); ...; anon.
sale Christie's 24 July 1980 (109, repr., as by
'W.J.') bt Leggatt for the Tate Gallery
Purchased (Grant-in-Aid) 1980

162 **Phillida Rejecting Mopsus** 1740

T 03112
Oil on canvas 635 × 762 (25 × 30)

163 **Phillida and Damon Reconciled** 1740

T 03111
Oil on canvas 635 × 762 (25 × 30)
Inscribed 'W.d G. [or 'W.VdG.'] Pinxit 1740'
initials in monogram

The paintings represent two scenes from Colley Cibber's one-act opera or 'after-piece' *Damon and Phillida*, which was first performed in 1729 in a somewhat longer version as *Love in a Riddle*. The simple story tells of the shepherdess Phillida who, while in love with the handsome but fickle shepherd Damon, is wooed by two boorish shepherds called Mopsus and Cimon. An unexpected dowry enables her to reject the boors and accept a reformed Damon. The ballad form of the piece aimed to capitalise on the success of John Gay's *The Beggar's Opera* of the previous year. In this it failed, but was saved from extinction by the singing and acting of Kitty Clive (1711–85) – then still Miss Raftor – in the lead. Cibber immediately changed the title and slimmed the piece down to centre on Mrs Clive's scenes, in which form it remained a favourite after-piece on the London stage for many years. Mrs Clive continued to play Phillida well into the 1750s and was painted a number of times in what became one of her most popular roles (Chaloner Smith 1883, pp.331, 1364, 1397, 1682). Known portraits of her correspond reasonably well with the Phillida in the Tate Gallery pictures. Damon was played by various people and was sometimes a 'breeches part', i.e. played by a woman, notably by Charlotte Clarke until 1739. In the 1730s Mopsus was played by one Oates, about whom little is known. The part of Cimon, on the other hand, was a great success for the comedy actor Joseph Miller, and an engraved portrait of him after C. Stoppelaer, published in 1739, does show a certain resemblance to the beetle-browed laughing buffoon in no.162. Miller died late in 1738, but his memory remained green with the publication of *Jo Miller's Jest Book* in 1739, which was a runaway success.

 This pair of paintings may be a response to the popularity of the entertainment and its leading actors, in the manner of Hogarth's famous scene from *The Beggar's Opera*, of which he painted at least six versions between 1728 and 1731 (see no.87). In treatment and style the pictures certainly show an awareness of Hogarth's work of the 1730s.

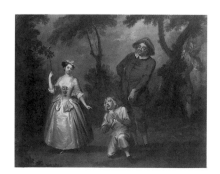

fig. 62 W. Van der Gucht, attributed to: 'Phillida Rejecting Mopsus'. Oil on canvas 610 × 737 (24 × 29). Christie's 20 November 1964 (91).

[234]

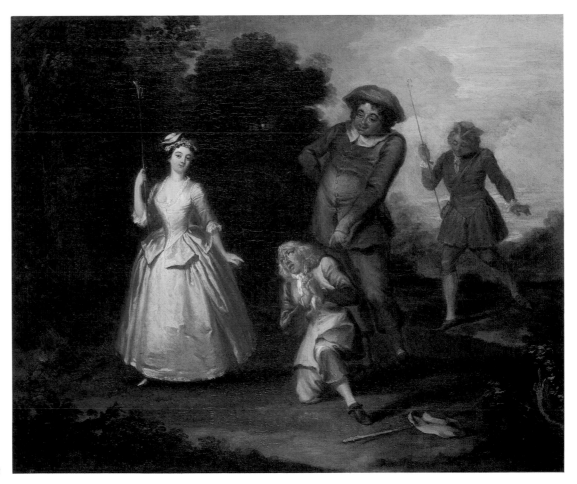

162

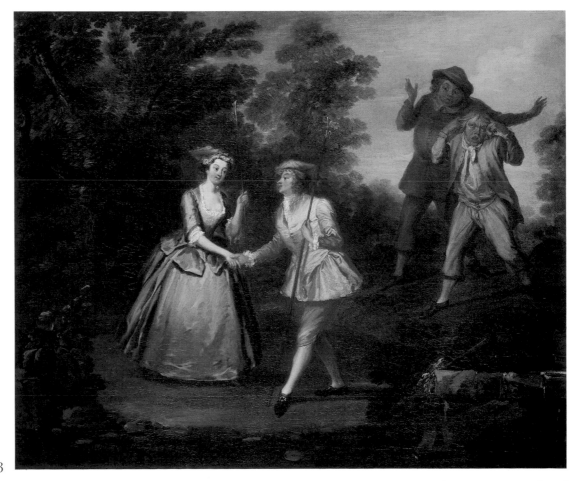

163

A version of no.162, unsigned and undated, was sold at Christie's 20 November 1964 (91, bt Marshall) with an attribution to Hayman, and was said to come from the collection of T.T. Cook of Messing, Essex, 1770 (fig.62). A version of the single figure of Phillida in no.162 was with John Mitchell & Son in 1963, also ascribed to Hayman.

Most of the very many editions of the play published throughout the 1730s and 1740s have a frontispiece designed and engraved by Gerard Van der Gucht (1696–1776). Its upright design is loosely but nonetheless undeniably related to both no.162 and its other known versions in oils, and in some of its elements also to no.163. Moreover, the first letters of the artist's engraved name 'V^{dr} Gucht' conflate almost exactly into the latter part of the otherwise unfamiliar monogram signature on no.163. Although the Van der Gucht family produced several illustrators, engravers and painters over three generations, there is so far no record of anyone whose name begins with a 'W', which is clearly the first letter of the monogram. Nevertheless, in view of the Van der Guchts' evidently strong links with the theatre and the sheer size of this as yet little-studied family (Benjamin Van der Gucht, 1753–94, the painter of portraits and theatre scenes, is said to have been the thirty-second child of the above-mentioned Gerard, and it is not known if Gerard's brother John, 1697–1733, also an engraver and occasional painter, had any children) it seems reasonable at this stage to assume that the painter here is an as yet unrecorded member of the Van der Gucht family of artists. The name Vandergucht appears also in the list of 'those painters of our nation, now living, many of whom have distinguished themselves and are justly esteemed eminent masters', published in the *Universal Magazine*, November 1748, but there is no indication as to which Vandergucht is meant. A small group of similar genre or theatre scenes, usually ascribed to Mercier, Hayman or even Hogarth, can be attributed to the same hand (e.g. an interior with several figures called 'Fortune Telling', with Spink 1937; another version of the same subject with Gavin Graham Gallery 1981). The compilers gratefully acknowledge the help of Clare Hughes in identifying the play and actors.

Research in progress as the catalogue was going to press suggests that the author of nos.162 and 163 is the little-known painter William Jones (active 1738, died ? 1747), and that the monogram in no.163 should therefore be read as 'W.J.'. His work as a painter of landscapes and portraits in Ireland is attested by a number of engravings after his works published 1744–47 (A. Crookshank & the Knight of Glin, *The Painters of Ireland c.1660–1920*, 1978, p.62). The distinctive landscape style of both Tate paintings and the handwriting of the signature in no.163 can also be seen in the four landscape overdoors in the Great Hall at Kimbolton Castle, Huntingdonshire, one of which has been found to be fully signed and dated 'William Jones Pinxit/1738'. The attribution is also upheld by closer inspection of the figures, which, however, are more roughly painted in the overdoors, which are designed to be seen from afar. These were presumably painted for William Montagu, 2nd Duke of Manchester (1700–1739).

According to W.G. Strickland's *Dictionary of Irish Painters*, 1913, Jones's last work would seem to have been a portrait of 'Charles Lucas', known only from an engraving inscribed 'Wm Jones pinxit 1747', and in February 'that year' (which could also be February 1748 New Style) Samuel Dixon advertised as having for sale at his shop in Capel Street, Dublin, landscape and history paintings 'done by the late ingenious Mr Jones'.

EGBERT VAN HEEMSKERK III active *c*.1700-1744

Singer, and painter of low genre in imitation of his father. This Haarlem family of painters can be traced back to Egbert Van Heemskerk I (1610–80) who imitated the works of Brouwer and Bega, and taught his son Egbert II (1634 or 5 – 1704). The latter is thought to have come to London in the 1670s, and one of his best works is 'An Election in the Guildhall at Oxford', signed and dated 'Oxon. 1687', now in Oxford Town Hall. His most popular subjects were tavern interiors, Quaker meetings and sick-bed scenes, of which many versions exist. According to Buckeridge (1706) he 'died in London about two years ago, leaving behind him a son whom he had instructed in his way'. Weyerman (1769) adds that the son had the same name and died in great poverty in 1744. J.T. Smith also says that he was a singer at Sadler's Wells. No documented works by this son exist, but a number of subjects derived from Egbert II, adapted to early eighteenth-century dress and executed in a much coarser manner, can be plausibly attributed to him.

LITERATURE
Bainbridge Buckeridge, 'An Essay towards an English School', in Roger de Piles, *The Art of Painting*, 1706, p.383; Jacob Campo Weyerman, *De Levens-Beschryvingen der Nederlandsche Konst-Schilders*, 1729–69, pp.344–52; J.T. Smith, *Nollekens and his Times*, 1829, II, p.347; F. Saxl, 'The Quakers' Meeting', *Journal of the Warburg and Courtauld Institutes*, VI, 1943, p.214

164 **The Doctor's Visit** *c*.1725

T 00808
Oil on canvas 747 × 625 ($29\frac{7}{16} \times 24\frac{5}{8}$)
Purchased (Grant-in-Aid) 1965

PROVENANCE
...; possibly this or another version sold by John Willett Willett, Cox 31 May 1813 (11 as 'Heemskerk: Interior, with a Man dying, surrounded by his Friends'); ...; Lucius O'Callaghan, sold Christie's 12 October 1956 (193 as 'Hogarth: The Death Bed') bt O'Roche; ...; Phillips (untraced sale) bt Claudio Corvaya, sold by him Christie's 19 November 1965 (90) bt Oscar and Peter Johnson Ltd, from whom bt by the Tate Gallery

EXHIBITED
Tate Gallery 1971 (12 as Hogarth, repr.); *Pittura inglese 1660–1840*, Milan 1975 (25 as by Hogarth, repr.)

LITERATURE
L. Gowing, 'Hogarth Revisited', *University of Leeds Review*, XIII, October 1970, pp.186–98, pl.4 (B); Paulson 1971, I, p.525 n.3

This representation of a sick-bed scene, with the apparently dying patient surrounded by doctor, priest, lawyer, praying child and lamenting friends and relations, is a simplified rendering of a subject that appears to have been part of the stock repertoire of the Heemskerk family of painters for two, possibly three, generations. One of the two earliest and most elaborate versions, both horizontal in format and certainly by Heemskerk II, is in the collection of the Earl of Wemyss, while the other (fig.63), signed and dated 1674, is still in the Evelyn family collection where Vertue first noticed it in 1733 (Vertue IV, p.53). The Tate Gallery

picture is loosely based on this last, with the costumes updated to around 1725. An intermediate upright version of this subject, also attributable to Heemskerk II, was on the art market recently (Phillips 20 July 1982, lot 58, repr., 597 × 508, 23½ × 20), and others, too numerous to list, have appeared in other sales this century. An inferior replica of the Tate Gallery picture, probably by the same hand, is also known (712 × 610, 28 × 24; Earnshaw, sold Sotheby's 19 November 1969, lot 7, bt in, offered again at Knight, Frank & Rutley 11 December 1969, lot 193, bt Adrian Korsher).

The handling of the Tate Gallery picture (which appears to be unfinished) also seems to derive from Heemskerk II, notably in the rough, high-contrast modelling of the heads and the broadly drawn, clumsily expressive gestures of the figures, for which one can find precedents in such documented works by Heemskerk II as 'The Oxford Election' (Oxford Town Hall), 'A Puritan Meeting' at Saltram, and others. Its markedly weak spatial construction, particularly noticeable in the angle of the bed, the priest's chair and the height of the lawyer's table in the background, speak of a painter who could imitate details, but was unable to reorganise them into a convincing whole. One could thus suppose that the younger Heemskerk was a useful helper in the family studio, but failed to develop beyond the imitative level after his father's death in 1704.

The earlier attribution of this painting to Hogarth was partly based on his affinity for low genre and his possible borrowings from Heemskerk's engraved works, as already pointed out by Antal (1962). There is also a superficial thematic resemblance between this scene and two drawings by Hogarth entitled 'An Operation Scene in Hospital' (Oppé 1948, nos.64, 65, pls.65, 66), but these appear to date from a later stage in Hogarth's career and could take their inspiration from many other sources. The tendency to attribute low genre scenes to Hogarth was already noted by J.T. Smith, who wrote in 1829, that 'Mercier, Van Hawkin [Van Aken], Highmore, Pugh, or that drunken pot-house Painter, the younger Heemskirk, who was a singer at Sadler's Wells' were all painters whom the unwary tended to confuse with Hogarth. The only reasonably documented possible work by Hogarth of this period, the 'Sign of the Paviour' of *c*.1725 (Yale Center for British Art, New Haven), exhibits an inventiveness in design and energy in handling that, however crude, seem to point towards greater developments, a feature wholly lacking in no.164.

fig. 63 Egbert van Heemskerk I: 'A Dying Man'. Signed and dated 1674. Oil on canvas 615 × 736 (24¼ × 29). Evelyn family Collection.

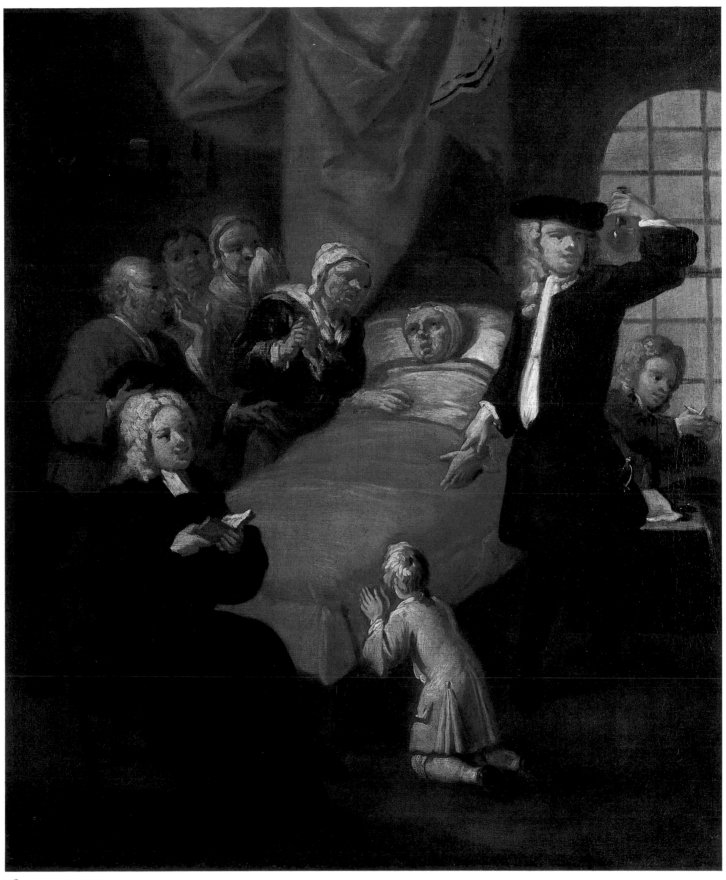

164

JOHN WOOTTON ?1682-1764

Painter of sporting pictures, battle scenes and landscapes. Born (?) Snitterfield, Warwickshire; probably encouraged to take up painting by the Countess of Coventry. Studied under John Wyck (1652–1700), who had a direct influence on Wootton's early battle and hunting scenes. Had probably settled in London by 1700; married there (i) in 1706, (ii) in 1716.

Wootton's reputation was established by 1714. In 1717, elected Steward of the Virtuosi Club of St Luke's, and is included in Gawen Hamilton's portrait group 'Conversation of Virtuosi' (National Portrait Gallery). Vertue noted in 1728 that Wootton was 'in great Vogue and favour with many persons of Ye greatest quality' (III, p.34); his patrons included George II, Frederick, Prince of Wales, the Dukes of Bedford, Marlborough, Rutland and Richmond, as well as his first major patron, Edward Harley, Earl of Oxford; large pictures survive in situ at Althorp, Badminton and Longleat. By 1741 he is said to have commanded 'the greatest price of any man in England' (quoted by Meyer, p.7).

Wootton's earliest dated topographical landscape is of 1716; later painted many classical landscapes in the style of Gaspard Dughet. Sold pictures from his studio and his collection of prints and drawings 1761; died in London 13 November 1764.

EXHIBITIONS
Arline Meyer, *John Wootton 1682–1764: Landscapes and sporting art in early Georgian England*, Kenwood 1984

165 George Henry Lee, 3rd Earl of Lichfield, and his Uncle the Hon. Robert Lee, Subsequently 4th Earl of Lichfield, Shooting in 'True Blue' Frockcoats 1744

N 04679
Oil on canvas 2085 × 2495 (80¼ × 96½)
Inscribed 'J. WOOTTON|Fecit|1744' on small rock nearer river-bank, above head of reclining pointer; 'R. Lee' lettered on collar worn by each of the three pointers
Purchased by the National Gallery for presentation to the Tate Gallery 1933

PROVENANCE
Presumably commissioned by George Henry Lee, 3rd Earl of Lichfield; by family descent to Harold Arthur (Dillon), 17th Viscount Dillon, CH, DCL, by order of whose executors sold Sotheby's 24 May 1933 (93, repr.) bt Leggatt Brothers for the National Gallery, by whose Trustees it was presented to the Tate Gallery

EXHIBITED
Kenwood 1984 (13, repr.)

LITERATURE
[Thomas Martyn], *The English Connoisseur*, 1766, reprinted 1968, I, p.31; *Catalogue of Paintings . . . at Ditchley*, 1908, pp.27–8, no.40; *Walpole's Correspondence*, IX, pp.289–90, 321. Also repr.: Basil Taylor, *Animal Painting in England from Barlow to Landseer*, 1955, pl.14

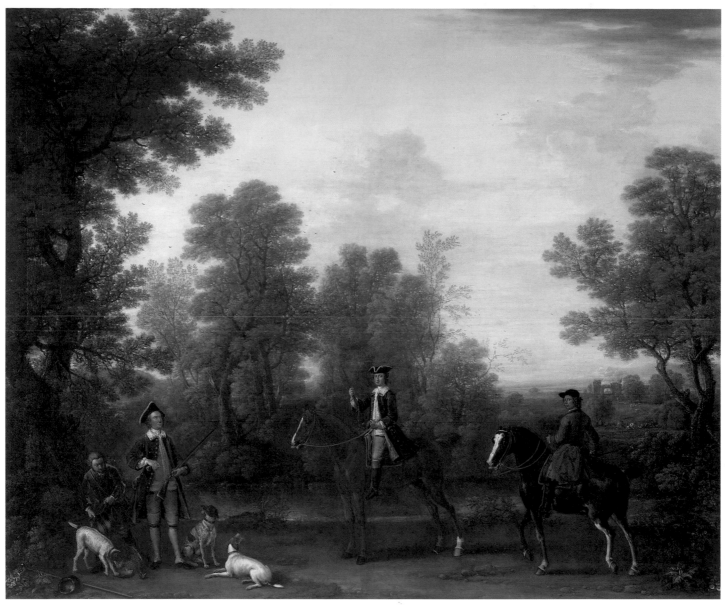

165

The chief sitters are George Henry Lee, 3rd Earl of Lichfield (1718–72), mounted on a chestnut horse in the centre of the group, and his uncle, the Hon. Robert Lee, subsequently 4th Earl of Lichfield (1706–76), standing on the left. Both men carry double-barrelled flintlock shotguns, and have evidently been shooting with three pointers, the lettering on whose collars indicates that they belong to Robert Lee (and were presumably bred by him). A gamekeeper stoops over a shot pheasant on the left of the picture, and a groom attends on the right. The landscape may represent the park at Ditchley (seat of the Earls of Lichfield), near Woodstock, Oxfordshire.

The picture has been known since it left the family collection as 'Members of the Beaufort Hunt', a phrase taken from the lengthy description under which it was sold in 1933, but misleading as a title, since the gentlemen are portrayed after shooting. It was more succinctly described in the 1933 sale catalogue's Foreword (based on notes compiled by the 17th Viscount Dillon, FSA) as 'representing the third and fourth Earls, wearing Beaufort Hunt coats'. The Beaufort Hunt in the early 1740s was permeated with Jacobite sympathies. The colour of the hunt coats was the same 'true blue' as that affected by adherents of the Young Pretender ('Bonnie Prince Charlie'; this choice was, in Horace Walpole's phrase, a 'loyal pun' (letter of 19 July 1760 to George Montagu). Walpole, describing his visit to the Earl of Lichfield's seat at Ditchley ('... a good house, well furnished, has good portraits, a wretched salon ...') particularly noted this picture; he described it as 'portraits of the Litchfield-Hunt [sic], in *true blue* frocks, with ermine capes'. The ermine capes appear to have been an embellishment to the Beaufort Hunt coats sported only by the Earl of Lichfield and his uncle, perhaps to symbolise their own Stuart ancestry; the 3rd Earl of Lichfield was by 1744 fourth in line of descent from Charles I.

The 1933 sale included pastel portraits by William Hoare of the 3rd and 4th Earls of Lichfield, the 4th and 5th Dukes of Beaufort and Sir Watkin Williams Wynn, 3rd Bart (lots 48–52 respectively), all portrayed in 'true blue' Beaufort coats, and all Jacobite sympathisers. Hoare's pastel portraits (present whereabouts unknown) were apparently not dated, but are likely to have been made *c.*1744–5. Sir Watkin Williams Wynn, who died in 1749, was particularly deeply involved in the Jacobite schemes which culminated in the rebellion of 1745, the year after the date of Wootton's painting; but neither he, the Lichfields nor the Beauforts were Jacobites to the point of recklessness. They had pledged themselves to rally to the Pretender's flag if his bid for the throne was supported by a French invasion: but 'on learning that the Young Pretender had landed in Scotland without French support they made no move' (Romney Sedgwick, *The House of Commons 1715–1754*, II, 1970, p.545). By November 1760, Horace Walpole was able to report that the Earl of Lichfield had 'kissed hands' at St James's: that is, had sworn allegiance to the Crown in the person of the newly acceded third Hanoverian king, George III.

George Henry Lee succeeded his father as 3rd Earl of Lichfield in 1743, having represented Oxfordshire in the House of Commons for the previous three years (as a Tory). He was High Steward of the University of Oxford from 1760 to 1762, and Chancellor of that University from 1762 until his death; he also (having sworn allegiance) held offices in the Royal Household as Lord of the Bedchamber from 1760 to 1762 and as Captain of the Gentleman Pensioners from 1762 until his death. Walpole described him in 1759 as 'unalterably good-humoured', adding 'if he did not make the figure that his youth had promised, the Jacobites could not reproach him, as he had drowned his parts in the jovial promotion of their cause – but of late he had warped a little from what they thought loyalty' (Lord Holland (ed.), *Horace Walpole: Memoirs of the Reign of King George the Second*, III, 1846, p.166). Lady Louisa Stuart recalled him as 'a red-faced old gentleman, shaking all over with the palsy, who had almost drunk away his senses, and seemed hardly to know what he was saying or doing' (Hon. James A. Home (ed.), *Lady Louisa Stuart*, 1899, pp.26–7). He was in fact only fifty-four when he died in 1772. He had married Dinah, daughter of Sir Thomas Frankland, but left no legitimate issue, and the title

passed to his uncle Robert. His will (PCC Taverner 368) left 'all my stud of Horses' (as well as most of his other property) to his uncle, 'requesting him nevertheless to take care that those of my Horses known by the following names (to wit) Old Billy, Mungo and Old Badminton are well kept and fed on the premises as long as life can be made agreeable to them . . .'

Robert Lee, youngest son of the 1st Earl of Lichfield, was aged seventy-six when he succeeded his nephew as 4th Earl in 1772. He died four years later, at Ditchley, as the result of a fall from his horse while hunting (the same fate had overtaken his fellow-member of the Beaufort Hunt and fellow-Jacobite, Sir Watkin Williams Wynn, in 1749). As the 4th Earl of Lichfield left no issue or heir, the peerage became extinct upon his death. It may be noted here that an earlier member of the Lee family, Captain Thomas Lee, is represented in the Tate Gallery in a portrait attributed to Thomas Gheeraedts (T 03028), also sold from the family collection in 1933.

The anonymous author (Thomas Martyn) of *The English Connoisseur*, 1766 noted that this picture, which he described as 'Landskip. by Wootton: in which there are introduced his Lordship, and the Hon. Mr. Lee, taking the diversion of Shooting', hung 'with three Hunting-pieces, by Wootton', in the Music Room at Ditchley. The present whereabouts of the 'three Hunting-pieces' is not known. Wootton's large painting 'Stag-Hunting at Badminton', portraying the 3rd Duke of Beaufort and others, is in the collection of the present Duke of Beaufort (sight size 2500 × 3650, 100 × 146). Wootton's painting called 'The Beaufort Hunt with the Duke of Beaufort', though apparently showing the central figure in a dark green coat, was formerly in the collection of Lt-Col. Harold Boyd-Rochfort, and was sold at Christie's 23 June 1978 (49, repr. in col.), bought by Ackermann.

The minutes of the Board of Trustees of the Tate Gallery record (20 June 1933) that no. 165 was purchased by the National Gallery 'for presentation to the Tate Gallery with a view to initiating a room of British sporting pictures'.

166 Muff, a Black and White Dog ?c.1740–50

T 02379
Oil on canvas 1250 × 1015 (49¼ × 40)
Inscribed 'J. Wootton' at the base of a stone
pillar on the left and, as if carved across the
middle of its column, 'MUFF'
Presented by Mr Paul Mellon KBE through
the British Sporting Art Trust 1979

PROVENANCE
?The 2nd Duchess of Portland (d.1785);...;
Mrs W. Duncan, sold Sotheby's 28 November
1962 (86) bt Oscar and Peter Johnson, from
whom bt by Paul Mellon 1963

LITERATURE
Egerton 1978, pp.25–6, no.27

This is evidently a pet dog of considerable charm but mixed breeding (?spaniel-pointer cross) and indeterminate sex. An old inscription on the back read (before relining) 'From the Collection of the Duchess of Portland'. That Margaret Cavendish, 2nd Duchess of Portland, should have asked Wootton to paint a pet dog is perfectly credible, particularly as her father, the 2nd Earl of Oxford, had been one of Wootton's earliest and most faithful patrons; but no painting of a dog called Muff is recorded in any of the catalogues of pictures at Welbeck Abbey, nor in the sales of the contents of the Duchess of Portland's Museum in 1786. A portrait by Wootton entitled 'Minx, a little Spaniel Bitch' is listed in a MS catalogue of paintings at Welbeck in 1747, and it is conceivable that 'Muff' was misread or mistranscribed as 'Minx': last recorded at Welbeck in 1861, that picture must subsequently have left the collection. Two paintings of dogs by Wootton remain in the Duke of Portland's collection: 'The Countess of Oxford's Spaniel Casey', described in the 1747 catalogue as a portrait of the bitch Casey lying on a cushion, with a picture on the wall of Mina and Die, two other dogs; and 'Two Dogs, Gill and Die, and a Dead Hare' (R.W. Goulding & C.K. Adams, *Catalogue of the Pictures belonging to His Grace the Duke of Portland*, 1936, p.x, and nos. 485 and 487).

One of Wootton's odder classical buildings in the background on the right offers no clue to the identification of the setting of the dog's portrait; John Harris (in correspondence) describes it as a pedimented loggia *in antis*, an improbable construction possibly based on a design by Marot or Le Pôtre.

Though chiefly known as a painter of horses, Wootton evidently received many commissions for portraits of dogs. Horace Walpole announced to Horace Mann on 25 April 1754 that his favourite dog Patapan 'sits to Wootton tomorrow for his picture'; Walpole hung Patapan's portrait in his bedchamber (*Walpole's Correspondence*, XVIII, 1954, pp.220–1). An inventory of pictures belonging to the Dukes of Hamilton, taken in 1759 after the death of the 6th Duke, lists three paintings of dogs by Wootton: 'A dog ... called Jewell', 'A Dog called Scipio' and 'A Water Dog ... called Trea' (Hamilton MSS, 13, pp.33 and 35).

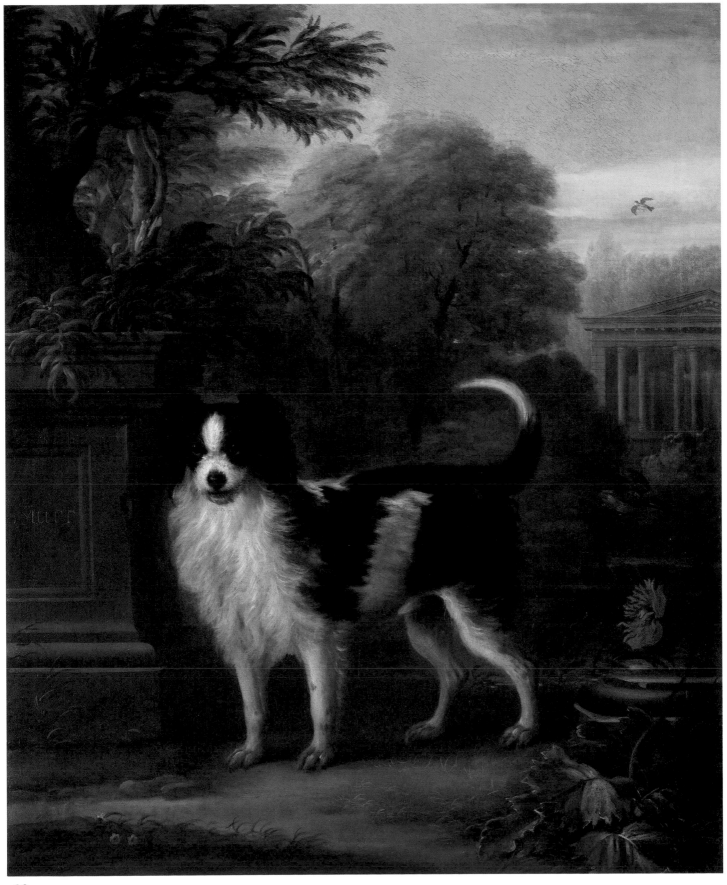

166

167 **Lady Mary Churchill at the Death of the Hare** 1748

T 02378
Oil on canvas 1060 × 1555 (41¾ × 61¼)
Inscribed 'J. Wootton|Fecit 1748' b.l.
Presented by Mr Paul Mellon KBE through
the British Sporting Art Trust 1979

PROVENANCE
...; The Hon. Rachel de Montmorency,
Dewlish House, Dorset, from whom bt by
Colnaghi 1962; bt Paul Mellon 1963

EXHIBITED
Clandon Park, Surrey, on long loan to the
National Trust from the Hon. Rachel de
Montmorency until *c.*1961; *Painting in England
1700–1850: Collection of Mr and Mrs Paul Mellon*,
Virginia Museum of Fine Arts, Richmond,
Virginia 1963 (308 as 'Lady on Horseback
with Huntsmen and Hounds')

LITERATURE
Egerton 1978, pp.26–8, no.29, pl.10

The lady was traditionally identified in the de Montmorency family as Lady Mary Churchill (*c.*1735–1801), Horace Walpole's half-sister, the illegitimate daughter of Sir Robert Walpole by his mistress Maria Skerrett, whom he married after his first wife's death. There seems to be little reason to doubt this identification, for although her portrait in no.167 is hardly a sharply distinguished one, there appears to be a sufficiently credible resemblance to Lady Mary Churchill's features as shown in Arthur Pond's portrait drawing (repr. W.S. Lewis (ed.), *Horace Walpole's Correspondence with the Walpole Family*, 1973, facing p.41), in Johann Eckhardt's portrait 'Colonel Charles and Lady Mary Churchill with their eldest son', *c.*1750 (exh. Yale University, Beinecke Rare Book and Manuscript Library, *A Guide to the Life of Horace Walpole*, 1973, no.46, repr.) and in Eckhardt's portrait of Lady Mary Churchill with a music book, *c.*1752 (repr. W.S. Lewis, *Horace Walpole*, 1961, pl.11).

Wootton had earlier painted several hunting pictures for Sir Robert Walpole, including a portrait with horses and hounds of 1727 (repr. John Steegman, *The Artist and the Country House*, 1949, pl.34). When Sir Robert Walpole died in 1744, his daughter Mary was still under age. On 23 February 1746 she married Charles Churchill (?1720–1812), the illegitimate son of her father's old friend General Charles Churchill by the actress Ann Oldfield. Charles Churchill served in the Army and succeeded his father as Deputy Ranger of St James's and Hyde Parks 1745–57. Lady Mary Churchill herself held Court appointments, as Housekeeper first of Kensington Palace and later of Windsor Castle. As her husband's name was never traditionally linked with no.167, the figure of the man in brown who ceremonially presents the dead hare is presumably that of a hunt servant.

Throughout his life Horace Walpole showed kindness and affection to his half-sister; she (in later years with her husband) frequently stayed with him at Strawberry Hill, and Walpole hung Eckhart's portrait of her in his Great Parlour there. Wilmarth Lewis (1961, p.170) suggests that the disappearance of Horace Walpole's letters to Lady Mary Churchill is one of the chief losses of his correspondence.

A remote red-brick house with a small turret in the background has not been identified. Lady Mary Churchill and her husband lived first at Farleigh Wallop, near Basingstoke, Hampshire, and later in a 'Gothick' house designed for them by Horace Walpole's friend John Chute.

The frame appears to be contemporary with the painting, and may be its original frame.

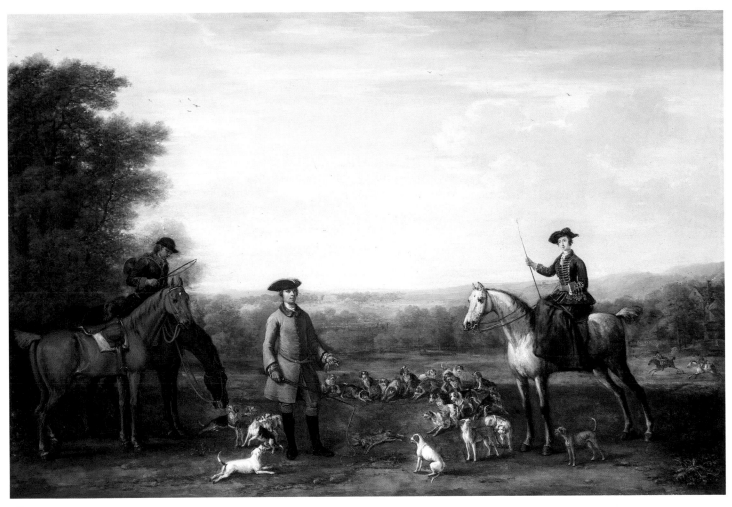

167

FRANCESCO ZUCCARELLI RA 1702-1788

One of the most highly acclaimed landscape painters of his day, occasional portrait and history painter, tapestry designer and possibly scene painter, influenced by Marco Ricci. Born in Pitigliano, Tuscany, 1702, but active in Venice from *c.*1730, where he was extensively patronised by British travellers and became friendly with Richard Wilson in 1750-1. Settled in London October 1752, but returned to Venice 1762. By February 1765 he had resumed his successful career in London, becoming a founder member of the RA in 1768. Exhibited RA 1769-73, FSA 1765-6 and 1782, and SA 1767-8. Returned to Venice in late 1771, elected President of the Venice Academy 1772, but soon retired to Florence, where he died towards the end of 1788.

LITERATURE
M. Levey, 'Francesco Zuccarelli in England', *Italian Studies*, XIV, 1959, pp.1-20; Croft-Murray 1970, pp.296 a-b, 297b; *Gentleman's Magazine*, LIX, 1789, p.276.

168 **A Landscape with the Story of Cadmus Killing the Dragon** 1765

T 04121
Oil on canvas 1265 × 1572 ($49\frac{3}{4} \times 61\frac{7}{8}$)
Purchased (Grant-in-Aid) 1985

PROVENANCE
...; said to come 'from the Earl Spencer's Collection', but not traceable in nineteenth-century catalogues of paintings at Althorp; ...; Thomas Capron, sold Christie's 3 May 1851 (40 as 'Jason Destroying the Dragon, in a Grand Woody Landscape, near a Cascade') bt Clarke; ...; anon. sale Christie's 19 November 1982 (49, repr.) bt Colnaghi from whom bt by the Tate Gallery

EXHIBITED
SA 1765 (211); *Views from the Grand Tour*, Colnaghi, New York 1983 (50, repr)

LITERATURE
E. Fryer (ed.), *The Works of James Barry, Historical Painter*, I, 1809, p.19; Levey 1959, p.12

The painting, which dates from Zuccarelli's second stay in London, takes its subject from Book III of Ovid's *Metamorphoses*, where Cadmus, on his journey to Thebes, is called upon to overcome a dragon sacred to Mars. The 'serpent', which dwells in a cave beside a spring in the primeval forest, destroys the hero's companions when they come to collect spring water for a libation. Protected by a lion-skin and armed with a javelin, Cadmus first throws a massive boulder at the dragon, then backs it against an oak tree and spears it to death.

Zuccarelli renders the scene with great accuracy of detail, but characteristically reduces Ovid's towering monster to proportions that do not interfere with the pleasantly Arcadian landscape and make the hero's victory reassuringly predictable. Similarly, the mangled remains of Cadmus's numerous companions have been reduced to two figures lying on the ground as if asleep. The result is a handsome painting which Barry, on seeing it at the 1765 exhibition, described as

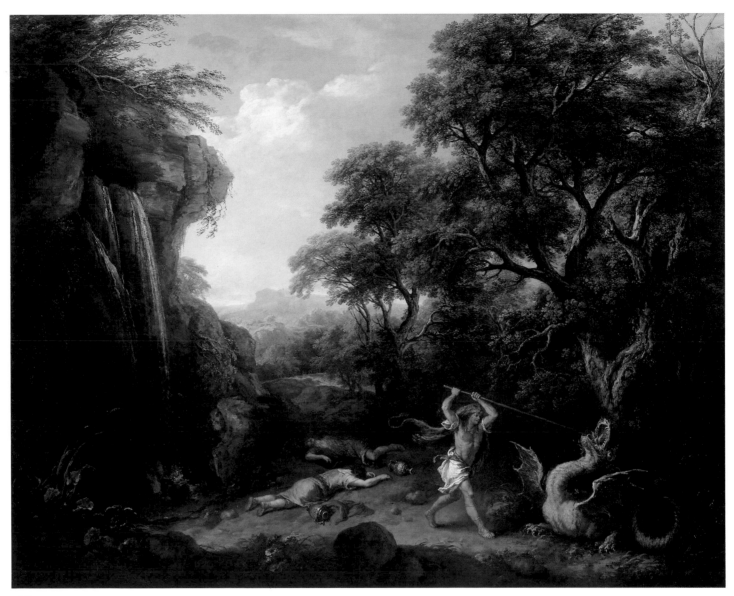

168

'an exceeding good landscape'. While enhancing its interest by the insertion of a classical subject, Zuccarelli lets the landscape element predominate, perhaps in order to associate himself more directly with the Claudean tradition.

In view of Zuccarelli's undoubted early influence on Richard Wilson, it is interesting to compare this pleasingly coloured Rococo composition with Wilson's gloomily dramatic rendering of an equally savage subject from Ovid a few years later, the 'Meleager and Atalanta' of 1771 (т 03366), in order to observe how differently Wilson had evolved his interpretation of landscape as a vehicle for dramatic and poetic expression, while retaining much of Zuccarelli's basic compositional formula.

INDEX